PERFORMANCE
IN THE CINEMA OF
HAL HARTLEY

PERFORMANCE
IN THE CINEMA OF
HAL HARTLEY

STEVEN RAWLE

CAMBRIA PRESS

Amherst, New York

Requests for permission should be directed to:
permissions@cambriapress.com, or mailed to:
Cambria Press
20 Northpointe Parkway, Suite 188
Amherst, NY 14228

Library of Congress Cataloging-in-Publication Data

Rawle, Steven.
 Performance in the cinema of Hal Hartley / Steven Rawle.
 p. cm.
 Includes bibliographical references and index.
 ISBN 978-1-60497-745-5 (alk. paper)
1. Hartley, Hal, 1959—Criticism and interpretation. I. Title.

 PN1998.3.H3695R39 2011
 791.4302'33092—dc22

2010054594

To my parents, Ralph and Barbara,
who have contributed more than anyone
to see that this project reached your hands

TABLE OF CONTENTS

LIST OF FIGURES

PREFACE

The genesis of this book goes back almost two decades. As a fresh-faced teenager, just awakening to the possibilities of cinema, I was fortunate enough to be able to see a season of independent American films on Channel 4 in the United Kingdom in the early 1990s. A couple films in particular stood out, which I seem to remember were *The Unbelievable Truth* and *Trust*. The films seemed different. The dialogue was unusual, the performances wry and witty, and the films were not like anything I had seen before. Although I was aware of other indie filmmakers, like Jim Jarmusch, Whit Stillman, John Sayles, Allison Anders, Spike Lee, Steven Soderbergh, the Coen Brothers, and later Kevin Smith (Hartley, the self-styled *auteur*, was horrified by Smith's thanks to him at the end of *Clerks*), this exposure in particular began my long interest in independent film, especially Hartley's work, that has culminated in the book in your hands.

The reason for mentioning this is that it feels like a bygone age. For many, the indie boom of the 1980s and 90s seems like a long time ago indeed and is cause for much nostalgia. For me, that whole scene was

linked to the sound and ethic of independent musicians, some of whom were involved with Hartley, like Sonic Youth (whose "Kool Thing" scores the dance scene in *Simple Men*), Yo La Tengo (who appear in *The Book of Life*), and David Byrne. Subsequently, corporate Hollywood strengthened its grasp on independent cinema and, although there are still filmmakers making indie-style films within the mainstream (for example, Wes Anderson, Spike Jones, Charlie Kaufman, Sofia Coppola), it still feels like a "lost" era to many. However, the use of digital technologies suggests that independent filmmaking, although it remains on the margins, might be on the rise. Cheaper cameras and computer editing software have made it possible for anyone to make and edit films, and platforms like *YouTube* and *Vimeo* make it possible to distribute those films. The question is how the potential young fan can access films like those of Hartley, and how to distinguish an indie film from a viral. With the sad decline of wide access to films outside the mainstream (especially in the United Kingdom, where even satellite television has only Sky's Indie Movie channel, which would more accurately be called an Indiewood channel). Festivals offer one avenue, although these are not accessible to most.

For Hartley, the Internet has become a key mode of dissemination for his work as he has shifted into self-promotion and distribution. In many ways, this book engages with the growing importance of web-based promotionand distribution for modern independent filmmakers, because funding and opportunities have dried up. As an educator of future filmmakers, I am very conscious that the independent avenue becomes a more and more significant career strategy for budding filmmakers. While the main discourse of the book is a critical analysis of Hartley's performance text, the issue of changes in the production and distribution of contemporary independent cinema becomes central toward the end of the book, and the final chapter charts the changing terrains, both industrial and technological, that have necessitated and facilitated a change in Hartley's methods, authorship, and aesthetics. If a filmmaker like Hartley, with a strong critical reputation behind him, is struggling to make

and distribute work, what hope is there for the young, committed artistic independent filmmaker?

There are many to thank for their patience, help, and mentorship throughout the process of researching, writing, and finishing this book. Initial gratitude goes to those at Cambria Press, who have been so helpful, to Toni Tan, and especially to Paul Richardson for helping to get the project moving, and everyone who has been involved in putting the book together. Thanks go to Paul Coates, Aylish Wood, David Hewitt, Martin Fradley, Lesley Harbidge, Geoff King, and Alan Marcus, who read the text in various guises, shapes, forms, and stages, and provided invaluable advice, guidance, and help in getting this into a shape that was in anyway readable. Great kudos to my current and former colleagues in the department of film and television production and the faculty of arts at York St John University, who have covered teaching while I have been on research leave and have listened to me complain and agonise over "the book". Thanks go to Celine Kingman, Kevin Gash, Wendy Burke, Jimmy Richards, John Marland, Lee-Jane Bennion-Nixon, Peter Cook, Robin Small, Andrew Platts, Liz Greene, Alan Clarke, Saffron Walkling, David Thom, Helen Lofthouse, and Lucas Swann. Thanks also go to those who helped organise my research leave and were good enough to support conference travel and research (often at the last moment): Robert Edgar-Hunt, Gary Peters, Jeff Craine, Steve Purcell, Robert Wilsmore, and Alison Rigg. Good cheers should also go to the friends whose support has been appreciated over nearly the last decade in which this book has been written. Thanks should also go to all of the students of York St John University and the University of Aberdeen, who, over the past six years, have been exposed to Hartley's work and have responded with critical ideas and kindness. Finally, thanks should go to my family, my parents, Ralph and Barbara, who did more than most to see that this book reached your hands, and my brother Andrew, who has listened to a great deal over the past few years. And then, to Lorna, who was not there at the beginning, but who has been instrumental in helping me get through the final year of work, and without whom this simply could not have been completed.

PERFORMANCE
IN THE CINEMA OF
HAL HARTLEY

THE CINEMA OF HAL HARTLEY AND PERFORMANCE

As a film-maker, I think primarily in terms of movement anyway. Even if that movement is very small. A close-up is, for me, still choreographed. I believe that as a storyteller I even conceive of characters physically. I like to know how a character walks, sits, stands, sleeps, etc. before I can write what they say. At this point I'm certain this is because, despite the fact that I love story, character and dialogue, when I isolate the primary elements of film I find photography, movement and sound recording—in that order. Only then do I consider dramatic action. Film is essentially graphic for me.[1]

A Hartley film can be analyzed and justified, and a review can try to mold the intractable material into a more comprehensible form. But why does Hartley make us do all the heavy lifting? Can he consider a film that is self-evident and forthcoming? One that doesn't require us to plunder the quarterly film magazines for deconstruction?

—Roger Ebert on *No Such Thing*[2]

A review of the DVD of Hal Hartley's *The Unbelievable Truth* (1989) praises the film as "quirky" and "engaging" but criticises "the atrocious acting", where most of the cast "seems to be performing in a high-school play ... in a large auditorium ... where it's necessary to yell".[3] The review highlights a common blockage that is not just specific to Hartley's films, but also to popular and academic criticism of film. A selection of both positive and negative reviews of Hartley's films emphasise the problematic relationship between performance and criticism with references to "laid-back silences",[4] "comically stylised hair-tearing",[5] "subtle, resourceful actors",[6] "deadpan non sequiturs",[7] "deadpan readings",[8] the "clipped, slightly elevated register",[9] "impassive", "wooden"[10] or "controlled and carefully composed" acting,[11] "stiffness and sparsity",[12] "percussive dialogue, spoken in flat tones",[13] "unbelievable performances",[14] "opaque stage business",[15] or "flat" and "unaffecting" performances.[16] Subjective opinions seem to decide whether Hartley's approach to performance is successful or not, although few critics seem able to decipher why Hartley should approach performance in this manner. Thierry Jousse's observation in *Cahiers du Cinéma* that Hartley's preferred mode of performance strikes an "equilibrium ... between the artificial and the natural"[17] is one of the few reviews to determine the function and consequence of Hartley's approach to the abstraction of performance.

Hartley has been considered a key player in the independent boom of the 1980s and 1990s, but often features, critically, as a notable, but largely secondary figure.[18] Hartley has never achieved significant cross-over success, unlike many of his peers. Like other noted independent filmmakers, however, Hartley portrays a highly developed authorial style, including tableaux-style composition, a distinctive writing style, particular ways of working with performers, and a recurring use of electronic and minimalist music (composed by him, previously under the pseudonym Ned Rifle). Born in 1959 and raised in Lindenhurst, Long Island, New York, Hartley grew up in an industrial blue-collar environment. After graduating from the State University of New York at Purchase, Hartley returned to this environment for his first film, *The Unbelievable Truth*, which was shot in Lindenhurst and provides

the working-class background to the story, which also frames later films such as *Trust* (1990) and *Simple Men* (1992). The imagery of washed-out colour and guitar-wielding mechanics seems indebted to Hartley's hometown, as does much of the language used by his characters—scripts and performance often turn into repetitious structures or have sudden shifts in tone and vocal intonation, sometimes incongruously when put in the mouths of working-class males. Later films move away from this territory, mostly to New York City, in *Amateur* (1994) or *The Girl from Monday* (2005), but a global focus has developed in Hartley's work, most notably in *Flirt's* (1995) with its three international settings, New York, Berlin, and Tokyo, and in *No Such Thing* (2001) and *Fay Grim* (2006). Although Hartley's milieu has expanded in the twenty years since the release of *The Unbelievable Truth*, much of his distinctive style has remained consistent, especially in the use of performance and performers. A regular ensemble including Thomas Jay Ryan, Bill Sage, Robert John Burke, Parker Posey, Elina Löwensohn, D. J. Mendel, Miho Nikaido, and David Neumann continue to feature in Hartley's work, while earlier collaborators such as Martin Donovan, Adrienne Shelly, Edie Falco, Matt Malloy, Chris Cooke, and Mark Bailey helped develop a distinctive performance style that (1) rejected empathy; (2) used flat or inexpressive vocal tones with staccato bursts of emotive language; (3) incorporated a dance-like, choreographed use of the body in scenes of violence and movement; and (4) emphasised the role of the performing in constructing the text. Although Hartley's visual aesthetic has developed, mostly in accordance with changes in film technology, such as the shift from film to digital, and to different collaborations with cinematographers,[19] this performance style has remained very consistent, just as Hartley's regular performers have remained fairly consistent across his oeuvre. It is this part of Hartley's work, and the problems with which it has presented critics, which concerns this book.

Academic film studies has long been guilty of undertheorising performance. John O. Thompson, as long ago as 1978, identified acting as a "gap" in the film studies project.[20] Peter Krämer and Alan Lovell contended that film theory has found it "all too easy for the work of the

individual actor to be discounted" as "the way technology mediates acting in the cinema is a disincentive to taking it seriously". Therefore, "many analyses of film acting are in fact discussions of a fictional character (whose creation is the work of a writer) rather than analyses of how that character is embodied (the work of an actor)".[21] Thus, as James Naremore referred to acting, the "aleatory, biological fact"[22] of the body's performative significance has been a secondary critical consideration.[23] More recently, following the work of Krämer, Lovell, and Naremore, Adrienne L. McLean has attempted to show how film theory has ignored the role of the actor's body in performance:

> Despite the importance of bodies and embodiment as the locations of narrative meaning and points of spectatorial identification in film, there are several reasons for the relative lack of attention paid to film acting over the past thirty years—the alliance in poststructuralist film theory of the body with generic psychic mechanisms such as voyeurism and fetishism; the feeling that technology intervenes between bodies and spectators such that *our experience of the filmed body is rarely felt as physical or material*; and, perhaps most pertinent, the lack of theoretical tools with which to explore embodied meaning.[24]

Although a theory of embodiment, such as that of Steven Shaviro, can suggest that the "flesh is intrinsic to the cinematic apparatus, at once its subject, its substance, and its limit",[25] the body is not posited as a site of performative capacity: "the ambivalent cinematic body is not an object of representation, but a zone of affective intensity, an anchoring point for the articulation of passions and desires, a site of continual political struggle".[26] Perhaps as a consequence, star studies have often overshadowed the study of film performance, where the emphasis on "the discursive, technological and economic structures within and through which stars are produced and circulated"[27] has promoted the study of star image over that of the performer. Performance has been viewed as an important element in the creation of star personae,[28] but the study of performance on film has often been left trailing.

As Paul McDonald has argued, it is perhaps the inability of screen performance to be scientifically theorized that has led to its relegation to the margins of film scholarship until now; as he proposed "the analysis of acting will never become a precise semiotic science".[29] Likewise, in *Reframing Screen Performance*, Cynthia Baron and Sharon Marie Carnicke postulated that the theoretical focus of film studies in the 1970s overshadowed the contribution of the performer to the screen experience because semiotic approaches focused almost exclusively on editing or the gaze of the camera.[30] Extending this methodological critique, McDonald argued that, although there is a degree of empiricism in the reading of film performances,

> that impression should not be mistaken for a lack of detail, nor should impressionism be regarded as preventing insightful analysis and criticism. Instead, what is at issue is how to integrate those impressions into an understanding of the contributions that acting makes to the construction of meaning in cinema.[31]

Like McDonald, Baron and Carnicke made a persuasive argument for the promotion of performance to a central position in thinking about cinema. Taking a stance against earlier interpretations of cinema, they attempted to demonstrate that "framing, editing, and production design do not *do all the acting* in screen performance".[32] Although their argument is necessarily polemical, their "reframing" of screen performance locates acting and the work of the actor as a critical part of film's own performance that plays a crucial role in interpretation, just as McDonald does. Baron and Carnicke argue that in the context of film's composite form "viewers encounter performance in relation to other cinematic elements". Their methodology, derived from theatre studies, theatrical practice, Prague structuralism, and film industry contexts, provides an "understanding of screen acting" that they believed "enables fresh insights into film practice generally, for the corollary is that audiences also interpret nonperformance elements through and in terms of their conjunction with acting choices".[33] Baron and Carnicke's "reframing" therefore is a reframing of cinema in terms of the composite elements

that combine to determine the affectivity of cinema *generally* rather than the previously hierarchised elements that have attributed all of cinema's effects to the work of nonperformance elements, whereas authenticity has long been rooted in the "liveness" of theatrical performance. Baron and Carnicke's book offers an important resituation of performance within cinema's discourse and a reclamation of the actor's physical and interpretative craft in cinema's own performance.

Other recent attempts to inscribe the performer into cinema studies have concentrated on the physical materiality of gesture and movement. Andrew Klevan, for instance, has attempted to expound "a method for sustaining attention to a *performance*" in order to facilitate, like Baron and Carnicke, "an exploration of the tight-knit relationship of the performances to the surrounding aspects of film style".[34] Likewise, in their introduction to *Falling for You: Essays on Cinema and Performance*, Lesley Stern and George Kouvaros considered "the broader issue of performance as a textual and corporeal process", and "how performance is manifested cinematically, how it registers semantically and somatically as *cinema*".[35] Klevan, Stern and Kouvaros all agreed that the study of cinematic performance is problematised by the "descriptive acts" necessary to effectively convey an onscreen performance through prose.[36] Nevertheless, performance is an intrinsic part of the cinematic image— the voice and body of the actor form a key component of the critical and affective appreciation of cinema and its effects.

Accurately noting that the "question of stardom problematizes the question of performance",[37] Philip Drake addressed the problematic relationship conflict between notions of presence and intention in the reception of film performance (especially star performances) in his article "Reconceptualizing Screen Performance". Drake, drawing on earlier work by Grahame F. Thompson, argued that "performance is not just the intersection of the text/actor/character", but "its 'mode of assessment'". Acknowledging "the centrality of interpretation, and an audience, to the process of performance",[38] Drake contended that "presence ... is a discourse produced *by* performance during its reception; it does not precede it".[39] Drake's analysis critiqued the ways in which star performances

are constructed in "different economies of acting and the motivation we assign to them",[40] that exceed narrative and diegetic space, where star performances are containable only as "the products of stars ... by varying the ostensiveness of performance, as well as external reframing signifiers (such as publicity and reviews)".[41] Although Drake's article concentrated mostly on the inter- and extratextual star texts that help to construct star performances, he also conceded that "not all screen performance is as committed to closing the gap between performer and character. Some forms of performance are designed to disturb or put aside questions of narrative coherence and motivation".[42] The exemplars here are those performances that exceed or complicate the ontology of performance, such as stunts, comedy, or song-and-dance routines, but the "broad spectrum" of performance, as Drake referred to it, encompasses performances, like those in Hartley's films that disrupt or construct a different "economy" of performance, and the "cultural practices"[43] involved. He argued that "a performance is not simply a text; it is, after all, a socially embedded experience".[44] This is an important contention for the films of Hartley, especially *The Unbelievable Truth* and *Trust*, and will be explored throughout subsequent chapters.

The intention of this book is to contribute to ongoing work in this problem area of scholarship in film performance and to address the shortfall in academic enquiry into the films of Hal Hartley. Despite Jonathan Romney's claim that "these days, people write PhD theses about Hartley",[45] academic inquiry into his work has been extremely limited. As I write, only a handful of sources exist, including just one PhD thesis.[46] In addition, the only book on Hartley remains Jason Wood's short *Pocket Essentials* monograph,[47] released in 2003. However, with the exception of Sophie Wise's "What I Like About Hal Hartley, or Rather, What Hal Hartley Likes About Me: The Performance of the Spect(actor)" in Stern and Kouvaros's anthology, Hartley's approach to performance is seldom discussed as a central aesthetic or thematic feature of his work.

Therefore, this book will explore the key aesthetic and thematic aspects of performance that run throughout his films. Performance is fundamental to the understanding of Hartley's work. The 2004 short

The Sisters of Mercy demonstrates a major facet of Hartley's approach to performance. Assembled from the outtakes of an earlier film (*Iris*, 1993), Hartley described the film as "a documentary concerning the periods between the actual takes".[48] The film exposes the labour and activity of the performers and the process by which a performance becomes fixed in the final text. The exposition of the performer as a performer, rather than as just a character, is a concept that runs throughout Hartley's work, from early work such as *Surviving Desire* (1991) to later films like *No Such Thing*. The performer is at the core of Hartley's oeuvre and influences much of the stylistic systematisation of his work, where the abstract text functions to emphasise the individual units of signification within a performance. By combining different modes of performing— including alienated acting, dancing, mime, and gestural movements—the activity of the performer is made abstract, exposing the illusion behind the conventional goals of the actor. In this respect, Hartley is heavily influenced by Brecht and Godard, whose modernist projects attacked the bourgeois realist text, where performances were hidden behind the illusions of character and spontaneity.[49] As such, the term "performance" is preferred to that of "acting" in this study because it suggests a whole continuum of possible activities, of which acting is just one subset of potential signs and outcomes.

Any movement performed by the body is tangible, materially enacted by the musculature of the performing body. Movements and gestures have a relationship with the space that surrounds them that more directly "meaningful" actions, such as speech and facial contortions, do not. A materialistic theory of film, like that of Robert Bresson, posits the physicality of the actor above the affective potential of the voice: "The things one can express with the hand, with the head, with the shoulders!... How many useless and encumbering words then disappear! What economy!"[50] The connotative abstraction of gestures therefore substitutes body movement for more systematised modes of communication. Bresson's theory of cinematography (a method for "writing with images in movement and with sounds"[51]) favours the abstraction of movement above the mimetic processes of acting that predominate in

most dramatic texts from the mid-nineteenth century onwards. In place of the conventional actor, Bresson saw the "human model": "No actors. (No directing of actors.) No parts. (No learning of parts.) No staging. But the use of working models, taken from life. BEING (models) instead of SEEMING (actors)". As such, Bresson inverted the system of performance in the Stanislavskian methodology: "HUMAN MODELS: Movement from the exterior to the interior. (Actors: movement from the interior to the exterior.)"[52] Although his theory is based around notions of transcendence, Bresson constructed a materialistic paradigm of performance. The use of the term "model" suggests an inert body ripe for manipulation on-screen—actors as machines—rather than the spirituality of the actor in modes of performance that effect a shift from interior to exterior where the actor "lives" a part. Bresson's "models" do not live a part, they perform—the external realisation of performance provides a means for transcendence ("BEING instead of SEEMING"). The performance of the "model" is therefore gestural, based in the physicality of the performer, rather than in the mimicry of real affective uses of voice, word, and nonabstract gestures that pre-exist the performance of the actor.

Hartley and Bresson are undoubtedly linked by their Catholicism—in films such as *Amateur*, *No Such Thing*, and *The Unbelievable Truth*, where faith is a key theme—but there is also a similar concentration on gesture and the movement of the body. Bresson's insistence on the mechanical performance of the models places an emphasis on the lack of emotional inflection in the performance of the body. This is a feature that Bresson developed through a rigorous repetition[53]—a facet that Hartley shares. Additionally, Hartley has spoken of his admiration for Bresson and what he perceives as their shared emphasis on minimalism:

> I am very affected by Bresson ... Sometimes it's just an emotional clarity that I sense in his films, that I try to bring to mine when I'm writing. When I'm shooting too. Bresson cuts right past everything that's superfluous and isolates an image that says exactly what it's meant to say.[54]

To illustrate his point, Hartley mentioned a moment in *Surviving Desire* (figure 1), where Jude reaches out to touch Sophie's hand. Rather than shoot the scene in two matching close-ups, as a traditional shot-reverse-shot pattern, Hartley recognised the "Bressonian" quality of the action, "that the gesture itself was expressive".[55] Therefore, Hartley films the action in close-up, isolating the gesture. The approach towards the body here is elliptical, abstracting movement to emphasise the expressive nature of the gesture, its ability to convey the interior of the character using body movement in conjunction with the isolating distance and angle of the camera. There is a similar moment in *Flirt*, where Hartley films Bill's hand touching that of a woman at a phone booth (figure 2). Again, the gesture is filmed in close-up, fragmenting the body, and

FIGURE 1. A close-up abstracts and makes a gesture expressive, "isolating an image" by fragmenting the body to focus on performance signs.

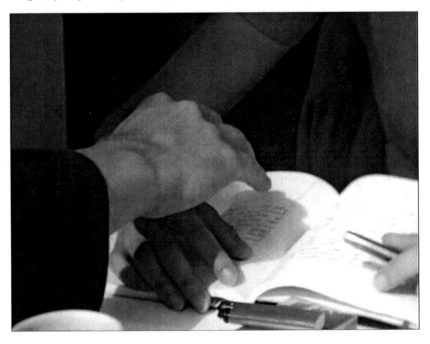

emphasising the expressive nature of the gesture in the context of the narrative, effectively demonstrating Bill's relationship with the unknown woman. Additionally, the moment in *Flirt* has something mystical about it, suggesting a haptic connection between the two characters that is intimate despite their seeming lack of knowledge of each other. What both these moments highlight, however, is Hartley's use of gestural modes of performance, where the camera abstracts and isolates units of potential meaning, where context and style supplement and frame other possible meanings.

The conception of performance in this exploration draws on a range of theoretical and analytical frameworks, from film and theatre, as well as from anthropological and sociological work. As Hartley's use of the

FIGURE 2. A recurring feature of Hartley's work, the gesture is emphasised by the close-up to focus on the performance sign.

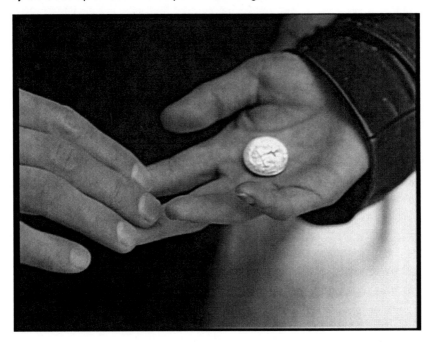

performer also unlocks a number of social and cultural concerns about performing in public and private spaces, the notion of performance utilised here is required to explore a different conceptual order from that of just acting, which is mimetic and limiting. The socio-anthropological conception of performance—as in Drake's argument that performance is composed of "cultural practices"—that runs throughout this work draws on the theories of key practitioners, such as Richard Schechner, Victor Turner, and Erving Goffman, whose works have not been fully embraced by the study of cinema, despite the obvious centrality of performance to both cinema and the presentation of sociocultural subjects. Hartley's focus on performances emphasises both the aesthetic processes of labour and creativity and the social and cultural modes of performance that lie behind the composition and maintenance of identity, gender, ethnicity, and social roles.

Despite the discursive centrality of the performer in this book, there is also a palpable authorial presence in the text. Hal Hartley is something of a self-styled *auteur*. In interviews he has professed his belief in the *auteur* theory[56] and his "understanding" that all his work will be "a Hal Hartley film",[57] implying that he buys into popular conceptions of the *auteur* as a means to "unify the text", to use David Bordwell's description of art cinema's authorial significance.[58] This sense of authorial expression and control has recently been magnified by his increased presence as a digital *auteur* through the Possible Films Web site,[59] which emphasises Hartley's role as the principal producer and distributor of his work. This book assigns a key role to filmmaker Hal Hartley as the main creative source of his films, and the figure most responsible for organising the finished film, yet he is not a critical foundation of meaning in the text. As such, the *auteur* appears herein as a function of the author-name, theorised by Michel Foucault as characterising "the existence, circulation, and operation of certain discourses in society".[60] Therefore, Hal Hartley appears in this text as both a proper name describing an individual filmmaker responsible for manufacturing a text and as a signifier of certain discourses that emerge from his films independently of the author's intentions.

Sharon Marie Carnicke has characterised two kinds of filmmakers: the ones who start with the actors and the others who start with the camera and the visual stylisation of the text:

> On the one hand, directors who start with the camera and emphasise the visual design may place high priority on collaborating with actors, while directors who attend to actors' objectives and their vocal and physical choices do not necessarily work collaboratively with them. Those directors who start with the camera but leave actors alone to do their creative work often view them as experts who contribute specialized knowledge and talents to the enterprise.[61]

Actors represent a source of specialised labour—they work with numerous directors and "single actors adjust their techniques as they move from film to film within the limits of their skills and anatomies".[62] Mirroring Baron and Carnicke's criticism of discourses of film outlined earlier, the agency of the actor does count for something in this taxonomy: the film director (as an overall agent of film style) does not do the acting for the actor, just as editing, camera movement, framing, and sound effects do not do the acting in a film's overall performance. The actor has agency within a system of performance. For the material quoted throughout the book, Hartley would appear to be a director who "starts with the actors", or one whose design for his films is focused significantly on performance, gesture, and working with actors. His collaboration over two decades with a significant recurring group of actors and performers stresses an important role for the ensemble in considering the development of a recurring style. Unlike traditional modes of auteurist criticism, the roles of these individuals cannot be attributed to the director's "vision", "personality", or "structure". Actors contribute important decisions and bring training, interpretation, and labour to the films themselves. Therefore, the performances in the films, although they derive from Hartley's scripts (the work of a writer) and benefit from Hartley's direction and organisation of performance in front of a camera (the performance of the image/editing/sound), the sole authorial agency cannot be attributed to a single organising consciousness or vision.

However, Hartley's association with an historical and industrial notion of independence and the authorial expressivity associated with an art cinema can be seen as determining his overarching style as well as encompassing an authoring of performance style, rather than authoring individual performances. This has been the case historically and analytically with key art cinema directors. As Doug Tomlinson noted regarding Bresson:

> Performance in Bresson's films is a product of the aesthetics of denial, notably a denial of all traditional rhetorical approaches. In his films, he attempts to defocalize performance by removing the immediacy of its effect. His central approach involves a denial of systems of projection and identification.[63]

Although this might help situate Hartley's approach to systems of performance in his own films, given the context provided by Bresson's work earlier in the chapter, Tomlinson's methodology is useful in articulating the role of Hartley's authorship in an analysis of performance in his work. Tomlinson attributed an "approach" to performance throughout Bresson's work, and he ascribed key decisions to him as director in organising performance across an oeuvre, in consistency of expression, and in important decisions such as casting and creating a consistency of visual expression. However, Tomlinson did not assign the physical performance to the director, locating it in the work of the actor. Similarly, reprinted in Baron et al., *More than a Method: Trends and Traditions in Contemporary Film Performance*, Tomlinson's article is joined by several others that locate the director as the organiser of systems of performance, but he discussed the work of individual actors or stars as separate and distinct discourses within the overarching discourse of the film text.[64] Likewise, this book situates the actor's agency as a key determinant in forming the performance text of an individual film in the important role the actor fulfils in defining a character in the physical and vocal performance, as well as situating the agency of Hartley, as writer-director-composer, in helping shape that text. Finally, though, it must be remembered, and this is emphasised throughout the book, following Drake, that performance organises a series of economies of performance, drawing on significant

"cultural practices", embedded in social discourses, that contribute to a reading of performance, not a construction of intention.

The book is laid out in a roughly chronological fashion and takes a pluralistic approach to theories of performance. Where Hartley used paradigms of performance (realist acting, dancing, mime, gestural movement), these require different theoretical and analytical perspectives. The first chapter provides a general exploration of the analytical frameworks followed in the book as a means of analysing the basic abstraction of Hartley's films. Exploring the stylistic and formal elements of Hartley's work, this discussion demonstrates how the stylistic systems of the films alienate, abstract, and attack the writing of the realist text. In so doing, this chapter introduces several of the key theoretical strands that run throughout the book: abstraction and the rejection of empathy, the Brechtian emphasis on alienation, and the focus on performance. These impulses, I argue, are fundamental to the subsequent abstraction and emphasis on performing that forms the core of my argument.

In the second chapter, I look closely at Hartley's first two features, *The Unbelievable Truth* and *Trust*. Following up on the emphases introduced in chapter 1, chapter 2 examines the ways in which Hartley's two early teen films self-consciously, with some abstraction of performance style, critique the ways in which the teen characters, especially the female leads of both films (played by the late Adrienne Shelly), role-play and experiment with adult roles. This is done differently in both films, but gender remains a central conceit of both. *The Unbelievable Truth* is explored from the perspective of the central character's experimentation with adult structures of economics and commerce while battling the controlling gaze of her father and the male characters in the film who seek to maintain control over her financially and visually. *Trust*, in contrast, is explored in significant depth as a key statement on Hartley's treatment of both his characters and his actors. Looking especially at the performances of Shelly and Martin Donovan, the bulk of this argument examines the rites of passage taken by Maria Coughlin as she deals with her pregnancy and expulsion from the family home, drawing on theories of ritual liminality and performance to show how this is developing

a theme around social performances that is significant for many of Hartley's subsequent films.

In chapter 3, I explore one of the most memorable and distinctive aspects of Hartley's early films—his use of dance. Although Hartley's films are known for their minimalism, he often allows the performers to express themselves through dance. I explore the use of dance as an extension of narrative space and time, as repetitions of key motifs and character plot arcs. Consequently, I look almost solely at *Surviving Desire*, a shorter work produced for public television. I draw on theories of dance, repetition, and memory to show how the use of dance relates to narrative action and works as repetition and foreshadowing of narrative action, rather than an arbitrary device that artistically distances the viewer from the narrative and characters, denying empathy. The other issue I discuss in chapter 3 is the use of the musical as an intertextual reference and how the dance in *Surviving Desire*, in particular, combines common features of the musical to critique the form, a sign of Hartley's postmodernism that becomes even more pronounced in later films. In order to demonstrate this, I draw on examples from a number of classic musicals and significant critical discourse surrounding the genre by Altman and Feuer. I also look briefly at another dance sequence in *Simple Men*—perhaps one of Hartley's most iconic scenes—which, it is argued, differs significantly from the one in *Surviving Desire* in its cultural focus on gender and gendered power relationships.

In chapter 4, I explore Hartley's films of violence and forays into the crime thriller. I initially extend the argument from the previous chapter by looking further at *Simple Men*. In this chapter, I explore the film as a commentary on masculinity and the self-deceiving performances in which the characters are engaged. Using the dance sequence as a starting point, I argue that the film is a comment on weak masculinity that is out of control. Where characters engage in conscious performances, they are often unable to maintain control over their performances and are apt to repeat previous unsuccessful behaviour, leading to frustration, violence, and misery. This is a consequence of characters that are unable to project a coherent image of self, but at the same time maintaining their belief

in a false image that they intend to project but are unable to master. In *Simple Men*, it is the failure to coherently project an "ideal" masculinity (if such a thing exists) that is the problem of the simple men of the title.

The second film I explore is *Amateur*, Hartley's "thriller with a flat tyre". Continuing from the discussion of *Simple Men*, this section further explores the liminal performances of the main characters and their attempts to portray themselves as other selves, performances that are ultimately doomed to failure, either from a lack of self-control or simple problems of fate where characters are unable to distance themselves from their previous selves (for reasons of amnesia or incompetence). Again, the focus is on Hartley's manipulation of performance, on both the aesthetic level and in the commentary on social, religious, and political topics, where *Amateur* engages with problems of faith, gender, pornography, and maintenance of a performed self. Finally, I explore Hartley's approach to generic violence, because both these films roughly fall into categories of the thriller. However, I argue that Hartley's approach to violence is distinctive, offering a Brechtian commentary on the processes of performing and consuming scenes of violence.

In chapter 5, I consider three of Hartley's most distinctive films: *Flirt* (1995), *Henry Fool* (1997), and *No Such Thing* (2001). Again considering the issue of performance, I look at the ways in which each film makes a distinctive, and shifting, contribution to Hartley's oeuvre. *Flirt* is first considered as a comment upon social performances. Although this is a key obsession of Hartley's, I consider the ways in which this is developed differently throughout *Flirt*, as a very self-conscious and self-reflexive statement on the processes of repetition, performing, and being watched in the social space. Next, I explore *Henry Fool* and the epic performances of the main characters. The film unfolds on a much greater canvas than previous Hartley works and is therefore considered as a grand statement on the systematic use of abstract performances in a largely realist film, both an extension of his previous works, considering social modes of performing and the ways in which bodily performance and mental states are intertwined, as well as a step away from earlier minimalisms to a larger, more epic form. In the final section of the

chapter, I discuss the disastrous *No Such Thing*, produced in conjunction with United Artists and Francis Ford Coppola, an unsuccessful main-stream flirtation. Again, this work is considered as a film that is both a continuation of previous work, exploring the fictional constructedness of performances (especially gendered ones) but displaying a greater inter-est in issues of postmodernism, terrorism (just pre-9/11, a reason for the film's partial suppression), and media representations.

In the final chapter, I examine the shifting concerns in Hartley's work since the very low-key release of *No Such Thing* in 2002. I chart Hartley's withdrawal from the Indiewood sector and the popular crossover inde-pendent sector that he was a part of during the 1990s. Contemporaries like Jarmusch, Soderbergh, and Haynes have gravitated closer to the mainstream, but Hartley's mainstream experience has forced him into a more marginal position, withdrawing from Indiewood studio-supported distribution into much greater control of his work through his company Possible Films, including the use of new digital technologies to expand his control over both the production and ownership of his work. This is the promotion of Hal Hartley as a digital *auteur*, an independent artist in the most romantic sense, something facilitated by digital photography, DVD, and Internet promotion. I also consider Hartley's digital works—*The Book of Life* (1998), *The New Math(s)* (1999), *The Girl from Mon-day*, and *Fay Grim*—and look at the ways in which they differ from earlier works in their increasing experimentation with visual manipula-tion and how they have less of a focus on the performance of body and character. Works such as these demonstrate Hartley's commitment to move away from the mainstream indie sector, even relocating to Europe in order to pursue art film production in ways that he feels unable to do while based in the United States. Finally, these films represent Hartley's shift closer to the avant-garde art cinema he admires, an influence that has always been evident in his work, but that is now more fully realised in the digital features produced in the last decade.

The committed Hartley fan might perceive a number of gaps and absences through the text here. First, perhaps surprisingly, there is no detailed consideration of repetition as a formal system in Hartley's work.

Repetition is referenced throughout, but it does not form a substantial part of the theoretical framework of the book. I have considered this elsewhere, however,[65] and this issue has also been explored by Wise and Deer in their work on Hartley. Second, there is no sustained exploration of key themes in Hartley's work, such as Catholicism. Some may see this as a stabilizing thread that runs throughout his work; nevertheless, it lies beyond the scope of this particular book. The intention of this particular project has been to engage with performance studies in cinema that have long struggled to come to grips with the physicality and materiality of the body and voice on-screen, beyond those emphases mentioned at the outset. The challenge to other scholars and critics is to extend this book's exploration of Hal Hartley further. If Hal Hartley represents an important moment, and subsequent shift, as I believe, in the conceptualization of independent filmmaking in the 1990s and 2000s, then much work remains to be done on Hartley's films beyond my argument here.

ENDNOTES

1. Hal Hartley, *Flirt* (London: Faber & Faber, 1996), xix.
2. "No Such Thing", *Chicago Sun Times*, March 29, 2002, http://rogerebert. suntimes.com/apps/pbcs.dll/article?AID=/20020329/REVIEWS/203290303/ 1023.
3. Mike Long, "The Unbelievable Truth", *DVDreview.com*, March 30, 2001, http://www.dvdreview.com/reviews/pages/321.shtml.
4. Todd McCarthy, "Simple Men", *Variety*, May 18, 1992, http://drumz.best. vwh.net/Hartley/Reviews/variety-sm.html.
5. Jonathan Romney, "Right Road, Wrong Track: Jonathan Romney Prefers Cheap Talking Heads to Fancy Forked Tongues", *New Statesman and Society*, November 6, 1992, http://drumz.best.vwh.net/Hartley/Reviews/ nss-sm.html.
6. Terrence Rafferty, "Flatlands", *The New Yorker*, August 12, 1991, http:// drumz.best.vwh.net/Hartley/Reviews/ny-trust.html.
7. John Anderson, "Hartley's No 'Amateur' at Pulling America's Leg", *San Jose Mercury News*, May 19, 1995, http://drumz.best.vwh.net/Hartley/ Reviews/sjmn-amateur.html.
8. Caryn James, "The Nun, the Amnesiac, the Prostitute and the Thugs", *New York Times*, September 29, 1994, http://drumz.best.vwh.net/Hartley/ Reviews/nyt-amateur.html.
9. Adina Hoffman, "Plot Is a Hal of Mirrors", *Jerusalem Post*, July 29, 1996, http://drumz.best.vwh.net/Hartley/Reviews/jp-flirt.html.
10. Jonathan Romney, "Apocalypse, Now with Powerbook", *The Guardian*, August 27, 1998, http://drumz.best.vwh.net/Hartley/Reviews/guardian-tbol. html.
11. Andrew Sarris, "Hal Hartley's Henry Fool, A Study in Rejection", *New York Observer*, June 22, 1998, http://drumz.best.vwh.net/Hartley/Reviews/ nyo-hf.html.
12. Laura Kelly, "Auteur Scores with Urban Myth", *Fort Lauderdale Sun-Sentinel*, July 17, 1998, http://drumz.best.vwh.net/Hartley/Reviews/flss-hf. html.
13. Laura Dempsey, "Pieces Don't All Fit Together in Henry Fool, But That's Okay", *Dayton Daily News*, August 28, 1998, http://drumz.best.vwh.net/ Hartley/Reviews/ddn-hf.html.
14. Chris Gore, "No Such Thing", *Film Threat*, March 28, 2002, http://www. filmthreat.com/Reviews.asp?Id=2021.

15. Jeff Rigsby, "No Such Thing", *Flak Magazine*, 2002, http://www.flakmag. com/film/nosuchthing.html.
16. David Litton, "No Such Thing", *Movie Eye*, 2002, http://www.movieeye. com/reviews/get_movie_review/614.html.
17. Thierry Jousse, "Love and Punishment", trans. Sébastien Walliez, *Cahiers du Cinéma*, no. 474 (1993): 74–75.
18. See Geoff Andrew, *Stranger than Paradise: Maverick Film-makers in Recent American Cinema* (London: Prion, 1998), 279–312.; Emanuel Levy, *Cinema of Outsiders: The Rise of American Independent Film* (New York: New York University Press, 1999), 191–197; Greg Merritt, *Celluloid Mavericks* (New York: Thunder's Mouth, 2000), 324, 361, 421; Hartley is also discussed throughout in his production and distribution context in John Pierson, *Spike, Mike, Slackers & Dykes: A Guided Tour Across a Decade of Independent American Cinema* (London: Faber & Faber, 1995), and in Geoff King, *Independent American Cinema* (London: IB Tauris, 2005).
19. From his first college short films until 1999, all of Hartley's films were shot by Michael Spiller. Since Spiller has moved into direction himself in television, Hartley has worked with several cinematographers, including Jim Denault on *The Book of Life*, and Sarah Cawley on *The Girl from Monday* and *Fay Grim*. The shift in style has partly been motivated by a change to working digitally, but the contribution of Spiller to the development of a distinctive Hartley visual style is immeasurable, given their long-term collaboration, and the unity of style in the films they produced together.
20. John O. Thompson, "Screen Acting and the Commutation Test", *Screen* 19, no. 2 (1978): 55. Thompson's commutation test, a process of substituting one actor for another in text, has been criticised for actually overshadowing the material practices of screen performance "because his substitutions operate only at the level of the whole actor"; See Paul McDonald, "Why Study Film Acting? Some Opening Reflections", in *More than a Method: Trends and Traditions in Contemporary Film Performance*, ed. Cynthia Baron, Diane Carson, and Frank P. Tomasulo (Detroit: Wayne State University Press, 2004), 26. McDonald's reworking of the commutation test attempts to effectively put the acting back into the analysis, whereas Thompson's work had assumed the actor as a stable set of meanings, rather than a material string of gestural and aural signs.
21. Alan Lovell and Peter Krämer, eds., *Screen Acting* (London: Routledge, 1999), 5.
22. James Naremore, *Acting in the Cinema* (Berkeley and Los Angeles: University of California Press, 1994), 20.

23. Naremore also stresses (ibid.) that "all acting has a biological dimension".
24. Adrienne L. McLean, "Feeling and the Filmed Body: Judy Garland and the Kinesics of Suffering", *Film Quarterly* 55, no. 3 (2002): 14, emphasis added.
25. Steven Shaviro, *The Cinematic Body* (Minneapolis: University of Minnesota Press, 1993), 256.
26. Ibid., 267.
27. Thomas Austin, "Star Performances", in *Contemporary Hollywood Stardom*, ed. Thomas Austin and Martin Barker (London: Arnold, 2003), 103.
28. Richard Dyer, *Stars*, 2nd ed. (London: BFI, 1998), 132–150; Richard de Cordova, *Picture Personalities: The Emergence of the Star System in America* (Urbana: University of Illinois Press, 1990), 23–46; P. David Marshall, *Celebrity and Power: Fame in Contemporary Culture* (Minneapolis: University of Minnesota Press, 1997), 86–89, 94–99.
29. McDonald, "Why Study Film Acting?" 39.
30. Cynthia Baron and Sharon Marie Carnicke, *Reframing Screen Performance* (Ann Arbor: University of Michigan Press, 2008), 59, 92, 232, 234. Baron and Carnicke identify this trend almost exclusively with Christian Metz and his work in *Film Language: A Semiotics of the Cinema*, trans. Michael Taylor (Chicago: University of Chicago Press, 1991).
31. McDonald, "Why Study Film Acting?" 39.
32. Baron and Carnicke, *Reframing Screen Performance*, 17; italics in original.
33. Ibid., 232–233.
34. Andrew Klevan, *Film Performance: From Achievement to Appreciation* (London: Wallflower, 2005), 103.
35. Lesley Stern and George Kouvaros, *Falling for You: Essays on Cinema and Performance* (Sydney: Power, 1999), 3. See also Cynthia Baron and Diane Carson "Analyzing Performance and Meaning in Film", *Journal of Film and Video* 58, no. 1 (2006): 3–6; this is the introduction to a special issue of the *Journal of Film and Video* on performance.
36. Klevan, *Film Performance*, 15–17; Stern and Kouvaros, *Falling for You*, 10–20.
37. Philip Drake, "Reconceptualizing Screen Performance", *Journal of Film and Video* 58, no. 1 (2006): 86.
38. Ibid., 85.
39. Ibid., 86; italics in original. The paradoxical presence/absence of the actor has long been a blockage to the understanding of film performance. As long ago as 1936, Walter Benjamin contended that the film actor was "absent" on-screen and, "for the first time", the actor functions without "aura", an

authenticity that he contended be replicated in mechanical reproduction; see Benjamin, *Illuminations*, ed. Hannah Arendt (London: Pimlico, 1999), 223. Baron and Carnicke go further than describing this as a "blockage", when they contend that Benjamin's essay "effectively discouraged future scholarship on screen acting" (*Reframing Screen Performance*, 3).

40. Drake, "Reconceptualizing Screen Performance", 90.
41. Ibid., 93.
42. Ibid.
43. Ibid. Drake situates performance as "a social and rhetorical event", one that is not reliant on the reading of a "reflection", a representation of an external reality, but of film performance as "cultural practices".
44. Ibid.
45. "Hartley's Globe-trotters", *The Guardian*, February 21, 1997, http://drumz. best.vwh.net/Hartley/Reviews/guardian-flirt.html.
46. Lesley Deer, "Hal Hartley", in *Fifty Contemporary Filmmakers*, ed. Yvonne Tasker (London: Routledge, 2002), 161–169; Lesley Deer, "The Repetition of Difference: Marginality and the Films of Hal Hartley", Thesis (Newcastle upon Tyne: University of Newcastle upon Tyne, 2000); Kevin Taylor Anderson, "Finding the Essential: A Phenomenological Look at Hal Hartley's No Such Thing", *Film & Philosophy* 7, no. 1 (2003): 77–91; Sophie Wise, "What I Like About Hal Hartley, or Rather, What Hal Hartley Likes About Me: The Performance of the Spect(actor)", in *Falling for You: Essays on Cinema and Performance*, ed. Lesley Stern and George Kouvaros (Sydney: Power, 1999), 243–275. I am also currently aware of two PhDs underway on Hartley in the United Kingdom and Denmark.
47. Jason Wood, *Hal Hartley* (Harpenden: Pocket Essentials, 2003).
48. Hal Hartley, *DVD Notes, Possible Films: Short Works by Hal Hartley, 1994–2004* (New York: Possible Films, 2004).
49. Deer's work "The Repetition of Difference"; "Hal Hartley" comments at length on the similarities between Hartley and Godard, and Wise has also reflected on certain Brechtian elements in Hartley's work.
50. Robert Bresson, *Notes on the Cinematographer*, trans. Jonathan Griffin (Copenhagen: Green Integer, 1997), 124–125.
51. Ibid., 16.
52. Ibid., 14.
53. Keith Reader, *Robert Bresson* (Manchester: Manchester University Press, 2000), 4, 129.
54. Graham Fuller and Hal Hartley, "Finding the Essential: Hal Hartley in Conversation with Graham Fuller, 1992", in Hal Hartley, *Collected*

Screenplays 1, (London: Faber & Faber, 2002), viii; excerpted in James Quandt, ed., *Robert Bresson* (Toronto: Toronto International Film Festival Group, 2000), 559.

55. Fuller and Hartley, "Finding the Essential", viii.
56. Dov Kornits, "Hal Hartley—Nobody's Fool", *efilmcritic.com*, May 17, 1999, http://www.efilmcritic.com/feature.php?feature=37.
57. Justin Wyatt, "The Particularity and Peculiarity of Hal Hartley: An Interview", *Film Quarterly* 52, no. 1 (1998): 4.
58. "The Art Cinema as a Mode of Practice", in *The European Cinema Reader*, ed. Catherine Fowler (London: Routledge, 2002), 97.
59. The implications of this form of digital authorship are considered in more detail in chapter 6.
60. Michel Foucault, "What Is an Author?" *Screen* 20, no. 1 (1979): 19.
61. Sharon Marie Carnicke, "Screen Performance and Director's Visions", in *More than a Method: Trends and Traditions in Contemporary Film Performance*, ed. Cynthia Baron, Diane Carson, and Frank P. Tomasulo (Detroit: Wayne State University Press, 2004), 44.
62. Ibid., 63.
63. Doug Tomlinson, "Performance in the Films of Robert Bresson: The Aesthetics of Denial", in *More than a Method: Trends and Traditions in Contemporary Film Performance*, ed. Cynthia Baron, Diane Carson, and Frank P. Tomasulo (Detroit: Wayne State University Press, 2004), 91.
64. Frank P. Tomasulo, "'The Sounds of Silence': Modernist Acting in Michelangelo Antonioni's Blow-Up", in *More than a Method: Trends and Traditions in Contemporary Film Performance*, ed. Cynthia Baron, Diane Carson, and Frank P. Tomasulo (Detroit: Wayne State University Press, 2004), 94–125; Robert T. Self, "Resisting Reality: Acting by Design in Robert Altman's Nashville", in Baron et al., eds., *More than a Method*, 126–150; Maria Viera, "Playing with Performance: Directorial and Acting Style in John Cassavetes's Opening Night", in Baron et al., eds., *More than a Method*, 153–172; Diane Carson, "Plain and Simple: Masculinity through John Sayles's Lens", in Baron et al., eds., *More than a Method*, 173–191; Carole Zucker, "Passionate Engagement: Performance in the Films of Neil Jordan", in Baron et al., eds., *More than a Method*, 192–216.
65. Steven Rawle, "Hal Hartley and the Re-Presentation of Repetition", *Film Criticism* 34, no. 1 (2009): 58–75.

CHAPTER 1

CRITICAL APPROACHES

I don't see the point of disguising the artifice of art.[1] Making *Simple Men*, I came to understand I wanted to work almost exclusively towards this integration of gesture, physical activity, and dialogue.[2]

In his introduction to the 1988 edition of *Performance Theory*, Richard Schechner contended that "performance is an illusion of an illusion and, as such, might be considered more 'truthful,' more 'real' than ordinary experience".[3] Likewise, film, which taps into many of the elements of performance, might be looked upon as a similar "illusion of an illusion". Some films attempt to cut through the illusion, David Lynch's *Mullholland Drive* (2001) for instance, attacking the realist, self-evident nature of film narrative. In the same way, *No Such Thing*, perhaps Hartley's most emblematic film, assaults the illusionary nature of the film text. But is "all the weight", as Roger Ebert suggested, "in the packing materials"?[4] What are "the packing materials"? Does Ebert mean to suggest that *No Such Thing* is too formal and lacking coherent content? Equally, the film can be looked upon as having all

too much content and not enough form, as dissolving into an intertextual hodgepodge.

Where *No Such Thing* succeeds is in its direct address of the performative, illusionary aspects of the world and the obscuring of the distinction between fictional and "truthful" representations. This is a film that exposes its constructedness from the outset. The antagonist is a fire-breathing monster, a fictional character made flesh in a postmodern world. As one reporter asks, "A monster, in this day and age? I mean, don't you find that, you know, like, irrelevant?" The narrative is illogical[5] and revolves around several events that could only be referred to as miracles (faith is, after all, a key theme). *No Such Thing* comments directly on its own marketing[6] and reception[7] through an intertextual allusion to *Beauty and the Beast* (Jean Cocteau, 1945).[8] The performances are, although Ebert is again scathing ("Characterizations are so shallow they consist only of mannerisms"[9]), gestural and reflexive. Formally, the film is especially abstract and critical of realist, self-evident representations of the way in which the world is perceived by those who experience it.

Although sometimes bordering on formalism, Hartley's films use the stylistic text to comment upon their content and to expose and explore the constructedness and artifice of film. Like *No Such Thing*, Hartley's films are engaged in a process of attacking the realist representation of mainstream forms of cinema, and this chapter will explore how Hartley uses various formal techniques to undercut the illusory aspects of cinema. This basic form of Hartley's films allows the texts to concentrate on the cultural and performative emphases that I argue are central to understanding Hartley's work. Consequently, I will explore the stylistic and formal elements of Hartley's work and how his films use their stylistic systems to alienate, and significantly make abstract, the realist text, leading to the emphasis on performance and performativity that allows Hartley to explore broader cultural themes. The process of looking at Hartley's films stylistically must necessarily begin by exploring the realist text, and where Hartley's films deviate from, and what, if any, opposition they adopt to, realism. The second step is to examine how Hartley's films subscribe to a Brechtian style of alienation and what methods are used to achieve this.

To this end, this particular section will explore two theoretical threads that dominate Hartley's work: abstraction and the rejection of empathy. The urge to abstraction is examined, following Wilhelm Worringer's work, as an opposite urge to the move toward empathy, as Bertolt Brecht makes his *V-effekt* the negation of empathy. Hartley also attempts to sidestep the empathetic impulse of realist representation in his work, and the theoretical emphases developed by Brecht and Worringer help to show how abstraction is developed in Hartley's work, and what purpose it serves.

The last issue here is performance. Hartley's films are principally *about* performance, as much about social and cultural forms and uses of performance as they are about the performances enacted by the performers in his films. This necessitates a broad set of theoretical emphases to fully understand the approach that Hartley takes towards the performances of both his actors and his characters. Roughly speaking, the approaches to performance explored in relation to Hartley's work can be split into three distinct categories of theorisation: (1) theatrical (physical) performance; (2) sociopsychological performance, as exemplified by Erving Goffman's work, which examines the everyday performances of individuals; and (3) anthropological performance, especially studies of ritual performance that help delineate the spaces in which performances happen in Hartley's work. The chapter's final section looks broadly at the first two of these theories—in the aesthetic and social approaches to performance taken by Goffman and Richard Schechner—and their relevance for the study of Hartley's films. Although there are numerous intersections between these theoretical emphases that need to be explored, it is necessary to look at how each of the different theoretical strands relates to Hartley's work and which theoretical approaches best serve a further examination of his films from this perspective.

REALISM

For the purpose of looking at Hartley's films, it is of critical importance to revisit earlier theoretical approaches to realist cinema to derive a workable definition of realism that will show how Hartley's films approach,

oppose, and critique realism on a formal level. Realism is a polysemous term. As Christopher Williams asserted, "realism is not a singular or univocal style". "In films and or television", he added, "where there is realism it is normally multiple and heterogeneous".[10] Similarly, Julia Hallam and Margaret Marshment maintained:

> Realism is not a fixed group of textual attributes but a continuum of signifying potentialities, a range of strategies used by filmmakers to mediate information about characters and their situations in reference to *dominant* conceptions of what constitutes reality. Realist films are those which combine these formal and thematic properties in combinations that are labelled "realist" by the discourses of criticism, critical reviewing, promotional literature and advertising.[11]

Therefore, realism can be seen as an effect of the text that relies on stylistic, thematic, and ideological factors to suggest that the film is a "truthful" depiction of reality. André Bazin commented that the goal of Italian Neorealism was "to make cinema the *asymptote of reality*".[12] The asymptotical relationship between reality and its filmed representation was one of imperfection, where reproduction was impossible. Realism, Bazin believed, is a style, one as valid as any other.[13]

Post-structural arguments against realism and the representational impetus of cinema were heavily influenced by Jean-Louis Comolli and Jean Narboni (and the rest of the editors of *Cahiers du Cinéma*), who questioned the ideological goals of mainstream cinema. Audience expectations about the closure-oriented experience of cinema were paramount objects of critique for Comolli and Narboni, especially the key "basic" assumption (or "*dominant* conception") of the cinematic apparatus, that "the cinema 'reproduces' reality"[14]:

> [Realist] films totally accept the established system of depicting reality: "bourgeois realism" and the whole conservative box of tricks: blind faith in "life", "humanism", "common sense" etc.... Nothing in these films jars against the ideology, or the audience's mystification by it.[15]

Such films represent the acme of "transparent" style, where the formal system of the film is self-effacing. Hartley attacks this conception of cinema in a film like *Flirt*, where he exposes and confuses the diegetic and nondiegetic worlds at the beginning of the film. Hartley himself asserted that *Flirt* is self-consciously reflexive, calling it "an essay about me making my work".[16] In this sense, Hartley's aim is to expose the process by which the film is made (and by extension how he works) and to explore the artifice of narrative style. At one point in the film, three German construction workers discuss the plight of the central character, Dwight. Like a Greek chorus, they ruminate on the fate of the characters in the film, about Dwight in Berlin and Bill in New York, and about the filmmaker's goal: "to compare the changing dynamics of one situation in different milieux". The construction workers think the filmmaker will fail, but Hartley is challenging the transparency of film narration, to, in his own words, "test the limits of a storytelling mode, [to] try to find new ways of saying things".[17] *Flirt* challenges the transparent realist style that Comolli and Narboni argued against. Overt uses of cinematic techniques are generally distancing, re-asserting the film's formal system rather than favouring a "transparent" style that forces technique to disappear in favour of the "unified, hierarchical, centered, closure-oriented experience" that Martin Rubin sees as inherent in realist forms.[18]

However, Hartley's films do not subscribe to realist style in any way that is typical of transparent narration. Perhaps paradoxically, Hartley's films do not fundamentally reject realism either. Hartley's films offer varying degrees of abstraction, often as juxtaposition to realist moments of narration; certain scenes provide a commentary or a reflexive shadowing of more conventional scenes of narrative. This is especially the case with Hartley's scenes of dance in *Surviving Desire* and *Simple Men*, where spacing and choreography mirror the character relationships and foreshadow future narrative developments. Scenes such as these mobilise abstract elements of performance that attack realist representation. The emphasis provided by moments such as these exposes the mechanics of performance, the iconicity of the performer, and the apparently inherent realism of performance (rehearsal, for instance, is an intrinsic element

of a performance, but it remains hidden, except in rare circumstances). Stanislavskian modes of performance, where the actor must "live" the part, remain most popular, making the processes and mechanics of performance disappear entirely. Essentially, there is no technique, only the "life" of the character. Assumptions regarding this form of performance are foremost in popular thinking about acting, where the realism of performance is taken to be inherent because the success or failure of the performance is judged on whether the viewer believes that the character is real, with the actor expected to disappear.

In order to attack the realist representation of the filmic illusion in this way, Hartley's films place scenes of abstraction in direct contact with those that are more realist in intent. Scenes that are more realist include those that provide narration but not any stylistically reflexive commentary, scenes of dialogue, exposition, development, and resolution, for instance. Hartley's most realist film in this sense is *Trust*, which, although it includes a self-conscious script and mode of acting, can be viewed as a realist moment, one where Hartley's narrating position is generally not obtrusive. However, where Hartley combines scenes of different styles of performance, whether dance, pantomime, physical comedy, or even martial arts (in *The New Math(s)*), with scenes of realist narration, a self-reflexive commentary on the function of cinematic style and performance is expounded, invoking abstraction without rejecting realism altogether.

Where abstraction appears in conjunction with realism, in a film like *Surviving Desire*, for instance, the abstraction appears as a direct opposition to the more realist impetus of the film's stylistic system. *Surviving Desire*'s general abstraction is low—the majority of the film is shot in a televisual style with an emphasis on close-ups, mid-two-shots, and matched continuity editing—but the abstraction offered by the musical sequences conflicts with the rest of the film. The unexpected, and arguably unnecessary, digression into dance and musical performance emphasises the different stylistic system and the manner in which it deviates from the overall realism of the film. The same can be said of earlier films like *The Unbelievable Truth* or *Simple Men*, where the overwhelming

tendency is towards realism—although a very minimal realism—with individual moments of textual abstraction that deviate in unexpected ways from the narrative-focused system of the film's text. Later films, however, like *Flirt*, move further away from realism by abstracting narrational and stylistic devices in broad strokes via the overarching conceptual repetition of the whole film; subsequent films, especially those shot digitally, move even further from realism with heavy image distortion, as in *The New Math(s)*, or still frames, as in *The Girl From Monday*, a technique Hartley uses to refer to Chris Marker's experimental sci-fi short *La Jetée* (1962).[19] The conflict between realism and abstraction in Hartley's work is thus something that tends to shift between films. True, it can never be said that Hartley's films are strictly abstract, but the realist impulse in his work is also not overwhelming, although it is generally dominant, given the general character-centric focus of his work and lack of overt manipulation in style and content in most of his films. Moments of abstraction defy the tendency to complete realist transparency, emphasising a push and pull between the two stylistic impulses in abstract instances of performance and cinematographic stylisation.

ABSTRACTION AND EMPATHY

The stylistically reflexive nature of Hartley's films is revealed in individual moments of abstraction, not in broad strokes. Prior to looking at this aspect of Hartley's work in more detail, some explication is required about abstraction. The very word, abstraction, implies a separation, a drawing off, or out, of a concept or style. As stated above, it would be difficult to categorise Hartley's films as entirely antirealist—they are certainly minimalist, but not entirely opposed to realism. However, abstraction of form and style remain a central feature of Hartley's work: the separation of space achieved by overt shifts from realist performance (in a broad sense, acting) to interpretive or nonrepresentational performing (such as dance) is just one way in which Hartley uses abstract style. Just a brief look at *Flirt* reveals a much stronger attack on representational styles by abstracting the narrative technique.

Theoretically, abstraction is a shift away from empathetic forms of realist representations. In *Abstraction and Empathy*, Wilhelm Worringer explored the antinomy of his title. Hartley's films are similarly predisposed toward a denial of the empathetic found in the kind of representational form best epitomised by Aristotle's theories of catharsis in the *Poetics*. This in turn became a key issue for Brecht, whose *Verfremdungseffekt* is a rejection of the Aristotelian concept of theatrical representation. These three theorists provide a method for looking at the relationship of abstraction and empathy in Hartley's work. The tension that develops in Hartley's work between abstract and realist forms is largely responsible, along with an alienated mode of acting, for the rejection of empathy in Hartley's methodology.

The antinomy of abstraction and empathy is, for Worringer, revealed in "the deepest and ultimate essence of all aesthetic experience", which he argues, is "the need for self-alienation".[20] In the urge to empathy, the degree of self-alienation is much less than the urge to abstraction:

> The fact that the need for empathy as a point of departure for aesthetic experience also represents, fundamentally, an impulse of self-alienation is all the less likely to dawn upon us the more clearly the formula rings in our ears: "Aesthetic enjoyment is objectified self-enjoyment". For this implies that the process of empathy represents a self-affirmation, an affirmation of the general will to activity that is in us.[21]

Empathy incorporates some of the will to self-alienation, although the desire of the spectator-viewer is to be incorporated into the object, into the representation. The viewer is thereafter positioned to experience the object as it exists for itself, not to analyse, but to share in the experience of *being* the thing. This is chiefly an externalisation of the self.

Similarly, Aristotle's conception of the most accomplished form of tragic theatre is predicated upon identification between spectator and character in which the spectator experiences the pleasurable effects of purging negative emotions such as pain and suffering, "effecting through pity and fear the purification of such emotions".[22] Aristotle's preferred

form of theatrical representation is uncomplicatedly concerned with the "correct" imitation of real phenomena. However, the urge to imitate is similar to that which Worringer described as the urge to empathy, which "finds its gratification in the beauty of the organic", while "the urge to abstraction finds its beauty in the life-denying inorganic, in the crystalline or, in general terms, in all abstract law and necessity".[23] Artistic creation for Worringer can be seen as an attempt to rip asunder the complex, confused fabric of existence and the real world to examine the object, not simply to reproduce an experience but to analyse and understand.

This particular urge to abstraction, and the coincident denial of "gratification in the beauty of the organic", is one that Hartley implied in a 1992 interview with Graham Fuller. In this interview, Hartley expressed his intention to strip his work of all extraneous material, defining his commitment to minimalism, to "finding the essential".[24] He stated that while his work is intended to be edited together as it is written, the first cut is always inadequate, and subsequent efforts are focused towards stripping the work down to only those elements that are required to "make meaning". "I cut [*Simple Men*] the way it was originally written", Hartley explained, "then had to cut things away to make it work. I had to have a little humility and say, 'All right, that's beautiful, but irrelevant. Get it out.'"[25] Hartley revealed Worringer's urge to abstraction by sidestepping the beautiful to reveal the essence of the object, or experience, in its abstract glory. As Worringer argued, the urge to empathy is revealed in the desire to find pleasure within the experience of the object, as "gratification in the beauty of the organic". Thus, as Hartley contends, his films attempt to avoid the easily gratifying pleasures of the beautiful, striving for the abstract essence of the object.

In this respect, Hartley's most significantly abstract film is *Flirt*. From the very beginning, *Flirt* is conscious of its own medium. During the opening credits, the soundtrack plays nondiegetic sounds from the film set; there are crashes and bangs as objects are moved around and the sound equipment is checked and tested (the first sound heard on a film set). Finally, a date appears on screen: "5th February 1993", the first day of production. Therefore, there is a collision between diegetic space and

nondiegetic space. In typically realist films, the presence of nondiegetic space on the film set is always masked by the production conditions, the camera forming the "fourth wall" that separates diegetic space from the nondiegetic space of the sound stage or location space (and the exhibition space). The sonic allusion to this always-offscreen space confuses the notion of diegetic and nondiegetic before the film shows its first diegetic space, an apartment in New York. For this brief moment before the narrative begins, the nondiegetic space precludes any notion of diegetic narrative space; it is consciously nonnarrative (no story is taking place yet), alluding to that which is never seen. Realist films, as noted above, generally attempt to hide the nondiegetic production space, presenting the narrative space as self-evident, existing of its own self. This hides the fact that the existence of narrative spaces is conditional upon unseen production spaces. In *Flirt*, Hartley anticipates the creation of a narrative space by exposing the nondiegetic production space in which the diegetic space has been manufactured. After this, the mechanism is bared, exposed even before the episode in Berlin where the construction workers discuss the success, or failure, of the project in which they are engaged (almost as though they are actors discussing their roles offscreen). When Hal Hartley himself appears in the final Tokyo segment as a film director called Hal editing his latest film, the cycle is complete, from the production space through to the editing of the film.

This baring of the film mechanism takes place again in *The Book of Life*. Although the film is already abstract, having been made on digital video, and using editing techniques that exploit the digitisation of the picture, the film is particularly conscious of its own form—the picture is vividly overexposed, lights burning on the screen. Early in the film, a character looks up at the sky at a plane flying overhead; his reverse point-of-view shot breaks up into wedges of digital blocks, as though the stream of coding is being inhibited. Hartley uses this digital fragmentation to create an impression of a world literally coming apart at the seams due to the coming of the new millennium. A similar technique is used in *The New Math(s)*, smearing the image, making the bodies of the performers look something like cartoon characters.

The primary manner in which abstraction is created in *The Book of Life* is through the ironic use of voice-over narration, which comments upon the manufacture and dissemination of performances. Roughly speaking, there are two voice-over narrations in the film, one by Jesus and another by Satan. The voice-over by Jesus is used in a conventionally mainstream fashion, offering the viewer an insight into the narrative and into the thoughts of the character. The viewer simply hears the thoughts of Jesus, but does not see him speak. For instance, when Jesus first opens the book of life (contained on a Mac PowerBook), and contemplates opening the fifth seal, thereby bringing the end of the world nearer, Hartley captures Jesus strikingly in front of the Empire State Building. Jesus' thoughts are heard as he opens the fifth seal:

> **JESUS (VOICE OVER):** When I had opened the fifth seal, I saw the souls of those who had been slaughtered for the word of God.
> (He sees a martyr, who speaks)
> **MARTYR:** Sovereign Lord. Holy and True. How long will it be before you avenge our blood on the inhabitants of the Earth?
> **JESUS (VOICE OVER):** It was the darkest hour of a long dark hour of the soul. The chill centre of divine callousness. What twisted fairy tale had I allowed myself to be tangled up into? What misplaced gratitude had I believed to be awe? Why had I let those souls believe there was anything other than sacrifice? Why were they comforted with dreams of vengeance? Why hadn't I interfered more? Agitated? Questioned? Panicked by both the legitimacy and hopelessness of their cries I rose to the occasion, and lied. (He speaks into the martyr's ear.) Rest a little while longer, until the number of your fellows will be complete. Those who will die as you yourself have died, for the word of God.

This passage of dialogue reveals much about the character of Jesus through-out the film and his doubting guilt about the coming apocalypse. This form of narration is very much in keeping with that described by Rubin, where the viewer is led on a unified, continuous trip through the narrative. How-ever, this passage is highly intertextual, quoting from and commenting upon the book of Revelation. This suggests a degree of narrational reflex-ivity that is not generally evident in most uses of voice-over narration. Voice-over narration usually acts as a suture, tying up any holes in the plot and promoting a reading of that text that explains everything to the viewer, denying multiple interpretations. In this case, the voice-over narration is used to reveal the character and progress the narrative, but also to comment upon the well-known story of divine vengeance and apocalypse at hand.

Jesus' narration is privileged by the film as the primary thrust of narration as Jesus speaks directly to the viewer via nondiegetic (i.e., offscreen) means. This form of narration is hierarchically dominant on the sound-track and helps the viewer follow and understand the story and charac-ters. The narration of Satan, however, is entirely different. At two points in the film, Satan illogically encounters microphones (figure 3). In the first instance, he goes to the bathroom in the hotel bar where he meets Dave and Edie, whose soul Dave will inadvertently sell to the devil. There is a microphone, which he speaks into:

> Sure. Go Ahead. Call me petty. But one more good soul snatched away from the all-knowing unknowable is still a feather in my cap. So what if it's the last day of the world. I'm not going to give in with-out a fight, come what may. Let God the almighty rule eternity. My precincts are the minutes and hours of the everyday. And as long as people have hopes and dreams, well then, I'll have my work to do.

Later in the film, after an encounter with Jesus in a bar, Satan is running through the streets. He encounters another microphone. Running past it at first, he stops suddenly and turns back towards it:

> He's a bastard after all. More human than me. Hard to Read (he walks away from the microphone again, but returns). But I can't

FIGURE 3. Satan (Thomas Jay Ryan) illogically encounters a microphone, as the film abstracts its use of narration and the hierarchical organisation of the film's narrations.

give up now. I've come too close. He has a weakness for sacrifice, and I know I can work that angle. I've gotta get my hands on that book!

What is notable in both cases is that Satan looks straight into the camera, addressing the audience directly. Although Jesus is also addressing the audience directly, he does so offscreen. Hartley has therefore bared the mechanism by which the voice-over is created and transmitted. This further privileges the narration of Jesus as an "authentic" (stylistically conservative) voice-over whereas the devil is an interloper taking advantage of any means possible to broadcast his message through the film. This self-conscious baring of the artifice is a technique that Hartley uses to similar effect in his work outside film. In Hartley's music video for Beth Orton's *Stolen Car* (1999), she is surrounded by three figures carrying microphones attached to the end of poles.[26] Whenever

she sings, one of the three figures thrusts a microphone close to her mouth. The technique is similar in usage to that of the devil in *The Book of Life*, but in this case Hartley is satirising the acceptable device used in music videos (and in musicals) that allows a singer to project her voice without amplification. In this video, the absence is filled (and confirmed) by the three microphone-wielding individuals of whom Orton seems only partially conscious. The self-reflexive exposition of artifice is a technique that abstracts narrative technique (in *Flirt* and *The Book of Life*) and goes hand in hand with Hartley's rejection of empathy, and it concurrently comments on the form and dissemination of performances.

The Book of Life is also especially self-conscious regarding its constructedness. Just prior to Satan's second moment of narration, he and Jesus have discussed their fictional beginnings, how, as religious figures, they have been created by human beings. But this in itself fosters a paradox in their dialogue:

> SATAN: Hey! Look, it wasn't my idea to give them souls!
> JESUS: Without souls they could've never invented us.
> SATAN: That's true. And we are their greatest creation.
> JESUS: There's no creation without responsibility.
> SATAN: Ah, yes. Remember Frankenstein.
> JESUS: Faust.
> SATAN: Rabbi Loew of Prague. (They chink glasses, and drink.)

The paradox is fostered as they discuss souls. If humans were given souls by God, only to then create God, who came first? Is one an absolute and the other an idea, an image, or a myth? The characters themselves position themselves as constructed from fiction, but it is a fiction that is mediated by other fictions of mythic proportions. Although Hartley is creating a commentary on religion, he is also commenting on the fictionality of this film and his work as a whole, because it cannot be escaped that Jesus is played by Martin Donovan, generally regarded as Hartley's on-screen surrogate, and Satan by Thomas Jay Ryan, fresh from his performance as the morally ambiguous Henry Fool. The message is self-reflexive,

opening a gap between noninterventionist realist storytelling and the abstraction of narrating technique.

ABSTRACTION-ALIENATION-DISTANCIATION

Sophie Wise has observed that "words can become as textual as images" in Hartley's films.[27] Specifically, Wise is discussing a moment in *Trust* where Maria pronounces naïve as "nave"; her pronunciation *is* naïve, a literal performance of the meaning of the word. Maria's "performance", contended Wise, "highlights that words and dialogue can be visual and imagistic".[28] Wise regarded the texts of Hartley's films as fragmented, unfinished, where the performance of the viewer is as important as that of the characters and actors within the films themselves. The fragmentation of the text is distancing, the interpretative activity of the spectator involved in the process of closing gaps in the text. Wise rightly viewed Hartley's technique as being influenced by Brechtian poetics: "Hartley's films demonstrate a Brechtian self-consciousness, drawing our attention to their means of production by exposing the *immaterial* cinematic apparatus—*the performance enacted between actor and spectator*".[29]

The abstraction of form and technique in the above examples is focused toward a critique of realist representation, on exposing and commenting upon film style and narration. However, as Worringer pointed out, the flip side of the urge to abstraction is the urge to empathy, fostered in the "gratification in the beauty of the organic". Aristotle's catharsis stressed how the urge to empathy encompasses an identification between the spectator and the object or representation, an experience that *feels* the purgation of emotion rather than commenting upon it or understanding it beyond the superficial. This empathetic relationship between the subject and viewed object is a key issue in Brecht's theoretical work. Brecht's theatre was to be "non-Aristotelian", avoiding the emotional content that Brecht saw as inherent in Aristotle's conception of tragic theatre. Although this might be particularly pleasurable for the spectator, the effect was one of distraction rather than engagement.

Brecht rejected the empathetic urge that is the antithesis of abstraction. While Worringer saw empathy as a projection of the spectator into the experience of the object, Brecht's conception of empathy is derived from Aristotelian catharsis, the purging of emotion at the resolution of a tragedy. The Brechtian dramaturgy emphasises empathy as the fundamental blockage to a critical reading of a performance. The development of epic theatre was focused on redirecting the spectator away from the urge to empathy, which Brecht felt was illusionistic and excessively focused on the individual. The epic theatre was to be "non-Aristotelian" ("not dependent on empathy"):

> The efforts in question were directed to playing in such a way that the audience was hindered from simply identifying itself with the characters in the play. Acceptance or rejection of their actions and utterances was meant to take place on a conscious plane, instead of, as hitherto, in the audience's subconscious.[30]

Thus, for Brecht, empathy is the antinomy of conscious, critical thought for the spectator. This conception of a new theatre brought Brecht to a definition of realism altogether different to that discussed in the previous section of this chapter. However, it does not understand realism as a transparent, self-effacing form, but posits realism as a style, albeit one that is *about* social reality. For Brecht,

> *Realist* means: laying bare society's causal network / showing up the dominant viewpoint as the viewpoint of the dominators / writing from the standpoint of the class which has prepared the broadest solutions for the most pressing problems afflicting human society / emphasizing the dynamics of development / concrete and so as to encourage abstraction.[31]

Brecht, especially his emphasis on gesture, has been a particularly strong influence upon Hartley's work, as the filmmaker himself has contended. The Brechtian conception of gesture does not refer to the movements and gesticulations of the body, but the social gestures that underlie societal relations, as in the notion of realism that Brecht

expounded. Brecht referred to this with the term "gest" rather than "gesture". As Brecht noted, "gest" is not supposed to mean gesticulation: "it is not a matter of explanatory or emphatic movements of the hands, but of overall attitudes. A language is gestic when it is grounded in a gest and conveys particular attitudes adopted by the speaker towards other men".[32]

The social gest (although Hartley sidestepped Brechtian politics to concentrate on social relationships) is a concept that is of particular interest for Hartley. As he described in an interview from around the time of *Amateur*, the social gest, especially as conceived in Brecht's "Street Scene" demonstration, was something that he was interested in developing in his own work:

> I think I manage to stay outside the minds of the characters in *The Heart Is a Muscle* and just look, conscientiously, at the outside of the hearts. I was rereading the collected writings of Brecht during that summer. A lot of that script is basically exercises in things Brechtian. I took Brecht's "traffic accident" example and put it wholesale into *The Heart Is a Muscle*. Near the end there's a truck driver who has accidentally killed Muriel. Although clearly distraught, he simply describes what happened and adds a brief note about his emotional state. I find this sort of gesture very moving, very compelling.[33]

This example from *The Heart Is a Muscle* could easily conjure images of the distraught truck driver relaying his story with big swinging gestures, around his body and toward his head, shaking or bowing of the head, or other body movements that embellish his emotional reaction towards the death for which he is responsible. Hartley's vocabulary here ("moving", "compelling") is emblematic of the tension between the abstraction of Brechtianism and the empathy of an Aristotelian dramaturgy. Although he rejected overt sentimentality in the scene, he still regarded the consequence of the action as affective. Thus, it represents a further moment of partial abstraction that does not reject realism altogether, but utilises individual, rather than broad, instances of textual abstraction.

In Brecht's "Street Scene", a model for the epic theatre acting, a demonstrator is called upon to repeat the "movements" of the traffic accident, not the emotional state that he or she is experiencing. The active demonstration is therefore a repetition of the accident scene, not a representation of the aftermath ("what you are seeing now is a repeat"):

> If the scene in the theatre follows the street scene in this respect then the theatre will stop pretending not to be theatre, just as the street-corner demonstration admits it is a demonstration (and does not pretend to be the actual event). The element of rehearsal in the acting and of learning by heart in the text, the whole machinery and the whole process of preparation: it all becomes plainly apparent.[34]

The goal of this exposition of the rehearsal process is to translate the events into the past, to distanciate the audience and develop an awareness of the historical aspect of the social gest. Whereas bourgeois theatre stresses the timelessness and universality of social conditions and relationships, epic theatre's alienating principle explicitly forces a historical recognition upon the spectator. The *A[lienating]-effect* (*Verfremdungseffekt*) enforces "the historical aspect of a specific social condition".[35] In "The Street Scene", Brecht also discussed an example where a bystander disputes the nature of the movements of the accident's victim. The demonstrator, Brecht maintained, should argue the point with specific attention to the detail of how the victim moved and how they acted: "the demonstrator achieves it by paying exact attention this time to his movements, executing them carefully, probably in slow motion; in this way he *alienates* the little sub-incident, emphasizes its importance".[36] In this way, with the "direct changeover from representation to commentary",[37] the key significance of the gest of the "street scene" is its apparent commitment to exteriority ("to stay outside the minds of the characters").

Brecht's *Verfremdungseffekt* (the *V-effekt* or *A-effect*) is a device used to expose the artifice of representation, to make the staged drama less familiar to the viewer. The technique is used to avoid the empathetic desire in the spectator that Brecht saw as inherent in both the theories

of Aristotle and the bourgeois theatre. Additionally, this is a method in which Hartley is particularly interested, as his example from *The Heart Is a Muscle* (and the title itself, almost a polemic for the rejection of empathy) testifies. This particular element of Hartley's work is most apparent in the form of acting used through his films, and the actor's manner of movement and diction. Stylistically, however, the drive for distanciation in Hartley's films works hand in hand with the urge to abstraction as discussed above. Hartley's films frequently expose artifice, attacking the urge to empathy. Although the abstraction is sometimes only partial, as in this moment from *The Heart Is a Muscle*, the presence of abstraction, and the exteriority of internal states, attacks the writing of the realist narration—an assault made more significant as realist styles are not wholly rejected.

Hartley has frequently been likened to Jean-Luc Godard for this alienating element of his work. Godard has long been a critical touchstone for many of Hartley's critics. Peter de Jonge, for instance, called Hartley "The Jean-Luc Godard of Long Island",[38] a reference to the contradiction of the blue-collar connotations of the area of New York and the highbrow art cinema aesthetic of Godard. Most notable, however, is Lesley Deer's invocation of Godard as a key methodological referent in her entry on Hartley in Yvonne Tasker's *Fifty Contemporary Filmmakers* anthology:

> [Hartley's] greatest source of inspiration comes from the European art-house aesthetic which Godard embodies and to which Hartley, in his evasion of and ironic play with genre, his iconic women, and the degree of control he maintains over his artistic output, aspires.[39]

Subsequently, *The Unbelievable Truth* is described as "a Godardian commentary on the commercialization of the body";[40] *Theory of Achievement* (1991) and *Ambition* (1991) "further exemplify Hartley's manipulation of genre and modes of expression, although this time through performance art and Godardian pastiche";[41] Deer also noted that Isabelle Huppert starred in both Hartley's *Amateur* and Godard's

Passion (1982); finally, "Hartley alludes both to Godard and to the art-cinema aesthetic Godard exemplifies".[42] In just seven pages, Deer reduced Hartley's artistic work to a desperate attempt to follow in Godard's footsteps. The allusions to Godard in Hartley's films are relevant, but to discuss his films as a repetition of Godard's films is reductive and ignores the original features that Hartley brings to his films that do not have direct antecedents in Godard's work. In addition, Deer also overlooked the interest in Brecht that the two filmmakers share. Godard's use of epic theatre styles, such as repetition, the exposition of the performer, direct address, and the baring of the narrating apparatus in *Deux ou trois choses que je sais d'elle* (1967) is a key example of the manner in which Godard's work shares Brechtian influences with Hartley. Both filmmakers share interests in Brecht, rather than the more simplistic, and depthless, postmodern intertextuality suggested by describing Hartley solely as an imitator of Godard's work.

Hartley's work does include numerous references to Godard's films: the dance sequence in *Simple Men* invokes the Madison sequence in *Bande à part* (1964); the use of aphorisms in *Theory of Achievement* is similar to Jack Palance bombastically reading aphorisms from a book in *Le Mépris* (1963); the use of direct address in *The Book of Life*, jump cuts in *Flirt*, or freeze frames in *The Girl from Monday* or *Fay Grim* could also be attributed to the influence of Godard. These intertextual references constitute additional methods whereby Hartley creates abstract moments in his films and distances the audience. The devices listed above, however, are already abstract. They constitute alienated moments in Godard's films as they are often used to disrupt the realist representation (expose the mechanism) and interrupt or delay.

Interruption is a key component of Brecht's theory, one elucidated by several of his commentators; as Walter Benjamin notes, the function of Brechtian dramaturgy is the discovery of "the conditions of life.... This discovery (alienation) of conditions takes place through the interruption of happenings".[43] Similarly, Roland Barthes saw the interruption, the pregnant moment, as the alienation of the Brechtian social gest ("the discovery of the conditions of life"): "The pregnant moment", Barthes

argued, "is just this presence of all the absences (memories, lessons, promises) to whose rhythm History becomes both intelligible and desirable. In Brecht, it is the *social gest* which takes up the idea of the pregnant moment".[44] The alienation of the gest is similar in Godard and Hartley as an interruption of the representation. Although the references that Hartley made to Godard involve devices that are already abstract, already alienated, in their interruption of the realist milieu and narrative, the use of these moments of homage adds an extra level of abstraction in an alternative intertextual manner, where the intended referent is not reality but the texts of Godard's films. Therefore these can rightly be called interruptions as Hartley looked to explore the filmic text further. Hartley's repetition of Godard is not all-encompassing, as Deer seemed to be implying, but rather constitutes one abstracting technique amongst others.

PERFORMANCE

Much of the drive away from empathy toward abstraction and distanciation in Hartley's work is focussed on the use of performance. *The Unbelievable Truth* begins on a country road. Josh Hutton (Robert Burke) is trying to get home. The opening titles interrupt his attempts to flag down a passing motorist willing to carry a hitchhiker. A driver with a family picks him up, but ejects Josh when he finds out that Josh is travelling home from prison. An erratic, drunk driver then picks up Josh. He asks Josh to drive the rest of the way, even though he does not have a licence. What links both of the drivers who give lifts to the hitchhiking Josh is their misrecognition of him—they both ask if he is a priest. Although this is a running gag throughout *The Unbelievable Truth*, this initial misrecognition is based solely upon appearance. Dressed in black, his costume conforms to the stereotypical look of a preacher. Costuming is generally held as being one of the key bases for assumptions in performing that inform an audience of what a character is like, even in broad terms such as this. Josh is not a priest, but a prison-trained mechanic. He also *looks like* a priest, or rather like a commonly held image of a

FIGURE 4. Josh (Robert Burke, on the left of the frame) is repeatedly mistaken for a priest, as other characters misinterpret "sign-vehicles" regarding his appearance and role.

priest (figure 4). The audience within the film that witnesses the arrival of Josh, the two drivers, judge Josh's character on the basis of this commonly held image, and come to an incorrect conclusion.

Josh's appearance is just one of the symbols by which a character can be judged. Erving Goffman calls these symbols "sign-vehicles", carriers of meaning that can be used to glean information about any individual that comes into contact with another, whether for the first time or not. "If unacquainted with the individual", Goffman contended, "observers can glean clues from his conduct and appearance which allow them to apply their previous experience with individuals roughly similar to the one before them or, more important, to apply untested stereotypes to him".[45] This is exactly what happens in the opening moments of *The Unbelievable Truth*, as the two drivers derive information regarding Josh first from his appearance, and then his conduct, to arrive at a conclusion about Josh's occupation, lifestyle, even belief system. However,

the conclusions see the application of an "untested stereotype" (doubly so in the case of the first driver, whose demeanour changes immediately when he discovers that Josh is travelling home from prison). The use of "sign-vehicles" to glean information in this fashion forms the basis of Goffman's theories of sociopsychological performance in everyday life. Goffman asserted that performances occur everywhere, consciously (sometimes self-consciously) and unconsciously, and that audiences are often present (even if they do not think of themselves as audiences). Goffman defined a performance as

> all the activity of a given participant on a given occasion which serves to influence in any way any of the other participants. Taking a particular participant and his performance as a basic point of reference, we may refer to those who contribute the other performances as the audience, observers, or co-participants. The pre-established pattern of action which is unfolded during a performance and which may be presented or played through on other occasions may be called a "part" or "routine".[46]

Performances can therefore be seen to spill over from the realm of the aesthetic into the everyday world. Hartley's films, of course, take place in an aesthetic world in which, at some level, however disguised or hidden, the performers are aware that they are engaged in a performance. Hartley, though, via a variety of techniques, developed a discourse around performance over and above that of the aesthetic, of the everyday and the cultural. This leads to a doubling of performance: on one side an aesthetic, physical form of performance, by actors, dancers, or mimes, and on the other a social conception of performance in which the characters in Hartley's films are engaged.

Richard Schechner expanded upon the definition of performance in *Performance Theory*. Schechner broke performance down to four concentric circles, each one broader and less well defined than the last. At the centre is "drama", then "script", "theatre", and finally "performance", the most diffuse of the four areas. "Performance" ("the whole event") can pertain to all that is going on within its sphere, the "drama" ("what the writer writes"), "script" ("the interior map of the production") and

"theatre" ("the specific set of gestures performed by the performers in any given performance").[47] Schechner also examined the ways in which these concentric circles can be split. Only since nineteenth-century Western theatre became the most popular mode of representation has the link between drama and performance been compressed to privilege the drama-script linkage. Mimetic forms have placed the written text into a sacred position, where little modification happens between the drama as envisioned by the writer and the physical and auditory performance of the actor. The audience in this case is excluded entirely, forced into a position that is outside the text. This privileges the viewing of texts without commentary or participation from the audience. Theatrical representations that collapse the drama-performance linkage are illusionistic, mimetic, and self-contained.

Similarly, performances need not stem from written texts, from what Schechner termed drama—they can be theatricalised spectacles in ritual displays or in play, such as sport. Some theatre practitioners have sought to break apart the bonds that tie the processes together, including Brecht, who, according to Schechner, "influenced both by documentary films and Chinese acting, exposed the seam between the theatre and the script: his *V-effekt* is a device revealing the script as of a different conceptual order than the theatre event containing it".[48] Brecht's abstract, alienated theatre allows performance to come back into the theatre whereas a theorist/practitioner like Stanislavski would seek to wipe the theatre of any trace of performance. Performance is a continuum of potential gestures, behaviours, and activities that exist around, outside, and independent of theatre. Performance is not necessarily theatre, but theatre does include performance.

In thinking about Schechner's circles, there is immediately a hurdle to overcome when considering them in relation to film. Nevertheless, drama, script, theatre, and performance can be adapted to consider the difference in medium between theatre and film. Where Schechner sees the drama-script link as one that is generally conceived as inseparable in nineteenth-century bourgeois theatre, the same can be witnessed in most films, where the written drama (the screenplay) does not exist for

viewers. Films do exist in a written form before being translated into material images, where *mise-en-scène* generally encompasses "the basic code of events", and the translation of the written script into images and sounds. Where film and theatre differ is in the collapse of the distinction between script and theatre into film because, although theatre and film are both concrete, film is not immediate and does not happen "live" for the viewer in the same auditorium. The codification of film that takes place at Schechner's script level involves the elements of performance that he includes in the theatre circle. Films can return to what Schechner defined as the drama stage because they can be remade, codified in different ways, and altered to reveal cultural and historical differences. However, script and theatre must coalesce into film. Film production tends to suppress the script, in effect suggesting that it never existed (except in *Flirt*, where Hartley reads lines that the audience have already heard from his own script), therefore promoting the final visual codification of the text (its "manifestation" as film) above the encoding of the text, the production process, and the pro-filmic (making the filmic text seem spontaneous in an illusionistic sense and equivalent to the pro-filmic).

The performance aspect of cinema, in Schechner's terms, is most apparent in the social and cultural rituals that have emerged around watching films, at shopping mall multiplexes or art house cinemas, and in the home. If all aspects of the performance of a film are taken into consideration, then the spectator's reception and even criticism can be included in the performance of a film. Films are even said to perform at the box office. The performance circle of film therefore stretches far beyond the projection of celluloid.

Hartley's films reflect on this specific circle as it corresponds to social and cultural performance. This is witnessed most noticeably in the Japanese section of *Flirt*, where other characters are always watching the performance of the central character. Miho is always in a position of being within a viewing space where she is posited both as an individual subject and as a projected subject by the audience. This means that Miho is conceived as a subject by both herself and the audience(s). However, the two conceptions of Miho are divergent. She is a reasonably studious dancer

in a Tokyo academy. The audience's perception of Miho is clouded by an incident in which Ozu, her dance instructor, is witnessed kissing her after arguing with his highly strung wife. Miho is subsequently cast as the titular flirt, but it is an unwilling position—she does not kiss Ozu. The kiss is framed in tight close-up, emphasising Miho's reluctant reaction to the kiss (figure 5). The viewer outside the text therefore has a different view from the viewers within the text.

Hartley's reconfiguration of the *Flirt* narrative, of which this is the third presentation, relies on repetition to develop the audience's recognition of Miho as contrasting with those of Bill and Dwight, the two previous flirts from New York and Berlin. The convergence of past and

FIGURE 5. The kiss in *Flirt*'s Tokyo sequence is framed in tight close-up, giving the audience a privileged view of Miho's (Miho Nikaido) reluctance and surprise.

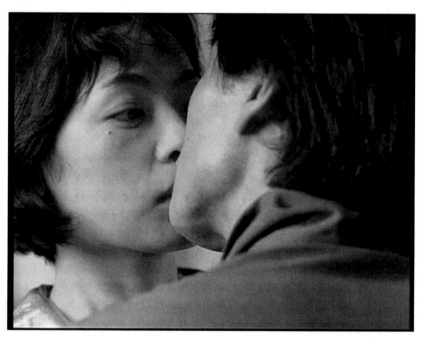

present that occurs in repetition[49] allows Hartley to present this as a pivotal moment in the film. This scene is a repetition of the previous two narratives, but this is the first time that the audience *sees* the illicit moment between the flirt and the married character take place. In New York, Bill performs the scene for a friend, while Dwight demonstrates the moment by kissing another male character, who is repulsed. The repetition of the scene is merely implied; in the first instance, the audience, like Bill's friends in the bar, are *told* what happened between Bill and Margaret, but in the Berlin scene the kiss is *shown* to those watching, stressing the moment of viewing for the audience. Hartley now shows the moment as a scene that is performed. This is made doubly apparent as the scene is performed before an audience.

The scene of the kiss from the Japanese segment of *Flirt* is witnessed as a performance that is at once both social and aesthetic. The audience is conscious of watching an aesthetic performance by two actors, as the audience in the school's corridor is conscious of watching an illicit social performance between two individuals. When Hartley's films comment upon social frameworks of performance, like the ones outlined by Goffman, social gests are being outlined, discussed, and commented upon. The social gest, as described by Brecht, is "the *mimetic and gestural* expression of the social relationships prevailing between people of a given period".[50] The aim of Brecht's *V-effekt* is to alienate the social gest "underlying every incident", to effect the "direct changeover from representation to commentary". This occurs through quotation, by turning the present moment of representation into history, as past moments. Hartley achieved this changeover, in this instance in *Flirt*, by abstracting the moment through repetition. Social gests are revealed in the relationships between individuals, but, as Goffman pointed out, those social relationships are conducted in a context bound by performance and observation:

> A status, a position, a social place is not a material thing, to be possessed and then displayed; it is a pattern of appropriate conduct, coherent, embellished, and well articulated. Performed with ease or clumsiness, awareness or not, guile or good faith, it is none the less something that must be realized.[51]

Goffman's awareness of the way in which individuals signify rather than possess social roles materially implies the existence of a form of sign system that can be used to turn the representation of social relationships (the main focus of Hartley's films) into a Brechtian alienated commentary on them by Hartley's films. As the earlier example showed, the signs projected by Josh's appearance and conduct were not appropriate to his social status, and therefore a misunderstanding was fostered. Hartley treated the repetition of the misunderstanding as a joke, but one that reveals the underlying social gest regarding perceptions of the clergy (and those regarding recently released convicts) in the way that Josh was treated before the misunderstanding was discovered. The repetition of the joke alienates the gest, if not the performance of the gest, because Josh's performance is not commented upon. Josh's comportment is not consistent with any stereotypical role—Hartley used the joke to comment on the image of the stereotype, not the performance of the stereotype.

Similarly, in *Flirt*, Miho is always engaged in a process of performing that develops and maintains an impression of her personality and social status before an audience. The moment in the corridor where Ozu kisses her is a performance disruption, which is only realised because an audience is present to witness and interpret the occurrence. Performance disruptions, Goffman argued, "have consequences at three levels of abstraction: personality, interaction, and social structure".[52] The disruption that Miho suffers is especially effective on each level for the audience, with whom Miho is seen rehearsing a *butoh* routine in the opening scene: the interaction with Ozu influences inferences about Miho's personality (as a flirt); affects future interactions with other team members (as performers rather than audience members); and influences Miho's social standing. There is a stronger indication of performance disruption later in the Japan segment where Miho is seen carrying a gun by an elderly couple. Miho has taken the gun from Ozu's wife, who is threatening to commit suicide. This compassionate act introduces a sign (the gun) into Miho's appearance that creates a disruption in the presentation of her personality. Miho's behaviour elsewhere in the film is not

consistent with the threat that the old couple perceive from the image she presents while holding the gun. The introduction of the signifier into Miho's presentational sign system is therefore a performative disruption on all three levels, but only because it is read in this particular manner by the elderly couple, just as Josh's appearance was held as signifying the commonly held image of a priest, because the audience has no knowledge of previous performances by the individual. Miho's actions may prevent danger, but the gun is a sign of violence, fostering the misinterpretation of Miho as a threat. Miho is arrested and briefly jailed, a serious disruption on all levels.

Goffman's theories on the creation and maintenance of successful and unsuccessful performances can be used to show how characters in Hartley's films, especially male characters, are often compelled to enact performances that are not successful. The success of performances by certain characters in Hartley's films is often dependent on where performances are allowed to take place, and how the prohibition on audience access is maintained. Miho's display, for instance, is disrupted because an audience gains access to an area from which they should be prohibited. Goffman differentiated between front and back regions. The front region of the performance is the area in which the actual performance takes place. This is explicitly the case in the first sequence of the Japanese segment of *Flirt*, where a performance is taking place. However, Hartley interrupted the performance with elements of rehearsal, with Ozu giving directions to his dancers. There is therefore an intermingling, and confusion, of the front and the back regions—the back region in Goffman's sense is the area in which the process of producing a performance remains hidden.

"The performance of an individual", Goffman claimed, "in a front region may be seen as an effort to give the appearance that his activity in the region maintains and embodies certain standards".[53] Standards of decorum dictate how appropriate behaviour in the front region is required and maintained so as not to disrupt the performance that takes place there. Ozu kissing Miho in the corridor would, for Goffman, constitute a breach of appropriate behaviour if it took place in a front stage region.

However, if this area is considered not as a front region, but as a back region, then the implications are considerably altered. In back regions, where "suppressed facts" take place, the audience is not granted a view of the behaviour that creates the front region performance.[54] Generally, in aesthetic performances that backstage area, like the rehearsal process, remains suppressed. With *Flirt*, the matter is complicated by the exposition of the production space in the opening credits, as discussed above. The exposition of rehearsal in the *butoh* sequence at the beginning of the Japan segment problematises the performance, where the dance mirrors offstage relationships. Miho's interaction disruption, the lack of continuity in her presentation of self, is created as an audience gains access to what should remain a back region, a private space. Ironically, in the previous moments, Miho herself has intruded on such a space, spying on the wordless argument between Ozu and Yuki. Miho now becomes a participant, although an unwilling one, in a new performance featuring herself and Ozu. The illicit moment between Ozu and Miho becomes a performance as soon as an audience becomes witness to the fact. Miho does not participate, her body tension is significant of apprehension and resistance, but the performance is such that inferences regarding her personality are made by the ghostly audience at the door.

The misunderstanding that the diegetic audience derives from witnessing Miho's (non)flirtation with Ozu has significant consequences for her social positioning. She is cast into the role of flirt, a role in which she is positioned by the actions viewed in her performance with Ozu, although this is a misreading of Miho's body positioning and tension. As Richard Schechner asserted, "most social behavior is constructed". These behaviours become segmented into "more or less fixed roles such as 'mother,' 'doctor,' 'teacher,' 'child,' and so on. The specific gestures, tones of voice, costume, and so on appropriate to social roles are well known".[55] Social roles such as these have appropriate, prescribed images and actions, including the flirt. Schechner has described what Goffman called "personal front", the appearance and manner of the individual performer. Appearance accounts for all the stimuli that suggest an individual's social status, such as clothing, insignia of rank or position, sex,

age, race, size, and looks. Manner includes all the stimuli that indicate the interaction role the performer will expect to play, including sign systems such as posture, speech patterns, facial expressions, and bodily gestures.[56] Miho's social role is misrepresented by the signs of her inter-action with Ozu, just as Josh's personal front in *The Unbelievable Truth* is repeatedly misread by other characters, but in Josh's case his social role is continually misrepresented by the other characters in the film due to the faulty nature of their information (small-town gossip) about his criminal past.

In *Trust*, Matthew Slaughter is also a performer who struggles to enact a coherent presentation of self. Matthew is perceived locally as a danger-ous loner, appropriately dressing in a long dark coat. In an early scene Matthew, after a disagreement with his supervisor in the manufacturing plant in which he works, clamps the supervisor's head into a vice. Mat-thew's public display of self, however, is complicated when Maria gains access to the back region of his display, his home. Matthew's aggression is fuelled by his relationship with his father, and it is made abstract by Hartley's stylistic repetition of cleaning the bathroom, which becomes shorter and more aggressively edited with each repetition. Maria gains access to the region in which the suppressed facts of Matthew's angry affective display are hidden. This disrupts Matthew's presentation of self, as the abused son becomes visible from the back region. Matthew can no longer be seen as the dangerous, black-clad loner who is violent in bars and carries a hand grenade with him, although those facts do still exist in his public persona. The exposition of his family life to Maria disrupts the presentation of the public Matthew, shedding light on a new self. Matthew's public performance is therefore disrupted.

Describing performances like these enacted by Hartley's characters obscures a second level of performance, which is acting. The term acting can be applied in many ways to a host of activities and aesthetic styles, but it refers simply to the use of actors to portray characters on-screen *that are not themselves.* Yet actors do not simply appear untransformed; acting is subject to the same push and pull of realism and abstraction that is discussed above in relation to the film text. Realist conceptions of

acting require the dissolution of the actor behind the mask of a character. The system outlined by Stanislavski in *An Actor Prepares* and *Building a Character* shows how the actor must use internal techniques to create an external portrait of a character that is a new, "real" personality. The process of turning the written character into a complete individual, a new self, is not simply a process of technique, or of stagecraft. The formation of the new individual is an internal process, utilising memory of emotional response and a clear purpose regarding the character's, and the play's, "super-objective". "Creativeness is not a technical trick", Stanislavski explained. "It is not an external portrayal of images and passions.... *It is a natural act similar to the birth of a human being*".[57]

As actors find themselves "on the threshold of the subconscious", all technique must disappear. The delineation of the character must be complete; every action or thought represented or explained by the actor must be truthful, believable and, realistic. For Stanislavski, "a characterization is the mask which hides the actor-individual. Protected by it he can lay bare his soul down to the last intimate detail".[58]

Reducible to an image and sound on-screen, the actor's technique becomes one of abstracting internal states of body and mind,[59] using a series of methods that include movement, gesture, inflexion, fluctuations of pace, and facial expressivity. Most performances would attempt to efface technique, "living the part", to arrive at an "imitation of life". Acting therefore is imitative, reproductive as well as representative. Certain mimetic acting techniques could also be said to be realist in the same fashion, making the technique and labour of performance transparent. Despite this, there is still technique behind the process of making of performance manifest, as Drake noted, "reading screen performance signs merely as representations of an external reality", makes performance "about something else: as a 'reflection' ... of this something".[60] The means by which dialogue is turned into the code of the everyday by actors is a technical process that is expressed externally. All elements of style—dialogue, facial movements, gestures, and so on—are focused on developing narration, characterisation, and emotion (in character and viewer). The process by which these codes are arrived at is hidden, in the

development of the screenplay and in rehearsal (sometimes a two-way process, by improvisation or interactive means); only the final performance, fixed in permanence, is visible.

Hartley's films utilise the signs of performance that actors often seek to hide in a manner that can be called abstract. Hartley's films sometimes expose the processes of rehearsal and repetition by which the fixed, visible performance is reached. However, the performer is also exposed, especially as Hartley tends to use the same actors repeatedly in his films, particularly Martin Donovan. When Donovan played Matthew in *Trust*, his first appearance in a Hartley film, his name had not gained the significance that has developed with his repeated appearances in Hartley's films. By the time Donovan played Jesus Christ in *The Book of Life*, the actor Martin Donovan had gained a significatory role in Hartley's work that changed the process by which the spectator related to the character he is playing (adding an additional loading to the loaded nature of the Christ character). Donovan's appearances in other Hartley films, such as *Surviving Desire* and *Amateur*, and, to a lesser degree, in other films, such as *Nadja* (Michael Almereyda, 1994) and *The Opposite of Sex* (Don Roos, 1998), meant that the signifier "Martin Donovan" had been altered through repetition and reproduction, crystallising audience perception about the kinds of characters played by the actor. The performer Donovan is inseparable from the characters he portrays. Donovan's craft gains agency from the development of a performance idiolect, a set of signs relating to his work—highly controlled gestures, bursts of aggressive vocal intonation, a furrowed brow—that mean the actor is always visible in his work without Hartley, and with other directors, where the idiolect is utilised. Hartley's use of a small ensemble partially abstracts the performer from the character, particularly where performers and characters share names, such as Donovan's appearance in *Simple Men* as Martin, or where the actor's performance idiolect is self-reflexively embedded in the character that the actor plays, as when Donovan appeared as Jesus.

The textual and stylistic fissures and gaps that this chapter has examined force the abstraction of Hartley's text into greater focus. Hartley uses abstraction to attack the realist representation of film. This is the basic

form of Hartley's films: they use abstraction as a counterpoint to realism and become alienated in those moments of juxtaposition. I have here introduced a number of the concepts that underpin most of Hartley's work: the urge to abstraction that Hartley, like Worringer, shows, that is, the opposite to the urge to empathy; the consequent rejection of overt forms of emotional display in favour of a style that is minimal, mired in the "essential"; the Brechtian alienation and maintenance of empathetic distance between audience and text that is required to achieve a critical stance toward the film; and the performative systems of signification that Hartley abstracts through his emphasis on the performative. Processes of performance, particularly the manner in which the performer abstracts internal states and experiences and turns them into external display, are made abstract in themselves, further denying the urge to empathy and illusory display of realist forms. These concepts form a starting point for understanding how Hartley's films place an overt emphasis on performance in relation to an abstract mode of signification that makes performance an essential consideration of the way in which actors, performers, and film perform. From this initial standpoint, Hartley is able to draw attention to the signification of performance, the roles occupied by performers, the social performances enacted by characters, and the cultural issues that Hartley addresses as performative and illusory.

ENDNOTES

1. Ray Pride, "Reversal of Fortune", *Filmmaker* 6, no. 4 (1998): 92.
2. Hal Hartley and Kenneth Kaleta, *True Fiction Pictures & Possible Films: Hal Hartley in Conversation with Kenneth Kaleta* (New York: Soft Skull, 2008), 54.
3. Richard Schechner, *Performance Theory* (London: Routledge, 2003), xix.
4. Ebert, "No Such Thing".
5. Kevin Taylor Anderson sees plot elements of *No Such Thing* as going beyond logic, as the term suggests an intent in the film that is lacking: "These elements should rather be seen as *alogical*; calling something 'illogical' suggests a certain degree of sloppiness or authorial indulgence, while deeming it 'alogical' implies that the director and film are not even *trying* to subscribe to a system of logic"; "Finding the Essential: A Phenomenological Look at Hal Hartley's No Such Thing", 81.
6. The marketing materials for the film all refer to the scene where Beatrice and the monster are paraded before the press, in which Sarah Polley, a minor starlet in Hollywood, wears a tight, revealing black leather outfit.
7. Hartley, eventually, may not have had much to comment upon, as all elements of the production, up to its release, were problematic. The production of *No Such Thing* was troubled following a poor reception at the 2001 Cannes Film Festival. This was Hartley's first venture with a major film studio, MGM-United Artists, and a co-production of Francis Coppola's American Zoetrope and Icelandic sources. The studio requested a recut following the critical failure at Cannes, but Hartley refused and was supported by Coppola, who granted Hartley "final cut" on condition that he follow Coppola's suggestions. However, given the emphasis placed upon terrorism in the film, MGM may have seen it as unmarketable following the terrorist attacks of September 11, 2001. *No Such Thing* was released very quietly on just nine screens on 29 March 2002 (this was cut to three screens after just two weeks) and rushed to home video just a few months later; Internet Movie Database, "No Such Thing (2001)—Box office / business", *Internet Movie Database*, 2002, http://www.imdb.com/title/tt0248190/business.
8. Hartley's *Beauty and the Beast* allusion is more in keeping with Jean Cocteau's version of the fairy tale than that made more popular by Disney or the recent television series. See chapter five for a more detailed discussion of this allusion in *No Such Thing*.
9. Ebert, "No Such Thing".

10. Christopher Williams, "After the Classic, the Classical and Ideology: The Difference of Realism", *Screen* 35, no. 3 (1994): 289.

11. Julia Hallam, *Realism and Popular Cinema* (Manchester: Manchester University Press, 2000), 123; emphasis added.

12. André Bazin, *What is Cinema?* trans. Hugh Gray, vol. 2 (Berkeley and Los Angeles: University of California Press, 1967), 82, emphasis added.

13. Bazin's most controversial theories of realism revolved around the notion of transparency, the intentional destruction of all marks of artifice. The concept of "transparency" appears only once in Bazin's work in an explicit form. In his essay "William Wyler, or the Jansenist of *mise en scène*", Bazin examines the use of deep-focus cinematography in a number of Wyler's films, finding that what is exhibited is a "perfect neutrality and transparency of style which must interpose no colouration, no refraction between the reader's mind and the story"; "William Wyler, or the Jansenist of mise en scène", in *Realism and the Cinema: A Reader*, ed. Christopher Williams (London: Routledge & Kegan Paul, 1980), 44. However, despite Wyler's "style without style", Bazin stresses that this remains an aesthetic representation of reality, not a simple transposition of a conventional form of "reality" onto film and then projected on a screen; it remains a "style".

14. Jean-Louis Comolli and Jean Narboni, "Cinema/Ideology/Criticism", in *Movies and Methods*, ed. Bill Nichols, vol. 1 (Berkeley and Los Angeles: University of California Press, 1976), 25. Comolli and Narboni problematise what is generally taken as a "given" of the filmic apparatus. The cinematic image is not, Comolli and Narboni allege, a "reproduction" of the world "as it is". Dictated by its own "language", cinema turns the "unformulated" world into narrative and an altogether more dreaded (for the Marxist critics) concept, "representation". Via "representation" the world "communicates itself to itself". Therefore, realism and "reality" are two complex constructions of ideology. Cinematic "reality" and the concrete reality experienced by individuals on a daily basis are two entirely different objects. One is controlled by aesthetic criteria and the accumulated knowledge of those standards, the other by experience determined by complex associations of perception and memory. The second form of reality controls the manner in which the first form, the cinematic form, is received and interpreted.

15. Ibid., 26.

16. Wyatt, "Particularity and Peculiarity of Hal Hartley", 6.

17. Ibid., 4.

18. Martin Rubin, *Showstoppers: Busby Berkeley and the Tradition of Spectacle* (New York: Columbia University Press, 1993), 19.

19. As Hartley's tendency toward abstraction has increased, his proximity to other prominent independent directors has decreased. Whereas other former contemporaries such as Steven Soderbergh, Jim Jarmusch, Todd Haynes, and Gus van Sant have moved towards a more conventional mainstream style—albeit still partly outside the studio system—Hartley has moved away from the Indiewood style, favouring an art cinema aesthetic above the more generally audience-friendly work of his former contemporaries. See Hill, "Resident Alien".

20. Wilhelm Worringer, *Abstraction and Empathy: A Contribution to the Psychology of Style* (London: Routledge & Kegan Paul, 1967), 23.

21. Ibid., 24.

22. Aristotle, *Poetics* (London: Penguin, 1996), 10.

23. *Abstraction and Empathy*, 4. The artistic volition, Worringer contends, is not the impulse to create imitations, but to "redeem the individual object of the outer world, in so far as it particularly arouses interest, from its combination with, and dependence upon, other things, to tear it away from the course of happening, to render it absolute" (ibid., 21).

24. This phrase has subsequently become an important hallmark for Hartley critics. Kevin Taylor Anderson's 2003 article on *No Such Thing* is actually called "Finding the Essential", while Sophie Wise uses the slogan as a subheading in her article.

25. Fuller and Hartley, "Finding the Essential", xxix.

26. This technique was also used by Hartley in his 2001 play *Soon*, as well as in his staging of Louis Andriessen's *La Commedia* (2008).

27. "What I Like About Hal Hartley", 258. Wise is influenced by Roland Barthes's notion of the "grain of the voice": "the materiality of the body speaking its mother tongue ... [that] forms a signifying *play* having nothing to do with communication, representation (of feelings), expression"; *Image-Music-Text*, trans. Stephen Heath (London: Fontana, 1977), 182; emphasis added.

28. "What I Like About Hal Hartley", 258.

29. Ibid., 265.

30. Bertolt Brecht, *Brecht on Theatre: The Development of an Aesthetic*, ed. John Willett (London: Methuen, 1974), 91.

31. Ibid., 109.

32. Ibid., 104.

33. Graham Fuller and Hal Hartley, "Being an Amateur", in Hal Hartley, *Amateur* (London: Faber & Faber, 1994), xviii.

34. *Brecht on Theatre*, 122.

35. Ibid., 98.
36. Ibid., 126; emphasis added.
37. Ibid.
38. Peter de Jonge, "The Jean-Luc Godard of Long Island", *New York Times*, August 4, 1996, http://drumz.best.vwh.net/Hartley/Info/nyt-profile2.html.
39. "Hal Hartley", 162–163.
40. Ibid., 163.
41. Ibid., 165.
42. Ibid., 168.
43. Benjamin, *Illuminations*, 147.
44. *Image-Music-Text*, 73.
45. Erving Goffman, *The Presentation of Self in Everyday Life* (London: Penguin, 1990), 13.
46. Ibid., 26–27.
47. *Performance Theory*, 71, 87.
48. Ibid., 72.
49. The confluence of past and present in repetition is a key concern for Gilles Deleuze in *Difference and Repetition*. Deleuze is here significantly influenced by Nietzsche's theories of eternal return and the negating, destructive power of repetition; *Thus Spoke Zarathustra*, trans. R. J. Hollingdale (London: Penguin, 2003). For Nietzsche, present moments are emptied of the uniqueness of experience as all that can be has been before in the past and all that will be has already been. As Joan Stambaugh has argued, this "superfluous repetition" in the present moment is linked to Nietzsche's theory of the nihilistic nature of everyday life; *Nietzsche's thought of Eternal Return* (London: Johns Hopkins University Press, 1972), 12–13. Deleuze, though, asserted that the "natural" systematisation of repetition can sustain three repetitions before the mechanism comes to signify itself, turning all subsequent recurrences into pure repetition. Deleuze's "triadic structure" sees the third moment that implies a systematisation of repetition as "the revelation and affirmation of eternal return"; *Difference and Repetition*, trans. Paul Patton (New York: Columbia University Press, 1994), 92. The eternal return can at times be hinted at in cyclical repetitions that do not reach a third level, "which alone merits the name of eternal return" (ibid., 93). Deleuze argued that, in repetitious structures, there is a synthesis of time that sees past, present, and future coalesce in eternal return. Where the double repetition implies the *potential* perpetuation of the eternal return of pure repetition by drawing a comparative analogy between the differing

moments of repeated dialogue, the triple (or more) repetition signifies nothing more than repetition in itself:

> In effect, on the one hand, the repetition in the first two moments no longer expresses analogies of reflection, but the conditions under which eternal return is effectively produced by means of some action or other; on the other hand, these first two moments do not return, being on the contrary eliminated by the reproduction of the eternal return in the third. (ibid.)

The initial signifier becomes the signified when first repeated, a comparative return, but with a final (third level) or subsequent moment of repetition, the ultimate signifier is pure repetition. For Deleuze, the past, present, and future of repetition all function in significantly different ways, but the referent is always the repeated; the present moment is the "repeater", the past is "repetition itself", while the future is that which is destined to be repeated, the "royal repetition", "which subordinates the other two to itself and strips them of their autonomy" (ibid., 94). In cases of multiple (more than three) repetitions, therefore, all repeated objects are one and the same, signifying repetition against time.

50. *Brecht on Theatre*, 139, emphasis added.
51. *Presentation of Self in Everyday Life*, 81.
52. Ibid., 236.
53. Ibid., 110.
54. Ibid., 114.
55. Richard Schechner, *Performance Studies: An Introduction* (New York: Oxford University Press, 2002), 176.
56. *Presentation of Self in Everyday Life*, 34–35.
57. Constantin Stanislavski, *An Actor Prepares*, trans. Elizabeth Reynolds (London: Methuen, 1980), 312.
58. Constantin Stanislavski, *Building a Character*, trans. Elizabeth Reynolds (London: Methuen, 1979), 30. There is a key difference between watching a stage play and viewing a film in terms of how an audience relates to the object before them, however. In "The Work of Art in the Age of Mechanical Reproduction", Walter Benjamin maintained that the uniqueness of a work of art, once a prized quality in any artistic object, has become obsolete in works that are reproducible on any mass scale, such as films or photographs; in an age where flawless and infinite reproduction is possible, the aura of the artistic object "withers" (*Illuminations*, 215). Nevertheless, Benjamin argued, the transformation enacted by an actor on-screen is affected by this

waning of aura: "for the first time—and this is the effect of the film—man has to operate with his whole living person, yet forgoing its aura. For aura is tied to his presence; there can be no replica of it" (ibid., 223). The film actor therefore has a double-edged, yet paradoxical, "presence". In effect, the actor is present on-screen, but her "presence" is limited to that in the physical (the pro-filmic) space of the film studio or location. The paradoxical "presence" that the viewer experiences is presence reduced to the image of a body and the sound of a voice. However, given recent work in screen performances, especially those of Baron and Carnicke and Drake, this is a paradox that is avoidable by locating the performer's body as an element of screen language.

59. For Benjamin, technical reproduction is always abstracting.
60. Drake, "Reconceptualizing Screen Performance", 93.

THE QUALITY OR STATE
OF BEING CHANGEABLE

> Vicissitude: 1A, the quality or state of being changeable; muta-
> bility; B, natural change or mutation visible in human nature or
> human affairs; 2A, a favourable or unfavourable event or situ-
> ation that occurs by chance… Fluctuation of state or condition;
> alternating change. See change. (Maria, *Trust*)

Hartley's first two features, *The Unbelievable Truth* and *Trust*, both fol-
low roughly similar lines. Both films feature the late Adrienne Shelly
as a teenage girl undergoing "natural change or mutation" in the pro-
cess of growing up and entering the adult world. In *The Unbelievable
Truth*, this happens through Audry's relationship with the returned, and
possibly dangerous, Josh, who the town believes is a psychotic killer.
Meanwhile, in *Trust*, Maria flirts with adulthood in a relationship with
another dangerous loner, the grenade-carrying Matthew Slaughter
(Martin Donovan), when she finds herself alone and pregnant. Another
similarity that the two films share is the initiation of Hartley's interest in

distanciated, alienated acting and social performances, in which characters undergo change and transformation, either consciously or not, in order to explore the liminal states they find themselves in. In these early films, this takes the form of teen narratives, coming of age, and rites of passage to enter the adult world.

Transformation is central to the experiences of Shelly's characters, as they attempt to perform in different (more "adult") social and vocational roles and structures. Hartley emphasises the modes of transformation that are central to the performances of the main characters, predominantly via external physical signs such as costume and make-up. Performative transformations are therefore doubly determined, as acting—the transformation of Shelly into Audry and Maria—and as performance—the transformation of Audry and Maria into adult subjects. In addition, *The Unbelievable Truth* explores and uncovers the materiality of performative signs, where "people are only as good as the deals they make and keep", to further demonstrate the efficacious function of metaphorical liminality that allows Audry to flirt with Reaganite economics, and resolve her adolescent role-playing in the film's farcical, yet happy, ending.

Transformation is central to almost all modes of acting. "An actor", Stanislavski contended, "is under the obligation to live his part inwardly, and then to give to his experience an external embodiment".[1] Stanislavski's style of acting presupposes realism (of action) in psychological motivation and believability. James Naremore's definition of acting is also relevant here; he proposed that the activity of actors "is nothing more than the transposition of everyday behavior into a theatrical realm".[2] Naremore's use of the word "transposition" implies that that "everyday behaviour" is transposed uncritically into "a theatrical realm". In one sense, that may be true—the actor is asked to disappear in the Stanislavskian dramaturgy, to dispel any trace of technique or mechanical repetition. Performances should appear natural, unrehearsed, and immediate. To use Stanislavski's terminology, the actor should not perform a role, but *live* it.

Performance in Hartley's films is often a process that exposes the performer as performer. Performances in Hartley's films do not just reflect

lifelike portrayals of characters lived by actors, but they expose the per-
formance behind the creation of character. The examination of *Trust* that
follows demonstrates how the mechanics of acting are manipulated to
reveal the performance inherent in the work of both the actor and the
character, where the two remain separate. Stanislavskian theory, how-
ever, posits acting as a conscious transformation, a change in the actor
from herself to *another* self; a subject formed in aesthetic terms through
dialogue, gesture, costume, make-up, and activity. The other character
may be a projection of some characteristic within the actor, but acting
implies the adoption of a self that is Other to that of the performer. The
actor is transformed by a series of physical and decorative means into a
character with the corollary that the actor's own self will be effaced.

Actorly transformations are overdetermined in Hartley's approach
to acting in many of his films. They are overdetermined because they
refer both to performance and acting, where performance refers to the
broader concepts reflected in the activity of the character, and acting
refers to the expressive activity of the actor. The expressive activity of
the actor includes all the physical means by which the actor can portray
a character: this includes motions of the body in action, gesture, facial
expression, vocal inflection and tone, rhythm, costume, make-up, and
spatial awareness. In the most realist sense, the actor utilises each of
these aspects to make the performance appear spontaneous, unrehearsed,
and lifelike. Acting is therefore illusionistic, and used in combination
with the cinematic apparatus, it can become nothing more than repre-
sentation. Although the actor is using a host of different techniques,
developed through rigorous repetition and training, he or she is required
to illusionistically disappear in front of an audience. Performance, in
contrast, sees these physical factors utilised in a very different fashion.
Abstract performances expose the means by which character is con-
ceived as a performance in a cultural realm, rather than an aesthetic one.
Socially, as Goffman asserted, individuals are constituted by the same
web of performative signs that constitute fictional characters. Similarly,
cultural performances can dictate the manner in which individuals are
perceived as gendered, ethnic, classed, or sexualised. Performances,

therefore, can present cultural stereotypes or deconstruct them by exposing them *as* performances. By overdetermining performance as social, cinematic, and aesthetic all at once, mobilising various different codes simultaneously, Hartley's films examine the performances behind the presentation of cultural roles.

The coupling of acting and performance sees the actor transformed into a character, but characters are also transformed as they experience change throughout their narrative trajectory. Performances become doubled. They are doubled as two performances are being enacted: one by the actor, the other by the character that the actor is portraying. This is problematic in cinema because just one body is enacting both performances, and there is no means to separate actor and role because, unlike theatre, the medium "fixes" the relationship between the two—Martin Donovan IS Matthew Slaughter, but Hamlet is Hamlet. The signs that combine to create the actor's performance are thus doubly articulated. Here I look at how acting and performance are intertwined in this overdetermined sense, and how Hartley employs a doubling of performance to further abstract the performance text and develop a discourse on social and cultural modes of performance. Consequently, my discussion will focus upon the performance dialectic that Richard Schechner termed the "efficacy-entertainment braid". He argued that efficacy and entertainment "form the poles of a continuum".[3] Schechner defined performance as a continuum of potential gestures, behaviours, and activities that exist around, outside, and independent of theatre. The polarity of the "efficacy-entertainment braid" marks the limits of this continuum of gestures, behaviours, and activities. For Schechner, it is "the whole binary continuum efficacy/ritual-entertainment/theater" that comprises "performance: an active situation, a continuous turbulent process of transformation".[4]

I first examine Hartley's teen films within Schechner's efficacious-aesthetic link, and how ritualistic performance, following Arnold van Gennep and Victor Turner, treats the signs of performance. I then turn to how the ritualised use of performance is contiguous with the mechanisms of acting. To this end, theories of ritual performance developed

by van Gennep and Turner, in addition to those of Schechner, are utilised to demonstrate how performances are enacted by individuals within rituals, and the fashion in which space and performance signs are manipulated—especially in relation to Turner's theories of metaphorical liminality and communitas. The concept of performative transformation in these anthropological theories will be used to show how Hartley's films overdetermine the link between acting and performance.

TRUST: VICISSITUDE

In *Trust*, the central character's narrative arc is a rite of passage. When Maria discovers she is pregnant, she leaves the family home. Taking shelter in an abandoned barn, she meets Matthew, an angst-ridden loner seeking refuge from an abusive relationship with his father. Maria and Matthew, deviating from the conventional movie love story, do not fall in love, but choose to form an ad hoc family structure within which they can raise Maria's child. This quasi-family allows Maria to embrace the role of mother and to experiment with an alternative role, as the film forces the viewer to align her with both her own and Matthew's (deceased) mother, whose dress she takes to wearing. In becoming involved in this experimentation with social structure and alternative social roles, Maria experiences a rite of passage. Films that feature rites of passage are certainly nothing revolutionary in American cinema—*Trust* was made just after a host of 1980s films that dealt with teen rites of passage (so-called coming of age movies), including *Stand by Me* (Rob Reiner, 1986), *The Breakfast Club* (John Hughes, 1985), and *Heathers* (Michael Lehmann, 1989). However, Hartley's differs in that it addresses the performative nature of such transformations via Maria's use of performance signs, including costume and props. Hartley does this in similar fashion in *The Unbelievable Truth*, but the link is not as pronounced as in *Trust*. The earlier film explores the social structures of 1980s economics that the liminal performer must negotiate to recompose herself as an individual within an adult society based around "deals" and financial bargains that are socially naturalised yet essentially performative.

Both sides of Schechner's "efficacy-entertainment braid" can be seen at work in *Trust*, where performances are taking place on both sides of the diegetic divide (within the film's narrative space and without, in rehearsal spaces and on set). Schechner broke his dyad down into a series of categories, as detailed below:

Efficacy/Ritual	Entertainment/Performing Arts
Results	For fun
Link to transcendent Other(s)	Focus on here and now
Timeless time—the eternal present	Historical time and/or now
Performer Possessed, in trance	Performer self-aware, in control
Virtuosity downplayed	Virtuosity highly valued
Traditional scripts/ behaviors	New and traditional scripts/ behaviors
Transformation of self possible	Transformation of self unlikely
Audience participates	Audience observes
Audience believes	Audience appreciates, evaluates
Criticism discouraged	Criticism flourishes
Collective creativity	Individual creativity[5]

Schechner argued that, although the table represents a series of oppositions, the two sides of the braid do not form a rigid structure but an intertwined relationship, "tightening and loosening over time and in specific cultural contexts. Efficacy and entertainment are not opposites, but 'dancing partners' each depending on and in continuous active relationship to the other".[6] In *Trust*, the relationship is a particularly active one, and it is difficult to define the film as efficacious in the real-world sense (although performing in the film may have had some transformative effect on Shelly or Donovan, it is hard to ascertain), but the film certainly comments upon the interrelation of efficacious ("real") performances and aesthetic ("temporary, illusionary"), acted performances. The crossover of performance signs from one type of performance to the other is particularly noticeable.

Before looking more closely at the contiguity of signs in both concep-
tions of performance, the manner in which *Trust* emphasises Schech-
ner's dyadic structure of efficacious-entertaining performances and how
the film reflects and utilises the structure and spatial construction of rites
of passage must be examined more closely. Only parts of Schechner's
helix are applicable to *Trust*'s narrative rite of passage, and specifically
only those that stress the possibility and efficacy of performance to effect
transformation in the performer/individual. Performance in entertain-
ment is, according to Schechner, either for fun or for efficacy focused
towards producing specific results in the individual. Primarily, perfor-
mances in *Trust* are geared toward creating pleasure for the viewing
audience. For the performers in the film, however, performance is a voca-
tion; therefore, the crossover from entertainment to efficacy is evident.
Secondarily, for the characters in the narrative, performance becomes
solely a conduit for transformation. Diegetic performance therefore is
efficacious for the characters, and it seeks to produce results in them.
Transformation is not only possible, but also the singular goal of the
performer/character's narrative passage. Thus, the narrative trajectory
of *Trust* becomes a ritualised process for the individual to move from
one state to another. The ritualisation may be unconscious or unintended
(Maria does not deliberately become pregnant to enter this ambiguous
state of social positioning), but the temporal and spatial construction of
the narrative becomes ritualistic for her.

In *Rites of Passage*, van Gennep described a structure that he main-
tained is common to all such rites. Transitional rites, such as those
involving pregnancy, childbirth, or passage from one group to another,
he contends, have a three-stage structure. Ceremonial and ritualistic pas-
sages involve three consecutive stages that determine different states of
being for the individual undergoing the passage. Therefore, as van Gen-
nep argued, rites of passage "may be subdivided into *rites of separation,
transition rites*, and *rites of incorporation*".[7] Different rituals may be con-
stituted in different ways, but they will include some form of each stage.
Consequently, rites of separation will predominate in funeral or death
rituals, but marriages will emphasise rites of incorporation following the

transitional rites of betrothal. Transition rites are threshold rites in which the participant, at times literally, stands on the threshold of incorporation into a social or familial group (or in some rites will literally be crossing the threshold of a temple or other sacred place). "Rites of the threshold", van Gennep asserted, "are therefore not 'union' ceremonies, properly speaking, but rites of preparation for union, themselves preceded by rites of preparation for the transitional stage".[8] Following the Latin *limen*, meaning threshold, van Gennep defined rites of transition as "*liminal*" (or "threshold") rites, the betwixt and between of the old and the new, but rites of separation are "*preliminal*" (in preparation for the transitional phase) and rites of incorporation "*postliminal*".[9]

The preliminal-liminal-postliminal structure of ritual that van Gennep described is particularly useful for identifying the structure of Maria's rite of passage, but with an important difference: Hartley left the ritual process unresolved. Maria does not experience a reaggregation into the adult world. Although Maria has an abortion, Hartley did not include a coda that indicates where she will go next, whether she continues to pursue her adulthood (and possibly a relationship with Matthew) or revert back to adolescence. Maria is therefore left suspended in a liminal stage. Hartley reinforced this by closing the film with an ambiguous tableau of Maria standing in the middle of a crossroads (figure 6); in the background a traffic signal shows green (previous shots show it red). The liminality of ritual process is prolonged, and the postliminal phase is only open to speculation. The image is hopeful but, above all, ambiguous.

The final moments of *The Unbelievable Truth* also reject postliminal closure. At the film's end, Audry relinquishes her role and financial success to her father and leaves with Josh; the ending is somewhat ambiguous, although it does see the formation of the heterosexual couple. However, the end of her deal with her father signifies Audry's liberation from the economic structures she has moved through during the film. She tells her father that she will "go to college when [she] feel[s] like it", defying *his* wish that she go to college to conform to the middle-class stereotype. In the original screenplay, she tells Vic that she is going to "travel" the world,[10] although in the film this line is deleted (the line

FIGURE 6. The final image of *Trust* leaves Maria (Adrienne Shelly) suspended ambiguously between states.

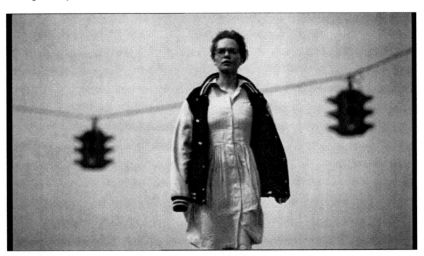

suggests another submission to middle-class stereotypes of late teens travelling through Europe). Audry does tell Josh that she wants to see the world—she feels that she cannot have faith in that which she cannot see. The use of simply the phrase "the world" instead of the notion of travel suggests an experiential attachment to space, rather than the typical bourgeois summer expeditions of children of wealthy parents. Audry's detachment from financial constrictions is an almost Buddhist avoidance of material possessions and the bondage of ownership. Yet it is her willingness to remain in the liminal sphere beyond societal relationships that is most telling. Audry dismisses the possibility of defining her role in adult society beyond a partial return to her state at the beginning of the film. As the film ends, however, the viewer is unsure if this is a partial return or a full reversion to her preliminal state.

After her reconciliation with Josh, Audry stops and asks him to listen. He asks what he is supposed to hear. She simply tells him to listen. The camera tilts away from the pair toward the sky, where it freezes in long

shot before cutting to the credits. What does Audry hear? Is she hearing the bombs again? Is it a lack that she senses, the bombs finally silenced? The viewer is unsure. The final "listen" is aimed more at the audience than Josh, and in the final shot of the film, this is exactly what the viewer is forced to do. But there is only silence. Consequently, the viewer is forced to experience the silence and contemplate it. There is a repetition implied by the silence because this reflects a moment earlier in the film where Audry asks her soon-to-be ex-boyfriend Emmet if he hears the bombs falling. Additionally, the first time the audience is introduced to Audry she is seen waking up in bed, where she "performs" an exploding mushroom cloud, puffing out her cheeks and swinging her arms over her head and out again in a release of tension. The final moments of the film recall these earlier moments (although elements of the scene with Emmet are repeated literally) but do not suggest closure for Audry. The repetition is left open, and with it Audry's liminality. The romantic comedy strand of the narrative finds closure, but the liminality experienced by Audry is not resolved. As in *Trust*, the postliminal incorporation is disavowed by the narrative, ambiguously suggesting the incompleteness of the character's transformation.

The work of van Gennep, especially his theories on liminal structure, has been notably influential on anthropological and social theories of performance, particularly in the work of Victor Turner, whose work has, in turn, been a major influence on Schechner. Turner's work on the anthropology of performance has developed van Gennep's theories to expand the structure of liminal rites to industrial society and has considered the ritual process as one that involves what he defines as "antistructure" and "communitas", both important categories for this discussion. In rites of passage, Turner saw a measure of performance that is applicable to the work of professional theatrical actors in industrialised societies. "Liminality", Turner argued, "is a temporal interface whose properties partially invert those of the already consolidated order which constitutes any specific cultural 'cosmos.'"[11] The liminal therefore is a state that stands outside the "natural" order of any society, positing disorder and chaos as the alternative to everyday life, "the scene of disease, despair,

death, suicide, the breakdown without compensatory replacement of normative, well-defined social ties and bonds ... both more creative and more destructive than the structural norm".[12]

In "*large*-scale societies", Turner maintained, elements of liminal passages exist differently in symbolic genres that are voluntary and temporary, rather than the transitional phases of efficacious, ritualised passages from preliminal stages to permanent postliminal social roles and identities.

Turner asserted that "the term 'liminality' properly belongs"[13] only to the ritual passages of tribal societies, but, in industrial societies, it is reproduced metaphorically within liminoid structures of play and work that replicate metaphorically the liminality of tribal rituals.[14] "Liminal" structures (metaphorical liminality) play a considerable role in forming the social personae of young adults. This is directly reflected in the experiences of Maria and Audry; both are involved in "liminal" performances that are metaphorical in Turner's terminology. Adrienne Shelly, in portraying Maria and Audry, is engaging in liminoid structures that metaphorically reproduce liminality, in effect as play rather than as socially mandated life-changing experience (in this respect, there is an homology between her and the characters she portrays). So, unlike ritual liminality, the liminoid is consciously focused on the uniqueness of individuality as it incorporates the societal desire for escape into the world of play, into the realm of art and sports, where the individual personalities of performers are of critical value societally and evaluatively. Liminoid performances also fit into Schechner's "efficacy-entertainment braid" in a complex way, combining both a means for personal transformation and "fun".

Turner's conceptions of liminal and liminoid embody some of the issues that are brought to the fore by the doubling of performance and acting. Acting is a liminoid activity, but performance of the kind discussed in relation to Maria's diegetic performance reproduces liminality metaphorically. Turner's theory of the liminoid is located in the crux between work and play and their attendant relationships to the structural norm. In industrialised societies, work and play form a binary

opposition between that which is regulated (industrialised, rationalised structures of "unnatural" rhythms and dictates) and that which is rhythmically more "natural" and necessarily less rigidly structured. The activities of leisure time represent a series of freedoms from the industry of work time. As Turner argued, leisure-time is the

> *freedom from* a whole heap of institutionalised obligations prescribed by the basic forms of social, particularly technological and bureaucratic, organization ... [and] *freedom from* the forced, chronologically regulated rhythms of factory and office and a chance to recuperate and enjoy natural, biological rhythms again.[15]

Leisure also offers the freedom to engage in "new symbolic worlds of entertainment, sports, games, diversions of all kinds", and most importantly the "*freedom* to transcend social structural limitations", in play, through thought and deed, and in a host of different artistic and physical genres.[16] The shift from normative to liminoid structures is a voluntary one, unlike that of ritual liminality, but also one that involves Schechner's tension between efficacy and entertainment, emphasising once more the push and pull of transformation and static enjoyment. For the two main characters in *Trust*, transformation takes place outside the structured environs of school or work (Matthew is even moved to violence by the compromises of work). Therefore, the freedom from institutionalised modes of work can be seen to reproduce liminality, allowing the two characters to transcend the structural norm and generate alternative forms of quasi-social structuring.

As an activity that can be both vocational and recreational (sometimes both simultaneously), acting is ambiguously positioned as both work and play. For professional actors, Shelly and Donovan for instance, acting is a performative vocation, involving activity that is tendered in exchange for economic remuneration. Others, however, engage in acting as a leisure activity, in amateur dramatics; acting is liminoid, as it offers an escape from rigid structures of industrialisation, into alternative, ambiguous modes of being. The degree of labour is very different to that of professional performers, but the amateur performer experiences the opportunity to experiment with antistructure, "the dissolution

of normative social structure, with its role-sets, statuses, jural rights and duties".[17] The place where this is most keenly felt, of course, is in rehearsal. Rehearsal spaces are deeply liminoid places, where identities are dissolved and reconstituted differently, allowing the participants to experiment freely with antistructural states. Turner offered a near-perfect definition of the metaphorically liminal experience of actors in rehearsal in his discussion of the self-reflexivity of performance genres (carnival, theatre, ritual, film, etc.) in relation to social dramas. Although not specifically referring to the rehearsal process, Turner's definition of "meta-performance" provides a concise description of how the liminality of performance might relate to rehearsal spaces:

> We find performances about performances about performances multiplying. Of course, as Goffman and others have shown, ordinary life in a social structure is itself a performance. We play roles, occupy statuses, play games with one another, don and doff many masks, each a "typification." But the performances characteristic of liminal phases and states often are more about the doffing of masks, the stripping of statuses, the renunciation of roles, the demolishing of structures, than their putting on and keeping on. Antistructures are performed, too. But, still within the liminal frame, new subjunctive, even ludic, structures are then generated, with their own grammars and lexica of roles and relationships. These are imaginative creations, whether attributed to individuals or "traditions."[18]

Rehearsals can be the setting where masks are removed, and where alternative roles are constructed, demolished, and reconstructed until a semblance of finality is brought to the role. In theatre, performances are never entirely finished, as each performance in a run brings a new audience and further possibilities to experiment. With film, however, rehearsal fixes a performance almost in its entirety, and the prohibitive costs of shooting deny the actor further room to continue the liminal experience of generating new structures, roles, and relationships.[19] For Hartley, the process of rehearsal is a period of experimentation that is aimed at translating words into gestures, focusing on the physicality of

performance, not necessarily to experiment with personalities, but with bodies. Hartley explained:

> What I want the actors to do is not to pretend—just *do it*. Our rehearsal time is an attempt to isolate and specify the appropriate gestures of expression. It's this physical expression that the actors fill up with their understanding of their characters. These physical gestures need to be understood and believed in.[20]

In the same interview, Martin Donovan claimed that this way of performing, which is "virtually choreographed",[21] is difficult for the actor, because Hartley is committed to a method of performance that is focused, as he notes above, toward isolating and simplifying gestures that are predominantly visual. This certainly becomes true in the moments of Hartley's films where rehearsal spaces seem to flow into diegetic, visible space: the moments where Hartley's films overtly document the labour and repetition of performance (all films do this implicitly) by exposing rehearsal space. In *Surviving Desire*, *Simple Men*, and *Flirt* in particular, the liminal rehearsal space is simulated, and the processes by which performers generally arrive at fixed performances are available for the viewer.

The liminal (following Turner's metaphorical use of the term) phase of Maria's rite of passage in *Trust* fully involves the "temporary interfaces" of threshold experience. That experience is also concerned with the experimentation with different forms of structure, alternative social roles, and the signs of performance that are involved in such an efficacious process. As many films have shown, including *The Graduate* (Mike Nichols, 1967), with its travel metaphors and references to the ambiguous, drifting social positioning of its main character, adolescence is the most liminal stage of the human lifecycle. I noted above that *Trust*'s invocation of ritual structure was incomplete because Hartley chose an ambiguous image with which to close the film, but the film does clearly demarcate the preliminal phase of Maria's experiences. The film opens with a close-up of Maria as she puts on lipstick. She demands money from her father in a brief, clipped dialogue that stresses the brazenness of her demeanour: "gimme five dollars", she insists repetitively. Maria's

parents want to know why she has been expelled from school and what she intends to do with her life. With the stereotypical fantasy of a teenage girl, Maria tells her parents that she will marry Anthony, her high school boyfriend, and live happily (and wealthily) ever after. What's more, she adds, he'll have to because she's having his baby. Her father calls her a "tramp". She pleads to her mother like a little girl: "Mom! Did you hear what he called me?" Then, in a very brief passage of dialogue, they trade insults: she calls him a "bastard"; he calls her a "slut". The rhythm is staccato, like gunshots. Maria once more reverts to her childish tone and cries out, "Daddy!" He orders her to leave, and she slaps him. With a final note of childlike impotence, Maria says, "so there", and leaves the house. After a brief pause, her father collapses and dies of a heart attack. This scene is an important point of caesura for the narrative and for the characters involved. In van Gennep's terminology, this scene functions as a rite of separation, the leaving behind of the preliminal stage and entry into the threshold stage of liminality. Although Maria is subsequently rejected by her boyfriend and ejected from the family home by her mother at her father's funeral (a significant symbol of rites of separation), this opening scene, with its violent, clipped dialogue and performances and the childish performance of Maria, emphasises that this is the crucial point of separation for her. Unknowingly, the action of slapping her father (just one of many moments in Hartley's films where women slap men) stimulates not only his heart attack, but also the rite of passage that she will undertake in the film. The absence of the father destabilises the family unit, emphasising the film's discourse on motherhood and the performative social signs that signal motherhood. Accordingly, this moment of separation is also significant for Maria's mother, Jean, as she eventually admits that the death of her husband is liberating rather than destructive. This moment of separation therefore facilitates Maria's movement into a liminal mode. Consequently, the familial space of Maria's home also becomes liminal—the absence of the father emphasising the "inbetweenness" of the home for Maria, her mother, and sister (who is also a mother, but has lost custody of her children to their father) as each is positioned in between old and new roles.

Maria finds herself excluded from the family home, a pregnant teenage stray. Therefore, stripped of the home comforts of adolescence, Maria is separated from the existence that defined her childhood. The childish language and performance that Shelly uses in the opening scene described above help delineate Maria as childlike at the outset. Having undergone the traumatic separation from family and home, literally crossing a threshold from the protective environment of the middle-class home, Maria becomes a liminal individual whose structural norm has been negated (although not by choice or necessity). When she meets Matthew in an abandoned house (another liminal space), Maria begins a process that will see her and Matthew experiment with different roles (adult, parent) and structures (familial, social, vocational) within the transitional phase that enables both of them to effect change.

As "threshold people", Maria and Matthew form a bond that facilitates the working through of experimental structures, roles, and personae. The liminal alternative to structure, Turner argued, is "communitas". Like liminality, communitas is immediate and temporary, and its "emphasis on spontaneity, immediacy, and "existence", Turner maintained, "throws into relief one of the senses in which communitas contrasts with structure. Communitas is of the now; structure is rooted in the past and extends into the future through language, law, and custom".[22] Therefore, these features of communitas make the status efficacious for individuals undergoing transitional rites, because it is possible and necessary to leave the condition behind once the common ritual experience is over.

The sense of participation that individuals derive from spontaneous forms of communitas facilitates the play with new forms of structure within it. This sense of being, and doing, however, cannot last forever (although, under certain circumstances, particularly in religious groups, Turner argues that communitas can become *normative*). Spontaneous forms of communitas must eventually produce individuals that reaggregate to normative social structure as transformed, with newly formed socialised selves. As Turner contended, "there is a dialectic here, for the immediacy of communitas gives way to the mediacy of structure, while, in *rites de passage*, men are released from structure into communitas only

to return to structure revitalized by their experience of communitas".[23]
Spontaneous communitas is a regular feature of Hartley's films, and
many of the marginal characters in those films experience similar forms
of (de)structuring: in *The Unbelievable Truth*, Audry experiences com-
munitas with the marginal ex-convict Josh; Isabelle and the amnesiac
Thomas experience a particularly acute form of communitas in their
attempt to discover his identity in *Amateur*. As both participants are
undergoing excessive rewriting of their vocational and personal identi-
ties, the liminal experience is more pronounced because both are expe-
riencing efficacious spells in their lives. When Isabelle and Thomas take
Sofia into their group, she participates in this shared communitas—she
too is attempting to discover a new self. Additionally, in *No Such Thing*,
Beatrice and the monster experience communitas—each seeks either the
restabilisation (for Beatrice, after the murder of her fiancé) or the end
(for the monster) of their life. However, in the antistructural freedom of
communitas both must reexamine the nature of their existence. Never-
theless, in cases like *Trust* and *Henry Fool*, characters who experience
communitas do not necessarily reaggregate at the end. As I have already
discussed, Maria, left suspended ambiguously by Hartley's final shot,
does not enter a postliminal stage. Similarly, in *Henry Fool*, Henry is left
suspended, running to or away from a plane in the final shot (a conse-
quence of the decontextualised spatial relationship of Henry to the air-
port terminal and plane, but explained in *Fay Grim*). Simon successfully
discovers a new self through communitas with Henry. Henry, in contrast,
suffers a descent into marginal liminality by effectively entering Simon's
preliminal position from the beginning of the film. For Maria and Henry,
therefore, new structures are not discovered—only possible structures
are explored. By choosing to end these two films ambiguously, Hartley
offered the characters no satisfaction, no relief from liminal statuses.

In *Trust*, the two protagonists experience a form of spontaneous com-
munitas motivated by their equivalent marginality. Maria and Matthew
simultaneously find themselves excluded from traditional familial struc-
tures: Maria is banished from her family, and Matthew is seeking refuge
from his violent, abusive father. The establishment of communitas is

also fundamentally founded on absent parental figures: Maria's recently deceased father, and Matthew's mother, who died in childbirth. This constituent lack in their lives facilitates the foundation of spontaneous communitas, which will produce a quasi form of structuring for these two marginal, liminal individuals. As noted above, the liminal phase of Maria's life is not entirely closed by Hartley's choice of ambiguous final images, but the spontaneous communitas formed by the pair is violently shattered by Matthew's grenade. Although the explosion briefly brings the pair closer together, the social, judicial response to the symbol (and consequence) of the grenade's potential (and real) danger is ultimately destructive for their union. Hartley represented this heightened form of communitas formally in an overhead shot that looks down on Maria and Matthew as they lie together on the floor, head to head, their bodies pointing in opposite directions. Like their relationship, the formation is not sexual, as their bodies are not intertwined; only their heads are close together (figure 7). This is then broken by society's intervention.

FIGURE 7. Temporary communitas is threatened in this visual arrangement, but it is subsequently shattered by social intervention and the restoration of structuring.

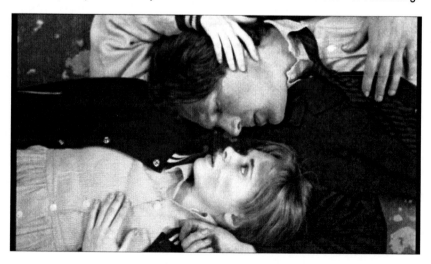

There is, however, transformation without reintegration: Matthew is arrested, and Maria is ambiguously positioned, but with a new resolve.

Within the quasi-structuring of spontaneous communitas, the liminal participants experiment with an adult family structure that is partly an interface for the transformation of the individuals involved, but it also a symbolic object that allows Hartley to critique and satirise representations of middle-class, small-town American mores. Hartley used the outward elements of performance, clothing, size, make-up, and props to make immediate points about characterisation or to confuse or contradict the external portrayal with its ultimate meaning. These performance signs are crucially doubled in aesthetic and social terms. As Goffman contended, external signs such as performance, clothing, size, make-up, and props are essential elements in the composition and maintenance of a social front.[24]

The "sign-vehicles" that Goffman groups under the heading of "appearance" correspond to the performative symbols that Hartley utilised throughout *Trust* to delineate the transformation of the two central characters. Those "sign-vehicles" include the significatory apparatus available to the actor to effect a transformation: "insignia of office or rank; clothing; sex, age, and racial characteristics; size and looks; posture; speech patterns; facial expressions; bodily gestures; and the like".[25] Certain symbols remain more fixed than others, such as race and sex, but others are open to transformation, such as clothing and looks. In addition, the temporary symbols of "manner" that dictate the interactional mode adopted by the performer—posture, speech, facial expressions, and gestures—are open to almost infinite manipulability. It is in these signs that compose "appearance" and "manner" that Hartley made the doubling of efficacious and entertaining performance most keenly felt.

The transmutability of these signs makes the doubling of performance in both the aesthetic and social sense possible (this forms the core of Goffman's thesis, that social performance can be read in aesthetic terms). This pairing is also implied by Naremore's contention, quoted at the outset, that "acting is nothing more than the transposition of everyday behavior into a theatrical realm".[26] Hartley, however, used a

form of visual stereotyping in *Trust*, and other films, as a form of visual shorthand, using colour and symbolic associations to aid the delineation of character. In a sense, this form of external characterisation is akin to wearing a mask,[27] but whereas a theorist such as Stanislavski would see characterisation and the internal emotional apparatus at the actor's disposal as a mask, the external mask (either that of a character or a Brechtian-quoted stereotype) becomes more abstract. The abstracted external mask is subsequently mobilised to scrutinise specific gender roles, especially those that refer to Maria.

Conceptions of gender are based on external signs that denote, for the observer (although those signs may be consciously mobilised by the individual), roles and characterisations that are specific to gendered social positions. In *Gender Trouble: Feminism and the Subversion of Identity*, Judith Butler concluded that there is no such thing as a "natural sex" into which the subject is interpellated upon entry into language. In "ritual social dramas", Butler argued, "the action of gender requires a performance that is *repeated*. This repetition is at once a reenactment and reexperiencing of a set of meanings already socially established".[28] For Butler, conceptions of gendered subjects are constructed socially by repetitious performances. Gender is an "act", a construct of a binary system that sees male and female paradigms as more or less stable and temporally unchanging. However, Butler contended, "the body is not a 'being,' but a variable boundary, a surface whose permeability is politically regulated". "Consider gender", Butler maintained, "as *a corporeal style* ... which is both intentional and performative, where '*performative*' suggests a dramatic and contingent construction of meaning".[29] Public constructions of gendered roles are constituted as repetitious performances, enacted upon the surface of the body, and not fixed temporally or socially.

In *Trust*, Maria's performances of gender roles are explicitly presented *as* performances. The metaphorical interface of liminality provides an opportunity to emphasise the lack of fixity in gendered performance that is enacted exclusively upon the surface of the body. The performances therefore make specific reference to cultural standards of feminine

identities that are explicitly stereotyped performances—those that are fixed through repetition. Maria's performances as the sexually precocious, and pregnant, middle-class teenager, the mother, or the spinsterish librarian are masquerades[30] that have accepted, and fixed, social meanings. In one sense, Hartley is substituting one cliché for another, but the manner in which Maria slips between these roles by changing costume, make-up, and accessories demonstrates the artificial constructedness of gendered social roles. This is made especially clear by the film's ambiguous ending, which leaves Maria's ultimate role undetermined, where no postliminal formation is projected. The lack of authority in the signifying acts of gender roles, especially female ones, is demonstrated by many of the female characters in Hartley's films, where superficial alterations of external determinants such as costume, make-up, location, and narrative function to articulate the artificiality of accepted gender roles. In *No Such Thing*, Beatrice is specifically cast as the ingénue, and dressed in tight fitting, sexually provocative black leather. The role is at odds with Beatrice's performance thus far, but those manipulating the diegetic media narrative of the film's *Beauty and the Beast* scenario require a public articulation of seductive female sexuality to fit the ingénue role. The sexualised Beatrice is therefore explicitly a performance—one that even she is taken in by—that is constructed from clichéd presentations of displays of female sexuality. Similarly, Audry in *The Unbelievable Truth* and Isabelle in *Amateur* accept, or are forced into, alternative social roles that are dictated and constructed by superficial acts and accoutrements. The acme of this tendency in Hartley's films remains Miho in *Flirt*, where the performance is subject to an audience's misreading within the diegetic space of the film.

Performance signs and narrative contexts in *Trust* often invoke different social roles, such as motherhood and librarianship. However, by subverting and combining different roles (and the signs by which they are represented) in the context of the narrative the temporary, transitional nature of these roles for Maria are expressed. Her experience of the narrative transformation is liminal and plays with alternate roles and different structures. The shifting, contradictory nature of sign-vehicles such

as these emphasises the liminality of the efficacious performance that Maria is undertaking via the use of these signs and sign systems.

The most evident form of visual characterisation, by the use of cliché, is Maria, whom Hartley's screenplay describes as "a spunky, well-intentioned, but troublesome and thoughtless seventeen-year-old with big hair, supermarket clothes, and a mouthful of chewing gum".[31] Shelly is immediately recognisable as this character by the use of colourful clothing and her big mass of bright red hair that appears as a contrast to the muted, washed-out colours of the rest of the palette of the film. Later, when Maria undergoes her transformation in appearance, she loses this colourful style, dressing in Matthew's mother's sky-blue dress (again highlighting the associations between Maria and motherhood introduced by the congruity between the film's opening shots), flattening and straightening her hair, and wearing glasses. Rather than clashing with the colour scheme of the rest of the film, Maria now fits more comfortably into the world that the film creates. An external sign such as Maria's glasses is subverted by Hartley: Maria says she avoids her glasses because they make her look like a librarian, but when Matthew says he likes librarians she decides to wear them. However, instead of making Maria brighter or more knowledgeable, like a librarian, her naiveté and lack of understanding become *more* apparent, as she mispronounces words and asks for meanings.

Donovan's characterisation of Matthew is also drawn via the use of external signs. Apparent immediately is his name, Matthew Slaughter, with its connotations of savage excessive violence and murder. Most importantly, however, is the use of a symbolic prop (the grenade) to suggest Matthew's rage. Although this rage occasionally spills over into violence, such as his assault on the deli man in the bar (retribution for his attack on Maria perhaps), the grenade is inactive. A symbol of war and *potential* violence, the grenade offers Matthew solace, as in the scene where, having been berated by his father for not cleaning the bathroom, he sits holding the grenade almost sensually, expressionistic lighting streaking across his face from the window. These visual signs stress the potential for violence in Matthew, the audience having already seen him

"vice Ed's head". Of course, when Matthew finally pulls the pin, the grenade initially proves impotent. When the explosion finally comes, Maria sparks it.

The use of visual shorthand such as the grenade and Matthew's black, unkempt clothing are a form of Eisensteinian typage, whereby the meanings of these visual signs are immediately graspable by the audience. External characterisations do not simply hold to representational purposes and the demands of realist believability, but they have an abstract usage delineating character in a very straightforward manner. The exterior appearance of the characters relates directly to internal states, supplementing performance and the technique of the actor by effectively forming a mask that symbolically defines character without the use of the interpretation of deeds or verbal language. The visual imagery used in this manner forms an idiolect that draws on sources outside the film, but it relates them directly to the character to which they are applied; from performance signs are abstracted, subverted, or developed as they relate to particular characters within the narrative.

THE UNBELIEVABLE TRUTH: A PERFORMANCE OF GENDER

In *The Unbelievable Truth*, positions and statuses are mistaken, unconsciously, as material (in contradiction with Goffman's assertion that they are immaterial) in the context of a discourse surrounding the Reaganite "Greed is Good" ideology of the 1980s. Audry Hugo begins the film as an angry, disillusioned teenage girl. Constantly hearing atomic bombs going off, she finds herself at odds with her father, Vic Hugo (Hartley's first character name to refer to a noted author), over her choice of college degree. She meets Josh Hutton, as enigmatic ex-con who has recently returned home, and she falls in love. The town is awash with rumours about Josh, his involvement with Audry's friend Pearl, and whether he killed Pearl's father and/or sister. Eventually, Audry begins modelling, and she becomes an article of trade in her father's economic plan. She moves to the city, but when her father sees what he believes to be pornographic pictures of her in a commercial (which the audience never see),

he pays Josh to go and get her back. The film descends into farce by its end, where motivations are unknown, trusts are stretched, and deals are broken.

As Audry tells Josh, "you can't have faith in people. Only the deals you make with them. People are only as good as the deals they make and keep". The body is a key material factor in Audry's ideology. Her body becomes a commodity, an item of exchange for herself, and for the unscrupulous photographer who launches her modelling career. Personal relationships become networks of exchange within which Audry becomes a liminal performer, consciously exploiting the economic structures of adult society to determine a new social position for herself. The logic of performance is manipulated as Goffman's notion of immaterial positions and statuses is reversed. Like the running joke in which Josh is mistaken for a priest, people are forced to fit into roles and selves that are predefined and subject to misinterpretation by diegetic audiences. Hartley extended this to the generic logic of the small-town teen comedy by exploiting and subverting preexisting, clichéd characterisations—the precocious teenage girl (a role subjected to greater exploration in *Trust*), the promiscuous waitress, the angry father, the dim-witted mechanic, the reformed criminal, and the sexual predator exploiting a professional relationship.

The conscious materiality of roles is a source of delusion for some characters; Todd, the photographer who launches Audry's modelling career, is repeatedly compelled to display his camera as proof of his role, as though owning a camera is irrefutable evidence of a professional career photographing young girls. The camera becomes a material signifier of a role, yet one that is subject to suspicion. When Todd first tries his pitch on Jane in the restaurant, she doubts his credentials, despite the presence of his camera. She simply suspects that he cannot pay his bill and reports him to her manager as a "troublemaker". Audry's father, Vic Hugo, however, is not so suspicious of Todd's intentions. Vic is quickly taken in by Todd's proposal, immediately presenting Audry to his new friend. Vic and Todd, though, are soon at odds over the cost of Audry's portfolio. Vic is indignant: "But I hardly know you! How did you get

in here?" he screams. However, they eventually reach an agreement to produce a series of photographs for six hundred dollars. In this moment, Audry has become an article of trade—for just six hundred dollars, Vic can market his daughter for exploitation.

Whereas Deer saw the film as "a Godardian commentary on the commercialization of the body",[32] the film also maps onto discourses surrounding performance and the labour of acting. Actors *are* articles of trade (the portfolio is also a key marketing feature of the actor—a series of head shots of the actor in various guises, and portraying a range of emotions). They tender their bodies in exchange for financial recompense. Trade journals such as *Variety* develop discourses surrounding the "deals" involving actors. Although many of those discourses map onto other discourses around individual stars, the commodification of the actor is rife in contemporary cinema cultures. The actor is literally only as good as the deals he or she makes. In his postscript to the 1998 edition of Richard Dyer's *Stars*, Paul McDonald suggested a reconceptualisation of star studies—a shift away from "what does stardom mean?" to "what does stardom do?" McDonald proposed a move away from text-based analysis to work "by which stars and moviegoers may be better thought of as social 'agents'. Agency does not presume that stars and moviegoers can freely determine structures of representation or power, only that they can negotiate movements within these structures".[33] Social agency here equates closely to Goffman's notion of individuals as social performers, and the manner in which they "negotiate" within structures of presentation or power with little ability to change or create such structures. These structures are taken as self-evident by most performers; as Goffman argued, the performer "can be sincerely convinced that the impression of reality which he stages is the real reality", whereas it is only the cynic who "will have any doubts about the 'realness' of what is performed".[34] Despite this, the structures of power and presentation remain performances constructed socially and culturally through which the performer must negotiate. Audry negotiates through the structures of commerce: she is a cynical performer. She is not taken in by her act— she understands that her flirtation with these structures is temporary and

necessary to take on her intended adult social role. Therefore, Audry is equally aware of her status as a liminal performer, one outside the social realm in which she will take her place as an adult (i.e., she works in New York City, the mythic centre of commerce constructed in the opening shots of the film with Josh on Wall Street, but she will return to Lindenhurst before going to college).

In *Simple Men*, Bill argued that the "exploitation of sexuality has achieved a new respectability because some of the women whose bodies are exploited have gained control over that exploitation", and Hartley charted similar thematic water in *The Unbelievable Truth*. Audry's ability to control the means of exploitation—and to make most of the money—is a reversal of the traditional structure of patriarchal exploitation of the female body. She understands that she is an article of trade, a performer involved in an economic transaction, and as such is able to maintain her end of the bargain. It is the deals between men that fail in the film. Vic pays Josh five hundred dollars to go to the city to sleep with Audry and bring her home. This posits Audry as a very different article of trade, one in which she has no agency as a performer, as it is a deal in which she is not complicit. Ironically, this forces Audry into the very position that Vic had perceived in her lingerie adverts. Although he baulked at the sexual explicitness of those images, he has little reluctance in selling his daughter as a sex object to Josh for just five hundred dollars. This is just one more failed masculine performance in Hartley's films. Vic's deal with Josh is an overt attempt to buy patriarchal authority and assert the control over his daughter that he feels is his right. The fact that he tries to assert his role as father through a financial transaction restates the parallels between patriarchal society and commerce that the image of Washington on a banknote emphasises throughout the film. Vic sees his role as material, a social status and power relationship with his daughter, that is defined by his economic worth and superiority over her. However, Audry's adoption of a new role has negated Vic's ability to exert financial control over her, thereby dissipating his paternal authority over her. As their relationship is dictated by economic statuses, her success and apparent superiority over her father allow her to transcend the

patriarchal structures of commerce by which she is forced to negotiate in order to define her adulthood (adults have money, children do not). Finally, she relinquishes her financial gains to her father, freeing herself of her responsibility to her father's deal and relinquishing her status as a commodity.

By performing as a commodity, Audry adopts a typical position of femininity in contemporary society, as an image to be looked at, but, however, she also performs as an adult in control of her sexuality in order to negotiate the social structures of exchange and economic relationships that ease her transformation from a childhood to adult role. She allows herself to be turned into a commodity, not just as a body to be looked at in the diegesis (as the audience never actually see her body in her modelling shots), but as an article of trade through her relationships with others. The negotiation of economic structures facilitates the efficacious role-playing that helps her negotiate her own liminal status as an adolescent on the cusp of womanhood. In an environment where people are "only as good as the deals they make and keep", the body becomes a key article of exchange. However, this is never vouched in terms of sexuality—the failure of Audry's deal comes as Todd attempts to seduce her. It is never implied that Audry exploits her body for profit, only the image of her body.[35]

Images of the body gain exchange value in the text as consumable commodities. As Foster Hirsch argued, this is a key function of the actor's body onscreen: "Actors are usually the primary focus of what the camera sees.... The presence of the recording, glaring, probing camera transforms the actor into an object, a commodity to be scrutinized".[36] The images of Audry's body that are implied in the film, being withheld from the viewer, gain social value only in their monetary value. As Audry notes, she is paid almost a thousand dollars for a photograph of her foot wearing a shoe. By subjecting herself to the commodifying gaze of corporate America, Audry has turned herself into a consumable object where her foot is worth almost a thousand dollars. But, in consciously submitting to these objectifying forces, does Audry submit to a controlling patriarchal ideology? Audry's oft-repeated belief that people

only have worth equivalent to the contracts into which they enter is a cynical reflection of the consumer society in which she lives. Indeed, she sleeps under the watchful gaze of George Washington on a large dollar bill mural on her wall. The image of Washington, as actualised on the almighty dollar and mythologised as the honest hero of independence, dominates the early stages of Audry's relationship with Josh. When she first meets Josh, she describes herself as a "big fan" of Washington and what he represents:

> He's singular. One. He's the one dollar bill. And just look at the man—he's not very attractive. But he's got dignity. And he's a farmer ... Down to earth. And I can't help thinking that were he alive today, doing the job he did then, leading that particular revolution, he'd be locked up. Or worse. All of them. Jefferson. Paine. Franklin. They'd be executed.

This dialogue emphasises the contradictions inherent in the image of Washington, both the populist hero *and* the father and symbol of capitalist commerce. This is the contradiction highlighted by Audry's exploitation of her own image. Dabbling in both ends of the political spectrum at once, Audry follows both the right-wing self-interest of capitalism and the liberal left-wing agendas of nuclear disarmament and peace. This, the film seems to suggest, is a contradiction embodied by America, just as Frank Capra's depression era films, such as *American Madness* (1932) and *Mr Smith Goes to Washington* (1939), did.[37] The small-town, blue-collar Long Island setting of *The Unbelievable Truth*, just across the river from the economic centre of Manhattan, evokes a populist notion of a close-knit, supportive community. The commodifying drive of capitalism is in sharp contradiction to this nostalgic, rarefied image of America, yet it dominates the landscape of personal relationships in the film.

Audry's final desire to see "the world" highlights a desire to get away from the constructed, artificial nature of her world to experience "the world" in its natural glory. This is a rejection of the consumer society that has dictated her use-value throughout the film and the commodification of her body. She is no longer a performer defined through her

visibility alone. The intangible nature of Hartley's final image and its ambiguity imply a rejection of the visibility of consumable objects. As Jean Baudrillard argued in "Consumer Society", the proliferation of visible, consumable objects in modern society is an unnatural nature, one where objects, like the characters in *The Unbelievable Truth*, are defined by their monetary trade value: "they are in actuality the *products of human activity*, and are controlled, not by natural ecological laws, but by the law of exchange value".[38] The deals people make in Hartley's film turn them into the "fauna and flora"[39] of an ever-visible world of commodities and objects. Audry flirts with this world throughout the film, allowing herself to be objectified (to become a *product of human activity*) in order to fulfil the conditions of the deal into which she has entered with her father. However, this activity is a performance, an adoption of an alternative role of which she is a cynical, incredulous performer. She is not taken in by the role and understands its temporary, transitory nature. Where the young characters in *Trust* engage in the creation of quasi-structure in liminality, Audry role-plays in the adult world, using her incredulous performance of adulthood (and conventional female sexuality) to negotiate her passage from childhood to adulthood via the liminal structuring of adolescence. However, as in *Trust*, Hartley's final images suggest the unresolved nature of liminal experience, where the role playing and experimentation result in no absolute adult identity being forged. In this, both films suggest that liminality extends into adulthood, where the fixity of identity and social roles is problematically contingent upon historically and culturally constituted performances.

TONALITY AND THE "MANNEQUIN" PERFORMER

Throughout his career, Hartley has focused on a distinctive style of performance, one very much linked to the performance styles of his regular ensemble. This is something developed right at the outset of his career, and it is a technique that links very much to the themes and meanings discussed so far in this chapter. Like many of Hartley's films, *Trust* uses the technique of the actor in ways that are unconventional for

mainstream cinema: internal states and processes are often not represented by the external states of the actors but are frequently externalised in dialogue; moods and changes of tone are not always logical or coherent; the impulse is generally toward frustrated inaction rather than action.

How does Shelly become Maria, and how does Donovan become Matthew? Since performance is a central theme of the film, *Trust* poses this question of itself, as the actors are playing characters that are trying to play roles themselves, although neither character is particularly suited to the casual domesticity they desire. Matthew is unwilling to compromise, and Maria is unsure about her newfound independence and maturity. As in *The Unbelievable Truth*, Hartley positioned the main characters to critique different areas of commodity culture—Matthew is dispirited by the cheap, low-principled consumer electronics that he fixes, and Maria rejects the clothing and make-up by which she feels she has been commodified.

Hartley's implicit critique of a certain mode of acting (a mode of performance that emphasises the "acting out" of emotions and human relations) in *Trust* is significant within his oeuvre because it does not contain the sort of overt stylisation that characterises the performance modes in *Surviving Desire* or *Flirt*. Although *Surviving Desire* can be looked at as a film that is stylistically conservative, the dance scene frames the way that the issue of performance is looked at in the film. *Trust*, in contrast, is performed entirely within a more naturalistic/realistic mode. The realistic mode, however, is limited by the relative abstraction of the stylistic system discussed below, inviting the viewer to look more intently at the processes of characterisation and emotional response (in the character and the viewer). *Trust* is not necessarily an openly emotional film; Hartley used the performances of his actors and his screenplay to question how emotion is created and conveyed by partially abstracting performance signs and externalising emotion in dialogue. Hartley has said that a smile is "an easy win" that can disturb the balance of the work, where the subject may be overwhelmed by the acting.[40]

In *Trust*, choreography, rhythm, and inaction partially abstract the style of acting, its technique, and how the screenplay develops or interacts

with that technique. Hartley's dialogue is particularly conscious of how emotion is conveyed externally by the actor, and how relationships are frustrated by emotion, behavioural alienation, and lack of communication. When Matthew engages in a drinking contest with Jean to decide whether Matthew stays with Maria (and in her house) or not, he talks about his relationship with his father and whether he loves him or not. Matthew repeats his earlier declaration he made to Maria that he does not love anyone. For all intents and purposes the viewer could accept this as true; the relationship between the couple is treated as chaste, without the kind of signs taken for granted in a Hollywood romance—kissing, dancing, intimacy. The pair mimics a form of domesticity as Matthew returns to his job at the electronics firm to provide for Maria and her baby. Talking to Maria's mother, however, Matthew describes his relationship with his father in metaphorical terms; the behavioural connotations describe the repetitious rhythms of their relationship or lack thereof. This is mirrored in Donovan's performance of the dialogue, which is fractured and discontinuous:

> JEAN: Do you love him?
> MATTHEW: Who?
> JEAN: Your father.
> MATTHEW: I don't love anybody.
> JEAN: Yeah, right. I keep forgetting. Drink up.
> MATTHEW: You know, with me and my dad, it was as if our relationship was a record album. You know, and the phonograph that the record was playing on has a very old and worn out needle. Know what I'm saying? There were these skips. Bad skips. These painful gouges. But in your head, you know, you compensate for it. You keep the beat because you know the song ... Most people buy laser discs now. You know, CDs. They don't wear out. You can't damage the surface of CDs. They're digital. Not analogue. Would you like for me to explain to you, Jean, the difference between analogue and digital recording?
> JEAN: No.
> MATTHEW: It's really fascinating stuff.

> JEAN: I'm sure it is.
> MATTHEW: Jean.
> JEAN: Huh?
> MATTHEW: I think … I think I'm … I think I'm actually drunk.

Matthew's monologue is delivered almost directly to camera. The focus of the performance is very much his face. However, Donovan performs with very little expression. There is some furrowing of the brow, twitches of the eyebrows, but the way in which the scene is lit makes it almost impossible to see his eyes. The scene is lit almost expressionistically with cold blue light (to signify nighttime) and chiaroscuro patches of low light and dark shadow. Shadowing across Matthew's face obscures his minimalist expressions. The stylistic schema that Hartley utilised in this scene works in conjunction with Donovan's physical performance to effect meaning, disrupting the naturalism of the representation by partially obscuring the actor.

Donovan's performance is linked directly to the metaphor carried in the dialogue. The fractures of his relationship with his father are mirrored in the broken rhythms of his speech patterns, suggesting not simply his drunken state (which is conveyed with none of the stereotypical signs of drunkenness), but the thought he puts into constructing and vocalising the metaphor. Hartley's dialogue conveys the emotion that Matthew claims not to feel, the longing for a normal relationship with his father rather than the violent "skips" and "painful gouges", which he sees as a digital relationship instead of an analogue one, that cannot be scratched or damaged (even though Matthew is wrong—CDs *can* be damaged, just like records—and digital communication is generally discontinuous and fragmented, with "skips"; the error is symptomatic of his unconscious compulsion to repeat in his destructive relationship with his father). In this case, the actor's technique combines with the passage of dialogue to externally represent an internal state without the use of expressive visual signs.[41] Matthew's speech is expressive as metaphor, but it also uses fractured rhythms and different speeds of delivery to make that metaphor have emotional resonance. Indeed, the fractured rhythms of Matthew's speech are themselves typical of digital communication,

rather than the analogue mode he fetishises. Discussing the histrionic code of silent acting, Roberta E. Pearson argued that the gestural system of performance developed by Delsarte and carried over into early cinema was a digital mode of communication distinguished from more realist, verisimilar codes by "discrete, discontinuous elements and gaps".[42] The gestural code is made discontinuous by the pause-marking of gestures (gestures performed, then held for emphasis,[43] and therefore less realistic). The verisimilar code is made more realistic, Pearson asserted, by continuous analogue communication, with the insertion of psychologically motivated bits of "business" by the actor to make a character appear more real. Martin Donovan's performance in this scene taps into less realistic modes of performance, stressing the digital over analogue forms of communication, thereby making the performance expressive of Matthew's fractured, gap-riddled psyche.

Despite the general difference between the Stanislavskian and the Brechtian conceptions of acting that can be drawn upon to enable a reading of Hartley's work, there is a parallel between the use of rhythm in this scene and Stanislavski's use of a musical motif to describe the actor's use of dialogue (verse and prose) and action, emphasising the use of the voice and likening it to training as a singer with meticulous attention to rhythmic tones and changes:

> *tempo-rhythm, whether mechanically, intuitively or consciously created, does act on our inner life, on our feelings, on our inner experiences.... [I]t often appears as a direct, immediate or else sometimes even an almost mechanical stimulus to emotion memory and consequently to innermost experience....* There is an indissoluble interdependence, interaction and bond between tempo-rhythm and feeling and, conversely, between feeling and tempo-rhythm.[44]

In this example from *Trust*, Donovan's performance consciously and explicitly manipulates the rhythm of performance to externalise the emotional memory of the character. The rhythm motif in the metaphor of the fractured, broken surface of a vinyl record and its imperfect playing demonstrates how performance is externalised explicitly by dialogue,

and how performance supplements dialogue. Strictly speaking, Donovan's performance is not emotional; there are no conventional outward signs of inner pain—tears or fractures in the tone of Donovan's voice—nor does Hartley use any flourish of *mise-en-scène* to emphasise the performance or metaphor. However, by consciously manipulating this key element of performance, and drawing attention to it in Matthew's monologue, Hartley's nonperformance elements give the moment an emotional resonance despite a self-reflexive attitude to performance. The technique of the actor therefore functions in an expressive manner (exposed acting), rather than the actor using technique to become expressive (hidden acting).[45]

The character to which the most significant conception of acting applies is Maria, who attempts to undergo a transformation during the film. The passage of dialogue in which Maria reads aloud the meaning of the word "vicissitude" from the dictionary (which prefaces this chapter), explicitly demonstrates that a change is taking place in her personality and social role by stressing the applicability of the word to her. However, dialogue is used to suggest at certain points that Maria is perhaps not undergoing a change at all but simply adopting a new role according to circumstance. First, she asks Matthew the meaning of the word "empirical": "information based on experience... You can't know something unless you experience it first". Later, when Matthew and Maria are waiting for the man whose wife Maria believes kidnapped a baby, she explains that they will recognise the man because he will appear "childish. Like a boy. Kinda nave". Maria means "naïve". The mistake expresses Maria's own naïvety.[46] Moments of dialogue like these reinforce that, although Maria is involved in a process of transition, she partially remains a child. The fact that the man will appear childish is simply something that she was told by his wife on the bench outside the delicatessen before the baby was taken. The repetition of dialogue in this manner emphasises the childishness of Maria, as when she demands that both her parents and the woman on the bench give her five dollars ("gimme five dollars!"—repeated three times in the film's opening lines).

At the beginning of *Trust,* Hartley casts Maria as an impudent, image-conscious teenage brat, a conventional stereotype of the teenage girl, especially in American teen comedies, a role often filled by cheerleaders or promiscuous young girls. When she leaves home after having slapped her father to death, she visits a clothing store where she buys a new top using her father's credit card. The commodification of Maria is a comment on the commodification of the actor, especially female actors, where the female body is turned into an object for speculation (not to mention scopophilic desire). Hirsch made a distinction between actors whose body language is purely externally codified and those whose use of their body suggests a greater depth of emotional and physical articulation. Hirsch described the former as a "mannequin", where the focus of the body is on display. Gestures are played externally, often lapsing into clichéd representational signs (i.e., hands to head = grief or extreme sadness) or simply a surfeit of surface.[47] The role in which Shelly finds herself is one where the "mannequin" style, the clichéd objectification of body, is a necessary starting point for Maria's change from teen comedy (or TV movies about teen pregnancy) archetype to a more complex, and contradictory, character. This allows the style, and image, to be critiqued and deconstructed. The alteration of performance style and performance signs allow Hartley to expose the cliché as a cliché, where conceptions of the roles performed by women (and therefore by Maria throughout the film) are portrayed as social constructs—repetitious acts—rather than "natural", "real" women.

Maria herself begins as a "mannequin", therefore Shelly's performance requires her to utilise the same technique, effectively putting her body on display, applying make-up or buying new clothes. Even the gesture she performs in the changing room of the clothes store is something of a standard gesture, the newly pregnant woman touching her soon-to-be swollen belly. The gesture is an external sign, a clichéd one at that. However, the technique that Shelly adopts at the beginning of the film is soon brought into question as Maria questions her objectification and her own shallowness. At her first meeting at the abortion clinic after her rejection by Anthony, another spoiled-teen archetype ("the jock"),

she questions how she was viewed by her boyfriend. Since this is an early scene, Hartley uses it to question the stereotype that Maria embodies. Firstly, dialogue continues to suggest the superficiality of Maria's character. However, instead of portraying Maria via the "mannequin" style of performance, her image and impudent style, the dialogue externalises that emptiness. Maria says "I don't know" four times before she finally accepts that she does not know anything at all. In the opening scene, Maria was cocky, accepting that she had already mapped out her life and knew all the answers. Now, all that having crumbled with Anthony's humiliating rejection of her, she begins to question herself, her emotional states, and her place in life.

Shelly's performance in this scene is unconventional as she does not emote via her tone or inflexion; her vocal performance can only be described as flat or monotone, even almost stumbling over her words when she says, "I don't know, sorta special or something". Unlike the scene featuring Donovan that was analysed above, Shelly does not use her technique to express Maria's confusion and hurt, only her own sense of hollowness. Shelly plays the scene without emotion, without tears, in conjunction with Hartley's dialogue, allowing the dialogue to speak for itself, acknowledging the actor's role as "mannequin", as object, and Maria's own position in the narrative as a character that is questioning that objectification (as an actor and a sexual object). The use of highly emotive language, particularly taboo words, stands out as Shelly does not say "cunt"[48] with any emotional inflexion, simply emphasising its use by a brief pause. Shelly's inexpressive use of technique, draining the speech of its emotional resonance, allows the audience to stand back from the scene and reflect upon its own reaction to what is being said, rather than see it as the stereotypical hysteria of a teenage girl who suddenly finds herself pregnant and abandoned (figure 8). Therefore, the transformation from Adrienne Shelly to Maria Coughlin is partially incomplete.

Certain elements of performance in *Trust*, such as the visual transformation of stereotyped appearances, the use of at times inexpressive vocal and facial performances by Donovan and Shelly, and the externalisation of emotion in dialogue, achieve a partial abstraction of the technique of

FIGURE 8. Using the most emotive of language, Shelly's performance is inexpressive, as a "mannequin", in its avoidance of explicit expressive signs.

acting. Consequently, the film exposes the relationship between the two kinds of performances enacted by the bodies presented in his film—the aesthetic and the social—how the actor is transformed into a character and how those characters perform socially. This methodology partially undercuts the emotional relationship between actor and viewer that is mediated by empathy (and demanded by Stanislavski). The abstraction, and consequent diminution of empathy, in *Trust* (and, to an even greater extent, in other Hartley films) is mediated by individual moments that briefly and implicitly expose the actor in the process of creating a performance. The corollary of this device is the overt exposition of the processes of social performance as they are enacted throughout the narrative through the liminality and communitas of the two central characters. Therefore, the double articulation of performance (in the signs enacted by the multiple bodies of the actors/characters) is made apparent for the viewer. Hartley used moments such as those described above to explore the technique of the actors, and how they portray character

by the use of language, intonation, and rhythm, altering the way that the viewer relates to character and the representation of emotion. Transformation is such an important theme in *Trust* that the central concepts of acting are simultaneously being explored as the narrative plays out before the audience: role playing, pretending, and internal and external changes are taking place overtly in the narrative but also implicitly in the use of professional actors to portray characters. The manipulation of the technique of acting, by the actors in conjunction with Hartley's film style and script, extend the exploration of the vicissitudes of the (social and aesthetic) performers.

ENDNOTES

1. Stanislavski, *An Actor Prepares*, 15.
2. Naremore, *Acting in the Cinema*, 21.
3. Schechner, *Performance Theory*, 130.
4. Ibid., 156, 157.
5. Schechner, *Performance Studies*, 71.
6. Ibid.
7. Arnold van Gennep, *Rites of Passage* (Chicago: University of Chicago Press, 1960), 11.
8. Ibid., 21.
9. Ibid.
10. Hal Hartley, *Collected Screenplays 1* (London: Faber & Faber, 2002), 126.
11. Victor Turner, *From Ritual to Theatre: The Human Seriousness of Play* (New York: PAJ, 1992), 41.
12. Ibid., 46–47. For Turner, the ambiguity of liminal states is a form of negation, the dissolution of identity within a normative social structure, although the aim of many tribal rites of passage is the subsequent formation of a new self within social structure. The tribal ritual aids the subject in grasping the rules of that structure, having experienced a quasi form of structuring within the ritual. The dissolution of the individual's identity is central to liminality, where a process of self-abnegation takes place. The subject is stripped of her individuality to become an anonymous participant. This can take many forms: the removal of names, ranks, and clothing, the wearing of masks. There is thus a measure of role playing in the ritual, of performance; however, the negation of self is central in liminality.
13. Ibid., 29.
14. One of the key structural antinomies Turner identified for industrial society is that between work and play, within which are located symbolic forms of antistructure that are specifically leisure genres. Turner identified this new category as liminoid rather than liminal. The liminoid (the "-oid", Turner explains, "derives from Greek-*eidos*, a form, shape, and means "like, resembling"; "liminoid" *resembles* without being identical with "liminal" [ibid., 32]) merely resembles liminality without the same transformative effects. Large-scale modern industrial societies are not like the "tribal or early agrarian societies" in which religious rituals play key roles in life cycles; therefore Turner contended that the "play" with antistructure cannot have the same degree of efficacy in both. Turner viewed the liminoid as the

"successor of the liminal in complex large-scale societies"; it resembles liminality without replicating it; *The Anthropology of Performance* (New York: PAJ, 1988), 29. In effect, Turner argued that the liminoid replaces the liminal as the qualitative difference between industrial and tribal societies and alters the role of antistructural experimentation.

15. *From Ritual to Theatre*, 36–37.

16. Ibid., 37.

17. Ibid., 28.

18. *Anthropology of Performance*, 107.

19. Improvisation is not a technique that Hartley commonly uses. He admitted that he would occasionally include objects and ideas that are created through rehearsals, but generally does not allow improvisation on camera. As he discussed:

> The two actors, Parker Posey and Dwight Ewell, who play Nicola and Ted, the squatters who find Edward and bring him back to life [in *Amateur*], were almost incapable of settling down long enough to rehearse anything without throwing things in. They've been in smaller parts in other films of mine and they're very good friends, who joke around constantly, like two kids. And I really like that energy; I love working with them. I think the dialogue I wrote for them was probably culled from the two or three rehearsals we had.
>
> **GF:** *Do you allow any dialogue improvisation on camera?*
>
> **HH:** No. I prefer not to let that happen. Sometimes we get a particularly unruly actor who will do that kind of thing, and if it works, it works. On a film like [*Amateur*], I think I would just let it go, even if it blew the take. I wouldn't necessarily reprimand them. On this film I allowed myself to watch actors a lot more, to let the camera run. There were a lot more takes and there are a lot more shots in the movie that are "full shots", where the actors are all head to toe in the same frame, and they move around within the frame without me cutting....
>
> I guess that's a level of improvisation. I think that's happening more as time goes by and I make more films. You may not deviate from the script or even from the way you want the actors to move around the room, but that still leaves you open to a huge amount of possibility. (Fuller and Hartley, "Being an Amateur", xxiv)

Although the example from *Amateur* goes some way to demonstrate Hartley's minimal use of improvisation during rehearsal, the roles played by Posey

and Ewell are also examples of Hartley's proclivity for writing parts for the members of his preferred ensemble. This measure of improvisation may have already been included in Hartley's screenplay, so the degree of authorship on the part of both actors and writer is disputable.

20. Fuller and Hartley, "Finding the Essential", xx.

21. Ibid., xix.

22. *The Ritual Process: Structure and Anti-Structure* (New York: Aldine, 1969), 112–113.

23. Ibid., 129.

24. *Presentation of Self in Everyday Life*, 34–35.

25. Ibid., 34.

26. *Acting in the Cinema*, 21.

27. The use of visual signs like masks is similar to that advocated by Antonin Artaud in *The Theatre and Its Double*, where masks and other unusual objects appear "by the same right as verbal imagery, stressing the physical aspect of all imagery and expression—with the corollary that all objects requiring a stereotyped physical representation will be discarded or disguised"; *The Theatre and its Double* (London: Calder, 1993), 75–76. The physical aspects of an actor's characterisation can become just as expressively significant, via metaphorical or symbolic associations, as the vocal signs uttered by actors. Hartley used clichéd appearances to make his characters instantly recognisable to the audience before he begins to change or subvert their appearance and thus their characterisation. In this sense, the stereotype becomes discarded, as Artaud advocated.

28. Judith Butler, *Gender Trouble: Feminism and the Subversion of Identity* (London: Routledge, 1990), 140.

29. Ibid., 139.

30. Mary Ann Doane, "Film and the Masquerade: Theorizing the Female Spectator", in *The Sexual Subject: A Screen Reader in Sexuality* (London: Routledge, 1992), 234–235.

31. Hal Hartley, *Simple Men & Trust* (London: Faber & Faber, 1992), 91.

32. Deer, "Hal Hartley", 163.

33. Paul McDonald, "Reconceptualising Stardom", in *Stars*, by Richard Dyer, 2nd ed. (London: BFI, 1998), 200.

34. *Presentation of Self in Everyday Life*, 28.

35. Laura Mulvey ("Visual Pleasure and Narrative Cinema", in *Movies and Methods*, ed. Bill Nichols, vol. 2 [London: University of California Press, 1985], 303–315) would certainly see the image as indicative of society's misogyny in general. The general function of Hollywood narrative to

separate spectacle from narration, Mulvey argues, sees "woman as image, man as bearer of the look" (ibid., 309). The female image appears on-screen for its "*to-be-looked-at-ness*", which limits the narrative agency of female characters almost to nil. The general tendency of patriarchal film style to present the woman as passive spectacle and male as active agent of narrative determination is reversed in *The Unbelievable Truth*, however. As a film produced outside the Hollywood system for just seventy-five thousand dollars in 1989 (Douglas Bauer, "An Independent Vision: Film Director Hal Hartley", *The Atlantic*, April 1994, http://drumz.best. vwh.net/Hartley/Info/atlantic-profile.html), the motivation for specta-cle of any kind is low. Hartley, however, has expressed a fondness for producing images of beautiful women (Fuller and Hartley, "Being an Amateur", xliv.) (He is not unlike Godard and his nouvelle vague con-temporaries in this regard.) But Hartley's films do not fit comfortably into the model identified by Mulvey, because the female characters in Hart-ley's films gain strength from the exploitation of their sexualised images. Alternatively, Hartley claimed that he consciously avoids moments of overt sexuality, perhaps conscious of the very consequence of narrative paralysis that Mulvey conceives; "Titillation", he contended, "is too easy. It immediately unplugs everything that's interesting" (ibid., xlv). Thus, *The Unbelievable Truth*, in accordance with Hartley's other films, con-sciously eschews images of nudity or sex. All images of Audry's model-ling are hidden from the audience, meaning that her commodified image only has "*to-be-looked-at-ness*" (Mulvey, "Visual Pleasure and Narra-tive Cinema", 309) for viewers within the diegesis, where the extradi-egetic audience is confronted only with the reactions of those in the film who view the images. Presumably, Hartley is attempting to sidestep the scopophilic drive of the audience—he believes images of partially clad or unclad women stimulate reactions in the audience that "unplug" the issues. Hartley may be reflecting on the notion of scopophilia itself, but appealing to the corresponding drive in the audience itself would deny a critical distance that the film requires to examine the concept in terms of its discourse on economic relationships.

36. Foster Hirsch, *Acting Hollywood Style* (New York: Harry N. Abrams, 1996), 17.

37. See Charles J. Maland, "Capra and the Abyss: Self-Interest versus the Com-mon Good in Depression America", in *Frank Capra: Authorship and the Studio System*, ed. Robert Sklar and Vito Zagarrio (Philadelphia: Temple University Press, 1998), 95–129.

38. Jean Baudrillard, *Selected Writings*, ed. Mark Poster (Cambridge: Polity, 2001), 33.

39. Ibid.

40. Fuller and Hartley, "Finding the Essential", xviii.

41. In "Hollywood Movie Dialogue and the 'Real Realism' of John Cassavetes", Todd Berliner quite rightly found that movie realism and real life are two quite different realms dictated by different rules. Berliner suggested that (American) movie realism is governed by five rules that relate to the content of dialogue, character motivation and their uses of language, and narration:

 1. *Dialogue in American movies either advances the plot or supplies pertinent background information.*

 2. *American movie dialogue tends to move in a direct line toward one character's triumph and another's defeat.* ("Characters frequently win or lose a scene by means of what they say".)

 3. *Characters in Hollywood movies communicate effectively through dialogue.* ("Conversations in movies tend to stay on subject, and, unlike real people, movie characters usually listen to one another and say what they mean".)

 4. *Whereas most real people adjust what they are saying as they speak, movie characters tend to speak flawlessly.*

 5. *When a film breaks one of movie dialogue's rules, the transgression normally serves a direct narrative function.* ("Hollywood Movie Dialogue and the 'Real Realism' of John Cassavetes", *Film Quarterly* 52, no. 3 (1999): 4–5; emphasis in original.)

 Berliner argued that these conventions of realis*t style in fil*m speech and characterisation are principles that film has adopted from the stage, just as styles of acting shifted from the stage to the screen at the beginning of the age of the talkies. Silent film acting relied on more intensified movements and gesticulations that could be argued as nonrealistic. The increased realism of modern screen acting may only be an illusion: as Berliner maintained, movie "dialogue may strike us as realistic, but it is most unlike real speech. This contradiction becomes more intelligible, though no less curious, once we understand "realism" to be not the authentic representation of reality but rather a type of art that masks its own contrivance" (ibid., 5). Thus, James Naremore's description of acting as the "transposition of everyday behavior into the theatrical realm" may only be partial.

42. Roberta E. Pearson, *Eloquent Gestures: The Transformation of Performance Style in the Griffith Biograph Films* (Berkeley and Los Angeles: University

of California Press, 1992), 24. Pearson is here quoting Roland Barthes: *Elements of Semiology* (New York: Hill and Wang, 1977), 48–54, 71–88.

43. Ray L. Birdwhistell, *Kinesics and Context: Essays on Body Motion Communication* (London: Penguin, 1970), 197.

44. Stanislavski, *Building a Character*, 243.

45. Exposed acting tends to emphasise form and abstract shapes and lines in the body (as in German Expressionism) above the verisimilitude of "hidden" performances, which minimise overt technique to stress the expressivity of sentimentality (or the mimicking of sentiment). In this scene in particular there is also a double level of performance by a character because Jean is only pretending to be drunk, emphasising all the overt, stereotypical facial grimaces and twitches that typically accompany the drinking of straight spirits on-screen.

46. Sophie Wise referred to this moment as "literally performing naïvety"; "What I Like About Hal Hartley", 258.

47. *Acting Hollywood Style*, 72.

48. Censors still frown upon the use of the word "cunt" by women in a sexual context. The British Board of Film Classification explicitly comment on the use of this word in their certification guidelines, where "the strongest terms (e.g., 'cunt') will be acceptable only where justified by the context". In order to gain a certificate of "15" from the BBFC, the makers of *Bridget Jones's Diary* (Sharon Maguire, 2001) were forced to excise the word "cunt" from the film. As the board's Web site details, "Company chose to remove the word 'cunt' from the dialogue line 'ham fisted cunt' in order the achieve a 15 [*sic*]. An uncut 18 was available to the distributor". In a well-documented case, the subsequent DVD release was also cut to obtain a "15" certificate since the director referred to this incident in an audio commentary; British Board of Film Classification, "BRIDGET JONES'S DIARY rated 15 by the BBFC", *BBFC.co.uk*, April 2, 2001, http://www. bbfc.co.uk/website/Classified.nsf/c2fb077ba3f9b33980256b4f002da32c/d 0e2732a7ea21a7080256a24002aedee?OpenDocument&ExpandSection= 2#_Section2.

CHAPTER 3

DANCE

The word choreography is coming up more and more in rehearsals of all my films. And it is true that I am very formal with my gestures.[1]

I don't like rock videos, but I like to see dance. I like to hear music and play it. I like that live recording, that documentation, that authenticity. That has a lot to do with the dance sequence [in *Surviving Desire*] as well—the documentation of the work and concentration that goes into the execution of a simple spectacle. Here, it's men dancing ... Somewhere we began talking about it and it became more and more elaborate. It introduces archetypal gestures that we were very conscious of: the grabbing of the crotch (we were deliberately quoting Madonna, who was already quoting an existing cultural gesture herself), the crucifixion, *West Side Story*, etc. That dance is not disturbing particularly, but it is very emotionally confusing. By the time they get to the end, I feel that what started out as a lighthearted dance of joy, because he's been kissed, is turning into a complex expression of vague doom.[2]

Like the circular conversations and repetitions of his early films, Hartley's work in the early 1990s was marked by concerns with dance. The dance

sequence in *Simple Men* is probably one of Hartley's most distinctive and popular sequences in his entire oeuvre. Unlike in the films explored in the previous chapter, dance functions at a different level of abstraction, and the actor is often not engaged in a process of transformation. The character becomes secondary to the performing individual. Musical stars like Gene Kelly or Fred Astaire were promoted above the agency of their characters by their skill and the pleasure of watching the body move on-screen. Dance turns the body into a spectacular object—something to be looked at—and, even more so than the methods explored in the previous chapter, a material object that denotes the social function of the performing body.

Dance is a considerably different mode of performance from acting and therefore should be viewed as an altogether different mode of signification. Acting relies predominantly on codes of the everyday.[3] Dance, however, relies on an alternative system of codified gestures and movements that may refer to everyday behaviour, but not merely as representation. Dance theory, as Francis Sparshott argued, is indeterminate because dancing generally resists conventional interpretive activity and has a host of functions, including aesthetic, social, cultural, and recreational uses. Some dances have set parameters and movements (Tangos, Waltzes, rituals), others do not (theatrical, avant-garde performances). "The arts of dance", Sparshott claimed, "are the arts of the human body visibly in motion".[4]

Dances are visible displays enacted by a human body in whatever context they happen to appear. Professional dances, like those seen in Hartley's films (even though the dances appear rough and amateurish, they are still performed by professional performers), are notable, and perhaps problematised further because they occur within systems other than their own. Dances become contextualised within an interpretive system that is codified differently to that of the dance. "Dance as a performance art, in which professional dancers put on a show for an audience", Sparshott argued,

> may differ from other arts in the way its meanings are embedded in systems of meaning other than its own. Not only are dances

performed professionally as parts of other performances ..., but
the forms and values of performance dance are continuous with or
overlap those of dance activity in other contexts.[5]

Dance, therefore, is heavily contextual when integrated into certain sys-
tems of interpretive meaning, especially since dance often cannot be
interpreted in terms of classical forms of representation.

Where Hartley used dance in a number of his films, most notably
in *Surviving Desire* and *Simple Men*, it appears as a form of repeti-
tion that employs a different mode of signification to repeat and com-
ment upon past moments of narration and also to foreshadow future
narrative developments. Hartley's scenes of dance also make cultural
allusions to phenomena such as music and pop star iconography and
refer to generic motifs from the Hollywood musical. The effects of
this swing toward another mode of signification and are not limited
solely to the movement of bodies—there are important consequences
for the function of narrative space and time when repetition observes
past moments reconstituted in present images, while space is made
abstract. Sequences of dance, especially the one in *Surviving Desire*,
effect a much greater abstraction than other moments of abstracting
techniques (such as repetition or the systematisation of gesture); the
temporal and spatial schema of dance sequences differs significantly
from those of other scenes in the films. Dance scenes tend to function
abnormally (as discussed later) in relation to the coherence and logic
of realist space and narrative signification throughout the rest of the
texts they are situated within. Therefore, the degree of abstraction is
much greater, thereby emphasising dance's stylistic and performative
difference from modes of performance and narrative that are realist or
even partially abstract or alienated.

This chapter examines dance in Hartley's films from this perspec-
tive, as a mode of repetition that encompasses a shift to an alternative
mode of signification that has consequences beyond the movement of
bodies for narrative, time, and space. In particular, here I will focus pre-
dominantly on *Surviving Desire* in order to examine repetitious images

recoded from prior textual and intertextual signs into a different form, reconceptualised in dance choreography.

The systematic relationship between past and present that Hartley made a condition of repetition in these cases is also indicative of a form of cultural allusionism. The most crucial repetitions within these scenes have textual origins, but many intertextual referents are also invoked by the imagery. Scenes of dance occur most frequently in films that are recognisable as musicals. Such films have a determining logic that allows scenes of singing and dancing to take place without disruption to the overarching diegetic composition. Hartley's films, however, do not resemble musicals, and scenes of dancing take place in isolation—only once in both *Surviving Desire* and *Simple Men*—and consequently there is no preexisting generic logic involved in making these scenes fit comfortably with the style and form of the rest of the film. Therefore, the virtual traces of the musical that are encoded within, or implied by, the dances make these scenes problematic, disrupting the temporal and spatial schema of the films. To fully understand the manner in which narrative time and space are problematised by the repetition of intertextual elements, I will focus on the generic elements referenced by dance sequences in Hartley's work, citing examples from musical films and critical work on the Hollywood musical.

SURVIVING DESIRE: DANCE, PERFORMANCE, AND CULTURAL IMAGES

In *Surviving Desire*, having grown more and more enamoured with Sophie, one of his most conscientious, less violent students, Jude, a frustrated college professor, arranges to meet her in a bar after she finishes work. They initially discuss the mundane banalities of school and work. Jude admits that he feels that his teaching is uninspired—flummoxed by a paragraph from Dostoyevsky's *The Brothers Karamazov*, he has no answers, only questions—but when he discovers the ability to teach, to articulate, his thoughts are of her. She tells him that it is because she is

pretty, but Jude thinks that it is more complex than that. Sophie shares her self-perceptions with Jude; they seem rehearsed, but paradoxical. ("I appreciate being taken seriously. But I'm always concerned that I'm not sufficiently serious".) Finally, Jude asks why Sophie told her roommate that she was meeting some girlfriends at the bar. She tells him that she is afraid other people might believe that she is sleeping with him in order to get a better grade. "But we're not", Jude retorts. "Not what?" Sophie asks. "Sleeping together". Sophie leans across and kisses Jude, and then, grabbing her bag, tells him, "not yet, anyway", and leaves. Jude is left agog. This scene prefaces the dance sequence that forms the core of the film.

The concept for the dance in Hartley's screenplay is startlingly simple:

> Ext. Street. Evening.
>
> Jude swaggers out of the bar and skips gracefully out into the street, gradually breaking into a shuffling dance step. Two other men fall into step with him. Together they perform a musical dance number as they move up the street.
>
> They reach the corner and go their separate ways, walking normally.[6]

As Hartley implied in the quote at the outset of this chapter, the finished sequence exposes the labour employed by the actors/performers on the set and the processes of rehearsal and performance that endow any dance or set of movements with their form and style. The dance is somewhat ragged, completely unlike the slickness of movement and precision customarily found in musical performances. Indeed, this is a musical performance without music, stripped to its bare essentials: performers and a space in which to perform.

After leaving the bar, Jude jumps on a gate that separates an alley from the street and swings gracefully past the camera, which pans left to follow the swinging gate (figure 9). The physical separation of the alleyway from the street by the gate is significant as the space of the street is a drastically different location in terms of generic and realist space. The dislocation is marked by the generic quotation of Jude's

FIGURE 9. Jude's (Martin Donovan) swing on the gate is connotative of a musical performance tradition, although it lacks the obvious performative signs.

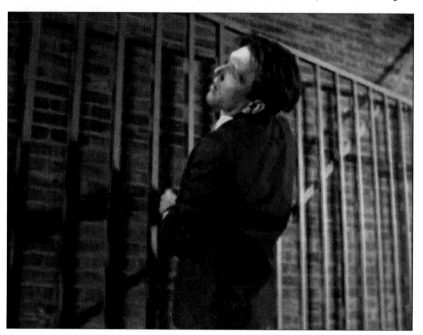

joyful leap onto the gate. *Surviving Desire* is perhaps—the dance and musical performance that follows later in the film aside—Hartley's most stylistically conventional film. Produced for American Playhouse, part of the public television institution PBS, the film is noticeably televisual in style, dialogue based, and composed in close-ups and medium two-shots. Therefore, the dislocation, the shift from the direct realist style of most television drama to an abstract mode, is made much greater by the sudden juxtaposition in stylistic content and the shift from a representational style of performance (acting) to a nonrepresentational[7] one (dance/ movement). This shift, Hartley has noted, is arbitrary: "I wanted to concentrate on the fact I was creating a one-hour television programme. *I wanted to choreograph a dance number and film a rock-'n'-roll band*

live". The shorter form provided Hartley with a medium that supports—almost demands—the oppositions, fragmentations, and ambiguity of *Surviving Desire*: "Shorter films don't insist on resolving. They don't cry out for the rhythm of conclusion. They can merely collapse, explode or disintegrate. *Surviving Desire* falls apart".[8] The rupture that occurs outside the bar following the kiss is thus an integral part of the structure of the film.

The dislocation caused by the insertion of the dance scene into the film at this point is an overt deviation in the film's narrative flow; ruptures develop in the temporal and spatial schema of the film. As the gate swings open, so does a new space in stylistic terms, a setting where time, movement, and space are significantly modified. The movement from narrative to "number" is literalised by Jude's swing on the gate. Specifically, the movement recalls a joyous, spontaneous outpouring, a reflection of Jude's thrill at having been kissed by Sophie, the object of his affection. However, Martin Donovan's body and face portray none of the emotion that the movement suggests. Hartley is quoting the musical in an explicit manner, creating a clichéd virtual image that is flattened and can be read in just one manner. Donovan leaps onto the gate, grasping the bars with both hands, his arms bent, pulling his body close to the gate. His back is arched back and his head lolls backwards. As the gate swings open the camera tracks left, following Donovan as he is propelled into a closer medium shot from the long, wide shot of the gate that followed the cut from the scene in the bar. But as Donovan's face moves into sharper focus, it reveals an expressionless neutrality. Simply, his eyes face forward and his mouth opens slightly as he turns his head to look into the alley before he drops off the gate and passes out of frame into the alley. In a sense, Donovan's expression is still that of the final shot of the previous scene—a blankness that ambiguously suggests both his titillation and surprise at having been kissed by Sophie.

Despite the lack of expressive movement or emoting from Donovan (i.e., a lack of acting in the conventional sense of mimetic reproduction of lifelike facial expressions), the movement is still connotative of Jude's joy. The move itself, irrespective of Donovan's cipher-like bodily

and facial features, is quoting a preexisting movement from a generic source. The transformation of everyday objects into props in dances, such as gates, lampposts, chairs, or tables, is a static motif of the musical, as, according to Jane Feuer, "the primary positive quality associated with musical performance is its spontaneous emergence out of a joyous and responsive attitude toward life".[9] In self-conscious musicals, such as *Singin' in the Rain* (Stanley Donen, Gene Kelly, 1952):

> the impression of spontaneity in [numbers such as "Make 'Em Laugh", "Singin' in the Rain", and "Good Mornin"] stems from a type of *bricolage*; the performers make use of props-at-hand— curtains, movie paraphernalia, umbrellas, furniture—to create the imaginary world of the musical performance.[10]

The quotation therefore signifies not Jude's outpouring of joy, but the joyous spontaneity of this form of *bricolage*. The use of *bricolage* in this fashion is an abstract image, meant to signify the musical in among the feelings of joy projected by Donovan's leap onto the gate (the use of a "prop-at-hand"). Jude's joy is a generic joy, derived from a preexisting source. The image is repeated by Hartley to connote a specific feeling.[11]

Although the dance can be seen using clichéd images,[12] the sequence is complex and can be read multiply rather than as a succession of flattened images. The dance is confusing (not just in the emotional way that Hartley described), even disorienting at times, because the virtual connections are not made explicitly by the performers or the director's chosen manner of capturing the performance, in particular the way in which space is conceptualised. These all rely on a succession of quoted images that can be read in a series of ways, not all of which I can address here. Therefore, the viewer is required to perform much of the work required by the text to understand the scene and make the virtual connections[13] that occur within the quoted and repeated images of the dance,[14] which often defy obvious interpretation. Quotation, such as that examined above, is similar to that of a Brechtian dramaturgy that emphasises the efficacy of conscious quotation over the illusionistic form of performance that accentuates naturalness as if all performance

were improvisational. This, Brecht stressed, sees the abandonment of the actor's "total transformation"[15] into the character. Hartley complicates the role and shifting properties of the performer by showing the labour of performing, the rehearsal process that creates the paradox of the polished spontaneity that is in fact a repetition of practiced gestures, movements, and words.

Rehearsal is a repetition that most films attempt to hide in the illusionary spontaneity of realism. Here, rehearsal returns in the finished product, but as a trope that testifies to the manner in which these images have been produced. The performers in the dance in *Surviving Desire* count the beats of the dance ("1... 2... 3... 4... 5... 6... 7... 8..."), a necessary element of rehearsal that is never included in finished performances. The lack of music, however, denies the unifying rhythm that the counting of the performers provides. The portrayal of the labour of the performers therefore complicates the role of the performer: Are they playing characters, or not? Martin Donovan's blankness in the opening swing on the gate would suggest that the performers are not necessarily portraying individual characters as such, but do have a semantic role to play as performers, or as types—emphasising another form of quotation, or repetition. This is another consequence of the dislocation from narrative to "number".

The quotation from musical entertainment that begins the dance in *Surviving Desire* suggests a functional property of the musical that is shared by Hartley's film. As Jerome Delamater explained in his essay on ritual performance in the musical:

> The transition from diegesis to ritual may occur within the same space and time as the narrative or it may occur by means of editing; but in either case the ritual functions "abnormally," irrespective of the excuse for the number's diegetic possibilities.[16]

The "abnormal" function of the scene that follows Donovan's swing on the gate sees the properties of space and time significantly altered; the transition in this case is achieved through a combination of a shift to abstract movement and elliptical, fragmenting editing.

The presentation of space proves a key perceptual problem. The alley itself is not necessarily a setting in the realist sense like the other locations in the film, such as the bar, the bookstore, and Jude's apartment; spatially these places are exactly as they appear. The location of the alley is as blank and unrepresentative spatially as Donovan's face was emotionally. Space in the alley is not filmed as homogeneous[17] and coherent. The elliptical editing and arbitrary changes in lighting define the space as fragmented and definitely not in line with a realist narrative space where the location is determined by a static style of presentation (continuity editing, ambient sound, or narrative logic). The alley is not determined in this style.

The abnormal functions of space and time are also of critical importance in defining the signification of movement and the relationship of movement to narrative. Divisible space is clearly demonstrated by Hartley's approach to shooting the dance. In addition to the elliptical editing, the camera moves in an almost-arbitrary manner. The staging of the dance dictates the positioning of the camera, but the shifts in location between movements are marked by radical jumps in camera angle and positioning. The fragmentation of space by the ellipses and jumps from angle to angle mean that the alley does not exist in the sense of being a location with 360 degrees; offscreen space is not present or alluded to. Therefore, space tends to collapse on itself, emphasising the movement of the performers. In *The Movement-Image*, Deleuze described spaces that are *"deconnected"* or *"emptied"* as "any-space-whatevers".[18] Such spaces are literally abstract. However, the alley is not truly an "any-space-whatever" exhibiting only a partial abstraction; it remains clearly identifiable as what it is—an alley—and there is no affect, no "'auto-affection'... *identical to the power of the spirit*".[19] The fragmentation of space that Hartley achieved in his "deconstruction" of the dance means that the space is incoherent and difficult for the audience to grasp as a necessary narrative locale. There is no master shot, and Jude really has no logical reason to be in the alley with the other two men, whose presence is never explained. The alleyway therefore tends to take on partial aspects of the "any-space-whatever", especially the fourth shot of the

sequence when the men, organised in a diagonal line, spin toward the camera, rising from a crouch as they turn. The lighting has changed, swamping the extraneous space in darkness. Unlike the rest of the dance, this shot *"empties"* the surrounding space of the alley altogether. The only space that is left is the spotlight in which the three men stand and perform; in this moment the alley most resembles an "any-space-whatever"; space is truly *"deconnected"*. Additionally, Hartley cut from the first phase of the dance (the marching and strutting) to an area of the alleyway that is suddenly *"emptied"* of bodies. This cut is more surprising than the other elliptical edits in the sequence as the intense focus on the performing bodies is undercut by their momentary absence before they run back into shot.

The *"deconnected"*, occasionally *"emptied"* space of the alleyway takes on aspects of the "any-space-whatever" and Deleuze's complementary concept of the "determined milieu". Whereas the "any-space-whatever" belongs with the idealism of the affection-image, "milieux which are geographically and historically determinable" stress the realism of the action-image.[20] The alley therefore is a space that is different to other milieux in *Surviving Desire*. The space tends to function, as in the musical, "abnormally". The abnormal space of the alley in *Surviving Desire* is marked by its solitary use as a space for the dance. The fusing of a dislocated "any-space-whatever" and a "determined milieu" sees the location of the alley take on a complex relationship with space in the rest of the film. The alley is a designated performance space. When Donovan glides gracefully, yet blankly, into the alley, the quotation from the musical conjures a series of discursive resemblances and contiguities from the generic source. The function of space in the musical as both separated ("abnormal", unreal) and diegetically determined ("normal", realist) is self-consciously mimicked and parodied. When Graham Fuller described the dance sequence in *Surviving Desire* as "the quintessential musical number, shorn of classical artifice and genre tropes",[21] he was perhaps only half right. The dance *is* stripped of its "classical" generic spectacle,[22] but the relationship with the genre is very clearly evoked by Hartley in the demarcation of space and its relationship with

narrative and time. But, where the musical tends to stress the normality of singing and dancing within a diegesis that incorporates the spontaneous harmony of professional, trained levels of performance, Hartley emphasises the artificiality of such spaces. The space that Hartley creates for his interpretation of the musical "number" is just as artificial, but the levels of performance, their documentation of the labour involved in the work, and the emphasis upon the performer-character merger parodies the artifice of well-known generic motifs, stripping them to their basic units of abstract movement. The principal manner in which the musical is referenced in *Surviving Desire* is in its creation and demarcation of different spaces for performance and their complex relationship with narrative and temporality.

Martin Rubin's work on Busby Berkeley is of critical importance in this area. Discussing Berkeley's work at the height of the backstage musical's popularity in the 1930s, Rubin regarded the narrative-spectacle link as constructed and demolished by the tension between narrative space/discourse and the performance space/discourse that is located in the musical spectacle. Rubin discussed Berkeley's work in cinema and theatre in terms of discourse in two areas: space and narrative. Ultimately, since Berkeley, at the height of his popularity during his time at Warner Bros in the 1930s, was not a film director *per se* but a dance director with strong control over the musical numbers in films such as *Gold Diggers of 1933* (Mervyn LeRoy, 1933), *Footlight Parade* (Lloyd Bacon, 1933), and *Dames* (Ray Enright, 1934), the argument for separateness in terms of style and narrative (where Berkeley-directed scenes essentially had none) seems obvious, where Berkeley's work retains a degree of autonomy. Rubin's argument, however, locates the split in terms of spatial schema dictated by the audacious "impossibility" of the Berkeley spectacle and the realistic "normality" of narrative scenes, generally set in a diegesis totally separate from that of the *Berkeleyesque*. Rubin argued:

> As with the stage revue and its related forms [the developmental stages of the filmic *Berkeleyesque*], a spatial concept is essential

to determining the effect of the Warners/Berkeley narrativized film musicals. Spatial elements are exactly aligned with discursive elements in these films. Unlike in the typical film musical, the "impossible" discourse of the numbers does not encroach on the "realistic" discourse of the narrative. This distinction is then doubled and reinforced in spatial terms: performance space is kept separate from narrative space, with each having its own qualities, laws, and modes of address. The "musical-ness" (a quality commonly associated with artificiality, impossibility, antirealism) of the Warners/Berkeley musicals is exclusively concentrated in the space of the musical numbers: a designated, demarcated, "official" space (e.g., a theatrical stage) in which the impossible can occur.[23]

The "impossible", "abnormal" space of the theatricalised spectacle of Berkeley's work in the backstage musicals of the 1930s, for Rubin, sees the discourse of space rigidly aligned with the discourse of performance; "impossibility" is completely opposed to "realism" in an inflexible either/or system that defines the separation of space and narrative between scenes of "realistic" narrative (dialogue/acting) and "impossible" musical numbers (singing/dancing). The opposition became more fluid later in Berkeley's career (during the early 1940s, he worked for Arthur Freed's MGM unit), where the "unrealistic" performance space was determined more by narrative contexts than in the backstage musicals, where "realistic" performance spaces were already present (theatres, rehearsal rooms). In the MGM films, "the 'unrealistic' mode is not used to open up" performance space to the extent that it does in the Warners/Berkeley musicals, which often becomes "impossible" through excess, where space becomes illogical as it is stretched to infinity beyond the logical limits of the diegesis. Instead, the "unreality" (or "impossibility") of the numbers is largely restricted to their spontaneity, but the scale and effects of the numbers remain (except for some deviations around the edges) within the range of a "massive stage production".[24] The opposition still continues to dictate the manipulation of space in Berkeley's MGM films, but it is crucially restricted by a narrative logic that sees space and the discourse of performance as more unified and homogeneous (i.e., as more "realistic").

In *Surviving Desire*, the separation of space is less rigid, but no less consciously divided from conventional narrative space. The "impossible" space of the performance arena (in *Surviving Desire*, the alley; in Berkeley, stages, rehearsal rooms) differs from the "realistic" space of the narrative (this is more obvious in the backstage musicals of Berkeley, where songs and dances do not necessarily influence the logic and causality of the story) where space is rendered as close to that of perceptual space. When the line is crossed into performance, there is either an "opening up" of space, as in Berkeley, or a fragmentation, as in *Surviving Desire*.

"Impossible" space, Edward Branigan argued, challenges the audience's perceptual assumptions regarding space. Gaps and distortions testify *"to space which can not be justified as existing wholly within the diegesis"*. Therefore, Branigan maintained that "impossible space leads to perceptual problems of a new kind that force the spectator to reconsider prior hypotheses about time and causality".[25] Technically, the alley space is not "impossible"; it does not open up to infinite proportions like Berkeley's famous kaleidoscopic water ballets, but it is overtly fragmented and does not follow the conventions of continuous space. Hartley's choice of camera angles and editing style is not consistent with the kind of shot-reverse-shot editing that usually renders space as homogeneous and unified. This is especially unexpected because *Surviving Desire* is generally conventionally shot, implementing a great deal of shot-reverse-shot editing and two-shots. The scene in the bar that precedes the dance is a good example. When the scene opens, Jude is stood in the corner of the bar to screen left; a giant clock occupies the top-right corner of the screen to Jude's left. The bartender begins to talk to Jude, who walks across to screen right towards the bar. As he walks, the camera tracks with his movement until he reaches the bar and the bartender, making a two-shot to Jude's left. When the bartender is called offscreen by another customer, Sophie enters into the foreground of the shot making another two-shot, this time with Sophie on Jude's right as he leans toward the bar. Sophie tells Jude she needs to make a phone call and exits screen left towards the camera. The bartender reenters, re-creating

the earlier two-shot with Jude. Hartley then cuts between this shot of the bartender and Jude and a reverse shot of Sophie on the phone to her roommate. The construction of space in this case is logical since the shots of Jude and Sophie are roughly opposites of each other. As Jude is left alone in shot and finally sits down, the emphasis is upon Jude looking at Sophie. Jude's gaze testifies to offscreen space, as he continues to stare off in the direction in which Sophie is seen exiting. The difference in angle between the two shots is also 180 degrees, obeying the rules of continuity editing. After Sophie returns to sit with Jude, the clock that was seen in the first shot is again visible in the top right-hand corner of her close-up. The conversation that follows is filmed in alternating close-ups of Jude and Sophie. The rhythm of the editing is slightly disjointed as Hartley cuts the scene on the dialogue, allowing the performances of the two actors to supply the rhythm for the conversation. Again, the two close-ups are mirror images of each other; the camera remains in front of both characters, so the shots are not over-the-shoulder point-of- view shots but are separated at an angle of approximately 90 degrees. Space, however, is rendered as divisible, but unified. Hartley obeyed continuity rules, without cutting between shots that differ by more than 180 degrees or less than 45 degrees. Perceptually, therefore, this space is realistic, unified, and continuous.

When Jude leaves the bar and opens up a new space that does not strictly obey these rules of conventional film style, perceptual problems are evident. The disjunctive cuts, indeterminate changes of angle, and the lack of a master shot dictate the perceptual relationship of the audience and the space of the dance. The conservative style of the rest of the film builds certain assumptions in the audience regarding narrative logic and the unity of space. The space that Hartley created during the dance allows these assumptions to be challenged. Space becomes "abnormal" as the editing and camera pattern suddenly changes, irrespective of the shift in performance style that is not motivated by the logic of the narrative to this point. There are four cuts within the dance (not including the cuts that begin and end the sequence), and each is emblematic of the "abnormal" and "impossible" treatment of space. The generic quotation

that begins the dance—Jude's graceful swing into the alley—"opens" the new space. As the referent of the quotation is so overt (the cliché of generic *bricolage*), the space is prepared for a conscious shift in the rules and expectations of the manipulation of space. Musical space, separated, or divided, by editing or sudden or magical shifts in locale, is space transformed. Audiences' expectations are different; musical space is not expected to be the same as perceptual space. In *An American in Paris* (Vincente Minnelli, 1951), the camera pushes into a close-up of Gene Kelly as he contemplates the loss of Leslie Caron to another suitor. As the music swells, Minnelli dissolves to the ballet. The audience enter a new space of vivid colour and impressionistic design; this is an externalisation of Kelly's inner space and reiterates the main themes and content of the film in dance. The new space is opened, and space itself is transformed by a series of transitions and match cuts.

In *Surviving Desire*, Hartley, like Minnelli, used a dissolve to move from the opening of the new space, the performance space, to the action of the dance. The new shot is more obviously spatially oriented than those that will follow (space can still be identified as homogeneous). The gate is still visible in the background. The angle cuts to front-on to reveal most of the alley, the lit windows in the background, and the barren area in which the performers will dance. Aurally, the space also becomes more abstract as the music dies away during Jude's first movements; this is a musical number without music. The space, and expectations that have been prepared, are already different, "abnormal" in a sense of their "musical-ness" because the nondiegetic music has disappeared and realism has been unexpectedly reimposed, signalling a return to a more realist diegetic space less associated with the musical and more so with the film as has it existed up until this point. This forms a further point that emphasises the complex relationship between realism and abstraction in Hartley's work, where the two impulses are conflicting, or in this case, partly confused, as there is some overlap between spaces and their stylistic rendering.

The first cut of the dance proper comes after the three dancers' first movement. They strike a very brief tableau and disappear. The angle

changes to a previously unseen area of the alley. Most noticeably, how-
ever, the performers have disappeared. The cut is suddenly and unex-
pectedly elliptical, briefly disorienting the viewer; this could even be a
new location. Empty space therefore causes a clear perceptual problem.
Additionally, as the performers have disappeared, space overwhelms
their movements, imposing itself, becoming more overtly present. Only
when the three men run back into shot is the audience's visual orienta-
tion reasserted. The change in motion, from still to running, and a very
sudden directional disparity—from facing right to running left—mean
that, in terms of filmmaking convention, there is no continuity from one
shot to the next. The adjacent shots are separate and distinct. Therefore,
the separation of space can take place on two levels, within locales (the
difference between the alley and the bar) and within individual shots
(the difference between the first shot of the alley and the second). Ele-
ments of Deleuze's "any-space-whatever" can be seen as operating indi-
vidually from shot to shot, so consciously "deconnected" is each shot
from the next.

The conceptual "any-space-whatever" is seen most explicitly in the
next shot. From a front-on shot of the three men in a staggered line,
Hartley cut to a very different, but still almost head-on, shot of the three
men arranged in a diagonal line facing away from the camera. Although
the camera eventually tracks left to finish in front of them after they turn
to face the camera, the cut is again disorienting. The closing down of
space is achieved by a sudden change in lighting that places the three
men in a rough spotlight. A consciously theatrical effect (again stress-
ing the status of this area as a performance space), the spotlight denies
the presence of a real locale, the alley, and completely disconnects the
space in this shot from that in others—including the shot that follows, a
direct reverse of this one. This focuses the attention of the viewer on the
movement of the actors. But, having emphasised the palpable presence
of empty space in previous shots, Hartley closed it down completely to
convey the theatricality of the space; its "musical-ness" in a generic, and
particularly Berkeleyesque, sense, where the theatrical manipulability of
space is stressed by "impossible" changes in lighting and camera angle.

Hartley also stressed the manipulability of space through its divisibility and discontinuity. Space is broken down, excessively fragmented by its "impossible" nature—that is, it is impossible to construct a theoretical model of the alley space because Hartley did not show the alley as spatially unified or like other narrative spaces in the film prior to this scene, where continuity of movement, style, and rhythm are maintained. The separated nature of the performance space is finally emphasised as Hartley closed the space in the reverse manner to its opening: music swells, instead of diminishing, while Hartley dissolved *from* the final tableau of the dance to Sophie writing in her kitchen. Just as the first dissolve marked the shift into the performance space, the second denotes the transition out of it.

However, in accordance with the concept of the optical-image, viewing the dance as an evocation and distortion of generic tropes is only one of many ways in which the dance can be read. Whereas the notion of fragmentation of space provides a perceptual difficulty, the relationship of dance to narrative presents an additional set of problems for the virtual/actual dichotomy that complicates the temporal relationship of images within a narrative. Rather than occurring in succession, images in the dance reflect other images in the narrative. Past (virtual) images become coexistent with present (actual) images. The past is repeated in the present for the audience as a virtual connection, but crucially it *is only one possible connection among others*. The quotation that Hartley derived from the musical in this scene is what Deleuze defined as a "crystal image", which connects material, actual images and, memory-activated virtual ones.[26]

The opening movement of the dance, for instance—Jude's swing onto the gate that opens the "abnormal" performance space—is a complex image that illuminates the virtual/actual couple in this scene. As examined previously, the spontaneity of the movement reflects a form of *bricolage* specific to musical entertainment wherein everyday items form the motifs of scenes of song and dance. The movement therefore quotes from musical cliché, making a specific image and perception of a genre its referent; the element that Jane Feuer called "spontaneous

self-expression though song and dance".[27] The potential virtual image, the audience's recollection of this feature of the musical (if the viewer has this image in their virtual repertoire), coalesces with the actuality of Jude's jump onto the gate,[28] suggesting the emotional expression in the character that is not "performed" by the actor (Donovan's expression does not correspond to that of joy or elation, that is, it is not a representative sign). Although this is suggested by the performance of the text, there is the possibility that there may be a moment of failed recognition for the viewer, where the necessary virtual recollection, of the Hollywood musical, is absent, leading the viewer to miss the point of coalescence in the virtual-actual linkage.[29] Where the recollection is present in the viewer, however, the two sides of the image in the movement can merge to the point of indiscernibility in which the "shadowy" virtual image gives an actual image a meaning by suggesting a quotation (the mirror of the musical, but distorted).

However, another virtual connection can be posited by this action. Jude's leap onto the gate reflects one of the constituent elements of dance, its everyday use. Addressing the readability of dance, Sandra Kemp argued, "that performance is essentially *sociable*".[30] The action performed by Jude reflects one of the social functions of dance, the nonaesthetic expression of happiness (as an un-self-conscious display intended for personal pleasure rather than the look of others). Dance is a social phenomenon, an un-self-conscious, spontaneous performance of the body experienced as pleasurable. Energies and rhythms of music are literalised in the movements of the body in a nonaesthetic expression of enjoyment that can be read externally as pleasure, specifically the pleasure derived from the very act of dancing. Hartley drew on this social function of dance in expressing Jude's joy in this manner, in which the un-self-conscious movement of his body is connotative of happiness. Furthermore, the concept of happiness is also addressed in the Dostoyevsky quotation with which Jude is obsessed. Therefore this cannot be read simplistically as an intertextual reference that makes a single virtual connection obvious for the viewer (because this would not be virtual), but as a movement that invokes several, making the interpretive activity of the

viewer more complex. This complexity is further enhanced by several palpable absences from the scene's quotation of the musical: the lack of music, the nonrealist presentation of the numbers (scenes of song and dance in the musical are presented as "normal" in terms of diegetic representation despite their lack of everyday "normality"). These absences create distortions in actual/virtual pairings. In this instance however, the virtual/actual reflections signify a constituent lack in the actual image as the virtual, the recollected referent (the genre that Hartley is evoking), is a more complete set of motifs and icons than Hartley is quoting.

The narrative of *Surviving Desire* is based heavily in quotations.[31] Therefore, the cultural images of the dance are not necessarily unusual in this overall context. The relationship between text and movement is more concrete than would at first be expected as the narrative moves from its realist, "determined milieu" to that of the "abnormal" spaces of musical entertainment and from representational signs to those that are nonrepresentational. The abstraction of the dance is not motivated by narrative logic and has only partial sensory-motor extension beyond the spontaneous joy of Jude as he leaves the bar having kissed Sophie. But, where the movement's allusionistic basis (in Brecht's sense of the actor privileging the quotation over seemingly improvised performance) is tied so closely to the broad thematics of the film, virtual and actual images are brought into play more freely and consciously. Virtual images are present in actual movements, and actual images extend into future moments and in turn become virtual.

The Dostoyevsky quotation that haunts Jude is an important example of how a virtual image can become actual when literalised in dance. Repeated several times throughout the film to the point where its repetition negates the significance of individual words (the virtual recollection of the quotation in the dance, however, reemphasises its meaning and relevance for Jude), the passage reads:

> I believe you are sincere and good at heart. If you do not attain happiness, always remember that you are on the right road. Try not to leave it. Above all, avoid falsehood, every kind of falsehood, especially falseness to yourself. Watch over your own

deceitfulness: look into it every hour, every minute. Avoid being scornful, both to others and to yourself. What seems bad to you within yourself will grow purer by the very fact of you observing it. Avoid fear, though fear is only the consequence of every sort of falsehood. Never be frightened at your own faintheartedness in attaining love. And don't be frightened overmuch at your own evil actions. I am sorry I can say nothing consoling to you. For love in action is a harsh and dreadful thing compared to love in dreams. Love in dreams is greedy for immediate action, rapidly performed, and so everyone can see. Men will even give their lives if only the ordeal does not last too long but is soon over with all looking on and applauding as if on a stage. But active love is labour and fortitude.[32]

The final movements of the dance can be read as translating this short passage into movement, prefiguring Jude's existential downfall. Earlier movements of the dance develop the archetypal, culturally derived and generally gendered nature of actions by the performers, but the final sequence relates directly to the conscious development of virtual/actual images, or, more correctly, the consciousness of narrative moments past and present. Although the final shot of the dance is most specific as a crystal image, previous moves in the dance have prefigured the final actual image that will be become virtual. These images can be read as having partial narrative qualities (as explored further on). However, as the movements performed in these images take no part in developing the narrative of the film, the sensory-motor stimulus is low or nonexistent, making the relationship between the narrativised images and the over-arching narrative of *Surviving Desire* just one more virtual connection among others.

The third shot (or group of movements) contrasts strongly with the celebratory unity (Jude swaggers, while the other men appear from nowhere and are able to join the dance) of the preceding movements. The opening action of running into the door, can be read as the beginning of the degradation of Jude's machismo (a partial narrativisation), prefiguring his downfall in the story, and the futility of his actions with Sophie. Subsequent actions of the dance attack the integrating quality of

the previous shot. The audible counting of beats, an uncommon exposition of the mechanical quality of dance, replaces the internal rhythm and momentum of previous actions. Evoking the rehearsal process sees Jude, the character, become a "shadowy", "opaque-limpid"[33] presence as the actuality of character gives way to the virtuality of the performer Donovan. Leading the dance, he is copied by the other two men, adopting the role of the children in need of direction. "Jude" therefore is now the dance's leader, its choreographer (he is, after all, a teacher), followed by children simply seeking to copy the knowledge that he can provide, like his students in the opening scene. In terms of its effect on narrative discourse, this group of movements is transitory, partially recapitulating narrative information, while foreshadowing future events.

The final sequence of *Surviving Desire*'s dance scene is broken into two groups of abstract gestural movements. An elliptical cut from the previous sequence reveals the men facing away from the camera; they immediately spin anticlockwise to face just offscreen left. As they perform the following series of gestures, the camera tracks left a short distance until it is directly in front of them. In a single bar of four beats, the men, in unison, perform four gestures:

1. Stamp their right feet at the end of their spin
2. Clap their hands
3. Slick back their hair with their right hands
4. Tweak their codpieces with their left hands (figure 10).

Finally, they swagger forward four paces before again rotating anticlockwise to face away from the camera, cutting to the exact reverse on the spinning motion. The tone is aggressively masculine, and the referent of the gestures is overtly sexual. Hartley has argued that the tweak of the crotch is a conscious quotation from a cultural source; in this case, like *Simple Men*, the referent is Madonna, who, Hartley argued, is simply quoting a preexisting archetypal gesture.[34] But although the intended referent is Madonna, the virtual image is unfixed and reminiscent of other performers, such as Michael Jackson. The quotation of such a figure

suggests the affective nature of this form of sexuality (it is a trope rather than a sexual use of the body, signifying rather than conveying sexuality), essentially unattainable, and thus, as this proves for Jude, futile.

In the reverse shot, the other two men are arranged around Jude in a diagonal line. Shuffling forward in tiny steps, Jude mimes a digging action. He thrusts the imaginary spade down, throwing it up and over his left shoulder; with precise and definite accuracy, he repeats the action four times. On the final repetition, he throws the "spade" up, spreading his hands wide apart to finish in a posture of crucifixion, his head lolling toward his right shoulder (figure 11). Meanwhile, the other two men clap their hands together in prayer. Shuffling forward in the same way as Jude, they twice throw their hands above their heads, then back down and

FIGURE **10.** The dance again quotes from a preexisting musical performance tradition and from a repertoire of masculine gestures.

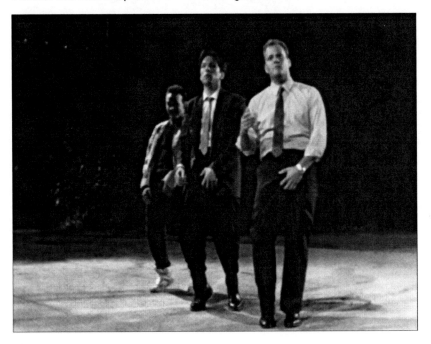

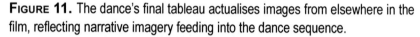

FIGURE 11. The dance's final tableau actualises images from elsewhere in the film, reflecting narrative imagery feeding into the dance sequence.

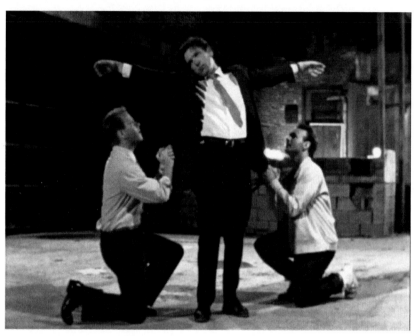

together again. When they clap hands the final time, they turn inwards to kneel at the feet of the "crucified" Jude. As they hold this pose in tableau, a church organ is heard in the background. However, when the shot cuts away from this scene, the organ is revealed as the introduction to a pop song that Sophie is listening to in her kitchen.[35]

The final sequence and tableau in the dance sequence can be read literally. Simplistically, the movement suggests that Jude has a martyr complex. His infatuation with Sophie and inability to comprehend the knowledge that he attempts to teach pre-empt his impending failure. This tableau, where the sensory-motor link is weakest—there is no motivation for the movement to cease—is a direct "sound and optical" image in the Deleuzian sense.[36] Therefore, the image is conscious of its

temporal implications. Whereas previous images feed backwards into the text (Jude's position as teacher, as leader) and have allusions to cultural images that are shadowy and virtual, this final tableau is an actual image that becomes virtual at the narrative's end. This foreshadowing (a concrete movement that becomes shadowy) portrays the *future* futility of Jude's actions with Sophie.

In *The Brothers Karamazov*, the Elder tells Lise's mother that she "will, of course, get nowhere in [her] heroic attempts at active love; it will all merely remain in [her] dreams".[37] The lack of sensory-motor situations that Deleuze saw in musical comedies, particularly those of Minnelli, which defined the genre as the "implied dream", whose scenes of realist motivation converge upon those of an "optical and sound" nature, can be seen in the dance in *Surviving Desire*, where Jude's attempts at love are portrayed through his own "dream", his dance. "Active love", the Dostoyevsky passages tells, "is labour and fortitude", and "love in dreams is greedy for immediate action, rapidly performed, and so everyone can see". Jude dances, "so everyone can see". In the end, he "will even give [his life] if only the ordeal does not last too long but is soon over with all looking on and applauding as if on a stage". The quotation therefore becomes concrete in actual movement in the dance, and in the overall narrative arc of the film, which, as Hartley has noted, disintegrates without definite resolution. The film ends with Jude lying in the gutter giving confused directions to a man who asks if he needs help. Jude chooses to perform his despair in public places, first in the classroom, then the street, screaming as he drives his car, and finally the gutter. Via the plot of the film, Jude lives the arc of the dance, from joy to despair.

Finally, when Sophie has rejected Jude, he stops quoting from Dostoyevsky and begins to recite to the class facts about the author's life, which fail to elucidate the work, as he writes on the blackboard. When he finishes writing, he sits and contemplates what he has written. He tells the class that he cannot teach them anything. They drift out in a series of dissolves until he is alone with Sophie peering over his shoulder, but she too disappears after another dissolve. Jude is left alone. Only then do we

see what he has written—Goethe's maxim, "Knowing is not enough".[38] The quotation is fragmentary and forms another "shadowy" virtual recollection for the audience: the full quote reads "knowing is not enough, we must apply; wanting is not enough, there has to be action". This is Jude's lesson, that without empirical reasoning, knowledge is meaningless. But the maxim is incomplete, and consequently Jude does not grasp its full implications. In the final shot of the film, Jude lies in the gutter, but he tells another man that he will be all right after ten or fifteen minutes, but Sophie is left in the bookstore in which she works asking the same question over and over again ("Can I help anyone?"), the repetition highlighting her failure to learn anything; she cannot help anyone.

Hartley used a series of techniques to delineate the dance's relationship to the rest of *Surviving Desire*—spatially, temporally, narratively, and performatively. The sequence draws heavily upon visual and textual forms of quotation in the form of actual and virtual images that coalesce into Deleuzian "crystal images" that define the manner in which images of time (past and present) within and outwith the narrative provide significance in images of movement. Overall, the dance shares a close relationship with many of the generic motifs and stylistic signatures of the musical, particularly those of Busby Berkeley and the MGM musicals produced in the 1940s and 50s. But the dance is complex and distanciated, lacking the directness of those earlier, audience-focused musicals. Hartley employed a musical sequence later in *Surviving Desire* to stress the lack of direct emotion in the dance scene. A rock band (Hub Moore and the Great Outdoors) performs a song in the street. The song is a syrupy ballad called "Gonna Miss You", directed towards a girl who leans out of an overhead window to watch; she smiles (unlike Jude). The fact that this scene is addressed to an intended audience marks it as significantly different from the dance. Spatially, it is not separated from conventional narrative space and does not function "abnormally"; shots of the band and the girl in the window are roughly opposite. Jude, however, plays no part in the scene; he simply walks in front of the band, oblivious to the noise that has brought the locals out onto the street to dance in

wild abandon. He meets his friend Henry in the street; they talk, but their words are not audible over the band. This scene, therefore, takes no part in the story (it was, like the dance, another of Hartley's arbitrary inclusions in the film), but it contrasts sharply with the stark, unemotional nature of the dance. Emphasising social functions of performing, community (the dancing audience share the "stage" with the band) and the couple (Moore and the girl at the window), and the use of song to express emotion, this is a completely different form of performance that shares a casual relationship with what Rick Altman, in *The American Film Musical*, called the "folk musical".[39] Tellingly, this is a sense of community and direct emotional expression from which Jude is excluded.

SIMPLE MEN: DICHOTOMIES OF PERFORMED IMAGES

The dance sequence in *Simple Men* offers a very different perspective on the use of the dance and its relationship with narrative imagery. The dance itself, like much of *Simple Men*, is concerned with images and the slippages that occur between personal and public images. The dichotomy of personal/public images reflects indirectly on the virtual/actual linkage that is so crucial in the signification of choreography in Hartley's films, like the dance in *Surviving Desire*. *Simple Men* problematises the relationship between simple clichéd images and more complex optical-images. The problematic relationship revolves around the images cast by a self, either intentionally or unintentionally, and their decoding by another individual. Personal images of self, and the public reading of signs intentionally projected by other individuals, are key themes in *Simple Men*, and the virtual/actual coupling in the cliché/optical-image opposition casts light on the manner in which these images are interrogated, especially in the dance and the party scene of which it is part.

The film tells the story of two brothers, Bill (Robert Burke) and Dennis (Bill Sage), the former a white collar criminal and the latter a bookish student. Having been double-crossed by his girlfriend and partner in a recent heist, Bill returns home in need of money. When he meets

up with Dennis again, they hear that their father, a legendary baseball player turned revolutionary has escaped from custody in hospital after a stroke. Dennis decides to pursue their father, while Bill, asked by their mother, tags along to keep an eye on him. They eventually find themselves in a small town on Long Island (the film was actually filmed in Texas), where they encounter their father's Romanian girlfriend (Elina Löwensohn), the earth mother figure Kate (Karen Sillas), and the man who loves her, Martin (Martin Donovan). The film taps into modes of problematic performance, where individuals find themselves, especially Bill, unable to maintain a coherent presentation of self, and the compulsions to repeat that lead the film into a circular structure of implied eternal return.

The whole film revolves around the projection of clichéd images by individuals read problematically as more complex signs by other characters. Beyond Bill's slippage in dramatic maintenance (I explore this more fully in the next chapter), the control and dissemination of images is crucial to all the characters in the film, and the dance scene lies at the heart of this theme. For Elina, the epileptic, Romanian girlfriend of Dennis and Bill's father, the dance underlines the strength that is established in her image. All of Elina Löwensohn's performances in Hartley's films are endowed with a strongly iconic quality (with her dark bobbed hair, she resembles Louise Brooks), particularly in *Amateur* where her mysterious iconicity has such gravitas for Isabelle. Hartley also lent considerable weight to Löwensohn's features in *Theory of Achievement* when she locks herself in the bathroom and reads from unidentified, but lofty tomes. The lighting of those scenes places emphasis upon the lines of Löwensohn's face and her iconic beauty.

In *Simple Men*, Elina, like almost all of the other characters, is marked as different, as an outsider. She is, quite literally, foreign. However, in the dance, Elina takes on a central position as a leader. She defines the parameters of the dance; her spontaneous movements become the moves of the dance; Dennis and Martin copy and repeat her "natural" movements. As in *Surviving Desire*, Elina's spontaneity conforms to the spontaneous self-expression of the musical, but the generic quotation

(Jude's swing on the gate) that defined the referent in the earlier film is disguised in *Simple Men*, referring to a film that refers to the musical: Godard's *Bande à part* (itself a film about outsiders, emphasised by its American title *Band of Outsiders*). Elina's spontaneity simply marks her as the central figure of the dance and codes those that follow her as "different" (outsiders).

Lesley Deer claimed that "through her movements [in the dance], [Elina] is denying the difference by which she is otherwise so forcibly characterised",[40] and that "her real strength lies in the image".[41] If the dance, therefore, is for Elina a "denial of difference", then the dance should quite clearly be one that is integrating and uniting for all the characters involved. However, it is not. The central conceit of the dance is its self-consciousness regarding the images that the characters portray and control, but the "denial of difference" is only ever partial and offers only limited integration. Dancing traditionally offers the possibility of integration into a homogeneity by making all the moves and rhythms of a group of people the same. The structure of popular dances stresses conformity, and presumably the "denial of difference" that Deer would see as crucial for Elina in this dance. The dance in *Simple Men* lacks any sense of conformity for any of the characters as it continues to mark them as outsiders, as different from one another.

Elina is consequently graced with strength by her central position within the image, but her followers cannot match her movements closely enough to make her lead (the leading is not intended) effective (figure 12). The sloppiness of Dennis and Martin's choreography characterise the performers by their actions and rhythms. Different time signatures are used to stress different meanings for each character; Elina's movements are on the beat, Dennis's are behind, and Martin's are ahead. Elina's movements are fluid and coordinated; she might as well be dancing alone, lost as she is in the music. Dennis's actions are uncoordinated and lack precision. With each repetition his actions are different; they are long and drawn out, resulting in his rhythm being awkward and off the beat. Martin's dance is also considerably different. He is constrained and, unlike Elina, totally lacking in any impression of spontaneity. Martin

FIGURE 12. Elina's (Elina Löwensohn) central position in the dance grants her a dominant position that others struggle to follow.

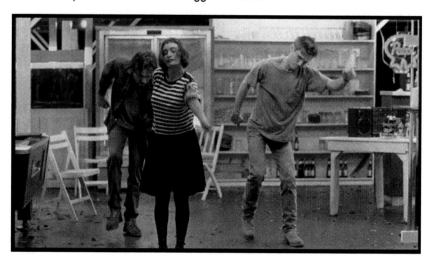

appears tense, his arms remaining tucked into his sides, crouching down, effectively looking like he is trying to make himself as small as possible. He also misses actions while trying to follow Elina's movements, resulting in him being ahead of the beat (and Elina) while repeating the moves of the dance. Martin is only ever a partial participant in the dance; although he is trying to follow Elina's movements in the dance, his eyes generally tend to fall outside the frame. Following the second repetition of the dance's moves, Kate and Bill drift into the frame, and the camera follows them as Bill circles her seductively. Kate stands straight while Bill is slightly stooped, granting her a dominant position over him. When Elina, Dennis, and Martin return to shot in the background, Hartley pulls focus so that, as they pass behind Kate and Bill, the emphasis shifts to Martin, who has been watching Bill's attempted seduction of the woman with whom he is smitten. Once more, themes of repetition and copying are evoked, as the structure of the dance and roles of the characters are

necessarily repetitious, although the shift to Bill at this point emphasises the personal modes of repetitious behaviour that are relevant for the male characters here; all of them are in the process of repeating actions in the dance, or, for Bill and Martin, repeating patterns of destructive behaviour.

The dance sequence in *Simple Men* revolves around a central intertextual reference to *Bande à part*. In Godard's film, the three main characters, Franz, Arthur, and Odile, dance the Madison (a popular partnerless dance at the time) in a bar. Hartley constructed a similar *mise-en-scène* to that of Godard, placing the female character between the two males. In both cases, the female character is the leader of the dance—significantly, Odile is also the last to finish dancing. Therefore, the dance is an articulation of a strong female sexuality. Odile's gaze is active, directed towards the two men. In Godard's voice-over (a "digression"), he tells the viewer that Odile is wondering if the men are noticing her breasts moving under her sweater, while Arthur is watching his feet and Franz is musing philosophically. So, while her gaze is active—her eyes can be seen moving up and down Franz's body as she dances behind him—it is not returned. This is not the case in *Simple Men*: Hartley marginalises the male participants in the background of the shot and presents their looks at the female as powerless. While Martin gazes wistfully at Kate dancing with Bill, Dennis keeps his eyes firmly on Elina, struggling to match her movements. Meanwhile, Elina's eyes stay shut, unconcerned as she is with the movements of others. In one key moment, however, Elina deviates from the pattern of the dance to circle Dennis, from whom she takes a cigarette. This is the only time she opens her eyes during the performance. She dances seductively around Dennis, swaying her hips, enticing him with a potent display of sexuality. Following the dance, Dennis tries to kiss her, but is rebuffed. Crucially, Dennis has misread both the performance of Elina and the effectiveness of his own display, which is inept, simply a poor repetition of her own actions. Like Odile in *Bande à part*, Elina is the dominant player in the performance: her centrality in the *mise-en-scène*, and the accuracy and grace of her movements place

her in a superior position to her male followers, whose actions are weak by comparison. But unlike Odile, Elina does not place herself in a position to be looked at—her autonomy in the dance is emphasised by her independence from the other participants. Consequently, Elina does not deny her difference as an outsider or a woman, but she celebrates the strength and power granted her by that difference. She places herself in a position of potential objectification, only to deny the objectifying gaze of the male characters and the camera. This is where the allusion to Godard ceases to be relevant—Odile welcomes the objectifying gaze and is disappointed when it is not returned, whereas Elina denies the potential marginalisation of her role in the dance and in the narrative as a whole, although this marginality is necessarily diminished as the female characters are not involved in (and, as such, displaced from) the unsuccessful schemes of the male characters. She and Kate are pivotal figures in the narrative but do not have agency in the picaresque trajectory of the plot, right up to the final moments where Kate's choice to lie for Bill is left ambiguous by the final cut to black.

The dance therefore stresses the dominance of the women over the men, and the failure of their masculine performances. The song that accompanies and structures the dance also echoes this. Performed by Sonic Youth, the song (called "Kool Thing", written and sung by Kim Gordon) stresses the mobilisation of one image of submissive femininity but its eventual denial. The first part of the song mobilises a cultural image of female subjugation that is conventionally stressed by popular music ("Turn me on baby-o"). The second part offers a denial of that form of masculine domination ("I'll be your slave"). The break that accompanies the seductive dance of Kate and Bill is even more engaged with the denial of the image of women as the "weaker sex" subjected to the dominance of men. The techniques used in this passage of dialogue are typical of Sonic Youth, a New York–based rock band with experimental leanings that are conscious of intertextuality and subversion of musical form, attacking the "clean", bland production of most popular music. The male voice in the break is Chuck D from the radical rap group Public Enemy, and the song uses its cultural, political text of

ethnic revolution to emphasise the dominance of the feminine. At one point, Gordon asks, "fear of a female planet?" echoing the title of Public Enemy's album *Fear of a Black Planet*, released the previous year (1989). The text of the song therefore is of critical importance in shaping, and reinforcing, the theme of the dance, while, at the same time, providing its structure.

Surviving Desire and *Simple Men* both explore problems with masculine performance. The dance sequences deploy complex optical-images to examine the problematic nature of male performances. The maxim from *Simple Men*, told by Bill to Ned (played by Matt Malloy), that "there is no such thing as adventure. There's no such thing as romance. There's only trouble and desire", echoes the problem for many of Hartley's male characters. There *is* only trouble (in the form of the law and violence) and desire (usually desire for the female, although there is also a concern with a desire for redemption or knowledge). We often find Hartley's films featuring female characters of stability and control, while men remain, as is stressed by the title of the film, simple.

Dance generally resists easy interpretive activity, and Hartley's scenes of dance are no exception. The dance sequence in *Surviving Desire* is especially so and revolves around the repetition and production of images. Alternatively, *Simple Men* engages in a discourse on the control and circulation of images. Both make virtual connections to engage with repeated virtual/actual images of narrative, intertextuality and, social and cultural images. The virtual associations that can be derived from these scenes make the interpretive effort on the part of the viewer, or critic, all the more difficult, because the virtual images are multilayered within the actual images rendered on-screen. Therefore, Hartley's uses of dance are composed of multiple optical-images that can be read in a host of different ways, commenting upon narrative and cultural production. At the heart of this process is once more the use of repetition, but that repetition is less obvious than in other instances in Hartley's films. Repetition is produced in the virtual images that the viewer recalls and fuses with the actual images during the perception and interpretation of

these scenes of dance. These are not images composed consciously on the part of the filmmaker, although they form part of a self-conscious allusionism within the text, but a consequence of the viewer's experience of spectatorship in her perception of the imagery on-screen. Thus these *potential* virtual images are infinite, as is the signifying potential of body movement.

ENDNOTES

1. John Fried, "Rise of an Indie: An Interview with Hal Hartley", *Cineaste* 19, no. 4 (1993): 39.
2. Fuller and Hartley, "Finding the Essential", xxvii, xxviii.
3. As James Naremore contended: "acting is nothing more than the transposition of everyday behavior into a theatrical realm" (*Acting in the Cinema*, 21).
4. Francis Sparshott, "Dance: Bodies in Motion, Bodies at Rest", in *The Black-well Guide to Aesthetics*, ed. Peter Kivy (Oxford: Blackwell, 2004), 279.
5. Ibid., 285.
6. Hal Hartley, "Surviving Desire", in *Projections*, ed. John Boorman and Walter Donohue, vol. 1 (London: Faber & Faber, 1992), 240.
7. Richard Dyer located the utopianism of the wish fulfilment element of entertainment within a general systematisation that portrays a certain kind of feeling. Dyer saw this as "an effective code that is characteristic of, and largely specific to, a given mode of cultural production"; "Entertainment and Utopia", in *Genre: The Musical: A Reader*, ed. Rick Altman (London: Routledge & Kegan Paul, 1981), 177. Whereas dance in Hartley's film is very conscious, and critical, of modes of cultural production and repro-duction—particularly the Madonna discussion that is the postscript to the dance in *Simple Men*—Dyer's argument is most useful as he divides this cultural code into opposing strata: representational and nonrepresenta-tional signs. Representational signs are the most prevalent and frequently discussed; they pertain to lifelikeness, the believability of character, set-ting, or narrative logic. Nonrepresentational signs, however, do not nec-essarily reveal the realism of particular situations: Dyer argues that the "non-representational icon is one of resemblance at the level of basic struc-turation" (ibid., 178). In *Surviving Desire*, the dance sequence proceeds in fits and bursts of movement, gesture, and cultural allusions. The scene maintains a basic rhythm, but is not based simply in one form of sign.
8. "Surviving Desire", 223; emphasis added.
9. Jane Feuer, "The Self-reflective Musical and the Myth of Entertainment", in Altman, ed., *Genre*, 162.
10. Ibid., 163.
11. Where direct quotation is involved, as in *Surviving Desire*, cultural images (adapting the terminology of Deleuze), which are more complex, continu-ally amorphous with no fixed meaning, are evoked within the images of the narrative, echoing the past of the audience rather than that of the film's

characters. The cultural image that enters into this circuit is an unfixed virtual image that becomes actual in the quoted movement, but, as the cultural image is ever changing with time, the crystal image does not have the same fixity as the actual image whose referent is within the text. More direct movements and sequences address virtual images that are specific to narrative meaning (i.e., as the past of the characters involved in the story).

12. Optical images are images made personal by their activation of attention and the recollection of virtual memory images that is required to decode their multiple meanings. The optical image stimulates the viewer's engagement, making cinema an increasingly participatory experience, because the viewer must comb through her private collection of memory-images to read the ambiguity of the image. Cliché, in contrast, is nonparticipatory, since it tends to hide what is in the image rather than revealing what *could* be there. Cliché, Deleuze argued in *The Time-Image*, is "a sensory-motor image of the thing"; but the "pure optical-sound image" is "the whole image without metaphor"; *Cinema 2: The Time-Image* (London: Athlone, 2000), 20. The cliché, Deleuze asserted, is less rich than the optical image, closed and shut off from potential multiple readings. The cliché therefore is laden with virtual images, but these are cultural images, derived from the past, where certain images gain prescribed meanings through repetitions. Images are flattened, easier to read, without the multiple (to infinity) associations of optical images. Perception only sees the cliché in the actual, the oft-used virtual image. Thus, "we do not perceive everything", Deleuze contends, "the cliché hides the image from us" (ibid., 21).

13. Laura Marks reflected on the difference between, and uses of, clichés and optical-images in her work on collective memory and deterritorialised cinema. Marks argued that the cliché is a blockage to the activation of memory and the virtual connections that give images meaning, making the linkage between virtual and actual images problematic. "The emptied-out cliché", Marks maintained, "is one example of failed recognition"; "A Deleuzian Politics of Hybrid Cinema", *Screen* 35, no. 3 (1994): 254. In contrast, the optical image mobilises *attentive* recognition, "because the viewer cannot confidently link the optical image with other images through causal relationships, she is forced to search her memory for other virtual images that might make sense of it"; *The Skin of the Film: Intercultural Cinema, Embodiment, and the Senses* (Durham, NC: Duke University Press, 2000), 47. Marks is here following Bergson's argument that "the progress of attention results in creating anew not only the object perceived, but also the every widening systems with which it may be bound … [in] a higher expansion

of memory ... [and on] deeper strata of reality"; *Matter and Memory*, trans. N. M. Paul and W. S. Palmer (New York: Zone, 1996), 105.

14. Although this is partly assumed, there is some evidence to suggest that a cult audience exists around Hartley's work that prizes repetitious elements of his work in an auteurist sense and is willing to perform the required activity implied by the text. One audience member, posting on the *Internet Movie Database*, identifies the repetitious elements of Hartley's style that are most highly valued: "Hartley's signature quirks—non-sequiter-laden [*sic*] dialogue, slapstick, existentialist rhetoric, and deliberately flat performances"; kintop432, "The Unbelievable Truth (1989)— IMDb user reviews", *Internet Movie Database*, August 27, 1999, http://www.imdb. com/title/tt0100842/usercomments. Meanwhile, other fans are more concerned with articulating subcultural capital—Pierre Bourdieu, *Distinction: A Social Critique of the Judgement of Taste* (Cambridge, MA: Harvard University Press, 1984); and Jeffrey Sconce, "'Trashing the Academy': Taste, Excess and an Emerging Politics of Style", *Screen* 36, no. 4 (1995): 371–393—in opposition to mainstream Hollywood: as one viewer notes in reference to *Henry Fool*, "if it's not your cuppa [*sic*] tea you've still got *Runaway Bride* etc"; David, "Henry Fool (1997)—IMDb user reviews", *Internet Movie Database*, August 27, 1999, http://www.imdb.com/title/ tt0122529/usercomments?start=30. Even where Hartley fans do not enjoy his more recent work, there is still an effort to demonstrate cultural capital by referring to their enjoyment of previous Hartley works, as was the case in the reception of *Flirt*; see Anon., "Homage to Hal Hartley—a place to discuss film making genius", *Homage to Hal Hartley—a place to discuss film making genius*, June 1, 2002, http://movies.groups.yahoo.com/group/ homagetohalhartley/message/187; and Charles Herold, "Flirt (1995)— IMDb user reviews", *Internet Movie Database*, November 30, 2009, http:// www.imdb.com/title/tt0113080/usercomments. This cult of Hartley, which exists predominantly in Web-based fan activity, suggests a willingness on the part of the "typical" Hartley audience member to articulate their cultural knowledge and capital via the activity of both their interpretive efforts in regard to Hartley's films and subsequent discussion (i.e., performance) of fandom in cult spaces. Thus, there can be an effort on the part of the Hartley viewer to perform part of the work required to interpret and complete the actual scene and make virtual connections drawn from previous aesthetic experience, partly as an articulation of cultural capital, especially where independent or marginal filmmaking is concerned. This is the viewer that is discussed throughout this chapter.

15. Brecht, *Brecht on Theatre*, 138.
16. Jerome Delamater, "Ritual, Realism and Abstraction: Performance in the Musical", in *Making Visible the Invisible: An Anthology of Original Essays on Film Acting*, ed. Carole Zucker (London: Scarecrow, 1990), 61.
17. The notion of the homogeneity of space and its infinite divisibility are key concepts discussed by Bergson, and it has important consequences for the division and fragmentation of space in Hartley's films. "Abstract space", Bergson argued, "is ... nothing but the mental diagram of infinite divisibility" (*Matter and Memory*, 206). Space and duration are critically linked in marking the literal relationship between matter and memory, the perception of objects in the present and mental images of the past. Therefore:

> Homogenous space and homogeneous time are ... neither properties of things nor essential conditions of our faculty of knowing them: they express, in an abstract form, the double work of solidification and of division which we effect on the moving continuity of the real in order to obtain there a fulcrum for our action, in order to fix within it starting points for our operation, in short, to introduce into it real changes. (ibid., 211)

Space and time mark the extensibility of perception, and the external situations that frame movements (objects), then images (memory). For the intellect, Bergson saw only two forms of mental association as having "vital utility": resemblance and contiguity (ibid., 242). The quotation and allusionism of Hartley's dance sequences place a heavy emphasis upon the role of resemblance, in particular, in drawing meaning from the abstract movements of the performers, which have little significance in a realist milieu because they do not correspond to everyday actions.
18. Gilles Deleuze, *Cinema 1: The Movement-Image* (London: Continuum, 2001), 120.
19. Ibid., 117.
20. Ibid., 123.
21. Graham Fuller, "Shots in the Dark", *Interview*, September 1992, 84.
22. Presumably Fuller is referring to the motifs of excess that categorise the musicals produced by MGM at the height of the studio system, such as *An American in Paris* (Vincente Minnelli, 1951) or *Easter Parade* (Charles Walters, 1948).
23. Rubin, *Showstoppers*, 39.
24. Ibid., 147.
25. Edward Branigan, *Narrative Comprehension and Film* (London: Routledge, 1992), 44.

26. In "crystal images", Deleuze contended:

> the actual image itself has a virtual image which corresponds to it like a double or a reflection. In Bergsonian terms, the real object is reflected in a mirror-image as in the virtual object which, from its side and simultaneously, envelops or reflects the real: there is "coalescence" between the two. (*Cinema 2*, 68)

The circuit between the two sides of the crystal forces images of virtuality and actuality—the pure recollection and present perception (past and present)—to merge in an irreducible unity to the point of indiscernibility ("coalescence"). This "smallest internal circuit" is in a continual state of flux":

> the virtual image becomes actual, it is then visible and limpid, as in the mirror or the solidity of finished crystal. But the actual image becomes virtual in its turn, referred elsewhere, invisible, opaque and shadowy, like a crystal barely dislodged from the earth. (ibid., 70)

The crystalline circuit defined in Deleuze's theory is too small and confining to explain the virtual/actual couple in which the "abnormality" of dance space and movement is involved. The "smallest internal circuit" of the "crystals of time" is not sufficient to capture the whole significance of images of dance and movement. Images from earlier in the film, the past of the text, are joined by images that preexist the production of the text, forming a larger circuit between the virtual and actual images. This in a sense is a "largest *external* circuit" significantly different from Deleuze's internal circuit. The internal circuit can see crystal images that are fixed, as the narrative is unchanging, the past and present of the text's images are unchanging with time.

27. "The Self-reflective Musical and the Myth of Entertainment", 162.

28. See note 14.

29. This is another moment in which the text idealises the viewer, promoting the activities of cult readership and cinephilia.

30. Sandra Kemp, "Reading Difficulties", in *Analysing Performance: A Critical Reader*, ed. Patrick Campbell (Manchester: Manchester University Press, 1996), 160.

31. Jude's teachings all take the form of quotations, but they are not illuminated by understanding; they simply beget more questions. Outside sources are therefore of considerable consequence for the narrative of *Surviving Desire*, just as they are in the dance. For instance, Jude is tortured by his inability to teach Dostoyevsky's *The Brothers Karamazov* to his students.

They have been stuck on the same paragraph (the Elder's advice to Lise's mother) for a month. He asks more and more questions of his students but provides them with no answers, no knowledge that will help them pass the final exam. The students seek knowledge as a commodity, material that will further their learning without providing understanding. (They seek it so badly that a student assaults Jude in the opening scene.) Ironically, this is exactly what Jude does in his pursuit of and rejection by Sophie, who in turn is translating Jude into a character in a story she is writing. Jude has bookish knowledge but no empirical experience, and Sophie has neither, but she seeks experience *as* knowledge (she writes down all Jude's questions in class, but does she answer them. Can she answer them?).

32. Fyodor Dostoyevsky, *The Brothers Karamazov*, trans. David McDuff (London: Penguin, 1993), 62.

33. Deleuze, *Cinema 2*, 70.

34. Fuller and Hartley, "Finding the Essential", xxviii.

35. Several of Hartley's films, including *Flirt* and *The Book of Life*, play with this device of confusing and partially disorienting the viewer by using sound bridges to confuse diegetic and nondiegetic music.

36. In *The Time-Image*, Deleuze argued that as sensory-motor extensions (where stimuli "must permeate the character deeply and continuously, and on the other hand the character who is thus permeated must burst into action, at discontinuous intervals" [*Cinema 1*, 155]) diminish, action-images give way to "pure optical and sound situations". Deleuze saw the musical comedy as embodying the collision between situations of a motivated, sensory-motor nature and those of a purely "optical and sound" nature:

> On one hand we think that musical comedy gives us in the first place ordinary sensory-motor images, where the characters find themselves in situations to which they will respond through their actions, but that more or less progressively their personal actions and movements are transformed by dance into movement of [a] world which goes beyond the motor situation, only to return to it, etc. Or we suppose, on the other hand, that the point of departure only gave the appearance of being a sensory-motor situation: at a deeper level it was a pure optical and sound situation which had already lost its motor extension; it was a pure description which had already replaced its object, a film set pure and simple. (*Cinema 2*, 62)

The metamorphoses, where sensory-motor situations become those that are of a purely "optical and sound" nature, are generated by the stylistic

impulse that sees a separation of two spaces. The loss of the sensory-motor aspect affects the manner in which the two interrelate.

37. *The Brothers Karamozov*, 62.
38. It is maxim number 689 in Johann Wolfgang von Goethe's *Maxims and Reflections* (London: Penguin, 1998), 93.
39. Rick Altman, *The American Film Musical* (Bloomington: Indiana University Press, 1989), 272–327.
40. Deer, "The Repetition of Difference", 189.
41. Ibid., 188. Deer characterised *Simple Men* (and Hartley in general) as identifying the feminine with marginality. She also saw the marginality of the female characters as displacing them from the narrative. However, in a film in which almost all of the characters are posited as outsider figures (the two mechanics, Vic and Mike, are actually refugees from another Hartley film—Vic is Audry's father in *The Unbelievable Truth*), the displacement of the female characters from the narrative, in this case Dennis and Bill's journey and their search for their father, is a necessary consequence of a story that is about the absurdity of its male characters. If the female characters are displaced (this includes not only Kate and Elina, but also Bill and Dennis's mother, Bill's ex-wife, the nun that wrestles with the policeman and the Holy Virgin Mother), they are forced to the narrative's centre, not its margins. Compared to the absurdity and irrationality of its male characters, the women in *Simple Men* are the film's moral and ethical centre.

CHAPTER 4

"THERE'S ONLY TROUBLE AND DESIRE"

I love a lot of really violent movies. I like the seeming reality of deaths in them and the bloodshed.... I'm more attracted to the movement, the construction. It's all based on the fact I'm not interested in naturalism.... The shoot-out on the hill is basically a dance—the actors spent hours out there working out the scene. All of our expressive energy went into movement instead of blood splatters. In the screenplay I'd written, he shoots him again and again and again. I figured this was me telling myself excessive.[1]

Following up on from the previous chapter, I continue to engage with *Simple Men*, exploring the problematic nature of performance, especially masculine performance in the film. Whereas the dance sequence conducts a critique of images, the majority of the film examines the performances of its titular characters. Discipline and maintenance of self are problematic for the male characters involved, who struggle to conform to a culturally accepted form of masculine control and domination,

something which expels them to the margins of the narrative. The other film considered in this chapter is *Amateur*. Again, the characters in Hartley's thriller struggle with performance of a consciously conceived self. The use of performance in *Amateur* exploits the physicality of the performer in the process of the character becoming a subject. Unlike other early Hartley films though, *Amateur* draws on and distorts generic iconography, reflected in the liminal roles adopted by its characters. The physicality of performance extends into probably the most significant performative aspect of the film: its adoption of tropes of violence.

Hartley's presentation of violence in *Amateur* forms both an internal and external commentary on representations of violence in the texts themselves and culture at large. In his films, violence is generally choreographed as a performative act, not presented as realistic in the sense of most popular contemporary action cinema. This discussion engages with the aesthetics of violence in modern cinema, but the predominant focus remains performance, and how Hartley presents violence as essentially *performed*.

Hartley's films often quote from a vocabulary of gestures and movements culled from physical comedy and cartoons. Like slapstick comedy, cartoons are all about movement, both the creation (the key to the medium) and negation of movement as the economy of animation often calls for gesture and movement to sometimes be localised in individual parts of the body to reuse certain parts of drawings. In addition to *Amateur*, Hartley has produced several short films in which the portrayal of violence is equally based in the use of gesture and often focused entirely on the movement of the body, utilising cartoon-like motifs such as violent chases, aphoristic dialogue (or no dialogue in the case of *The New Math(s)*), and, above all, repetition. These short films, much more so than *Amateur*, quote from a well-established vocabulary of gestures, situations, and actions used figuratively to defamiliarise the action on-screen. There is no attempt to make the action look realistic nor to excite or shake the viewer into attentiveness. As violence in cartoons is often used to distance the viewer from the effects of violence, the invocation of and quotation from the cartoon form transplants a form of abstract

violent movement into a realistic idiom (again juxtaposing realism and abstraction), generating a commentary around the viewer's responses to representations of violence.

The use of performance in Hartley's scenes and narratives of violence, therefore, will be shown to have specific parodic content. In this sense, the argument will show that Hartley's treatment of violence is gestic in the sense that Brecht argued, to effect the "direct changeover from representation to commentary",[2] as a social/cultural gest that is intended to criticise the action that other films would tend to represent in a graphic, realist manner.

SIMPLE MEN: THE FAILURE OF MASCULINE PERFORMANCE

Simple Men is a text where the deconstruction of gendered stereotypes is predicated upon the performance of a projected self and the problematic moment of reading. As the title suggests, *Simple Men* is about men who are simple (although, because the word "simple" has multiple connotations of stupidity and straightforwardness, the title is not simple). However, the intended projected selves of the two brothers at the centre of the narrative are a great deal more complex than they themselves are in actuality. At the heart of the film are a series of discourses surrounding performance that reflect on the construction of character both within and without the diegesis. The masculine performances in the text are generally failures, either through a failure to perform in structured instances, such as the dance, or due to repetition compulsion. Masculine performances in *Simple Men* are therefore doomed to failure. Bill's intention to seduce and abandon "the next good looking woman" he sees is contingent upon the adoption and maintenance of an alternative projected self; yet this is a character that he fails to perform successfully due to his uncomplicated self.

The failure of masculine performance in *Simple Men*—not just the inability to present a coherent self, but also the inability to succeed in tasks traditionally reserved for masculine film characters (heists, searches, sexuality, and emotional distance)—dominates all the male

characters in the film. Bill, the elder brother, is a failed criminal, betrayed by both his business and romantic partners, and reluctantly led into the search for his father by a request from his mother to watch after Dennis, his younger brother. By the end of the film, Bill has fallen in love again, been pursued by the police, and, finally, rejecting his father, captured by the local sheriff. Dennis, the younger brother, is a bookish student, who romantically undertakes the search for his radical baseball-player father, who, like Bill, is a criminal on the run. During the course of the film, however, Dennis discovers that empirical knowledge is totally opposed to book knowledge. Martin, the local fisherman, is continually pushed to the margins of the narrative, lacking in agency, and his only function in the plot is to own the boat that might help Bill and Dennis's father flee the country. Instead, Martin is crippled by his unrequited love for Kate, and tortured by her acceptance of Bill. In many senses, Martin's performance is the most failed in the film, as he is both emasculated and marginalised; although he does attempt to steal scenes with articulations of (white) masculinity, his assertions are both ill timed and struggle to be coherent, as in the dance and the dialogue scenes that follow. Other characters, even more marginal than Martin, also fail to perform adequately in masculine roles—the sheriff agonises in sorrow over a failed relationship; when we first see Vic, he is returning from his divorce (perhaps from Audry's mother from *The Unbelievable Truth*, as he is a repetition from that film); and Mike, Vic's partner, in an attempt to impress some girls, mistakes one European language for another. In each of these instances, the male performer fails to live up to the expectations of the role in which he sees himself. They are uncomplicated and unable to conform to filmic or social conventions of masculinity. The dance sequence is a key scene in which Hartley explores the mechanics of performance and exposes the discourses of masculinity that run throughout the film.

As noted in the previous chapter, the whole film revolves around the projection of clichéd images by individuals read problematically as more complex signs by other characters. Iconographically, the brothers in *Simple Men* are clearly delineated as that which they claim to be (figure 13): Bill is generally dressed in a long coat and carries a gun,

Figure 13. The appearances of Bill (Robert Burke) and Dennis (Bill Sage) conform to the roles that they intend to project; it is a coherence that they will struggle to maintain.

and Dennis wears glasses, carries a book when first seen (he is literally "bookish") and discusses Long Island with Bill in terminological fashion (it is "a terminal moraine", he tells him, "the dirt dumped by a glacier when it recedes", as Bill puts it later, attempting to use the knowledge to impress a woman). However, neither brother is quite able to mobilise their intended images, especially Bill. Despite his position as a criminal, Bill's gun is broken. He prefers to use the gun's image as deterrence. However, when Bill gives his gun to Ned in exchange for a rundown motorbike, the gun finally goes off, for which Ned is arrested. For an ordinary man like Ned, this is exactly what he discovers when he covets Bill's gun, the representation of his outsider status—as Bill tells him, there is "nothing but trouble and desire". When Bill intends to use an image for gain he fails. Having been betrayed by his girlfriend in his previous robbery, Bill explains to Dennis that he will not fall in love with the next beautiful woman he sees; he will make *her*

fall in love with him, then reject and degrade her; it is a role in which he intends to *perform*.

Bill is attempting to perform a repetitious, cultural role (the womaniser) but instead is compelled to repeat a more personal psychological role.[3] This is a theme developed by an important moment of structural repetition that sees dialogue being switched between different characters: spurned and double-crossed by Vera in the computer heist, Bill bitterly explains his plans to take revenge on all women:

> Tomorrow, the first good-looking woman I see, I'm *not* going to fall in love with her. That'll show her. Yeah, the first good-looking *blonde* woman I see. I'm gonna make her fall in love with me. I'll do everything right. Be a little aloof at first. Mysterious. Seem sort of thoughtful and deep. But possibly a bit dangerous too. Flatter her in little ways. But be modest myself. They all fall for that shit. Make her fall hopelessly in love with me. Yup. Mysterious. Thoughtful. Deep but modest. And then I'm gonna fuck her. But I'm not gonna care about her. To me she's gonna be another piece of ass. Somebody else's little girl who I'm gonna treat like dirt and make her beg for it too. I'm just gonna use her up. Have my way with her, like a little toy, a plaything. And when I'm done, I'm just gonna throw her away.

The next attractive blonde woman that Bill meets is Kate, the film's central mother figure, who is identified with the comforting and nurturing Madonna symbol that is so crucial in the film. Bill quickly falls in love with her. When it seems that his misogynistic fantasy might actually be coming true, Kate uses exactly the same words to Bill, who becomes nervously agitated by the repetition of his own words. She calls him "mysterious", "thoughtful, deep", which Bill, uncomfortable, denies. Kate tells him that he is just being "modest". He has slipped into a cycle of stereotyping that is impossible to break. His intended narrative is reliant on a series of stereotypes, most notably his adoption of a womanising, abusing masculine domination over a demure feminine body, another common stereotype, especially when considering that his perfect woman must be good looking and *blonde*. Nevertheless, Bill has tried to

play another type to win the woman over in his projected scenario—
the enigmatic stranger, "mysterious", "thoughtful", "deep but modest".
His discomfort upon hearing his own words repeated to him stems from
a recognition of the inevitability of the outcome of the clichéd narra-
tive he has set in motion—he is being disempowered by the loss of his
own words. Bill's performance in the stereotypical sequence of events
he has set in motion, and bought into moreover, fails as he is compelled
to repeat his previous disappointment (a sign of unmasculine weakness
in his mind) with Kate. The clichés into which Bill buys precede him in
the collective unconscious—therefore Bill is denied agency in his own
plan. The success of his plot relies on his mastery of the situation; Kate's
repetition of his words sparks his unpleasure at his lack of control in
the situation and the inevitable outcome of his projected image within
that narrative. Whereas his plan is contingent upon Kate's performance
of the stupid blonde stereotype, Bill's performance merely confirms the
reality of the stereotype about him. Therefore, he is no longer in con-
trol of the narrative but merely a reflection of the signs and scripts of a
culturally constructed masculinity that is doomed to failure. Bill simply
confirms his simplicity, while Kate resists easy stereotyping—although
she is blonde, she does not fit comfortably into Bill's plan (she rejects his
advances after summarising his characteristics) in the way he intended,
instead confirming Bill's unconscious acceptance of the role he believes
he is projecting as a means to dominate and abandon a "weak" woman.
Hartley complicates the situation by portraying Bill's performance as
consciously constructed (while later confirming its role in the failure of
masculine performances) and linking Kate's performance to nature and
her positioning as motherly; her performance is later revealed to be more
complex and less self-evident than first presented via her appearance
(which resembles the blue dress of the motherly Maria in *Trust*) and a
desire to grow trees that subsequently proves fruitless.

A form of eternal return is implied for Bill, where the cyclical repeti-
tion sees a process of dissolution, a return to the earlier stage. The circu-
larity is implied by Bill's failure to carry out his plan, his compulsion to
repeat the same behaviour over and over again. This is his downfall at

the beginning of the film and will be again in the finale. Bill's compulsion to repeat can be seen in light of the ego's repression of memory that forces the past to resurface as repeated action.[4] The behavioural compulsion to repeat made so apparent by Hartley's formal use of repetition demonstrates Bill's ego's desire to repress the unpleasure of the past by acting out those very impulses that lead to the trauma of the beginning of the cycle. In this, as Freud noted, Bill gratifies the pleasure principle by denying the reality principle, thus resisting unpleasure experienced in the past. Bill therefore experiences not only Deleuze's "eternal return" of repetition, but also Freud's "eternal recurrence" in his compulsion to repeat.

The dissolution to an earlier stage of repetition also has particular relevance for Bill's conception of his own social performance. Bill would undoubtedly see himself as one of Goffman's "cynical performers"—he claims to be savvy and street-smart but proves ineffectual and simplistic. As a criminal, Bill is already a cynical performer, having admitted to Dennis that he posed as a software salesman to pull off the ill-fated heist in which he was double-crossed. "When the individual has no belief in his own act and no ultimate concern with the beliefs of his audience", Goffman argued, "we may call him cynical, reserving the term 'sincere' for individuals who believe in the impression fostered by their own performance".[5] Bill seeks to project a self that he does not believe to be himself, but this repetition of his cynically intended self confirms that Bill is a poor cynical performer, not just taken in by his own performance, but actually confirming a lack of cynicism, thereby presenting the intended self as the "real reality". In this case, Bill's performance is not "dramaturgically disciplined", a crucial feature of the maintenance of a performance; as Goffman argued, the "actual affective response must be concealed and an appropriate affective response must be displayed".[6] Bill's lack of discipline ruptures "the expressive coherence" that Goffman saw as a crucial component of performances when hiding the "discrepancy between our all-too-human selves and our socialized selves".[7] Dramatic coherence masks the heterogeneous selves that lie behind the performance's outward appearance. However,

in attempting to hide his cynical performance, Bill actually confirms the performance, as his response is appropriate to the self that he is trying to embody but must now mask, although his performed selves are less divergent (and coherent) than he believes.

Bill chooses to present his actual self as a character that he is uncomfortable performing. Outlining the signs of his performance, he intends to project a self that he will willingly contradict ("and then I'm gonna fuck her"). When Kate confirms his success at projecting this self, he becomes unable to conform to the pretence of his intended self. Bill settles instead into his repetitious behaviour, confirming the self that he wished to contradict. Thus Bill fails to perform in character. He creates a drama for himself and a script that he outlines to his brother. However, the particular self that his personal front, his manner especially, portrays does not correspond to his own script. "A performer who is disciplined", Goffman noted, "dramaturgically speaking, is someone who remembers his part and does not commit unmeant gestures or *faux pas* in performing it".[8] Bill, however, lacks the discipline to carry out his intended self, and is unable to play the cruel womaniser when Kate begins to confirm his projected, scripted self. His attempt not to play modesty is in fact an affective display of modesty, only intriguing Kate further. The system of signification that Bill attempts to project is complicated by the repetition compulsion that he enacts through his inability not to repeat actions of the past, as he repeats the past in action rather than resolve the psychological imperative that forces him to repeat and consequently to act in this ineffective fashion. His performance lacks dramaturgical control, his image failing to conform to intended parameters, leading to performative failure and a disparity between the intended self as projected and the self that is read and decoded by an audience.

The uses of intertextual elements, particularly those drawn from music, are developed in *Simple Men*, where the dance is closely associated with the scene of dialogue that follows. Shot in a very simple series of five close-ups of each character in turn (themselves images offered for the audience's contemplation), beginning with Kate, followed by Elina, Dennis, Bill, then Martin, the group discuss the circulation and

control of images in culture. Crucially, this scene comments upon the previous dance, effacing the transparency of textual discourse by discussing the manner in which personal authority can control the manner in which images are consumed. Taking Madonna as their template, the group confront the exploitation of her image of sexuality in the media and whether her control of (and the financial rewards gained from) that image is crucial in her being thought of as a victim by her audience. (The use of Madonna in this fashion is effectively a pun, considering that *the* Madonna is a key image of comfort and protection in the film; although the reality is somewhat different: such images are not comforting at all.) As the following dialogue demonstrates, the text is highly self-conscious regarding the production and consumption of images:

> DENNIS: (in close-up, from below): Everyone is involved in exploitation: The person whose body it is, the salesperson, and the audience that is entertained.
> BILL: The significant distinction is: Who earns more money, the exploited body or the salesperson?
> KATE: And what about the audience?
> DENNIS: What about them? (Cut to close-up of Bill.)
> …
> BILL: Exploitation of sexuality has achieved a new respectability because some of the women whose bodies are exploited have gained control over that exploitation.
> DENNIS: They earn more money.
> BILL: They call the shots.
> KATE: They're not thought of as victims.
> BILL: If they earn the most money, no, they probably don't think of themselves as victims either.
> DENNIS: But what about the audience?
> BILL: What about them? (Cut to close-up of Martin.)

The effect of this short scene is to reveal the text's self-reflexivity toward its own creation and consumption of images. This short extract of dialogue illustrates the fashion in which the text is consciously demonstrating the manner in which images are manufactured and consumed, and by whom. Effectively, the salesperson in this argument is the author of

the text (Hartley), but in another sense the characters and their visual mobilisation of self (at least, that which they perceive for themselves), and the audience that reads, or misreads, those texts.

Perhaps most crucially, this scene problematises the relationship of the audience to the visual text and the schism between personal self-image and perceived image. The repetition of the question, "what about the audience?" and its reply, "what about them?" (and the subsequent cuts that emphasise the repetition) primarily conveys the manner in which Bill and Dennis are hopelessly unaware of the contradictory ways in which their projected selves are being decoded and misunderstood. Crucially, Martin is once more only a partial participant as he fails to address the topic at hand, only interjecting that he thought they were talking about music. Finally, Martin ends the discussion by reading a list of bands, all of whom are generally associated with white, male-oriented rock 'n' roll:

> Hendrix. Clapton. Allman Brothers. Zeppelin. Tull. BTO. Stones. Grand Funk Railroad. James Gang. T. Rex. MC5. Skynyrd. Lesley West. Blackmore. The Who. The old Who. Ten Years After. Santana. Thin Lizzy. Aerosmith. Hot fuckin' Tuna.

In a sense, his list confirms the discussion and the importance of image and the dissemination and control of images in culture, especially music. But it also stresses the failure of his performance, his abject masculinity, and the repressed rage and frustration that bar his access to the discussion. Martin has little understanding for the process of dissemination and reception that the other characters are discussing. More than any other character in the film, Martin most typifies the simple men of the title.

AMATEUR: PERFORMING VIOLENCE

Amateur deals with a set of characters that are out of step with culture, society, and most importantly, themselves. As a parody of the crime thriller, Amateur deals with the seedy underbelly of international corruption, drugs, and pornography. However, the main cul-

prit of the criminal violence is stripped of his identity before the film begins. When the film opens, Thomas (Martin Donovan) is seen lying in an alley, having been pushed out of a window above by Sofia (Elina Löwensohn), his wife and the notorious star of ostensibly violent pornographic films produced by Thomas and his partners. Suffering amnesia, Thomas enters a nearby diner where he meets Isabelle (Isabelle Huppert), a former nun who writes poetry masquerading as pornography and claims to be a nymphomaniac, in spite of her virginity. Isabelle helps Thomas rediscover his identity, on the condition that he makes love to her when he eventually recovers his memory. Meanwhile, Sofia, believing Thomas dead and her former life behind her, plans to become a "mover and a shaker". However, she chooses to embark on a troublesome path when she attempts to blackmail Jacques, an international gangster who works for a "highly respectable yet ultimately sinister international corporation with political connections" for one million dollars. Consequently, she becomes subject to a ruthless pursuit by two bloodthirsty corporate assassins who are as interested in mobile telephone technology and commodity relations in the pornographic film industry as they are in torture and murder. The pursuit brings Sofia and Thomas together again, and brings the past into focus for Thomas and Isabelle, who discover that he was a dangerous, violent criminal who coerced Sofia into pornography and drug addiction with threats of disfiguring violence.

Tragic in the most traditional of senses, *Amateur* confronts issues of identity and redemption. Thomas is finally able to repent his sins and find forgiveness from Isabelle, a surrogate virgin mother, despite the fact that he has no memory of having committed any transgressions. Having achieved some measure of redemption and forgiveness via Isabelle, another fallen figure (she renounced her devotion to God), Thomas is shot by a police gunman in a case of mistaken identity: the police are really chasing Edward (Damian Young), Thomas's former accountant and partner, who has escaped from police custody, wounding an officer in the process. The ending is doubly ironic in that Thomas has achieved

redemption and is killed by mistake, but he receives divine retribution, not for his crimes, but for those of the "old" Thomas.

Much of the critical interest regarding *Amateur* has focused upon its unusual treatment of generic iconography and scenes of violence. Ryan Gilbey has claimed that the comic treatment of violence is a standard element of Hartley's aesthetic: "Hartley has always filmed violence as though it was part of a Gary Larson cartoon— the father and son fighting in *Trust*, the nun wrestling the cop in *Simple Men*, the torture scenes in *Amateur*".[9] As I discuss in the following section, the scenes of violence that Hartley chooses to portray, such as the cop and nun wrestling on the ground in *Simple Men*, are key elements in Hartley's gestic approach to screen violence, not simply the manner in which the body is used in scenes of violent conflict (their gesticulatory quality). Lesley Deer has also commented on cartoonish violence, but she sees this as located more within the generic iconography that is subverted in *Amateur*:

> *Amateur* ... indulges in the characteristics of the [thriller]. The signifiers of the thriller that *Amateur* utilises include the film's urban setting, since the film marks Hartley's move into city of New York from Long Island. There is also the use of guns, car chases, police pursuit, and episodes of violence. These episodes are at once real, such as the torture scenes, and cartoon-like, such as the shooting of Jan [one of the corporate assassins].[10]

Both critics fail to address just how the violence in Hartley's films is cartoonish. No doubt, one could argue that the violence in an Arnold Schwarzenegger film is cartoon-like (or at least comic-book-like). There are elements of Hartley's approach to violence that can be described as cartoon-like: the use of repetition, the focus on the gestural performance of the body, especially the pause-marking of gestures,[11] and chases. Nevertheless, these elements form a part of Hartley's abstraction within a more general realism: it provides a defamiliarisation of violent action from the generalised norms of the representation of violence and focuses the viewer's attention onto her own investment in the pleasure of watching such representations. But how does the violence in Hartley's films

differ formally from such "normalised" representations? In what way is it distinctive and emblematic of Hartley's overall aesthetic? The answer is found within the treatment of performance and the actors' use of the body in such scenes. However, where a narrative of violence is evident, as in *Amateur*, the whole system of acting is analysable from the perspective of violence and the body's role in its portrayal.

Amateur employs performance to emphasise the body in scenes of violence: the shootout on the hill in *Amateur* is, as Hartley noted at the beginning of this chapter, just like a dance. In many ways, it functions in a similar manner to the dances discussed in the previous chapter, where the performance of dance produces an interpretive problem for the viewer because the movement of the performer is made abstract by its significant difference from realist modes of performance; the performance of violence in *Amateur* is no different. Hartley realised violence by consciously eschewing realism and de-emphasising the sensationalism of screen violence. Instead, Hartley located the effects of violence in the performers' bodies. In the hill shooting, the body of the assassin jerks spasmodically as a deranged accountant fires bullet after bullet into him; yet no blood is shed. The assassin's body eventually ceases to move as his life ebbs away. The final reflexive spasms give way to motionlessness. By rejecting the realism of violence in this fashion, Hartley alluded to other cinematic representations of violence—both past and present—to distanciate the viewer from the spectacle of violence in order to confront the desire for pleasure in watching violent spectacles. The thirst for and thrill of watching violence is conspicuously absent, often descending into overstated comic farce, forcing the viewers to examine their own reaction to the violence they are watching, and why violence often provides enjoyment and pleasure so lacking from the experience of real violence. In this, Hartley's approach to the performance of violence explores the cultural and textual effects of violence by sidestepping realism in order to pose an interpretive difficulty for the viewer and a significant blockage to straightforward enjoyment.

In modern cinema, the "stylistic amplification"[12] of violence is generally significantly heightened. The excess of violent commercial cinema

is centred, predicated in fact, on an aesthetics of excess. Is there a difference in, say, the destruction of a building at the beginning of *Lethal Weapon 3* (Richard Donner, 1992) and the grossly overstated shoot-out on the hill in *Amateur*? Perhaps only quantitatively. At the beginning of *Lethal Weapon 3*, the detectives Riggs and Murtaugh are sent to defuse a bomb planted in the basement car park of a high-rise building. They are unsuccessful, and the building collapses in a giant fireball. What the audience is witnessing is the real destruction of a derelict building soon to be torn down. The spectacle is therefore "authentic": a huge scale "event" designed to "open" the film (in both the sense of kicking off with a bang and the promotion of the film) with as much emphasis as possible on chaos and destruction. However, in *Spectacular Narratives*, Geoff King argued that modern action blockbusters are augmented by what he called "impact aesthetics": elements of style that emphasise chaos, speed and, demolition.[13] King's examples—a huge explosion in *The Long Kiss Goodnight* (Renny Harlin, 1996) and a car chase of absolute carnage in *The Rock* (Michael Bay, 1996)—demonstrate how, in both cases, the filmmakers have used aggressive stylistic techniques in sound, rapid editing (akin to that of music videos), and fast-moving cameras to amplify the literally explosive content being represented. The difference between these scenes and the demolition of the building in *Lethal Weapon 3* is that the carnage of the collapsing building is presented as real without significant stylistic modification, rather than as a scene that is heavily transformed by the stylistic choices of the filmmaker to increase the potential effects on the viewer. This is a fact that the film promotes by placing the scene at the very beginning of the film, before the credits and with no relevance to the plot that takes place afterwards. This is purely spectacle, the explosion calculated to be "experienced" by the audience, not just witnessed. This form of spectacle *and* "impact aesthetics" are, thus, characterised by their excess. The excess of *Lethal Weapon 3*, however, is in the act that is presented, not the representational methods. In this sense, the scene has low stylistic amplification, while King's examples of "impact aesthetics" are, in Stephen Prince's terms, heavily amplified by the use of overt stylistic elements.

By eschewing the impact of film style, *Amateur* locates the effects of violence in its performances. One of the earliest movements in *Amateur* deals specifically with abstraction of an internal perception relating to violence: the body in pain. Violence enacted on the body is one of the key spectacles of modern Hollywood cinema, in every conceivable genre: action cinema, war films, slasher movies, pornography, maternal melodramas.[14] James Elkins's *Pictures of the Body: Pain and Metamorphosis* examined representations of the body, and how pain is "felt" (shared) by the viewer:

> Pain is the *general condition of being alive*, a state of sensation, a sensual monitoring of the body, a care or awareness of its health and its status, an attention to what are sometimes known as "raw feels." A neurological concept is close to what I mean here, and that is "proprioception" ... : the body's internal sense of itself.... Pain signifies that mode of awareness that listens to the body and is aware of its feeling—whether that feeling is the low-level muttering of a body in good health or the high pain of illness.... "Proprioception" is apt because it denotes feeling that occurs in the body rather than bodily movements.[15]

Elkins argued that representations of the body produce an effect akin to proprioception, in which the viewing body feels the sensations of the represented body in order to bring meaning to the image before it. Adrienne McLean contended similarly in her discussion of Judy Garland's implied performance of suffering, where the "filmed body produces meaning that my own body seems to feel and understand".[16] The spectating body does not necessarily feel pain but understands pain via the empathetic embodiment of pain as it is represented on-screen, hence the many sharp intakes of breath heard in cinemas around the world as the heroine of *Erin Brockovich* (Steven Soderbergh, 2000) is sideswiped by another driver in the unbroken opening shot of Steven Soderbergh's film. The spectacle of the accident is translated by the audience into the *potential* pain suffered by the protagonist. The long take emphasises the reality of the pro-filmic event simply through a lack of manipulation. The audience invests in the actual danger of the

moment, anticipating the possible pain suffered by the character and, crucially, the star playing her. Although this moment does not involve the spectacle of a body being damaged or tortured, it ably demonstrates how signs in the image are sensed by the viewer as pain, which becomes embodied in a physical reaction. In addition to empathy, other processes may dictate the embodiment of pain, such as sadism or masochism, but fundamental to the representation of pain and viewers' ability to derive meaning and/or pleasure from such representation remains the body's ability to sense the general well-being of another body via its image.

Hartley's cinema often works to obstruct the empathetic embodiment of pain in a Brechtian fashion: the viewer is not distracted by a direct appeal to the emotions but made to examine the act of viewing such representations for reasons of pleasure. *Amateur* generally delays understanding of sensations felt by the bodies of characters, and, by alienating the spectacle of the body's suffering, denies the realism of such moments. When the audience first encounters Thomas, he is lying on the ground in a cobbled street contorted, slightly turned away from camera so that his face is not visible. Before he rises, Sofia enters in the background and comes forward tentatively to check his ostensibly dead body before turning to run off again. When Thomas rises after the credits, his back faces the camera and is noticeably tense as it extends to its full length. Having sat up straight, Thomas turns his head to look around, but he does so without turning his shoulders, retaining the stiffness in his back. The lack of active movement in Thomas's initial movements is not necessarily mimetic in showing a body in pain. The movement is symbolic of Thomas's pain, but it is also necessarily ambiguous as the initial shots of the film introduce characters about which no narrative information is granted, nor will it be granted for some time (especially in the case of Sofia). The lack of expressive movement and narrative information is tied to the generic ambiguity of the amnesia thriller in which the main character is involved in a search to rediscover his identity. That generic formula is developed further as Isabelle's voice-over hints at the inevitability of the thriller genre's often tragic ending. Over the final moments

of Thomas's struggle to sit up, she reads "this man will die". Initially, this purports to be an omniscient narrative voice-over, but the cut reveals Isabelle writing a pornographic story on her computer in a nearby diner. Hartley uses this technique later in the story, when Sofia flees the corporate assassins at Grand Central Station. "In even the smallest things, she saw the pointlessness of hope", Isabelle reads as Sofia, her dream to become a "mover and a shaker" in tatters, makes her getaway in a taxi, realising her mistake in dealing with ruthless international criminals. Hartley undercut the use of voice-over by cutting to Isabelle's scene of rejection at her publisher.

Amateur is shot predominantly in medium close-ups; therefore, gestures are often limited to movement of the head, neck, and shoulders. The bodies of the main actors in *Amateur*—Donovan, Huppert, Löwensohn, and Young—are restricted in this sense, limited in the realism of their movements as their bodies tend to be passive, inactive—although expressive gestures (symbolic gestures that abstract emotions or thought) are emphasised when they do become visible. Only at certain key moments do their bodies become active. The fragmentation of the body is one of the key elements of film style and has been a significant issue for film theorists such as Laura Mulvey, who, in "Visual Pleasure and Narrative Cinema" saw the fragmentation of the female body (dictated by scopophilia) at the hands of the camera or editor's scissors as anathema to the illusion of realist space demanded by the conventions of the traditional Hollywood narrative.[17] This fragmentation turns the body into a cutout, an icon, which lacks agency and demands that the viewer identify with the viewpoint of the almost always male protagonist. However, in *Amateur* the fragmentation of the body often masks and denies the body, focusing on the movements of the characters' heads. If the characters are in any way forced to become iconic in *Amateur*, it is through their agency and in the subversion of generic types that Hartley draws upon in the narrative (the criminal with amnesia, the nun suffering a crisis of faith, the *femme fatale*), even if the film subsequently ironically exposes the gap between the roles that the characters *think* they inhabit and those that they actually occupy.

The essential fragmentation of the body by the camera and editing locates the general style of filming the characters in *Amateur* within the broad gestic approach adopted towards screen violence in the film. Violence and conflict are two of the essential elements of film style. In effect, the fragmentation of the body by Hartley's direction is literally "chopping" the actors' bodies into pieces, forcing the audience's focus onto a particular body part. This is emphasised importantly in how Hartley chooses to show Edward's torture at the hands of Jan and Kurt, the two corporate assassins out to apprehend Sofia. Jan and Kurt take Edward to an abandoned warehouse, where they tie him up. At first, they question him regarding the whereabouts of Sofia with just the threat of violence. Kurt pulls the cord from a lamp, exposing the electrified ends where the cable's outer casing is stripped off. When Edward lies to them, claiming not to know Sofia's whereabouts, Kurt places the negative and positive ends of the cable against Edward's temples. The first two electric shocks are shown in medium to big close-ups; Edward's eyes roll back in his head and his body becomes stiff and rigid, active only in the sense of being tensed. The final electric shock comes after Jan leaves to make a phone call. He tells Kurt to question Edward some more. However, Hartley cuts directly to the final shock, so no more questions are asked. But unlike the first two shocks, Hartley concentrates on Edward's feet to show the final, decisive electrocution. The most significantly violent and disturbing scene in the film, Edward's torture is finally shown by a symbolic use of movement in the feet. Although his ankles are bound to the chair, his feet are free to move. The heels are lifted off the ground, raising the chair slightly. Edward's feet spasmodically tremble and twitch (figure 14). These two movements gain significance only in combination with the previous two shocks received. The violence committed towards Edward in this scene is represented first by the symbolic pain in Edward's constricted lack of movement while bound to the chair. The final cut, an unexpected one (signifying Hartley's use of stylistic amplification in the scene), emphasises the violence connoted by Young's performance; the similar movement of his feet therefore conveys Edward's convulsive twitching. The disturbing violence of the action is emphasised in this

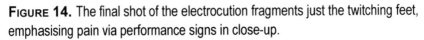

FIGURE **14.** The final shot of the electrocution fragments just the twitching feet, emphasising pain via performance signs in close-up.

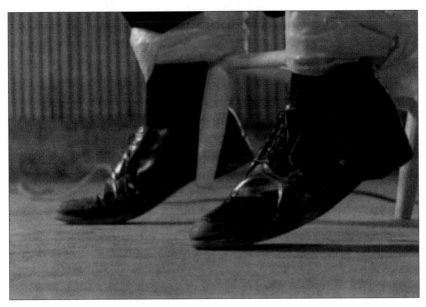

gesture, following the way the pain was emphasised by the lack of gesture and Edward's eye movement in the first two shocks.

The violence of the cut, and the implied ellipsis, testify to both the violence of Kurt's electrocution of Edward and the implicit violence of film style ("shooting" and "cutting"). William Rothman, following Alfred Hitchcock, characterised film as "a medium of taxidermy", an inherently violent apparatus with the ability to forcibly strip chunks of the world from their moorings in the real world and force "malignant ideological effects" upon unsuspecting viewers.[18] The most famous view of the cinema apparatus's violence is that of Sergei Eisenstein, who saw the violent conflict of images on-screen by montage as the most significant aspect of the medium. Eisenstein argued that *conflict* is "the essential basic principle of the existence of every work of art and

every form".[19] Eisenstein's "'dramatic' principle" is that "montage is not an idea composed of successive shots stuck together but an idea that DERIVES from the *collision* between two shots that are independent of one another".[20] Although Eisenstein did not necessarily advocate violence as the means or object of his dramaturgy of montage, his vocabulary is notable in its use of violent imagery ("conflict", "collision"). Hartley drew on this concept of screen violence when he used the fragmentation of the body and the violence of editing to emphasise a gesture that directly stresses the painfully violent and disturbing nature of Edward's torture. The use of these techniques is therefore not limited to abstracting the gesticulatory quality of Damian Young's performance as Edward, but it also linked to the gestic in Hartley's stylistic approach to showing that gesture.

The style of performance developed in *Amateur* is reminiscent of a similar use of actors in thrillers by Alfred Hitchcock. In his analysis of ensemble playing in *Rear Window*, James Naremore contended that part of the film's interest as a "performance text" lies in "the way it makes structural contrasts out of the most extreme forms of acting, as if to comment on the historical development of screen rhetoric". Therefore, the audience sees James Stewart

> frozen in the wheelchair, his movement limited mainly to reaction shots and "gestureless moments," ... an actor who works completely within the dominant contemporary mode, whereas the supporting players in the apartment windows have to gesticulate emphatically, performing with their full bodies and regressing to an earlier, almost nickelodeon, style.[21]

Hartley used a similar system of performance (although based more subtly in a passive/active split) to achieve altogether different goals. The main characters in *Amateur* can generally be seen to fit closely into a category of film actor of which Hitchcock was reportedly fond: "a man who can do nothing extremely well".[22] As the film's two main characters, Thomas and Isabelle, Donovan and Huppert embody Hitchcock's favourite type of actor. Both bring iconic associations to their roles (Donovan

from his other Hartley films, *Surviving Desire, Trust,* and *Simple Men*;
Huppert from her work in French cinema, including Godard's *Sauve qui
peut (la vie)* (1980), Tavernier's *Coup de torchon* (1981), and Chabrol's
Madame Bovary (1991)), but performative activity is limited mainly to
just two parts of the body: head and neck, and shoulders and trunk. Even
facial expressions are limited. The intonation and cadence of dialogue
is stressed in the lack of expressive movements in the head and face.
Movement in other areas, when it is apparent, tends to fulfil a function
that is neither necessarily mimetic nor symbolic but refers to elements of
rhythm. *Amateur* is, in essence, a mystery; the rhythm of the actor's per-
formances is therefore perhaps the most important device in controlling
the more or less languid pace at which the film develops, especially as so
much of the film is shot in medium close-up. Kent Jones saw this style
running throughout Hartley's aesthetic in "the way that he counterpoints
the various physiognomies of his actors, usually from the waist up". [23]
The "counterpoint of actor physiognomies" in *Amateur* is closely bound
with notions of gesture and character, leading to an increased emphasis
on the "biological fact" of acting, its use of individual body movements,
and postures. In *Amateur*, the presentation of performance in scenes that
are not violent places a heavy emphasis upon the bodies of the perform-
ers that extends critically into scenes of violence.

As the key protagonists in *Amateur*, Thomas and Isabelle are linked
closely to the stylistic performance of the film, its mystery, and its
rhythm. This is perhaps most evident in the scenes in Isabelle's apart-
ment, and, when they discover it, Sofia's apartment, the scene of the
attempted murder of Thomas. There are two key exchanges between
Thomas and Isabelle in her apartment that clearly exemplify the form of
performance that Donovan and Huppert are developing in their portrayal
of characters who, throughout the narrative, rediscover their identities.
Unlike Thomas, who has lost an identity, Isabelle has forsaken hers to
masquerade as a nymphomaniac writer of pornography, a role in which
she is poorly cast and ill at ease. By utilising a form of performance
that locates the majority of movement in the shoulders, neck, and head
in the scenes in Isabelle's apartment, Hartley can form an identification

between the icon of the Madonna on the wall and both characters. In the icon, the Madonna remains fixed, her gesture unchanging, essentially a performance *without* duration. Therefore, the gesture is iconic and abstract, rather than representative. The system of acting aims at a similar iconic system. Combined with a slow, unemotional tone of speech, both actors are minimalist in their use of expressive gestures, limiting movement to functional movement—smoking, bathing—that looks to dictate the rhythm of these expository scenes. In the first of these exchanges, Isabelle has returned from her brief date with Warren, the man she met through the "hot phone sex party line". When she returns, Thomas is lying in the bath reading a pornographic magazine. As he is lying down in the bath, his body is masked up to his neck, so any body movement is hidden (and therefore partially fragmented). He has the magazine pulled out in his hands and stares up slightly to look at it. Thomas takes no pleasure at looking at the magazine; he simply raises his eyebrows briefly and shakes his head slightly before turning a page. He seems to take no scopophilic pleasure from looking at the pictures. His movement is ambiguous and suggestive of the detached, objective viewpoint that Thomas may hold as a producer of such images himself.

As written, the dialogue in this scene is fairly rapid and punchy, utilising short statements, questions, and retorts that create a quick rhythm. The written speech looks and reads like the dialogue in *His Girl Friday* (Howard Hawks, 1940) or the opening of *Pulp Fiction* (Quentin Tarantino, 1994), where the short, snappy dialogue structures the scene and its internal rhythm. Hartley wrote snappy dialogue in this style, but the performance of the two actors in the scene contributes to an entirely contradictory rhythm. This slow, almost languid or methodical pace focuses the scene on its expository nature, the development of the mystery at the heart of the film, and the unusually internal contrastive nature of the characters (i.e., Isabelle as the former nun who writes pornography and claims to have always been a nymphomaniac or Thomas, the good-natured cipher who turns out to be a ruthless, dangerous criminal and abuser of women), and their essential amateur-ness.

Hartley emphasised a lack of expressive movement, gesture, and intonation to highlight and contribute to the slow, ponderous nature of the scene. The actors remain relatively still and use subtle gestures or functional movements to punctuate dialogue or suggest, rather than represent, emotions and internal thought (subtle exteriority). The subtlety of Thomas's initial movement in the scene is exemplary. While looking at the dirty magazine, Donovan's performance is striking in its ambiguous lack of expressivity. The expected reaction of a man looking at sexual pictures of women is excitement: the brief raise of eyebrows is suggestive of this, although the movement could also stress surprise at particularly unpleasant imagery. The shift from movement in one area, the face, to another, the head and neck, portrays a sudden change in thought. Thomas very briefly nods his head a little. Is he now troubled by something he sees, or displeased? With hindsight, having discovered Thomas's true nature at the end of the film, the movement is *a posteriori* suggestive of professional displeasure at poorly produced, unerotic imagery. In this very brief minimal expression, there is a contrastive element in the shift from one gesture to another that is ambiguously suggestive of Thomas's old personality and his role as a user and abuser of woman, but also of his new nature as sensitive, slightly titillated, but troubled by the objectification of women in the pornographic industry. The ambiguity of the gesture, its range of interpretable meaning, introduces the mystery into the scene from the outset, before Isabelle returns to talk to Thomas.

When Isabelle does come into the bathroom to speak to Thomas, she stands initially in the doorway, just inside, looking down at Thomas. The fact that she is looking at him bathing naked is not noted in the scene, in dialogue, or Isabelle's movements—it is simply accepted. The lack of acknowledgement of this fact stands as a counterpoint to Isabelle's perceived role as a nymphomaniac. The majority of moments of gesture in this scene are of the purely interactional variety: nods and shakes of heads, repositioning of the head to look at each other or away when guarded (especially in Isabelle's case). There are also functional motions that are used for rhythmic purposes, but have no special communicative role: Isabelle smoking, Thomas washing and shaving. Finally, the scene

is filled with nuances of gesture that externalise the characters' emotional states, particularly Isabelle's slightly awkward reticence: shrugs, body inaction (and points where action ceases). The gestural content of the scene is especially complex in its minimalistic use of body motion, given the lack of expressive gestures that are obvious in their externalisation of broad emotions.

Nevertheless, the movements of Donovan and Huppert stress *Amateur*'s general systematisation of gesture and the de-emphasis of the broad body motion that comes to stress the importance of minimal gestures in conveying nuances of character. The majority of movements by the two actors in the scene are describable in a fairly basic manner, as shrugs, turns of the head, or as smoking; there are no motions that do not fall into identifiable categories (like the movements in the dance in *Surviving Desire* for instance, where the aim was not necessarily life-likeness). For instance, when Isabelle tells Thomas that she has never had sex, Thomas is rubbing his chin. The simple action of rubbing the chin has no specific contextual meaning, except to signal that Thomas thinks he might need to shave, but he also says that shortly after (echoing Hartley's use of dialogue to externalise emotion in *Trust*). The gesture is pause-marked[24] to separate the two discrete movements; first, the rubbing of the chin, and then the end of that motion; second, a lowering of the hand away from the chin. The motion represents a shift in Thomas's concentration. (Throughout the scene, he concentrates much more on washing or clipping his toenails than he does on Isabelle.) This gesture connotes his surprise at the incongruity of a nymphomaniac who has never engaged in any sexual act. Donovan's voice does not register Thomas's surprise—there is no explicit intonation of shock, an increase in volume, or change in pitch, only a slight acceleration. The pause-marking of the movement conveys Thomas's disbelief: his concentration shifts away from the performance of his previous action. Additionally, the pause has comedic value—it is a double take, a standard performative motion of the comedian. Therefore, Hartley and his actors are engaging with the kind of comedic vocabulary that is seen in the rendering of violence throughout his films. This scene foreshadows, and

creates a counterpoint, to the presentation of other, more violent actions. In addition, this gesture tends to refer back to the cartoon, in which the double take is a standard pause-marked gag (such as the character who realises they are suspended in midair, only to plummet once they become cognizant of their suspension). The pause-marking of cartoon-like gags is quoted here in a Brechtian fashion as a method of suggesting the commonality of the gesture (an important part of the gag's humour) and its source as a repetitive feature of cartoon and comedic narratives. The gesture performs a partial abstraction within the scene, and its minimalism is part of the overall system of the scene, although its quoted nature is a reminder of the general abstraction within the almost-realist diegesis that extends to the presentation of violence throughout *Amateur*.

The rhythmic gestures in the scene tend to refer mainly to Isabelle. The most obvious of these is her smoking. Isabelle takes a drag on her cigarette three times during the scene, each one used as a point of emphasis for the dialogue immediately preceding or following the movement. The most significant occurs when Thomas asks how Isabelle could be a nymphomaniac *and* a virgin. Once more using comedic timing linked to performed gestures, she takes a delaying drag on her cigarette before delivering the punch line, giving it added emphasis and humour. Moreover, when Isabelle lights the cigarette, the violent movements of tearing the match from the pocketbook and striking it add accent to the dialogue, which again does not have any specific tonal variation. The moment that Isabelle strikes the match she says "no", answering Thomas's question about her religiousness. The violence involved in the gesture adds an emphasis that stresses something of her regret at having hidden herself away in a convent while she knew her destiny lay in the world outside.

The great length involved in analysing just one scene in *Amateur* for its minimalistic approach to body movement and gestural significance is testimony to the general style of performance in the film that stresses an important emphasis (by way of de-emphasis) on the body. The inactive/active split at the heart of the gestural system in *Amateur* is necessarily contradictory: the inactive body stresses the activity of gestures in individual parts of the upper body. This is an important consideration given

the contradictory nature of most of the characters in the film, a blending of roles that are identifiable as generic standards and individuals at the same time struggling to conform to those standards. Generically derived criteria are responsible for establishing the parameters within which each character's identity is established: gangster, porn actress, accountant, and nun. However, each has experienced circumstances in which they have become removed from those criteria that define their existence within the film, either by choice or *in extremis*. The problematic nature of identity is crucially linked to both the inactive/active body and the portrayal of violence in *Amateur*. The central conceit of the film is amateurishness, of beginnings, the adoption of a new lifestyle or worldview. This is valid for all of the characters: most obviously with Thomas, who as an amnesiac has been stripped of his identity and is forced to begin again; Isabelle is newly arrived "out here in the world" from the convent, trying to make a living as a writer of poetic pornographic stories; they both adopt the generic role of amateur sleuths trying to uncover the mystery at the heart of the film; Sofia is attempting to forge a new life for herself, having ostensibly killed Thomas to free herself, she ultimately becomes a poor blackmailer. What links each of the characters is that the role they choose or are forced to adopt is a performance in itself, of a new social role or a generic function of the narrative's internal iconography. Like cartoon characters, they are flattened, not fully fleshed out, in the process of being fully formed subjects (like cartoon characters, their formation is also limited).[25]

In *Amateur*, therefore, the ambiguity of identity in the main protagonists locates each within the sphere of the liminal, either by choice (the adoption of a new persona, or wearing of a mask) or by violence (being shoved out of a window or electrocuted). Where the means of entry into the liminal is violence, the negation of identity is not simply a change of demeanour or image, but a dynamic shift in mode of performance. This particular element of performance relates most directly to Edward, and signals much of Hartley's systematic approach to violence in his films, their gestic quality and the links with comedy and cartoons. The moment of violence described above where Edward is electrocuted is disturbing

in its cartoonish simplicity (lacking only the flashing lights and X-ray view of his skeleton) and the way it utilises the cinematic apparatus to demonstrate both the violence in the gesture itself and the violence inherent in the mode of filming that gesture. The aftermath of Edward's electrocution and subsequent descent into the realm of the liminal is achieved by an overt shift in Damian Young's performance. Immediately following his ordeal at the hands of Jan and Kurt, Edward stops talking altogether. His movements become his only means of portrayal and his loss of identity and social conditioning, in a sense, becomes animalistic. The performance system that was examined above is based on small movements, generally performed in individual areas of the body and paused for moments after their initial performance. Edward's actions, however, are completely contrastive to this generally inactive form of acting; his movements are frequent, broad, and focused in violence or on animal urges such as eating or drinking. The general system of acting in the film, which emphasised the head and small gesticulations in other areas of the body, is ripped apart, substituted by a mode of performance that locates the character completely within the liminal sphere, outside social structures and almost literally out of his mind.

When the two squatters, Nicola (Parker Posey) and Ted (Dwight Ewell), first discover Edward's body in the warehouse in which he has been electrocuted and left for dead, he comes "alive" with a quick, spasmodic jerk that signifies the return of life to his body. When the squatters first discover Edward's body, it is still and lacks movement; they therefore initially mistake him for dead. Nicola discovers the body offscreen, telling Ted that "there's a dead guy in the corner". Shocked, he drops his lamp (the instrument of Edward's torture), but Nicola, who seems more interested in the décor, simply leaves the body and comes back into shot to play with the curtains blowing in the window; she jumps up, trying to grab them. They revive Edward by feeding him alcohol, bringing him back to life with the aforementioned spasm. Edward is confused and acts defensively toward them as they sit staring, discussing him. He adopts a posture toward the others that is bizarrely animalistic. His hair now flared outwards like a cartoon character that has been electrocuted,

he sits poised on his haunches, crouched in readiness. His right hand
is placed flat against the wall, forcing his arms and shoulder upwards
and raised above his head. He stares directly ahead at Ted and Nicola,
his head twitching very slightly from side to side. The kinesic stress
in this posture is of potential energy, the body inactive, but ready to
explode into movement at any moment. When he leaves the warehouse
he is almost unable to walk, his legs unable to support him, using the
wall to his right for leverage and balance. Ted and Nicola watch in the
background; Nicola is concerned for Edward's well-being, treating him
like a child, but Ted's reaction suggests that Edward is like an animal
set free to fend for itself. Edward is reduced to an almost cartoon fig-
ure, an anthropomorphised, childish animal. However, his primal, feral
actions, and his crucial loss of language, tend to emphasise Edward as
an aggressive figure of *real* violent potential. At this stage, his actions
are suspended between empathy and abstraction. On one hand, he is a
victim of violence, who attracts the empathy of the viewer, but on the
other, his actions are partially abstract in their quotation from cartoon
(including his electro-shocked appearance) and comic, obviously *per-
formed* nature.

From this point onward, Edward's actions are a frenzy of active
movement. He bursts into a diner and leaps over the counter. When con-
fronted by a member of staff he takes the cigarette from the other man's
mouth, puts it in his own, and shoves the man backwards out of shot.
The push is emphasised by the sound of the man crashing backwards
into a table, smashing dishes (echoing the cartoon's tendency to rep-
resent the effects of violence in offscreen sound). Edward throws the
cigarette to the ground and comes to the foreground of the shot where
he grasps a slice of pizza and starts chomping through it, tearing into it
like it were a slab of meat. He suddenly stops eating, grabs a pepper mill,
smashes it open and empties the contents onto the pizza before resum-
ing his assault on the overseasoned slice. He then stops again, looks left
then right. The scene then cuts to Edward gulping directly from a drink
dispenser, unable to quench his thirst. In this brief scene, and Edward's
later assault on a woman at a phone booth (and the phone, which he

rips from the booth), Edward is like a vicious animal, seemingly acting only on biological urges with no sociable skills. The raggedness of his movement is matched only by the violence of his actions, the shove of the waiter in the diner and the woman on the phone, whom he punches in the stomach. He is literally wild, thrust fully into the chaos of liminality, beyond any notion of social structure, even the marginal criminal structure with which he has been formerly associated as a mob accountant, like Kurt and Jan.

The key scene in which Hartley locates the link between the active/inactive body with the gestic quality of violence in *Amateur* is Jan's protracted death at the hands of Edward. Edward shoots thirteen times before all movement is eradicated from Jan's body, at which time Edward stops shooting. For Hartley, the gestic quality of the almost-slapstick violence is its most interesting aspect, its focus on the movement rather than the use of a gun. The movement in the shooting is thus emphasised at the expense of visceral verisimilitude. Films, particularly war films like *Saving Private Ryan* (Steven Spielberg, 1998) and *Black Hawk Down* (Ridley Scott, 2001), have revelled in the re-creation of violence in a way that applauds the faux-documentary realism of the depicted action (of their overt stylistic amplification of events that are behaviourally overdetermined to begin with). Hartley turned completely in the opposite direction towards the dramatic emphasis of violence in Hays code era films, where the movements of actors were called upon to suggest the impact of violence. Although Jan does not fall clutching his bullet-riddled body, the lack of viscera, the "blood and guts" approach to realistic screen violence, closely links the violence in *Amateur* with the old-fashioned style of pantomime Hollywood violence in the studio era.

The moment in *Amateur* is reminiscent of the opening of *Casablanca* (Michael Curtiz, 1942). A suspect is fleeing the police; when they shoot, he spins around; a hand to the performer's back emphasises to the audience where the bullet struck. The performance of the motion is centred around the point of his back that he clutches. The force of the gunshot and its effects are conveyed entirely by the performer's motion. In alluding to this past of cinematic violence, Hartley is creating a comment on

representations of violence. The very conscious rejection of the means to create a realistic (not to mention visceral) portrayal of violence—squibs, blood packs, pyrotechnics—and the adoption of an abstract, comic vocabulary defamiliarises the representation from the realistic, often extreme, violence of modern cinema. Viewers are generally accustomed to viewing violence as pleasurable, rendered for maximum impact and aesthetic entertainment. The importance attached to movement in the shooting stylises the violence, de-emphasising the realism that has become commonplace on film in the modern era. The impact of violence is therefore performed rather than mechanically reproduced; its wildly overstated nature and the manic sadism of Edward tend to place the scene more in the realm of comedy, as slapstick violence. The violent, comedic gest both highlights the absurdity of earlier cinematic representations, which portrayed movement as bloodless pantomime and was explicitly unrealistic although the lack of realism was disavowed by the text, and the modern bloodthirstiness of audiences, who clamour for more real and spectacular displays of gruesome violence. The gest forces the viewer to explore her desire for such representations and ask why the subversion of spectacle may initially produce humour instead of horror. Similarly, by quoting liberally from comic and cartoon vocabularies, Hartley exposed the general "acceptability" of violent actions abstracted as unreal and presented without the inevitable consequences of real violence. Placing the comic and the tragic in close proximity enables Hartley's work to defamiliarise both the acceptable, comic violence of Bugs Bunny or The Three Stooges and the pleasingly realistic, visceral spectacle of violence in the likes of Schwarzenegger's films.

Edward shoots Jan directly after his arrival at the house in Portchester where Thomas, Isabelle, and Sofia have sought sanctuary. Jan bursts into the house having been led there by Isabelle, whom he has kidnapped; he shoots Sofia, who tipped him off about the whereabouts of Thomas, who was supposed to open the door. As Thomas tends to the wounded Sofia, Edward shoots Jan, who staggers out the door, through which Edward pursues him. Hartley cuts to the exterior of the house, where the shooting takes place in a single shot that tracks the movement of Jan as he

staggers up the hill. In a medium shot, Jan is first seen stumbling up the hill, his body tensed in pain like Thomas when he was first seen rising from the cobbled street. Edward is briefly glimpsed behind Jan as he runs from left to right in the background. Jan then passes behind a tree. Edward shoots him twice. So, despite the surfeit of movement in this shot, the audience is denied a view of Jan's pain as he is shot for a second and then third time. Fractionally after Jan has been hit by Edward's third bullet, he emerges from behind the tree, still staggering, his upper body pitched forward very slightly. Edward crosses back right behind Jan and offscreen again; he then shoots Jan for a fourth time. Jan falls to the ground. Re-entering shot, Edward stoops to pick up Jan's gun and, half-running half-walking, bumbles away to the edge of the grass in the background. When he reaches this boundary, he turns right and disappears out of shot again. He shoots Jan again. This time Jan's knees buckle; he does not fall, but keeps staggering ever forward, his weight now pitched even farther forward so that he is bent at the waist. Edward now runs to the foreground of the shot, into the same plane as Jan; he stands with his arms outstretched, level with his shoulder. He shoots Jan again, the first shot seen on-screen in this sequence (figure 15). Running off again, Edward runs swiftly directly ahead and offscreen left. When he shoots Jan this time, Jan is propelled into a spin that originates in activity in his shoulders. The movement effectively shows the point where Jan has been shot: his left shoulder (figure 16); it is from there that all the movement in this action originates as Jan spins like a dancer performing a pirouette, shifting his weight to locate movement below the neck line. He ends the spin almost bent double, the weight of his upper torso seemingly now too much for his ailing body. This moment of dance-like movement is reminiscent of Hartley's interest in dance and the general abstraction of the body; it can also be linked to notions of balletic violence in the films of Sam Peckinpah or John Woo, of violence as a source of aesthetic contemplation instead of physical embodiment. Hartley's dance-ification of violence in this scene comments on this standard mode of critical description of violent films focused on the (usually slow-motion) performance of the body.

FIGURE **15.** The deranged Edward (Damian Young) shoots Jan (Chuck Montgomery) in a protracted, escalatingly absurd sequence shorn of conventional artifice, where no blood is shed.

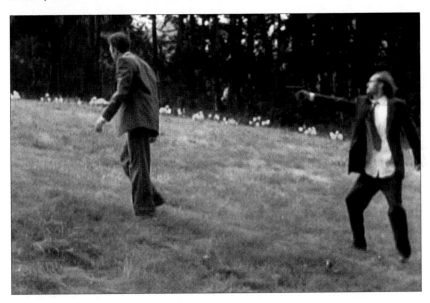

Edward rushes back into frame, pausing briefly to look at Jan before moving to the extreme right of frame. From here, he shoots Jan twice more. On the first shot, Jan crumples toward the ground; on the second, he slumps forward, finally falling; although the fall resembles a dive, as he propels himself forward. Crossing to Jan's fallen body, Edward stands over him and shoots twice more in quick succession. Jan's body twitches spasmodically (as Edward's had done when he was revived by Ted and Nicola), at first with considerable emphasis in the jerky movement of his limbs, then diminished when shot for the eleventh time. Edward then pauses briefly; he hesitates, lowering then reaiming the gun. He shoots Jan twice more. There is negligible twitching in Jan's body on the first of these two final shots. After the final shot, there is none. Only when all trace of movement is exterminated is Jan finally dead. His revenge

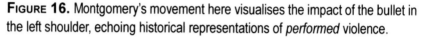

FIGURE **16.** Montgomery's movement here visualises the impact of the bullet in the left shoulder, echoing historical representations of *performed* violence.

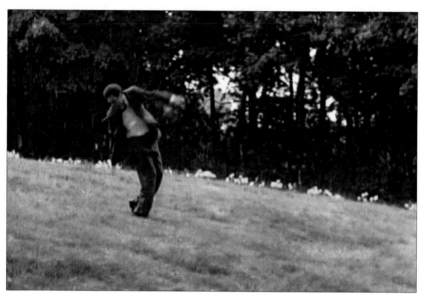

finally enacted upon Jan, Edward lets the gun drop from his hand. He stands over Jan's body for some time afterwards, but he looks around, off left and right, as if he is oblivious of the extreme measures he has just taken.

This scene is characterised by its excess of movement. Although Hartley admitted to having conceived the scene as carrying an excess of violence, the redundancy of much movement in this shooting is starkly contrastive to the economy of movement in the rest of the film, Edward's insanity excluded. The death of Jan therefore is the death of movement. Edward only stops when Jan ceases to move, even to twitch reactively when shot for the last time. After falling to the ground, Jan's body continues to move, however minutely, with diminishing action until all trace of activity is gone. The end of external movement signals the end of internal activity also.

The shooting in *Amateur* is also conscious of "impact aesthetics", but in a considerably different way to the violent spectacle of modern action films. The scene is excessive to the point of the absurd. Edward's movement is choreographed for comic effect, but as the scene wears on, his actions become less humorous and more disturbing in their sadism. The simplicity with which the scene is shot, a lack of speed and editing, emphasises the frenetic activity of Edward and the pained, constricted movements of Jan as the bullets "hit" him. Although the audience never sees a bullet hit Jan and no squibs go off to signify these shots, the choreography of movement completely captures the points and force of impact of all the bullets, especially when Jan is spun around by a bullet that hits his left shoulder. The absurd length of the scene is undoubtedly based upon and a parody of the excessive impulses of "impact aesthetics", wherein lies the gestic quality of the violence in *Amateur*. The conceptualisation of the scene by Hartley and the two performers analyses the subjective illusions of screen violence, in particular forcing the audience to examine their own reaction to the violent, sadistic actions on the screen. The comic opening of the scene, where Edward runs off beyond and around Jan, initially hidden by the tree that masks the first two gunshots on the hill, is similar in some senses to the slapstick violence of a Three Stooges short, where the violence is cartoonish and excessive, but never deadly. As Peter Brunette noted:

> No one really gets hurt in their films because theirs is the violence of cartoon figures, a kind of counter-mimesis that curiously reverses the usual direction and relation of visual signifier to signified. Their violence is not real; it is a trope, a figure.[26]

The trope of violence in *Amateur* becomes more figurative as the scene goes on; initially pleasurable in its comic overtones, the shooting extends into a form of movement that becomes more dance-like as the artifice of the scene becomes more apparent.[27] Like the violence of The Three Stooges, the violence in *Amateur* is very forcefully artificial; when Moe tweaks Curly's nose, it does not bleed; and likewise when Edward shoots Jan thirteen times, he sheds no blood.[28] The trope of violence in

Amateur therefore is very similar to this cartoonish form of violence, as numerous critics, quoted earlier, have remarked. The excessive, cartoonish style, based in the redundant length of the scene and the isolation of the sounds of gunshots sees the violence alienated, distanciated; the thrill of violence is dispersed as the scene slows to its disturbing conclusion rather than accelerating toward a thrilling climax. Hartley even concentrated on the flatness of the end of the shooting by holding the shot on the bemused Edward, showing his lack of reaction and the end of his own movement. Although the shooting on the hill relies in some part on "impact aesthetics", in its use of sound and movement particularly, the scene is not stylistically overdetermined, ignoring most of the elements of style (sound, editing, music, moving cameras, special effects) that action films usually rely upon to convey their dynamic nature and spectacular pleasure. Hartley and his performers turn toward a minimal use of movement, camera repositioning, and sound to expose the artifice of screen violence, its mechanical signifiers (focused on the body and pain). The violence is therefore gestic in Brechtian terms.[29] As the violence in *Amateur* draws on elements of the comic, particularly the playful slapstick violence of The Three Stooges, it is not only a trope, a presentation of "violence" rather than a representation (the representational space being ripped asunder as the scene expands), but a gest that interrogates a very particular attitude adopted by culture and the commodity fetishism of spectacular images in modern action cinema. As Hartley maintained:

> I have a very definite feeling about movies that have guns and people getting shot and making images of people getting shot. And it's pathetic. Guns sound like cowardice and people who have them seem pathetic. Ultimately revenge is futile. These are pretty clear things to me.[30]

Hartley's distaste for gun violence, and ultimately his distaste for creating realistic depictions of that violence, has significant consequences for the presentation of violence in his films, especially *Amateur*. Violence is generally tropic in his films at the best of times—the comedic fight

between the nun and cop in *Simple Men* is an obvious parody of the conflict between church and state—but in *Amateur*, the representation of violence (the stylistic amplification, to use Stephen Prince's terminology) becomes tropic in itself. The violent actions depicted in Hartley's thriller are treated as gestic in their opposition to contemporary standards of screen violence. The prolonged, excessive shootout on the hill is exemplary of this technique, as the audience is forced to confront its own reaction to the action as it becomes overstated, veering from comedy to sadistic torture and finally murder. The scene depicts a man being shot thirteen times by a deranged adversary suffering the traumatic aftereffects of torture. With its protracted single shot, the scene asks the viewer if this is really funny, or if it is in fact a disturbing, voyeuristic presentation of a man's demise. The bloodless lack of viscera denies the exciting spectacle, the performance alienated by its very performed-ness, as there is no accompanying performance by special effects or by the camera. The scene is Brechtian in this respect. However, this is generally true of Hartley's approach to violence in all of his features and short films. The presentation of violent action in Hartley's films is located predominantly in the performance of the bodies on-screen. Like the use of gesture in his films, this performance is positioned in the context of an overall scheme of performing that systematises movement as active, passive, repetitious, and/or tropic. In this respect, the performance of violence becomes a comment on both external, cultural representations of violence, and the viewers' reactions to such portrayals, and as counterpoint to the internal systems of performance developed by the text. As such, the use of violence is closely related to the use of dance in Hartley's films as the performance of both are coded as excess in comparison with the rest of the film and are into alternative styles of performance that either augment or retard the development of narrative meaning, or to highlight a cultural issue raised by the text's relationship with other systems of meaning.

ENDNOTES

1. Matt Hanson, "The Sophisticated Yet Ultimately Awkward World of an American Auteur", *Dazed & Confused*, January 1995, http://drumz.best. vwh.net/Hartley/Info/d&c-interview.html.
2. Brecht, *Brecht on Theatre*, 126.
3. The compulsion to repeat was expounded by Freud in two essays; first in "Remembering, Repeating, and Working Through" from 1914 and then in "Beyond the Pleasure Principle" in 1920. In the former, Freud looked at the psychoanalytical process and the importance of the repetition compulsion for transference, and in the latter he explored the drives that compel the patient to repeat. In both papers, however, Freud treated the compulsion to repeat as a struggle within the patient to manifest repressed memories as repetitious action. Essentially, as Freud described it, the patient's repression manifests the memory as repetition:

 > we may say that the patient does not *remember* anything at all of what he has forgotten and repressed, but rather *acts it out*. He reproduces it not as a memory, but as an action; he *repeats* it, without of course being aware of the fact that he is repeating it. (*Beyond the Pleasure Principle and Other Writings* [London: Penguin, 2003], 36)

 The treatment for such deep-seated memories is to return the patient to the past, reconstructing the repressed memory through the psychoanalytic process. Thus, as Freud argued, the illness should be treated "not as a matter belonging to the past, but as *force operating in the present*" (ibid., 38, emphasis added). Freud's theory of repetition compulsion offers a fuller definition of repetition, as the past "*operating in the present*". Seen in this light, the past and present moments, the repeated memory and its present *re*-presentation, are simultaneously abstracted from linear time.
4. The compulsion to repeat is manifest by the ego's resistance to remembering, whereby the repressed memory is exhibited as action. In Bill's case what Freud defined as the "eternal recurrence of the same" returns as *active* behaviour as intended by his plan, although the activity as it is actually displayed is more unconscious (ibid., 60). This compulsion to repeat that is determined by the resistance of the "conscious and pre-conscious ego" to remembering is linked to the pleasure principle. Resistance to remembering and the consequent compulsion to act again seek "to forestall the unpleasure that would be caused if the repressed part of the psyche were to

break free—whereas our own efforts are all directed at opening the way to just such unpleasure by calling upon the reality principle" (ibid., 58).

5. Goffman, *The Presentation of Self in Everyday Life*, 28.
6. Ibid., 211.
7. Ibid., 63.
8. Ibid., 210.
9. Ryan Gilbey, "Pulling the Pin on Hal Hartley", in *American Independent Cinema: A Sight and Sound Reader*, ed. Jim Hillier (London: BFI, 2001), 144.
10. Deer, "Repetition of Difference", 93.
11. In Chuck Jones's Daffy Duck cartoon, *Duck Dodgers in the 24½ Century* (1953), Daffy is wont to repeat the title of the cartoon, trumping his own overestimated abilities. Whenever he does this, he points his finger to the sky and jumps in the air, wherein he remains suspended until he has finished his fanfare, where he drops to the ground again. (One time he literally plummets to the ground as he misses the platform beneath him; when on the ground, he turns, moving offscreen, only to return in the other direction walking crouched, like Groucho Marx—once more the gesture is held). The *pause-marking* of gestures therefore is critically important in cartoons, for reasons of economy and comedy, where amusing poses, such as that of Duck Dodgers, can be held long enough to assume comic proportions (overstatement, like the shooting in *Amateur*).
12. "Screen violence", Stephen Prince argued, "is the stylistic encoding of a referential act"; *Classical Film Violence: Designing and Regulating Brutality in Hollywood Cinema, 1930–1968* (New Brunswick, N.J.: Rutgers University Press, 2003), 34. The referential act of screen violence is behavioural, modes of action by individuals or groups that are violent by nature, such as brandishing and firing weapons, torture, fist fighting, rape, medical mutilation, etc. These acts are generally assumed to be violence done to the body, where pain is inflicted, sometimes sadistically, and where the body (and, by extension, mind) is traumatised. The stylistic encoding of the violent action, which Prince plotted as *y-axis* to the behavioural *x-axis*, refers to the representational means by which the filmmaker renders the activity of violence on-screen. The negotiation of this axis, Prince argued, is the "stylistic amplification" of violence. Therefore, actions with relatively low behavioural levels of violence, such as brandishing an automatic weapon without firing it, elicited great public moral concern in 1930s gangster films, such as *The Public Enemy* (William Wellman, 1931) or *Scarface* (Howard Hawks, 1932). Alternatively, Prince contended, filmmakers soon

discovered that stylistic amplitude could increase the affectivity of violent actions that are largely unseen through the use of editing, sound, set design, lighting, framing, and choreography. Thus, in James Whale's *Frankenstein* (1931), the scene in which Fritz tortures the creature is subject to high levels of stylistic amplification (levels that were generally deemed unacceptable for contemporary censors).

13. Geoff King, *Spectacular Narratives: Hollywood in the Age of the Block-buster* (London: IB Tauris, 2000), 98–99.

14. See Linda Williams, "Film Bodies: Gender, Genre and Excess", *Film Quarterly* 44, no. 4 (1991): 2–13. Williams argued that the pleasures associated with these genres are typically organised around the viewer's oscillation between male/female and active/passive poles. Although nothing in Hartley's films is as excessive as the material that Williams outlined or Stephen Heath associates with the slasher film ("the body cut, sawn, rent, dismembered") (*Questions of Cinema* [Bloomington: Indiana University Press, 1981], 185), the associations between the image (and spectacle) of the body in pain and the mental activity of the spectator in response still requires some elucidation.

15. James Elkins, *Pictures of the Body: Pain and Metamorphosis* (Stanford, CA: Stanford University Press, 1999), 23.

16. McLean, "Feeling and the Filmed Body", 5.

17. Mulvey, "Visual Pleasure and Narrative Cinema".

18. William Rothman, "Violence and Film", in *Violence and American Cinema*, ed. J. David Slocum (London: Routledge, 2001), 39. Rothman's comments here emphasise one of the key ways in which performance is relegated in thinking about cinema, where the stylistic effects of the text are the ones that do the "talking" (enunciate), not the actors.

19. Sergei Eisenstein, *The Eisenstein Reader*, ed. Richard Taylor (London: BFI, 1998), 93.

20. Ibid., 95, emphasis added.

21. *Acting in the Cinema*, 241.

22. Ibid., 240. Indeed, Naremore saw Stewart's immobility in *Rear Window* as a metaphor for this type of actor.

23. Kent Jones, "Hal Hartley: The Book I Read Was in Your Eyes", *Film Comment* 32, no. 4 (1996): 71.

24. The basic unit of kinesic study is not simply a series of muscular contractions and alterations in body shape, but cultural, societal, and behavioural contexts determine that movements become what Raymond Birdwhistell called "kines". At a more complex level are what Birdwhistell defined as

kinemorphs, which combine individual "kines" in a temporal relationship to form complicated "chains" of movements that relay greater communicational significance. To analyse American movers, Birdwhistell created a process that involves dividing the body into eight separate areas: head and neck, face, shoulders and trunk, right arm, left arm, pelvic region, right leg, and left leg. *Kinemorphs* need not, however, be confined simply to movements ("kines") within one such area. To confine the *kinemorph* to one particular area would be to limit kinesic analysis to "an exhaustive list of microkinegraphs or articulations [and] provide us with relatively little concerning the kinesic system of the actor" (*Kinesics and Context*, 195). The *kinemorph* is time-dependent for its formation because individual movements occur within a given time-frame—"performance, not duration, determines the kine" (ibid., 197)—without necessarily being simultaneous. Birdwhistell describes three different ways in which *kinemorphs* can occur in a given time period:

1. synchronic kinemorphs; in which the component kines are simultaneous and of equal duration;
2. series kinemorphs, in which the kines follow one another in time; and
3. mixed kinemorphs which have both synchronic and series features but in which all component kines are not of the same duration. (ibid., 196)

"Kines", therefore, become *kinemorphic* when combined in a temporal relationship when the performer utilises certain signs that mark the transitional movement between the individual "kines" and their combination in more complex interaction in *kinemorphs*. The translation of "kines" into *kinemorphs* is therefore not an arbitrary process that immediately turns any sequence of "kines" into a *kinemorph*. Sequential movements become *kinemorphs* upon analysis as transitional modifiers can be abstracted in the movements that mark the beginning and ending of each grouping of "kines". Birdwhistell identified three different *kinemorphic* transitions:

1. *pause-marked*: *kinemorphs* that begin at zero and return to zero upon their terminus, where zero is defined as "attention without specific movement". The most common form of *kinemorph* transition.
2. *areal transition*: "characterized by onset of activity in one body part and is terminated by the introduction, from zero, of activity in another part".
3. *bound*: these *kinemorphs* are contrastive in that they occur when one particular *kinemorph* is replaced by another in the same body area that utilises the same points of articulation in the limb or body part but

exhibits a noticeably different order of movement or duration result-
ing in a complex whose meaning is considerably different to that of the
subsequent complex of *kines*. (ibid., 197)

25. The concept of the amateur stretches to Hartley himself. In many ways,
 Amateur was uncharted territory for him, a marginal low-budget filmmaker
 with numerous critical plaudits but no commercial success. *Amateur* there-
 fore represents a series of firsts for Hartley: his first consciously generic
 film; his first foray into the big city from the Long Island suburbs; and
 his first film with a big star (Huppert). So, for Hartley the amateur, the
 film itself was a series of challenges. This is noted in the basic identifica-
 tion between Hartley and Thomas, a filmmaker who has ventured outside
 of his natural environment. Thus there is a simple, superficial association
 between Hartley and his main character, but it would be overly presumptu-
 ous to suggest that Hartley had experienced an identity crisis similar to that
 of his main characters.

 In a radio interview, Hartley focussed on this superficial identification:
 "Hitchcock once said of Charles Laughton dismissively that he was "an
 amateur". And when that got back to Laughton, Laughton just shrugged
 and said, "Well. It means lover. I love my work". I've always liked that";
 Hal Hartley and Isabelle Huppert, "National Public Radio Morning Edi-
 tion: Director Hal Hartley Discusses his New Film, Amateur", interview
 by Pat Dowell, April 12, 1995, http://drumz.best.vwh.net/Hartley/Info/
 npr-profile.html.

26. Peter Brunette, "The Three Stooges and the (Anti-)Narrative of Violence:
 De(con)structive Comedy", in *Comedy/Cinema/Theory*, ed. Andrew S. Horton
 (Berkeley and Los Angeles: University of California Press, 1991), 185.

27. In some ways, Hartley's treatment of violence in *Amateur* is reminiscent of
 the portrayal of violence in Arthur Penn's *Bonnie and Clyde* (1967), espe-
 cially the seminal bank hold-up scene that ends with the bank manger being
 shot in the face. The scene begins with a light tone, comical almost, until it
 ends with the gunshot. The violence of the shot is enhanced by its presenta-
 tion as a single shot, directly violating the production code by showing the
 gun and the target in a direct causal relationship within the same shot. The
 scene's abrupt shift in tone is a result of the influence of the French New
 Wave on the New Hollywood movement of the 1960s and the influence
 of Godard and Truffaut on David Newman and Robert Benson, the film's
 writers. Hartley's treatment of violence shares this same interest in sud-
 den changes of tone, from the comic to the sadistic and disturbing; it is a

Brechtian emphasis that forces the viewer to explore their own impulses at the experience of aesthetic violence.

28. Brunette's essay on *The Three Stooges* offers a further key likeness between Hartley's cinema and the slapstick of Curly, Larry, and Moe. Brunette argued that "the slapping, the poking, the pinching ... occurs rhythmically, at regular intervals, and thus acts as a kind of punctuation, a system of commas, periods, and paragraph breaks, for the syntax of the ostensibly plotted, 'larger' narrative. This is especially true given that the violence is almost always accompanied by a variety of special-effects enhancements on the soundtrack" ("The Three Stooges", 176). If this is compared to Hartley's use of similar violence—the grappling nun and policeman in *Simple Men*, the numerous slaps in *Trust, Simple Men, Theory of Achievement*—the punctuating nature of the slapstick violence is immediately apparent. Although it is not possible to see this violence forming a sub- (or anti-) narrative within the larger narrative, as Brunette does with the Three Stooges' films, but as genuinely disruptive, as stops and shifts in tone and rhythm. Consequently, the slap has become one of Hartley's most distinctive stylistic traits, because it occurs so often, especially when, in *Theory of Achievement*, it is used as part of a domestic "dance" (influenced by Godard's *Une Femme est une Femme*, 1961).

29. Walter Benjamin, for instance, stated quite categorically that "epic theatre is gestural" in *Understanding Brecht* (London: Verso, 1998), 3.

30. "The Sophisticated Yet Ultimately Awkward World of an American Auteur".

CHAPTER 5

"THE WORLD IS A DANGEROUS AND UNCERTAIN PLACE"

Since the release of *Amateur* in 1994, Hartley's concerns have begun to shift. In many respects, *Flirt* signalled the end of an era for his work. The concerns with issues of repetition in particular come more or less to an end with *Flirt*, as the film's structure appears to be a final comment on the role of repetition in shaping the defining element of his authorship. Subsequent films have begun to shift away from this. The three features explored in this chapter, produced between 1993 (beginning with the original *Flirt* short) and 2001, document changes in Hartley's approach to his work. However, between the essay form of *Flirt* and the explorations in myth and genre in *No Such Thing*, the rigorous concern with issues of performance remains in his work. Although this feature remains an ongoing concern, it is generally framed in different conceptual, social, and political contexts.

In this chapter, I explore those films and the different contexts required to explore this ongoing concern with issues of performance. *Flirt*'s main

concern is social, and it is also concerned with the critique of images, performances, social observers as well as the gendered roles in which his characters are free or constricted to perform within. *Henry Fool*, Hartley's most successful feature financially, and winner of the Screenplay award at the Cannes Film Festival, documents less a concern with social modes of performing, although Henry is a consummate performer, than with the minimalism and systematisation of its performers' bodies. *No Such Thing* is, in some respects, a major shift in Hartley's concerns, and the film tackles much broader cultural concerns than his previous work in portraying the performance of the media and gendered fictions; it also addresses his continuing preoccupation with faith.

FLIRT: IMAGES AND DIFFERENCE

Flirt is Hartley's most consciously experimental feature, a consequence of recurring issues of repetition and difference. In the film, sexual difference in particular is emphasised as a performance, but one that is contingent upon reading by an audience. Gender roles, Judith Butler argued, are dependent upon a performance, "a dramatic and contingent construction of meaning",[1] that projects a social formation upon the subject: gender is an "act", as Maria's fluid, liminal, passage between female "acts" in *Trust* demonstrate. Formations of gender and sexuality are projections of ideology, where a phallocentric patriarchal society of compulsory heterosexuality posits femininity as castrated other, defined by its lack of the phallus. By disclosing the artifice of representational styles, *Flirt* concurrently exposes the artifice of socially mandated roles of gender and sexuality for critical purposes. Both are explored via the same means: difference and repetition. At times, *Flirt* does lapse into the use of stereotypes, especially female stereotypes, but are these reflections of a particular misogyny on Hartley's part, as Lesley Deer suggests,[2] or elements of a performative system that emphasises the constructedness of *socially imposed* difference?

Hartley bared the mechanism in *Flirt*, highlighting the film's own constructedness in formal experimentation. As the title of the film

testifies, the subject of Hartley's commentary is the flirt, a social role in which individuals cast themselves or are cast by others. By lining up three central characters in this role, Hartley consciously compared and contrasted the similarities and differences between the individuals: a heterosexual white male American in New York, a homosexual African American man in Berlin, and a heterosexual Japanese woman in Tokyo. Although each can be reduced to their respective cultural, ethnic, sexual, and gender labels (like the characters in *Theory of Achievement* do for themselves), the film interrogates the visual, auditory, and behavioural signifiers that combine to construct the performances of each. *Flirt* emphasises the difference inherent in gendered, sexualised roles, while simultaneously highlighting cultural difference through Hartley's use of formal technique and the transposition of the same narrative between milieux. That consequent difference, however, is imposed upon characters by the narrating position of the film and the audience within the text. The difference is socially constructed and projected.

The moment where difference and repetition are most keenly observed in *Flirt* is the final Tokyo segment—it is the epitome of social and cultural difference. This is particularly notable because the protagonist in this final section is neither male nor American. The New York and Berlin sequences offer variations on a single theme, the male American; first, within his own milieu of heterosexual white urban America (Hartley's America); second, the American male is decontextualised from his own surroundings and placed within an alien culture in Berlin—the male is also transposed from a heterosexual to homosexual milieu, which allows Hartley to explore masculinity differently. In Tokyo, however, the protagonist is female, and, with the exception of Hartley himself, all the characters are Japanese. The form of the final film also makes explicit reference to classically Japanese forms, such as Japanese theatre and the films of Yasujiro Ozu. By making cultural difference a condition of the production of the text, especially in the opening *butoh* sequence, *Flirt* becomes a particularly depthless experience.[3]

The resurrection of the manipulating puppeteer of Japanese theatre[4] in *Flirt*'s Japanese segment contributes to a depthlessness of image. The image is made depthless through the lack of transparency (lack of realist tropes), where the fragmentation of denotative material in the text exposes the constructedness of the diegesis and performances. In *Flirt*'s *butoh* sequence, the presence of rehearsal footage and a nonrepresentational stylistic strategy abstracts both performance and space, erasing representational and affective depth. The illusion of realist depth is effaced in favour of a visual iconography that functions explicitly as material signification on the surface of the image. However, this depthlessness relates to the activity of the image, yet it does not relate to the function of narrative. The narrating position (and hence the storyteller) is still contained within the text: narration is made abstract through the use of repetition across the first two segments. The "storyteller"—Hal Hartley—is eventually present on-screen,[5] but the marks of his narrating agency remain hidden, despite his role as a narrative agent. The manipulator, however, does return in the dance sequence that opens the final episode. The first two sections depict the experiences of male protagonists in a relatively uncomplicated stylistic fashion, yet the Tokyo sequence becomes the site of cultural difference through repetition and the use of recognisably Japanese forms (such as *butoh*). In *Flirt*, the repetitious structure makes the final Tokyo sequence the site of difference, as the "royal repetition" of the narrative(s) makes each subsequent repetition subservient to the same. Difference, therefore, becomes a key side effect of the repetitious. As Gilles Deleuze argued, "repetition is, for itself, difference in itself".[6]

The Japanese dance, and the manner in which Hartley chooses to present it, are indicative of the form of cultural difference that is evidenced in *Flirt*. When the Tokyo sequence begins, the viewer is suddenly confronted with a startling contrast. In white letters on a black background, the title card reads "TOKYO march [*sic*] 1995". From this dark frame, Hartley cuts straight into the dance. The sudden shift from black to a predominantly white setting is momentarily disorienting. Instantly, the viewer is confronted with a group of Japanese people, five

men surrounding one woman, each daubed in white make-up. The *mise-en-scène* is distancing—the costuming and make-up of the men and women clearly indicate their participation in a theatrical performance, but not a realist one. After a brief pause, another man, his face also covered in white make-up, enters from below, near to the camera. He slowly rises upward and turns toward the camera. For a moment, he stares off-screen to the left before spinning around to complete a circle that surrounds the woman. Suddenly, the men spin out of their circle to form a line facing the camera with the woman in the centre. Then the two men either side of her lift her above their heads. This is how the audience is introduced to Miho.

The men who participate in the dance with Miho and Yuki are manipulators, like the *kurago* of *bunraku*. These performers are marginal figures, and they do not participate in the dance, but remain peripheral, passively as viewers or actively as manipulators. In the final sequence of the dance, the men move Miho and Yuki like dolls, until they are left embracing in tableau. The sequence cuts directly into the action, as Miho is forced down to the ground by one of the men; the camera tilts down to reveal Yuki at her feet. Miho is pushed downwards until her chin comes to rest on Yuki's shoulder. Another dancer enters from the left, raising Yuki's left arm around Miho's right shoulder. He moves swiftly, passes behind Miho, and exits to the right. A bald dancer then enters from the right and wraps Miho's lifeless left arm around Yuki's back (figure 17). A final dancer then tentatively moves Miho's right arm around Yuki so that the two lie twisted together in an awkward embrace. Two succeeding shots show the women in tableau, helplessly trapped in this structure. Yuki stares mournfully over Miho's shoulder; Miho remains expressionless.

The manipulation of the women's bodies, by the male dancers and the director Ozu, stresses an allegorical function of the dance. The manipulation emphasises the materiality of the body, where the depthless image functions to highlight the signs that compose the movement and meaning in the body. Additionally, the social function of the body is acknowledged, and the social imposition of roles, particularly those associated

FIGURE 17. Miho (Miho Nikaido) is manipulated during the *butoh* rehearsal. Echoing the construction of her social role, she is moved into position by her male manipulators.

with gender, where female difference is a crucial aspect of the dance. The performance also has precedence in Masahiro Shinoda's *Double Suicide* (1969). Shinoda uses the traditional role of the *kurago* to distance the viewer and sidestep empathy in the audience's reaction to the drama. In Shinoda's film, the *kurago* move characters, props, and enact scene changes, but they remain outside the action, unable to interact with the characters, only ever able to move them ever closer to their tragic fate and watch as the action unfolds. As Claire Johnston noted, the "film is a close adaptation of Chikamatsu's 1720 doll-drama *Shinju Ten no Amijima* (*Double Suicide at Amijima*), and traces a basic conflict in Japanese drama, [*giri-ninjō*], between social obligation and personal

emotion in the bourgeois milieu".[7] *Flirt* also traces this traditionally Japanese conflict in the love triangle with Ozu and Yuki, where Miho must weigh her personal feelings against her social obligation to her teacher, his wife and, the scandal that would damage their careers. The dance implicates society in this conflict, and especially in the imposition of meaning upon Miho's body and the roles it plays. Two audiences witness Miho's performance: a nondiegetic audience, whose perception of Miho is crucially coloured by repetition (her similarity to the other "flirts" in the film), and a series of diegetic observers who form a chorus of onlookers, some of whom engage in prejudicial activity in reaction to Miho's actions.

The gaze of the camera becomes subjectivised, forcing a closer relationship between performer, audience, and apparatus. The more significant role played by peripheral, watching figures in the Tokyo segment in relation to earlier sections places an emphasis upon viewing and looking at performers in a public setting. The identification of the diegetic audience with point-of-view shots highlights the subjective use of the camera to manufacture an active gaze at the action, as opposed to the conventional passivity of most realist cinema. Furthermore, the text initiates a closer examination of the manner in which the "audiences" around the central character interpret subjective glances, where gendered difference between the projected, intended self and the decoded self becomes contingent upon socially and culturally constructed stereotypes projected onto the protagonist by other subjects.

The notion of flirting as public performance begins to emerge in the Berlin sequence but only as an objective, emotionless variety of performing. Dwight's encounters at the telephone booth with the prostitute and the fashion designer at the Postmuseum (particularly the lengthy opening shot of a statuesque, naked model) introduce the issue of the professional flirt. The professional flirt (Dwight is also a model) trades upon a mode of objective observation that exchanges a personal, sensual relationship (observe the almost mystical moment between Bill and the girl at the telephone booth) between viewer and viewed for a desexualised interaction based upon capital. When the prostitute suddenly grabs

Dwight's crotch following their curt, perfunctory exchange that follows his conversation with Werner, the motion is mechanical and without the interpersonal connections that Bill found so easily in the preceding section (emphasised through Hartley's insertion of slow-motion close-ups of contact between the hands of Bill and the unidentified woman on the phone). The detachment that Hartley achieved with the largely observational use of the camera during the Berlin section and the emphasis upon the autonomy of the single image reinforce the notion of flirting as a detached, public performance. Indeed, this scene is presented in a single three-minute take that follows a punctuating cut, thereby stressing the separation of this shot from the one that precedes it by consciously violating the 180-degree rule (Dwight exits frame right walking left to right, but enters the next shot from right moving right to left).

The mobile fluidity of camera movement matches that of the actors and the narrative. Dwight's movement within and without the objective gaze of the camera suggests the ambiguous relationship that exists between the actor and the apparatus, often committed and unified, but distant and detached at other times. (The concept of the flirt is a metaphor for the actor in this sense.) The professional flirting of Dwight, the model, and the prostitute also emphasises the fundamental difference in Hartley's presentation of gender and sexual difference. Hartley chooses to begin the scene at the Postmuseum with an excessively long shot[8] of a naked woman, a focus that either titillates or confuses the viewer because the woman has no narrative agency, she is simply on display for the cameras (both diegetically and nondiegetically). Likewise, the prostitute lacks agency in the narrative. However, the gaze of the camera and the looks of the majority of the characters in the scenes are not erotically charged. The excessive length of the shot of the woman is a digression from the narrative, thereby halting motivated movement, so the viewer tends to become apprehensive rather than aroused. Nevertheless, the naked woman is being objectified, although the presentational device does not do so for purposes of sexual gratification. Therefore, the female model is on display and the watching, professional audiences (the shoot is a performance of sorts, a display of body and affect

for the camera) emphasise the difference in gender: the objectification of the female—and sexuality—and the lack of eroticism in the display and the homosexual desire that is being played out in the narrative. This difference is focused at the audience's understanding of gender and sexuality in the scene, where the woman and men are the focus of the camera and narrative respectively. The consequent emphasis on gender difference draws similar conclusions to those of the watching labourers, who discuss flirting as "to exist in ambiguity". Modelling and prostitution imply a shifting subjectivity based in ambiguity, where different characters, gender stereotypes, and sexualities can be performed to satisfy, almost always objectifying, viewer/participant desires. In this manner, the focus of the Berlin sequence is on shifting notions of difference, where the performance is professional rather than unconsciously social or cultural.

In the Tokyo section, however, the concept of performance and perception is forced to the fore. The camera becomes subjectivised via the repetition of narrative units (where the unique, immediate significance of narration and dialogue has waned, leaving an abstract narrating position) and doubling (as the camera often adopts more than one gaze at a time), made active to replicate the gazes of several subjects in the film: the audience within the film that looks at Miho and those around her; individual characters in the film—Nagase, Miho, Yuki, Ozu, Hal, and the elderly bystanders, among others; the audience watching in the theatre or elsewhere. Whereas the performances of models and prostitutes in Berlin are portrayed as autonomous, objective images that are intended to be read by the film's spectator, the gaze of the camera in Tokyo is shared by the diegetic audience. The spectator is therefore confronted with the gaze of the camera but also that of the spectators within the text, such as Nagase and the dance students. Their presence *as* an audience is reinforced with the inclusion of point-of-view shots from Miho's perspective that show the audience watching. The corollary of this technique is the reflected nature of socially and culturally derived roles and performances that are only valid upon their decoding by audiences. Goffman asserted that a "status, a position, a social

place is not a material thing".[9] Although social roles are not necessarily material, the bodies in which those positions, statuses, and functions are located are certainly material. The signification of performances, and the manner in which those performances are read, is a consequence of the materiality of the body and its signifying matter—clothing, skin colour, body size, shape and weight, hair colour and/or style, gesture, rhythm, location, and so on. Each of these symbols is open to the interpretation of an audience, which can assume which role the performer is playing and derive the success or failure of that performance from their own social knowledge. *Flirt* is littered with moments in which observers assert their knowledge (or lack thereof) of the performer (the flirt) and their performances.

In chapter 1, I described Miho's kiss with Ozu in the corridor, in Goffman's terminology, as a performance disruption. Hartley chose to present the moment using point-of-view shots from the perspective of both Miho and the audience to develop the same kind of emphasis on looking that is analysed above, thereby subjectivising the gaze of the camera, making Miho the object of the camera's gaze while simultaneously denying her notional marginality as a woman and by emphasising her as both subject *and* object of the camera's gaze. The issue of sexual difference is crucial at this point. The differing degrees of subjectivisation granted to the presentational apparatus in each of the three *Flirt* segments forces the difference of female sexuality into the foreground. Of the three protagonists, only Miho is female, and it is in her sequence that Hartley makes the camera's look identify with that of a character. In New York and Berlin, the camera is largely distant and observational but operates in combination with editing techniques that subvert transparency, emphasising the text's artifice. Tellingly, both protagonists are male. The difference of repetition therefore becomes the difference of gender.

Giri-ninjō, the traditionally Japanese conflict of personal interest and social obligation, is at the heart of the social gaze, as are the manipulators in the dance scene. Miho's role in the drama is imposed upon her, but it is also the site of repression—her own, and that of society. Alan Ryan,

discussing *Antigone*, contends that Antigone, because of her divergent roles as sister and citizen,

> has no room for manoeuvre; it is in a sense bad luck that she is saddled with obligations she cannot fulfil except by breaching other obligations of equal stringency, but she cannot appeal to that as an *excuse*. It is this, the way the duties of the role press upon the private self, that we find so alien and alarming in Greek drama; and it is not surprising that some people have been tempted to deny that the Greeks even had a conception of the individual moral agent.[10]

Likewise, Miho is constrained by the obligations of her social role and her own desire. The social role in which she finds herself, however, is the product of social repression, where displays of sexuality are subordinated to the demands of social roles. The constructedness of such roles is implied by the role of the manipulators who force Miho and Yuki into their awkward embrace during the dance. Later, implicated by the consciously voyeuristic gaze of the camera, the manipulators, still in their ghostly make-up, become the voyeurs who glean information regarding the characters in the performance that they witness and make inferences regarding the appropriateness of the actions witnessed. In this sense, it is they who turn Miho into an object, something (a surface) to be read. Consequently, in comparison to Bill and Dwight, Miho has little narrative agency. Bill and Dwight are fully agents of their own narratives; they have a choice to make, but are free to do so. Miho, in contrast, is a victim of social repression, where she is forced to repress her own desire for Ozu in order to occupy her socially imposed role more comfortably *in the eyes of others*. Accordingly, things tend to happen *to* Miho—she does not motivate or initiate events—and her performance is divergent from that expected for the role in which she is cast by others. This is subsequently played out in front of the eyes of others, where the look of the camera is almost always linked to a voyeuristic viewing subject, emphasising Miho's otherness, her socially constructed difference as feminine, and the cultural difference of the Japanese society where

female repression is contingent upon the controlling gaze of others and the constraints of the *giri-ninjō* conflict.

The sense of female difference in the Tokyo sequence is increased by the inclusion of a trio of female stereotypes in the final version of the chorus scene. The chorus members in the first two segments are exclusively male. However, the interaction between the chorus and the protagonist is varied. In New York, the three men—one young, African American, smartly dressed, and ostensibly upper-middle class, another middle-aged and bearded wearing a business suit seated on the floor of the bathroom clutching his briefcase, and another grizzled, working-class man reading a newspaper on the toilet—transgress the stereotypes into which they initially seem to fit. The poetic, philosophical dialogue does not easily conform to the white- and blue- collar characters that Hartley presents. The role of the chorus in the Berlin sequence is also stereotype busting, but it fulfils a secondary function in relation to the self-conscious text. Rather than discuss the problem with Dwight, the three construction workers discuss Hartley and his project; with omnipotent foresight they discuss the plights of both Dwight and Bill. The self-conscious discourse on the artifice, constructedness, and experimental nature of the text is in keeping with Hartley's project—"to compare the changing dynamics of one situation in different milieux", as one of the German workers puts it—of examining difference through the use of repetition. However, when he approaches the Japanese sequence, Hartley reduced the function of the chorus to a purely representational one.

The Japanese chorus consists of three women of seemingly different generational and class backgrounds. But rather than twist the stereotypes, as he did with the New York and Berlin sequences, Hartley simultaneously confirmed and contorted the types through the use of aphoristic dialogue and performance. The three women are initially presented via their ages and styles of dress. Kazuko, the youngest of three, with long, straight hair, heavy make-up, and dressed in torn jeans and black leather jacket, manifests the common stereotype of the angry and disenfranchised "biker chick". Shoko, ostensibly a generation older than Kazuko, straddles the modern and traditional: she is dressed in

business-like fashion, but her gestures and posture are connotative of desperation and insecurity. Without the anger of Kazuko, she portrays a conflict between the traditional role of the woman, as wife and home-maker, and the modern expectations of career and material success. The final woman, Narumi, reflects the family-centric traditions of Japanese culture. Dressed traditionally in a kimono, and comfortably seated, she signifies a calm, philosophical outlook, either comfortable or resigned to her socially mandated role. The *mise-en-scène* is tellingly organised as Narumi is positioned between Kazuko on the left and Shoko on the right, suggesting that Narumi occupies the middle ground between the contemporary disaffection of Kazuko and the lonely desperation of Shoko. Additionally, to complicate the stereotyping, Shoko is situated in the position of power and stands, but the others are seated. However, rather than confirm a form of economic power from material success granted by her career, Yuri Aso's performance suggests just the oppo-site, with its tense posture and nervous gestures (arms folded, knuckles to mouth). So, again, it might be said that that body's performance of its intended role fails to correspond with its image and the expectations of the audience, once more addressing the problematic nature of the arbitrary stereotypes.

The simultaneous stereotyping and questioning of stereotyping in the figures of the three women in the Japanese sequence alone suggests that feminine difference is a key theme in *Flirt*, comparing the masculine positions of the first two sections to the female one in the last. Even though the rigid roles in which Hartley positioned the three women are a product of the social gaze rather than the active point of view aligned with any character, the mere fact that they are women stresses their lack of symbolic potency, but again this is something imposed by the social gaze that already sees Japanese women as deprived of agency. The male chorus members in New York and Berlin have a partial agency that the women lack. The predominantly lower-middle-class stereotypes that Hartley distorts through the eloquent use of language in the first two sequences appear untransformed in the third segment. By untransformed, I mean that no satiric or deconstructive role is granted to the women in

the Tokyo segment. The women simply exist as speculative objects, their visages more important than the words they speak. The three women speak in aphoristic, platitudinous statements that confirm, rather than deny (as with the men), the visual stereotypes to which they conform:

> KAZUKO: Fuck him! He's manipulating you! Who the hell does he think he is! A gift from God! Tell him to get lost! His leaving Japan is the best thing that ever happened to you! The fuck!
>
> SHOKO: Don't let him go! He'll get away! You were wrong to want more time! A girl has got to make a choice! You won't be young forever! Western men are more open-minded! They like Asian women!
>
> NARUMI: Nobody's perfect. We're all incomplete. We have to understand that the people we love have had lives before meeting us. They have histories. And their time with us is a separate history. No, nobody's perfect. We're all banged up and broken. It's embarrassing. Pathetic. Human.

With the repetitious structure of the film, the content of the dialogue, its linguistic signification, is effaced in favour of the all-conquering signified "repetition". This, as Deleuze argued, allows difference to come to the fore. The predominant difference in the scene is performance, as the aural tones and inflexions become privileged above semantic meaning as much has been heard before from the men in the bathroom in New York. In the previous sequences, language is critical and is granted a function over and above narrative agency. None of the men in New York or Berlin have any significant narrative function to fulfil, but they are critical in articulating meanings in the text, whether thematic in New York, developing a discourse on love and faith and their rituals, or distanciating in Berlin by discussing the artifice of the text. The chorus fulfils neither role in Tokyo; the women are trapped in rigid social roles, through their appearance, physicality, and vocal inflexions. Indeed, the rigidity of the roles into which these women are forced is reinforced by the prison in which Hartley locates them. The prison suggests they are confined, forced into

a social position that they are unable or unwilling to adapt to, and they are thus doomed to suffer at society's hand. The negations of the repetitive stylistic mechanism see feminine difference become the central conceit of the scene, as it is throughout the Tokyo segment. Additionally, the shorthand, comic way that Hartley portrayed the three women emphasises cultural forms of difference, because they can also be identified as typically Japanese stereotypes, especially the Orientalised Narumi and the salarywoman Shoko, trapped between modern and traditional roles of women in Japanese society (and by the Western images of Japanese women). The systems of performance that are developed in the Tokyo section also emphasise cultural difference, but the use of stereotyping in this manner draws attention to the cultural specificity of certain social roles performed or projected on to characters in *Flirt*.

HENRY FOOL: GESTURE AS CHARACTERISATION

In many respects, *Henry Fool* is a transitional film in Hartley's canon. Where *Flirt* brings the major concern with repetition to a close, *Henry Fool* extends Hartley's interest in the production and circulation of artistic work. *Flirt* "is an essay about making my work",[11] Hartley noted, and in *Henry Fool*, "Henry and Simon are both aspects of me".[12] Continuing this meditation on artistic production, Hartley focuses on Simon Grim's passage from withdrawn garbage man to renowned and infamous Nobel Prize winner to explore the artistic mindset. However, in exploring the cultural reception of art and the mediation of cultural phenomena, *Henry Fool* foreshadows the concerns with the media in *No Such Thing*. Although the earlier film is not metafictional like the later work, Hartley's concerns are beginning to shift from the personal to the cultural, and there is a move away from works about social relationships to stories of cultural and political mediation that extend from *No Such Thing* to *Fay Grim*.

Henry Fool follows the rite of passage of Simon, a withdrawn and abused garbage man living in Long Island. Ignored or assaulted by those around him, and a product of an emotionally dysfunctional home, Simon

searches for illumination in his life. One day, Simon meets Henry Fool, a scoundrel who claims to be working on the greatest literary work in history. Simon is inspired by Henry, who, it turns out, is astoundingly untalented and a convicted paedophile. Simon's life, however, is transformed by his interaction with Henry. He writes a poem, which his sister, Fay, posts on the Internet. The poem becomes a media phenomenon, and Simon an instant celebrity. His work is published, to more acclaim and scandal, but Henry's work is rejected. In a final indignity, Henry gets Fay pregnant, and he is forced into a shotgun marriage. In the film's epilogue, Simon has become a Nobel Prize–winning recluse and Henry is working as a garbageman. After accidently murdering a man, Henry is outlawed after it emerges that the man's abused stepdaughter had offered oral sex to Henry in return for the murder. Simon returns to help Henry escape to his place in Sweden, and the film ends with Henry running to freedom.

The focus on performance extends into the film. Unlike other films, however, there is not a rigorous concern with abstracted modes of performing. Instead, the performances in *Henry Fool* are stylised and systematised as a process of developing characterisation on a minimal physical level. Gesture and body movement are particularly consciously and systematically performed in order to externalise and partially abstract emotion and disparity. Disparity is a regular occurrence in Hartley's films, where characters regularly succumb to self-delusion, a characteristic that often leads to slippages in performative coherence, where dramaturgical discipline is not maintained. Brecht's conception of alienated acting plays a key role in gestural performances in Hartley's work, where the conscious use of gestures and movements highlights the performance of the actor's bodies and the social roles played by each of the main characters. This is especially true of *Henry Fool*, where the performance and systematisation of gesture is particularly evident. Traditionally, gesture and body movement on film is minimised. Overt displays of gesture are distracting, affecting the viewer's reaction to space as the eye tends to be drawn toward the movement rather than the speaker.[13] Hartley's emphasis on performance tends to be even more

minimalist, but the focus on gesture is made a central facet of his performers' work.

Gesture plays a key role in *Henry Fool*, and Hartley chose to emphasise this almost from the beginning of the film. Simon is standing outside his house when he seems to sense Henry's imminent arrival. Ominous bass notes begin to play on the soundtrack, and there is a crack of thunder. Then, like the old Western stereotyping of Native Americans listening for buffalo or a train, Simon reaches down to touch the ground with his hand. Hartley abstracts the gesture by choosing to shoot the hand touching the ground in close-up. The expressivity of the gesture is linked to the expressivity of the close-up; the gesture *is* the shot. Simon, having just been chased by a couple he watched having sex, and then drinking spoiled milk at home, is grasping for something intangible, something that he cannot express in words. Although he has been in almost every shot thus far, Simon has been unable to express himself through language, a lack of verbal expressivity that is contrasted with the experience of this simple gesture and the importance of touch. There are several moments like this in the film, of the affective gesture, where Hartley shoots touch in extreme close-up, including the first moment in which Simon puts pencil to paper to write his epic poem.

Adrienne L. McLean, influenced by Virginia Wright Wexman's seminal text on the subtlety of Humphrey Bogart's gestural performances,[14] has attempted to show how the body plays an important role in understanding the actor's role on-screen. The absence of the physical materiality of the body that McLean correctly identifies in critical responses to performance emphasises a problematic shortfall in film theory.[15] The materiality of the body plays a crucial role in signifying internal character traits by external means, a key point of abstraction that is central to all forms of cinematic performance (although it is a point of abstraction that is usually effaced by the conventional realist cinema, making it appear natural). The role played by the material body in this fashion is immediately apparent in *Henry Fool*. James Urbaniak (as Simon) and Thomas Jay Ryan (as Henry) are clearly different body types: Urbaniak tall and gangly, Ryan broad and slightly rotund. The physical characteristics

of the two actors immediately suggest their differences as individuals, although this shorthand (almost clichéd) effect of casting could be true of any film, where the appearance of the actor is an immediate signifier of character type. However, this simplification is subject to the contortions of abstraction, repetition, and the systematisation of social and stylistic contextualisation that places a much greater emphasis on physical modes of performing than other films.

James Urbaniak's self-conscious body performance as Simon Grim in the early scenes in *Henry Fool* can be explored through analysis of the *effort* and *shape* of his body. *Effort-shape* analysis is a particular form of methodology used to explore the nonverbal communication of the body in motion. As McLean succinctly explains, "rather than attempting to determine the universal meaning of any gesture …, effort-shape analysis pays attention to fluctuations of generic and idiosyncratic movements on a spatial and temporal continuum".[16] The analysis of the body's effort and shaping is concerned much less with explicating a universal body "language" than it is with detailing how the body of an individual relates to the surrounding space over time, regardless of behavioural changes. The way that the shaping of the body is regulated by the effort involved can represent the physiological relationship between the individual and surroundings. Urbaniak's performance demands a particular analysis of *effort-shape affinity*. Body movements are most natural when the efforts used to shape (or reshape) different parts of the body are in tune with each other. The effort required to shape the body is dependent on the plane of movement in which the body is attempting to move. For instance, when the body moves on a horizontal plane, from spread to enclosed, effort increases, since the body is more at ease when shoulders are open and relaxed. As the body tries to enclose itself, the effort required increases as the body encounters resistance from muscular and skeletal limitations. Similarly, vertical extension requires less effort than the force required to press the weight of the body toward the ground. When the effort and shape of the body do not show an affinity in this fashion, intended messages could be garbled, as the receiving subject is not accustomed to body displays

that appear less natural. However, nonaffinity of effort and shape can also convey a message that is directly linked to the inappropriateness of the combination of effort and shape.[17]

So, does the effort and shaping of Simon Grim's body movement display affinity, or does Urbaniak's performance convey characterisation by disparity? The movement of Grim's body, embodied by Urbaniak's performance of his own body (his apparatus) is conscious movement disguised as unconscious—rehearsal makes conscious gestures and movements appear to be unconscious, motivated by characters' spontaneous reactions and ingrained behavioural qualities. Simon's ingrained behavioural qualities are portrayed in Urbaniak's use of shaping and effort in creating a body-persona for the character he is portraying. Simon's body-persona is created just as the psychological persona of a character would be delineated in scripting, rehearsal, and performance. The result is a performance that consciously uses the body to deliver messages to the audience regarding the character's personality. Consequently, early in *Henry Fool*, Simon's movements are all distinguished by a high degree of effort put into each movement, even standing still. The constrictive effort that Urbaniak uses in moving means that his movements are slow, deliberate, and infrequent, connoting Simon's personality. When Henry first meets Simon, he uses his name, which surprises Simon, slightly in awe of Henry's strange mystical qualities. Henry's first appearance in the film is almost mystical, as if Simon has summoned him from his repressed psyche—if the film were not set in a realistic idiom,[18] Henry could perhaps be an anthropomorphised figment of Simon's imagination. This is another point at which Hartley puts realism and abstraction close together, utilising a combination of abstract gesture and realist representation to deviate from the naturalisation of performance in the milieu of the film. Simon asks how Henry knew his name. Henry moves around Simon silently and points to the name badge on his chest. Immediately defensive, Simon blurts, "I am not retarded". Henry retorts, "well ... I'll take your word for that". In terms of his body movement, though, Simon *is* retarded by the high degree of effort taken to restrict the motion of the body. This small joke reminds the viewer of the physicality of Simon,

while any possible mental retardation is rendered debatable by his role as *savant* in the narrative.

If Simon is characterised as slow, it is through his movements (in conjunction with protracted silences) that he is characterised as such. The lack of affinity between his body shaping and the high amount of effort in creating movement (or restricting it) can show how those external signifiers can contradict (or impede understanding of) what is internal to a character. The effort involved in keeping Simon's body (by Urbaniak) bolt upright is high, therefore the body movement is not an affinity movement, since body motions on a vertical plane generally decrease as the body becomes more upright in a natural shaping. The rigid, gangly frame of Simon's body is kept tightly upright. The effort appears to be applied to keep the body in a restricted position, where any motion that conveys any sort of relaxation is kept to an absolute minimum (which, as will be explained below, is in total contrast to Henry's more active, unconstrained body movements). This is why, when Simon performs a gesture that is genuinely expressive, such as touching the ground as Henry approaches, or even writing (the source of Simon's liberation), Hartley's close-ups provide extra emphasis, especially of gestures that involve touch, which are abstracted by editing and camera distance.[19]

The nonaffinity of effort-shape in this simple example of shaping in Simon's body conveys a message that supplements the vocal performance of Urbaniak. Simon's internal state is not expressed by external signs because the effort signifies a more general repression that the narrative seeks to overcome, an aspect that is augmented by the way he uses his voice. In the early part of the film, Simon's dialogue is marked by a restraint of language. Simon speaks in a series of short sentences, mostly questions or short statements ("I am not retarded" or "It hurts to breathe") that are punctuated by mid-sentence pauses to grasp for the correct words or simply trailing off to be spoken over by another character (usually Henry). The slowness and lack of more expansive movement construct an affinity with the dialogue and speech of Simon, presenting him as a character whose repression is both mental and physical. This affinity, which is created by the lack of effort-shape affinity in Simon's

movements, shows how movement can gain meaning within a narrative system. Because Hartley presented Simon to the viewer initially with no narrative context, the richness of the systematisation of movement in Urbaniak's performance (a system that slots into a wider structure of performed movement in the film) only becomes apparent when Simon is witnessed within a narrative context, because performed movement signifies in relation to story and the positioning and movement of other actors.

The potential meanings of gestures and movements are controlled by a host of variables that dictate how individual bodies are read: variables such as narrative logic, repetition, contrast, spatial relationships, and cinematic style. In nonverbal communication, individual motions do not have specific lexical meanings like the arbitrary sounds that convey fixed meanings in a language. There is no gestural equivalent of the word, a unit of language that has a fixed meaning. The relationship between bodily signifier and signified is not constant or arbitrarily determined. Birdwhistell made this assertion in *Kinesics and Context*, his seminal study of behavioural and psychological body "language". He argued that gestures do not have individual, specific lexical meanings.[20] Gesture therefore is not a language as such; body movement signifies within a communicational system that is interactional and contextual. No fixed lexicon exists to translate individual movements into single or complex meanings; there is no possible "dictionary" of gestures. In a system of body motion, not all adjustments that occur in the musculature and skeletal structure produce meaning because many movements have a functional capacity that excludes any meaning—walking has meaning only in relation to where the individual is walking toward or away from (in a dramatic narrative, walking could signal a change in narrative direction).[21]

Significantly, however, Birdwhistell maintained that kinesics is a "*social* system".[22] However, the object of study in this discussion is an aesthetic text, which is subject to alternative forms of systematisation, where all elements have been deliberately selected to have significance within a narrative system. Nevertheless, his model of contextual analysis

is relevant to the study of Hartley's films, where the social system is under critical scrutiny. Social relationships are the thematic core of Hartley's work. Therefore, social, contextual, and aesthetic systems are key determinants in the process of turning body movements into meaning.

The ending of *Henry Fool* highlights this, expanding upon the brief example given above regarding walking. Now a Nobel Prize–winning poet and reclusive celebrity, Simon returns home to help Henry—now father, husband, and garbageman–escape from the police. Henry has killed Warren, an abusive conservative, in self-defence, but he is in hiding after Warren's stepdaughter had offered Henry, a convicted sex offender, oral sex in return for murdering her stepfather to save her and her mother from further abuse. With a forged passport, Simon and friends from their community help Henry to the airport where he will flee to Sweden and freedom. Henry hesitates on the airport tarmac, leaving it unclear as to whether he stays to face his fate or run. In the film's final shot, Henry is seen running.

The movement in the final shot of the film is distinguished by its ambiguity. Principally, this is provided both by the presence and absence of different contexts that are qualitatively at odds (figure 18). In the context of the narrative, the frantic, imprecise motion of Henry's body—knees raised high, arms pumping hard—suggests that his body movement is carrying him away from the terminal towards the plane and away from his problems. Alternatively, however, Henry could be running toward the terminal with a newfound determination to clear his name (or a self-lessness to allow Simon his success). Both interpretations are possible; the film has presented Henry as a difficult, often contradictory character, both scoundrel and gentleman (although Henry himself tells the audience of his honesty and integrity). The double interpretation of Henry's movement is only possible because one important context is missing, and this is due to the way that Hartley has filmed Henry running. Henry is seen running towards the camera as it pulls back, framing him centrally. Filming from a low angle, however, has stripped the shot of a spatial context. Gestures and movements are marked by the way they extend into, and relate to, space around the body. The space that Hartley

FIGURE **18.** The absence of spatial context in the final shot of *Henry Fool* provides an interpretative problem, given that performance signs are bound by context for meaning.

creates in this final shot is without a specific context. Where is Henry in relation to the terminal? Where is the plane? In which direction is he running?[23] As there is no master shot demonstrating how Henry's movement relates to the space around him, so there is no spatial context, and the audience cannot determine whether Henry is running toward or away from the plane.

Hartley himself said that the original intention was to have Henry running toward the plane, but the way that he shot the scene meant that this was not as immediately apparent as he first thought:

> I shot the scene with Henry running toward the plane, and then, in the editing, I discovered it was perfectly possible to keep it ambiguous and that seemed much more interesting to me.... There was a cutaway of an air stewardess waving Henry on. I said, "If we got rid of that shot, it'll be completely up in the air whether he's running back toward Simon or toward the plane." Most people

> I've spoken to coming out of the movie don't know. They can't
> be certain one way or the other where he's going—and that ques-
> tion mark is good ... I think it's much more poetically deep not to
> close it—a much more beautiful gesture.[24]

Nothing in the shot, or the final scene, explains which way Henry is
running. The result fully involves the viewer in determining the final
reckoning of the narrative. Narrative resolution can be provided by
a viewer's reaction to prior contexts, or by whether the audience can
identify with this contradictory character and determine for themselves
which way Henry is running.

The lack of narrative spatial context for this movement focuses atten-
tion on the actual motion of Thomas Jay Ryan's body as he created the
shape and effort of Henry's action. In this running motion, the body is
especially active, creating active "kines" in all areas of Henry's body—
both hands, legs, trunk, head. The effort involved in producing the action
of running stresses that, although the destination of Henry's movement
might be ambiguous, Henry is a desperate individual. To what end his
desperation might be directed is not known, but his movement portrays
the meaning "desperation". The audience can only decode this message
from the context of Henry's dilemma and the possible outcomes. Con-
text therefore provides movement with meaning, even if that context
does not necessarily provide meaning in terms of narrative resolution or
advancement.

Movement becomes systematised as different characters (and actors)
move in different ways, developing contrasts and likenesses between
characters. Gestures and motions are also schematised in a temporal
fashion as movement alters as characters change; this is especially the
case in *Henry Fool*, which takes place over a more significant period
of time than Hartley's other films, a matter of years rather than days
or weeks, and accordingly the characters experience greater upheavals
and change in their lives. Hartley's earlier films deal more specifically
with a character or set of characters that are attempting to change or
resolve a single problem or facet of their lives, but *Henry Fool* follows

its characters through career changes, death, marriage, childbirth, and cultural upheavals across a greater period of time. The duration of the narrative provides a temporal context that is efficacious[25] for the characters; although the text might include disparities between changes in the body and a character's dialogue (characters might profess change, but act the same, or act differently with no verbal modification, reflecting the presentation of the unconscious body).

The systematisation of movement between the performances of James Urbaniak and Thomas Jay Ryan is fairly complex and changes significantly as the narrative progresses. Contextually, the progression of the narrative allows certain uses of gesture, posture, and body motion to be read as changeable, even interchangeable, since certain ways of moving become transferred from one character to another. Kinesic rhythms, effort-shape affinities, spatial relationships, and the repetitions so central to Hartley's work are all used to show the systematisation of movement between characters; not only Simon and Henry, but also Fay, Mary, Warren, Father Hawkes, and other characters even less significant are involved in the system of movement that defines characterisation and narrative progression.

The initial relationship between Simon and Henry is defined by a fairly simple contrast that articulates the differences in character as an antinomy between active body positions and ones that are inactive. Primarily, this opposition is similar to that posed by Foster Hirsch as that between a "mannequin" and a "live wire". These, Hirsch contended, are "the two dominant types of body language in Hollywood films".[26] Hirsch's "mannequin" is a more studied, conscious body type offered for the external spectacle, whereas the "live wire" has a less calculated, spontaneous body, whose gestures appear to be immediate rather than overrehearsed. The constricted body movements of Simon present an outward body display that is of the "mannequin" variety. The lack of effort-shape affinity in the early moments of the film that were examined above is an external performance that portrays Simon's internal state through a very conscious set of mannerisms that emphasise a lack in his personality. Behaviourally, Simon is as constrained as his body

display; he uses few gestures and generally remains as bolt upright as possible, almost seeming as if he is straining his neck forward.

In a very obvious contrast (Hartley himself has testified to the greater emotional immediacy of *Henry Fool* than that of his earlier films, which are more alienated and oblique), Henry is portrayed as Simon's polar opposite. Henry is the "live wire", his body an active site of numerous gestures and movements, all performed without the strained effort (or thought) that Simon puts into each and every movement. During their first scene together, the ease of Henry's motion is of an entirely different order to that of Simon's analysed above. Whereas Simon's effort is singularly focused on constricting the body— arms tucked into the body and the back, arms, and shoulders upright and still—Henry's energy is much less focused. Henry is most active in two areas: head and hands. His head tends to dart around, seemingly unable to keep his attention on any one point of focus. This contradicts the self-important confidence of his swaggering manner of speech.

The use of hand gestures by Henry is of particular interest. Henry uses a large number of hand gestures, termed "illustrators". These are "acts that accompany the verbal stream and are designed to do such things as pictorialize what is being said, aid in phrasing, augment volume, and gain attention".[27] Additionally, illustrators "may complement, contradict, accentuate, or repeat the verbal message and are usually done deliberately. Unlike emblems, they typically do not have a direct verbal equivalent and do not occur in the absence of conversation".[28] Henry uses many of these types of movements, especially to add emphasis and gain attention. In this first scene in the Grim basement, Henry displays two excellent examples of illustrator gestures with his hands. In the first, Henry is describing his *Confession* to Simon:

> It's a philosophy; a poetics. A politics, if you will. A literature of protest; a novel of ideas; a pornographic magazine of truly comic-book proportions. It is, in the end, whatever the hell I want it to be. And when I'm through with it, it's gonna blow a hole *this wide* straight through the world's own idea of itself!

When Henry says "this wide" he brings his hands up in front of his face, palms facing forward, and quickly moves them together and then apart beyond the edges of the frame. The gesture visually represents the size of chasm Henry believes his *Confession* will leave on the world. The quick rhythm of the gesture also demonstrates the violent impact Henry believes his work will hold. Hartley used this gesture not only to demonstrate how Henry thinks his tome will mark the world, but also to illustrate the size and force of Henry's personality. The kines (one in each arm) are expansive and actively delineate the character of Henry, foreshadowing the overbearing effect that Henry will have on Simon. (Hartley augmented this stylistically by shooting Henry from below, matching Simon's point of view and accompanying Henry's dialogue with the sound of bottles being smashed against the house.) The second example of an illustrator in this scene follows soon after; Henry, without motivation from Simon, decides to tell how he once escaped a Latin American mob by threatening to gouge out one of their eyes. As he tells the story he pauses at the vital moment, the moment the mob paused after he promised to inflict what would be his final, determined act of violence. He describes the mob's reaction, "silence", and holds up his hands to accompany the pause; his palms face forward with fingers spread wide (figure 19). The gesture is pause-marked and held for the duration of the pause in dialogue. This illustrative gesture dictates the rhythm of Henry's story, and the stillness of his hands during the pause demonstrates the anticipation of this part of the story. Henry uses many rhythmic and visual illustrators throughout the film, supplementing his role in the narrative as a type of preacher (think of the importance placed on the hands of the preacher in Charles Laughton's *The Night of the Hunter*, 1955), a larger than life character whose presence changes the lives of those around him; yet the rhetorical bluster may also mask a suppressed self. Another character for whom illustrators are important is Fay, who uses a significant number of rhythmic gestures to suggest her hyperkinetic personality. Again the active body of Fay contrasts with the inactive body of Simon. She is sexual (more because of boredom than desire) and impulsive, as in the moment when she throws a pan of boiling water over Simon (the moment is doubly important for

FIGURE **19.** Unfocussed energy and a frequent use of "illustrator" gestures mark Henry's (Thomas Jay Ryan) body persona, an energy that will noticeably shift as the film progresses.

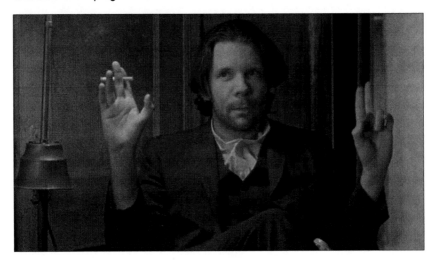

Simon because he has just begun to assert his personality on others, only to be maliciously attacked by Fay).

Active gestures such as these are utilised early in the film to emphasise general character traits, but, as the film progresses, Hartley systematised the active/inactive antinomy to colour more subtle changes in character, especially in Simon, as his confidence begins to grow and he becomes less the "mannequin" and more the "live wire". First, Simon's body begins to match some of Henry's movements in terms of shaping and positioning. Henry gives Simon a lecture on the various uses of "there", "their", and "they're" and advises him to quit his job to devote his life to poetry. He hovers over Simon, who sits in an armchair; "You can't put a fence around a man's soul", Henry proclaims as he looks out the window. Immediately, he breaks off his oratory to Simon and leaves suddenly. Significantly, Simon then stands up from the armchair and takes Henry's position at the window, mirroring the positioning that

Henry has just vacated. In another important moment, Henry is again lecturing Simon, this time on "the importance of cadence in the readability of form". Fay and her mother enter, scolding Henry for his sexual encounter with Mary. Henry flees, storming out the door and slamming it behind him; Simon then repeats the action. Repetitions and likenesses such as these suggest a partial transference of character traits from Henry onto Simon. Simon's relationship with Henry provides liberation from some of the forces that have retarded his social and emotional development, leaving him something of a cipher unable to express an opinion or an emotion. Indeed, the only character Simon initially seems most able to identify with is his mother, whose repression is caused by illness and the debilitating effects of medication. The inactive principle also applies to her movements, but without the strain that Simon's body seems to put into restricting movement. Therefore, Mary's effort-shaping is in affinity; little movement should be produced by little effort.

However, an alternative reading of this system of transference sees Simon's adoption of Henry's body type as a doubling of performance. In one sense, James Urbaniak is performing Simon, but in another Simon is performing Henry. Henry's performance of gestures provides a set of possible gestures that is appropriable by Simon in his transformation from passive to active. Simon's performance of Henry is a copy, a quotation from Henry's established pattern of movement. This suggests that Henry's performance is already abstract as a set of quotable gestures that preexist his performance of them. Brecht's theories are applicable here for demonstrating the social basis of Henry's gestures that make them less than natural. Brecht's concept of quotation sees the performer remove him- or herself from the need to represent the moment of performance as unrehearsed and spontaneous but still present the performance as a copy:

> Once the idea of total transformation is abandoned the actor speaks his part not as if he were improvising it himself but like a quotation. At the same time he obviously has to render all the quotation's overtones, the remark's full human and concrete shape; similarly the gesture he makes must have the full substance of a human gesture even though it now represents a copy.[29]

Simon is copying the gestural pattern of Henry's body movements and thus becomes a double himself. He renders the gestures as though they were real and spontaneous, but they are not specific to him. Simon adopts some of Henry's traits and begins to use illustrators in conversation.[30] Simon is becoming a repetition of Henry and actively looking to perform his own body as Henry uses his own spontaneously. The movements of Henry, however, are not natural to Simon's body; the audience have seen Simon perform without the fluidity of Henry's motions and can see the new pattern of movement as contrived when performed by Simon. However, if the gestures of Simon can now be seen as contrived, perhaps the bombastic manner of Henry can also be seen as contrived as he tries to fit into the role of "important artist" to which Simon would also aspire.

Making Henry's gestures quotable for Simon reveals the Brechtian gest in the performances of both Henry and Simon. Both aspire to a particular role in society and culture, as the artist—although Simon does this in a roundabout way by aspiring first to be Henry, and then an artist. According to Walter Benjamin, "making gestures quotable" is one of the key goals of Brecht's work. "An actor must be able to space his gestures the way a typesetter produces spaced type".[31] This can be achieved by the actor quoting her own gestures on stage or those from the performances of other actors, just as Simon quotes from Henry. The copying/doubling of Henry by Simon reveals the gest, the attitude of Simon towards Henry, and towards the social position that Henry holds in his eyes. "The realm of attitudes adopted by the characters towards one another", Brecht contended, "is what we call the realm of gest".[32] Physical gestures can reveal the gest in how the characters relate to one another. Simon's quotation of Henry's body movement portrays the relationship between the two characters physically, revealing Simon's adulation of Henry in his adoption of some of his gestures.

Movement also reveals power in relationships, such as that between Henry and Simon, Simon and his mother, and Henry and Fay, where affinities and changes in respective movements demonstrate changes in characters. Narrative contexts and dialogue allow certain movements

and gestures to gain significance. Changes in Simon's body shaping, effort, and uses of gesture go hand in hand with the upheavals in his life: his first meeting with Henry; the production and circulation of his poem; and finally his notorious celebrity. With his growing assurance as an individual, Simon can take greater control of his life by taking steps to publish his work and by becoming more assertive with those around him. In the library, he tries to tell Henry about meeting Mr. Buñuel, Henry's parole officer. Simon actually urges Henry to talk to Mr. Buñuel, but Henry badgers him into saying nothing more. Later, Simon tells Fay that she must get a job so that he can quit his to devote time to his new vocation. She resists, stating that someone must remain home to look after their mother, and she calls Simon retarded. Naturally, he is offended and tells her that he is not retarded but can see "with [his] own eyes", an important statement of independence. Again Fay asserts that their mother cannot be left alone. "Who's been keeping an eye on her while you've been out getting fucked by every OTB winner in town?" he retorts. Fay is shocked by her brother's insolence and throws a pan of boiling water over his back as he tries to run from her. Moments of assertion such as these are, at this stage in the narrative, always accompanied by violent retaliation, either physical or verbal. The very fact of their emergence in Simon's personality provides a basis for the changes in Simon's body-persona to come to the fore. Context allows movements and gestures to become expressive, participating in a system that is interactive; movement supplements dialogue and action, while narrative context allows the signifying potential of body movement to be fulfilled.

Whereas Simon gains assurance and assertiveness from his relationship with Henry, the opposite is true of Henry, where his dwindling aspirations are also matched by changes in body usage and positioning. Personality wise, Henry does not change; he remains bombastic, overbearing, and deluded. However, illustrator gestures drop out of Henry's bodily vocabulary. The disappearance of illustrative gestures from Henry's action is sudden, but the growing assurance of Simon's personality and body movements is gradual. Hartley offers two very significant moments that show the likeness between Henry's now altered body motions and

Simon's earlier in the film. The first is at his shotgun wedding with the pregnant Fay. Literally forced into the church, Henry is not a willing bridegroom; his wedding suit is clearly too small for him, constricting his movements (figure 20). Similarly, the uniform that Henry wears as a garbageman, after taking on Simon's old job to support his new family, restricts the freedom and ease of movement that distinguished his actions earlier in the film. Clearly, a fence *has* been put around Henry's soul. Societal and familial pressures have forced him to reject his previous career path, although Henry has lost none of his former bull-headed pretensions. His body movements are now as constricted as he feels his life has become, echoing his perceived relationship with a society that he feels oppresses the creative soul of the artist.

Highly choreographed and codified gestures have been a staple of Hartley's work, often echoing another strong influence from Godard's work, particularly that of *Une Femme est une Femme* (1961), his tribute to the Hollywood musical. Key scenes in Hartley's work are much

FIGURE 20. The costuming of Henry in the wedding scene constrains his movement, altering the energy and use of gesture in Ryan's performance.

more consciously choreographed than others, akin to domestic dances, in which the abstraction of performance is higher, and not necessarily justified by the dominant realist narrative form (of Hartley's films, *Henry Fool* and *Theory of Achievement* embody this aspect most fully). Most of Hartley's films, including *Amateur, Ambition, Theory of Achievement, Simple Men, Surviving Desire*, and *Flirt*, include obviously choreographed scenes with no dialogue. In *Henry Fool*, however, movement is more abstract, more obviously performed, in scenes without dialogue. James Naremore argued that this heavily gestural style of performance was ingrained in acting in the nineteenth century and was transferred to silent film as the dominant mode of performance. This style, Naremore contended, was "supple, demonstrative, [and] highly codified",[33] attesting to what the Parisian elocutionist François Delsarte called "the semiotic function of gesture".[34] The highly codified nature of this style of performance led Delsarte to attempt a lexicon of performance signs, where gestures were alleged to have specific meanings.[35] Although the Delsartean methods "ignore the contextual determinants of meaning",[36] his ideas have become ingrained in thinking about gesture in performance.

Some scenes in *Henry Fool* are especially heavily codified, although their performances draw more on context-specific interpretations rather than drawing on a dictionary of gestures. In one such instance, Henry comes into the World of Donuts with Simon's poem and hands it to Gnoc, the mute girl who works there. She takes the book from him, holding it in an almost sensual way. Turning away from Henry, she opens the book and reads. Gnoc crosses to another part of the counter with the book and tears a piece of sticky tape off a roll. She turns back to Henry and points to a piece of text in the book. Henry then takes the book and tape from her, tears out the page, and sticks it to the counter. This is the first way in which the response to Simon's poem is raised from the personal to the public. This scene has no dialogue but is heavily codified following Gnoc's earlier experience of the poem (after reading a brief passage, she began to sing). Her reaction to the book, her almost sacred handling of the object, is a response to her earlier experience of

the poem. The book has therefore been coded as a powerful item, but only for Gnoc, whose reaction is the first the audience sees before the poem's wider circulation to a community, then a whole culture. Gnoc's first gesture toward the book when Henry shows it to her is to reach out and caress it, silently representing her relationship to the item. Touching the book demonstrates Gnoc's powerful relationship with it, but pointing a finger is a more abstract gesture that signifies a direction. In this case, the point both emphasises the text of the poem that Gnoc wants to display and abstractly signifies a direction for the narrative: this is the sign that will ignite a new portion of the narrative as Hartley moves beyond the personal elements of the story into the broader cultural and political implications that Simon's poem, or any work of art, can have for a culture, especially one so subject to media sensationalisation, themes to which Hartley will return in *No Such Thing*.

Finally, Henry and Fay's eventual sexual encounter, crosscut with Simon's discovery of his mother's body (she commits suicide after reading Simon's poem), is staged without dialogue, like a dance. Henry discovers Fay reading his *Confession* and is enraged. She attempts to leave, but Henry blocks the doorway. He circles her, then roughly grabs her throat and thrusts her back against the wall. They kiss before engaging in aggressive foreplay. The tone of the dance is both sexual and violent. However, this is not an isolated incident in Hartley's oeuvre. This scene in *Henry Fool* is mirrored in *Theory of Achievement*, where a couple argue. The scene has a similar violent tone, but neither character involved has the questionable criminal background of Henry Fool, so the scene therefore has less menace (there is a brief suggestion that Henry might rape Fay). In the shorter film, two characters (played by Bill Sage and Elina Löwensohn) are engaged in an argument, and perform a short *pas de deux*: Bill is fretting in the kitchen after an earlier philosophical disagreement. He takes a book and slams it down on the counter, then loosens his tie, and takes a sip of water. Coming into the other room, he shouts at Elina: "Meaning is differential!" Elina looks at Bill. She goes past him into the corridor, slamming the dividing door behind her. Bill follows looking for her. They both go back into the front room, where

they face each other. Bill puts his right hand on Elina's cheek. She slaps it away. Bill puts his left hand on Elina's cheek. Again, she slaps it away. She steps to one side to go past him. He blocks her way. She steps around him to the other side. He grabs her arm and tries to pull her toward him. She slaps him. He stands, stunned, as she locks herself in the bathroom. The specific referent for both of these scenes is *Une Femme est une Femme*. Godard approaches the scenes of domestic battle (although without the allusions to violence that Hartley makes in his films) with a similarly choreographed approach to the movement of the body. The scenes with Anna Karina, Jean-Claude Brialy, and Jean-Paul Belmondo are so consciously choreographed that their rhythm and movement are like dance. But whereas Godard's domestic dance sequences take place in a diegetic world that refers to the colour and tone of the Hollywood musical, Hartley's do not. Therefore, the device in Hartley's work is even more alienating than in Godard's film, taking place as it does in a more realistic milieu without the other stylistic devices that Godard uses to alienate (direct address, music, parody). Hartley brings some of the performative aspects of movement to the fore; role playing and rhythm for example. In *Henry Fool*, Hartley uses the sex scene between Fay and Henry to contrast with Simon hauling his mother's body out of their house, looking for help. The alienated movement of the coupling couple contrasts with Simon's realistic movements. Crosscutting between the two activities produces a contrast in tone, sidestepping the potential for viewer titillation and emphasising the themes of life and death that run throughout Hartley's "epic"[37] text.

No Such Thing AND THE FICTIONALITY OF PERFORMANCE

Where the simple men of *Simple Men* address a problematic relationship between projected but intended self-(aware)image and the moment of reading, *No Such Thing* disseminates an image of performative gendering that is consciously a projection of a societal and cultural unconscious. Bill's attempted mobilisation of a culturally derived masculinity in *Simple Men* is reflected in the monstrous portrayal of masculinity in the

central character of Hartley's later film. Hartley's monster is a performative fiction, a construction of the myths that sustain a culture; there is no intended self, no choice, only the fixed performance of monstrosity. The monster is sustained by a culture obsessed with its own monstrousness— terrorism, governmental chaos, plane crashes, movie studio buyouts of public space—that is subsequently projected onto the monster. The final, beguiling shots of the film, where the monster is destroyed, create a sense of ambiguity around the figure of the monster: Is the monster destroyed? Is the world destroyed? The film closes before the questions can be answered, suggesting that the destruction of the monster is coterminous with the destruction of mankind. Are the world and the monster one and the same? Is the monster the *zeitgeist* of a postmodern society obsessed with obscenity? Are fiction and reality the same thing? Of what is there "no such thing"?

The film is a science fiction parable about a beauty and a beast. Beatrice (Sarah Polley) is a young intern at a TV news station. When her fiancé goes missing in Iceland, she is sent to investigate the tapes the station has received from the crew. En route, her plane crashes; she is the only survivor, miraculously picked up by a fishing boat. She becomes a messianic figure as she recuperates in hospital after a painful operation. Following her convalescence, she journeys to the town where her fiancé had disappeared, and she encounters the figure responsible: an immortal monster living in an abandoned missile silo (Robert John Burke). The two form an unlikely couple, and she convinces the monster to return to New York with her to find Dr. Artaud (Baltasar Kormákur), the inventor of the Matter Eradicator, the only contraption capable of killing the monster. The pair becomes instant media celebrities, but, when the monster is kidnapped by the army for weapons testing, Beatrice realises that celebrity is a distraction from their quest, and she, Artuad, and Beatrice's friend Dr. Anna (Julie Christie) fight to return the monster to his home, and to his death.

The figure of the monster in the horror film has long been associated with concepts of difference and otherness. Although Hartley's monster is an altogether more self-conscious and reflexive metageneric conception

of the monster, his creation still draws on more conventional notions of otherness in the horror film. In apposite fashion, given the film's pre-9/11 production, Hartley draws on contemporary fears of global and domestic terrorism, governmental intervention in personal human rights, globalisation, and corporate capitalism as well as more traditional horrors, such as those associated with gender and ethnicity. As Robin Wood noted, the traditional conception of the monster in the horror film accompanies societal and cultural repression and the concept of the other (that which is repressed). The other, Wood argued, is

> that which bourgeois ideology cannot recognize or accept but must deal with ... in one of two ways: either by rejecting and if possible annihilating it, or by rendering it safe and assimilating it ... [I]t functions not simply as something external to the culture or to the self, but also as what is repressed (but never destroyed) in the self and projected outwards in order to be hated and disowned.[38]

The monster in *No Such Thing* is not necessarily cast unambiguously as other; his appearance (the wooden horns on his head, his skin colour, and his Victorian style of dress), immortality, and violent temperament (although he's more cranky than monstrous) mark the creature as a marginal figure, but not necessarily as the other in conventional horror film terminology. Hartley's approach to the monster's dialogue partially normalises the monster's character, although his other metaphors promote a more generic reading of the monster's social fictionality. The monster lives in an abandoned missile silo off the coast of Iceland. That the missile silo is abandoned, and thus without missiles (an obvious metaphor for phallic lack), implies the castration of the monster, a symbolic lack of potency. Linda Williams regarded this as a key feature of the monster in horror films. She argued that the monster is often representative of disavowed castrated femininity rather than a more conventional reflection of repressed primal male sexuality (and "normal" society by extension), as a double for the woman; it is the reflection of "the feared power and potency of a different kind of sexuality".[39] "Clearly", Williams contended, "the monster's power is one of sexual difference from the

normal male".[40] Hartley's monster is invested with this potent sense of difference—his appearance, combined with the symbolic castration in the abandoned missile silo—which immediately links him with the likewise marginal figure of Beatrice. Therefore, *No Such Thing* connects the monstrous masculine with the difference of the feminine. This is another feature that Williams identified in a host of classic horror films:

> It may very well be, then, that the power and potency of the monster body in many classic horror films—*Nosferatu* [1922], *The Phantom of the Opera* [1925], *Vampyr* (1931), *Dracula* (1931), *Freaks* (1932), *Dr. Jekyll and Mr. Hyde* (1931, 1941), *King Kong* (1933), *Beauty and the Beast* (1945)—should not be interpreted as an eruption of the normally repressed animal sexuality of the civilized male (the monster as double for the male viewer and characters in the film), but as the feared power and potency of [...] the monster as double for the woman.[41]

Many of the films Williams cites are reflected in the sprawling intertextuality of *No Such Thing*; indeed, this was the main feature of critical responses to the film.[42] A key intertextual reference to Cocteau's *Beauty and the Beast* facilitates the main identification in the film between Beatrice and the monster. As the ultimate signifier of difference in the film, the monster is the source of a double repression: in one sense he is the embodiment of society's violent impulses, its fear and loathing of itself, but is himself stripped of his own monstrousness by his castration, rendering him less the other, and eminently able to assimilate into the culture that would reject him. Beatrice is similarly a locus of difference in the narrative—principally as female, but she also represents the disenfranchised figures of a global culture, both marginal and powerless. Likewise the monster, despite the outward signs of his mastery, the phallic horns and powerful masculine physique, is identified with Beatrice as castrated, abject and outside conventional structures of society and morality. As Williams also noted, "the strange sympathy and affinity that often develops between the monster and the girl may thus be less an expression of sexual desire (as in *King Kong* (Merian C. Cooper, Ernest B. Schoedsack, 1933), *Beauty and the Beast*) and more a flash

of sympathetic identification".[43] Hartley achieved a similar identification between the protagonists of his horror film, stressing the similarity between the two. Both exist outside conventional structures of society (especially with the death of Beatrice's fiancé, her last remaining tie to other people) and exhibit a pronounced difference in the eyes of viewers, both inside and outside the text. There is also no indication or implication of sexual desire in the monster, yet Beatrice is tempted by vice upon her return to New York, but with the vacuous trappings of celebrity, while the monster is excluded for those "rewards/distractions". Beatrice's elevation to messianic status in the eyes of those who view her miraculous survival in the plane crash (her beatification) sees her become a mother figure to some, a symbol of divine salvation.[44] This only serves to heighten her symbolic difference as a Madonna figure (a commonplace in Hartley's films), untouchable yet still unable to gain entry to the symbolic (and to the actual structures of power—she fulfils a very minor function in her job, and her boss cannot remember her name). Again, this is emphasised when she returns to New York with the monster, only to be draped in tight black leather clothing and turned into an object of desirable spectacle for the male audience. In effect, she and the monster are sold into a manufactured *Beauty and the Beast* scenario, when the very sexual desire Williams talks about as absent is presented as a natural consequence of the relationship between the two. The media even ask if they are romantically linked.

However, as the narrative testifies, the symbolic relationship between Beatrice and the monster is one of identification, based around their shared feelings of alienation and difference. In creating an identification between the protagonists that emphasises their shared difference, *No Such Thing* displays its constructedness and the cultural roots of the two main characters. Drawing on the central intertextual allusion to *Beauty and the Beast*, itself a film that displays the marks of its construction,[45] *No Such Thing* exposes its narration as manufactured, a theme linked to Hartley's portrayal of performative media in the film (see the discussion that follows). When the monster enters Dr. Artaud's chamber of horrors (or a chamber of cruelty, as the reference to Antonin Artaud suggests) in

the final moments of the film, his death is echoed in the fragmentation and breakdown of the diegesis. When the matter-eradication machine begins its cycle, the images start to become fragmented, spatially and temporally. The final shots of the film offer an equivalence of the gaze. We share the monster's point of view from the chamber and Beatrice gazes at the monster. The images are cut aggressively, light dancing on Polley's face in different intensities and colours. The overall effect is transcendental, that is, his eradication and her beatification, and choral music swells on the soundtrack. Her innate goodness is contrasted with his monstrousness, until their final eradication. The binary is eroded and their gazes become equivalent. Although this might suggest an equivalent monstrousness of both their gazes, this is finally emphasised as a fictional construction, along with the diegetic space of the film, which is destroyed. The other point of equivalence in this moment is the design of the matter eradicator, which offers clear parallels with the medical contraption into which Beatrice is strapped for her painful operation. Their interconnected abject suffering is emphasised in these mirrored moments of *mise-en-scène*.

The monster is a consciously fictional character (one who has lost his cultural relevance[46]), but the realist diegesis of the film initially posits Beatrice as a more realist presence. At times, Beatrice is forced (especially through costuming) into roles that are constructed, the *Beauty and the Beast*–style ingénue for instance, but her role in the film is as a contrast to the monstrousness of Robert Burke's monster, although one which is overcome by their mutual identification with their own difference. Thus, Beatrice and the monster become the same, constructed and therefore destroyed (or they transcend "normal" space) as the narrative closes. Matter and narrative are one (echoing Dr. Artaud's words), and as the narrative closes all matter is destroyed; it is all fictional, and therefore discarded as the film ends. This reminds the audience that, although the monster is consciously fictional (the audience within the diegesis is just as disbelieving as the one outside), Beatrice, the other characters, and the diegetic space are also fictional, constructed, unreal. The final *mise-en-scène*, however, achieved through editing, lighting, and optical

techniques, works to diminish the difference between the two individuals to the point where the individual is reduced to nothing. In doing so, the film suggests the constructedness and fictionality of its culturally derived characters and the sense of difference that is born out of social and cultural oppression.

The premise of the film plays with notions of performance and fictionality; the fictionality of the monster and its generic origins; the fiction of monstrous masculinity; the cultural fiction of feminine difference; and the fictions of performance. Performances are contingent upon place, space, and time for their different articulations of selves appropriate to the function required. As such, performances are generally contingent upon fluctuating degrees of fictionality dependent upon the perceived efficacious purpose of any role. As Erving Goffman stated, a "status, a position, a social place is not a material thing".[47] The final images of *No Such Thing* stress Goffman's claim: the roles played by the characters in the film are not material, only projections on a canvas, contingent upon cultural and social knowledge. There is effectively "no such thing" as a self-evident, autonomous role; it is *"not a material thing"*. The beauty and the beast at the centre of the film are cultural constructs of intertextual references to other aesthetic works and of social notions of difference and otherness manifested and sustained by those cultural texts. This is emphasised by the monster's monstrous performance of "difference from the normal male" (to use Williams's words). The monster embodies a performance of difference that is eventually exposed (through its eradication by overexposure) as a fictional construct, a projection of the society that created him. At times the monster muses on the nature of his existence, an acute existential crisis, wondering why humanity has forced him into being, when his existence in the modern world is unnecessary—he is ultimately passé to the inhabitants of twenty-first century New York, where the supposed "real" horrors are more relevant and threatening than a fire-breathing, horned demon more appropriate to the pages of nineteenth-century literature. Like the monsters of *Frankenstein* and *Dr Jekyll and My Hyde*, the monster of *No Such Thing* offers a mirror to social repressions and difference.

The double and the mirror are key staples of the repressed monster in horror fiction, nowhere more so than in Robert Louis Stevenson's *The Strange Case of Dr. Jekyll and Mr. Hyde*. Hyde represents the id of Jekyll, his repressed sexuality and the murderous violent rage born out of the respectable, genteel face of Victorian society that hides such "illicit" desire. Hyde is characterised as monstrous: "That child of Hell had nothing human; nothing lived in him but fear and hatred".[48] The mirror is linked symbolically to the doubling of Jekyll and Hyde and their frequent transformations. Jekyll even comments that the mirror is brought into his laboratory for "the very purpose of these transformations".[49] In *No Such Thing*, the mirror functions less explicitly as a means of doubling the monster with a general social repression than equating other characters in the film with opposing qualities of monstrousness and family. The most obvious doubling in the film is that of the monster and Beatrice's boss, the editor of a major news conglomerate. The current federal government strike is no longer of sufficient significance for the boss, only the prolonged tension over whether the president will commit suicide. As she tells her news team: "There's a world of bad news out there, ladies and gentlemen, a world of bad news. All we need to do is get our hands on the worst of it, the very worst news possible". Hartley parodied the media that would manipulate public feeling regarding emotive issues such as terrorism and then portray themselves as victims when the situation turns against them. Consequently, the link between the media (of which the boss is the key representative) and the monster is taken to excessive lengths. As the boss, Helen Mirren's performance is comically over the top, utilising overemphasised gestures and aggressive vocal inflexions. Like the monster, however, Mirren's performance makes the character less real (less believable), deviating as it does from norms of realist performance, whereas logical motivation and verisimilitude are eschewed in favour of the comic. Consequently, Mirren's performance is a standout in the film, where other performances are more controlled physically and aurally. In this sense, Mirren's performance is also a standout in Hartley's oeuvre because she deviates from the alienated norms set by earlier films such as *Trust* and *Simple Men*, where

performances are restrained and conscious of limiting overt expressions of broad emotion. Therefore, like the performance of the monster, the media boss is overtly unreal, a performance determined by milieu and professional role that is conscious of its intended diegetic audience, where her fiction (of reality) is manipulated to maximise emotional affectivity over documentary "truth".

The mirror of the media and monster are finally satirised when the boss is arrested after Beatrice has "spirited away" (this phrase even has connotations of magic and make-believe) the monster. Arrested by the government, the boss tells her team not to try to pressure the government into her release; she sees the situation as perfect, a "sort of demonisation of the media type of thing" ripe for exploitation. The boss manipulates and constructs the drama, echoing the role of a film director rather than news editor. This is the news in commodity form, like a movie played for maximum emotional and fashionable appeal. The "demonisation of the media sort of thing" is almost revealed as a generic standard, a key element of the developing drama, exploited, as the boss says, because, "this is news. We *produce* news". Produce? Or report? The portrayal of the media boss therefore reveals satiric dimensions in the standard horror genre use of the mirror, reflecting the conditions under which the film is produced and distributed. The doubling of the monster and the media is a constructed one, born of cultural standards and prior reflections of the media, especially those dictated by the media themselves.

The media are presented as conscious authors of fiction in the text. As such, they become a key source of repression and difference in *No Such Thing*, represented by the figure of the boss. By offering the monster as an object of spectacle, the media emphasise his difference, exhibiting him as a figure of novelty on display, just like King Kong, in a media-saturated environment. In this moment, the monster mimics a key moment of the horror film for Williams because he "displaces the women as a site of spectacle".[50] This places the monster in the position of the woman for a brief moment, and he becomes the object of speculation, made powerless, with a briefly diminished narrative agency. Again, the text creates a moment of identification between the monster

and Beatrice—she is once again made the object of spectacle. To fulfil her role in the drama, Beatrice is asked to wear the revealing, tight black leather outfit by the boss to emphasise her desirability for the viewing audience (figure 21). This offers an overt contrast from earlier scenes of the film, where Beatrice's body is veiled by loose sweaters, thick jackets, or dressed in a grey dress reminiscent of those worn by nuns that cover and de-emphasise her femininity, as well as reminding the audience of her innate goodness. In this change of costume, Beatrice is offered a change in character—an opportunity to perform another, little-explored self—and becomes the key object of spectacle in the film. This situation is mirrored in the advertising of the film that places a high value on the images of Sarah Polley in the outfit, trading on her desirability as a spectacular object and as a rising star in Hollywood. The corollary of this parallel in the text is the identification of

FIGURE 21. The costuming of Beatrice (Sarah Polley) places her in an uncomfortable constructed role, and emphasises her moment of communitas with the monster, as difference.

the monster and Beatrice with the powerlessness and marginality of difference. As such, the difference signified by Beatrice and the monster is therefore an effect of the machinations of the media boss, and a result of the performance of difference in a fiction in which the protagonists have been manipulated into performing. By exposing the constructedness of this difference as a side-effect of dramatic role playing, *No Such Thing* demonstrates how cultural and social roles have been constructed through media representations of difference that force otherness to become an object of speculation through a gaze that is presented as normative by the illusionary appearance of documentary truth as reportage. The film shows how these performances are contingent upon a gaze at fiction, where that look is as manipulated and constructed as any aesthetic fiction.

The culturally derived nature of the fiction in *No Such Thing* reflects on the performative characteristics of postmodernism, especially the figure of the monster. The monster appears to fit comfortably into the order of simulation. "Simulation", according to Jean Baudrillard, "masks the *absence* of a profound reality", to the point where the image "has no relation to any reality whatsoever: it is its own pure simulacrum".[51] The simulacrum is that without a template, a copy without an original. Once more reflecting the doubling of monster and media in *No Such Thing*, Baudrillard's degrading "Precession of Simulacra" sees representation giving way to simulation. The first order of representation reflects a basic reality; the second order warps that reality; the third merely plays at being a reflection of reality, a fetish that masks the absence of the profound reality held as self-evident in the first two orders; the final order is the disintegration of reality, where simulacra are signs without equivalence in the "real" world. The monster has no equivalent in the real world—he is a copy without an original in the real world (he reflects the creations of aesthetic and fantasy imaginations). Alienated from *his* "reality", the monster is a cultural product with no actual equivalent. The juxtaposition of "real" and simulated—the horned, murderous monster in a realist milieu (rather than the hyperreal environments of most monster movies, where the logic of the horror film

dominates)—maintains the contradiction between the monster and his new environment. Ironically, however, the monster is experiencing an existential crisis in a postmodern world, where the New Yorkers who receive him are too savvy to be scared of him—he is "irrelevant". The monster is understandably conscious of his predicament—he does not really exist—because he is cognizant of his status as a simulacrum. Therefore, it is he who experiences this malaise, whereas the inhabitants of the postmodern world in the film have succumbed to what Fredric Jameson calls "the waning of affect";[52] they have lost the ability to experience emotional depth in the images of the world. To them, the monster represents a depthless image (a pastiche[53] of monsters), and has thus lost his potency. Alternatively, however, it can also be argued that the monster is an original without a copy, as a manifestation of difference and monstrosity; hence, he posits himself as either a cruel joke on the part of God or is God himself; either way, however, he is "fucked". The monster *is* monstrosity (as difference), not simply analogous with monstrousness. The denigration of the monster as an affectless spectacle allows the viewing audience to disavow "the absence of a profound reality" in the images of the world fed to them by the media. The monster and the sexily clad Beatrice become fetish objects that mask the absence of a profound reality, just as the sexual fetish masks to disavow the monstrous castration of the female;[54] their collective difference masks an absence (there is *No Such Thing as Monsters*[55]). The spectacle shifts from the monstrosity of the monster to the sexualised objectification of Beatrice to mask both "the absence of a profound reality" and a (potentially frightening) supernatural otherness that has become irrelevant in a media-saturated contemporary society. In "The Ecstasy of Communication", Baudrillard argued,

> today there is a whole pornography of information and communication, that is to say, of circuits and networks, a pornography of all functions and objects in their readability, their fluidity, their availability, their regulation, in their forced signification, in their performativity, in their branching, in their polyvalence, in their free expression ...[56]

"Here we are far from the living-room and close to science fiction", Baudrillard contended.[57] Likewise, the monster in *No Such Thing* finds himself "far from the living-room" in the realm of science fiction, although Hartley's normalising of his dialogue attempts to situate him back in the living room. The "pornography of information" envelops the monster. "Obscenity", Baudrillard expounds, "begins precisely when there is no more spectacle, no more scene, when all becomes transparence and immediate visibility, when everything is exposed to the harsh and inexorable light of information and communication".[58] The communicational network that makes him visible to the world, the television news media, is obscene in its ubiquitousness, where a "world of bad news" is made available to the viewer at the touch of the button. The world of television news is the world made over as simulation. Hartley withheld the representation of the events referred to in briefings at the news network—like Audry's modelling in *The Unbelievable Truth* and Simon's poem in *Henry Fool*—to problematise the nature of the "news production" in the film (gestically developing a discourse around the issue, rather than overwhelming it with spectacular imagery). The events discussed in the film—the federal government strike, the buyout of Manhattan by a major movie studio, the threatened terrorist bombings, the gas attack on the subway[59]—all remain unseen, unavailable to the viewer. In this sense these events may not necessarily fit into the obscenity of communication discussed by Baudrillard, yet the displacement of this discourse, through the mirroring of media and monster, onto the visibility and availability of the monster (and the consequent discourse of fear surrounding difference and its media-derived fictitiousness) implies an obscenity of visible networks of communication into which the media fits.

The obscene visibility of the world of simulation has a significant effect on the function of performance. Where postmodern theory sees an escalating parade of signs followed by signs followed by signs, the subject behind the performance threatens to disintegrate or disappear. The ending of *No Such Thing* portrays just such an occurrence. The monster is consciously a performance, a fictional construct culled from the pages of science fiction and horror novels and from hordes of generic

films. Where the world has been available in its obscene visibility, a fire-breathing, horned monster holds no fear for a culture where the nightly news carries real-life horrors of inconceivable terror. Yet, images of horror have lost their effect in their ubiquity and lack of depth. The monster is similarly impotent and castrated (signified by the abandoned missile silo that is his home and his affinity with Beatrice). Effectively, the performance has no subject—the self behind the coding of performance is blank, missing, a fictional construct.

In the portrayals of the monster and the media-saturated New York, *No Such Thing* emphasises the performances implicit in images. Both the monster and the media are explicitly performed, where images do not cohere into a realistic whole; the media contort reality into fictional, affective narratives, and the monster is a mythic, cultural amalgam of generic codes. This is a postmodern conception of the world, where images fail to produce a trustworthy representation of any "profound reality". As Cristopher Nash contended, this is typical of the multiple signs of simulacra, where a monadic self and self-evident reality are problematically unattainable:

> The postmodern percept that at the bottom of every sign there's only another sign matches the narcissant sense that behind the panoply of others' gestures there is no one there. Under the burden, the pall, of our "performance", echoing only the apparent performance of all the others: the foundations disintegrate on which any value and any sense of reality might have been thought to rest. "Reality? I can't enter. Because I'm not really here—nor is *it*."[60]

No Such Thing explores the problematic performance of "reality", where fictions and constructs predominate. Accordingly, Hartley's characters do not exist either—they are ultimately fictional constructs like the monster and as such eradicated along with the narrative and diegesis in the final disintegrating, fragmenting shots of the film. By extension therefore difference is also seen as a fiction, a culturally and socially constructed concept manifested and sustained by a culture that is both repulsed and fascinated by performances that fail to conform to the norms created by dominant society.

ENDNOTES

1. Butler, *Gender Trouble*, 139.
2. Deer, "Hal Hartley", 164–165.
3. "All Japanese art, not just theatre", Donald Richie contended, "is … presentational"; *Japanese Cinema: An Introduction* (Oxford: Oxford University Press, 1990), 7. The presentational qualities of Japanese art surfaced most acutely in the spectacle of the moving image when *kat-sudô shashin* ("moving photographs"; Aaron Gerow, "The Word Before the Image: Criticism, the Screenplay, and the Regulation of Meaning in Prewar Japanese Film Culture", in *Word and Image in Japanese Cinema*, ed. Carole Cavanaugh and Dennis Washburn [Cambridge: Cambridge University Press, 2001], 3) were first exhibited publicly in the latter half of 1896 (Hiroshi Komatsu, "Japan: Before the Great Kanto Earthquake", in *The Oxford History of World Cinema*, ed. Geoffrey Nowell-Smith [Oxford: Oxford University Press, 1996], 177). Indeed, for Japanese audiences, like the majority of viewers of the cinema of attractions, the spectacle of the image was so enticing that the means of presentation were as fascinating as the *kat-sudô shashin* themselves, some exhibitors setting up additional rows of seats so that patrons could watch the projector being operated; Noël Burch, *To the Distant Observer: Form and Meaning in the Japanese Cinema* (London: Scolar, 1979), 78; Richie, *Japanese Cinema*, 2. The mechanics of presentation therefore, like the puppeteers in *bunraku*, were exposed and attracted as much interest as the cinematic representations on the screen.
4. Roland Barthes's comments on *bunraku* also demonstrate the presentational mode of traditional Japanese art, and its subsequent reflection in *Flirt*, as they articulate the separation of texts that is facilitated by combining different modes of movement, gesture, image, and word as a "total spectacle, but divided" (*Image-Music-Text*, 177). This is also true of the cinema of attractions; Tom Gunning, "The Cinema of Attractions: Early Film, its Spectator and the Avant-Garde", in *Early Cinema: Space, Frame, Narrative*, ed. Thomas Elsaesser (London: BFI, 1990), 56–62. *Bunraku*, Barthes alleges, "attacks the writing of spectacle", but in Western theatre, "such writing involves an illusion of totality" (*Image-Music-Text*, 174). Barthes saw *bunraku* as comprising multiple "writings" that are intended to be read simultaneously in three different areas of spectacle: "the marionette, the manipulator, the vociferator; the effected gesture, the effective gesture, the vocal gesture" (ibid., 175). Referring to early Japanese cinema, Noël Burch

refers to this phenomenon as the *"fragmentation of the signifier"* (*To the Distant Observer*, 84). Additionally, as Burch also argued, the role of the *benshi* (the nondiegetic storyteller), along with the exposed nature of the mechanics of narrative and presentation, made the surface qualities of the image function independently of their role as narrative signifiers (ibid., 79). The fragmentation of the codes of storytelling, performance, and presentational symbols flattens the diegesis, distancing the audience by circumventing the representational impulse. Thus, the spectacle functions in an altered fashion to that of the nonspectacular, narrative-driven, illusionistic, realist imagery of most Western theatre, and subsequently cinema.

5. Hartley's presence in the film is clearly an attempt to invoke an authorial presence in the diegesis. In the final shots of the film, Hartley is surrounded by film cans in the hospital that prominently bear the handwritten legend "FLIRT". His presence also implies the degrading nature of language in the use of repetition—the audience has literally "heard it all before". When delivering a key line of dialogue ("You don't need to see it if you know it's there"), Hartley takes a script from a shelf and reads the line blankly. This confronts the audience with the corollary of such repetition: blank quotation. The use of such quotation is Brechtian, historicising the action, literally quoting the two films that have come before, yet Hartley's presence also abstracts the action further.

6. Deleuze, *Difference and Repetition*, 94.

7. Claire Johnston, "Double Suicide", *Focus on Film*, no. 2, Criterion Collection DVD Notes (1970).

8. Kristin Thompson argued that temporal duration can be a key determining factor in the identification of excessive stylistic elements in a film text. Where the on-screen device exceeds its logical motivation within the narrative system, the illusion masking the heterogeneity of stylistic elements within the text is threatened ; "The Concept of Cinematic Excess", in *Film Theory and Criticism: Introductory Readings*, ed. Leo Braudy and Marshall Cohen, 6th ed. (Oxford: Oxford University Press, 2004), 518.

9. Goffman, *Presentation of Self in Everyday Life*, 81.

10. Alan Ryan, "Private Selves and Public Parts", in *Public and Private in Social Life*, ed. S. I. Benn and G. F. Gaus (Beckenham: Crook Helm, 1983), 137.

11. Wyatt, "Particularity and Peculiarity of Hal Hartley", 4.

12. Ibid., 5.

13. Similarly, Michel Chion contended that a "hierarchy of perception" exists to place speech above all other sounds, a similar hierarchy places the abstract performance of gesture above all other body movements performed on

screen. He argued that "in actual movies, for real spectators, there are not *all the sounds including the human voice. There are voices, and then everything else.* In other words, in every audio mix, the presence of a human voice instantly sets up a hierarchy of perception"; *The Voice in Cinema*, trans. Claudia Gorbman (New York: Columbia University Press, 1999), 5.

14. What is of most crucial importance in Wexman's study of Bogart is that she attempted to confront Bogart's portrayals of Sam Spade and Phillip Marlowe via the range of single and repetitive body movements and how they convey subtle textual and subtextual meanings that delineate character and communicate narrative significance; "Kinesics and Film Acting: Humphrey Bogart in The Maltese Falcon and The Big Sleep", in *Star Texts: Image and Performance in Film and Television*, ed. Jeremy G. Butler (Detroit: Wayne State University Press, 1991), 203–213.

15. McLean, "Feeling and the Filmed Body", 14.

16. Ibid., 5.

17. See Warren Lamb and Elizabeth Watson, *Body Code: The Meaning in Movement Body Code: The Meaning in Movement* (London: Routledge and Kegan Paul, 1979), 75–80, for a more detailed explanation of effort-shape affinity.

18. Hartley called the film "more consciously emotionally obvious", talking about the grand epic tone of *Henry Fool* in comparison to his other films; Pride, "Reversal of Fortune", 91.

19. If, as Deleuze noted, the close-up "faceified" the image (*Cinema 1*, 88), the close-up of a gesture might be thought to "gesturify" the image in the same way.

20. Birdwhistell, *Kinesics and Context*, 80. David Bevington also argued this point in relation to the use of gesture on the Shakespearean stage; *Action is Eloquence: Shakespeare's Language of Gesture* (Cambridge, MA: Harvard University Press, 1984), 16.

21. See chapter four, note 28.

22. *Kinesics and Context*, 193.

23. Even though these questions remain relevant for the ending of *Henry Fool*, they become obsolete with the release of *Fay Grim*, which answers all of these questions.

24. Graham Fuller and Hal Hartley, "Responding to Nature: Hal Hartley in Conversation with Graham Fuller", in *Henry Fool*, by Hal Hartley (London: Faber & Faber, 1998), xx–xxi.

25. Schechner, *Performance Studies*, 71.

26. Hirsch, *Acting Hollywood Style*, 71.

27. Judee K. Burgoon and Thomas Saine, *The Unspoken Dialogue: An Introduction to Nonverbal Communication* (Boston: Houghton Mifflin, 1978), 58.
28. Ibid.
29. Brecht, *Brecht on Theatre*, 138.
30. The scenes with Father Hawkes and Angus James are also significant in this fashion. Simon uses less obvious hand gestures than Henry, representing his lack of a need to dominate others. Tellingly, Simon is also mirroring the gesture language of Hawkes and James, who both use moderate illustrators to supplement the rhythm and emphasis of their dialogue.
31. Benjamin, *Illuminations*, 148.
32. *Brecht on Theatre*, 198.
33. Naremore, *Acting in the Cinema*, 53.
34. Ibid., 52.
35. An anthropologist like Desmond Morris may tend to agree with Delsarte here, as certain symbolic gestures can be argued to hold universal meanings. However, these are still dependent upon contextual elements (including historical, social, and cultural contexts) for an individual to decode an intended meaning. Therefore, any possible meaning of such gestures can only ever be tenuously fixed, even in an aesthetic continuum in which cultural meanings are being relayed. As such, it is possible to talk of probable meanings for gestures—signifiers are neither totally free and unfixed, nor imbued with definite connotative meaning; *Manwatching: A Field Guide to Human Behaviour* (London: Jonathan Cape, 1977).
36. *Acting in the Cinema*, 53.
37. Hartley has situated *Henry Fool* as an epic, in the tradition of David Lean's *Lawrence of Arabia* (1962) and *Dr. Zhivago* (1965); Wyatt, "Particularity and Peculiarity of Hal Hartley", 4.
38. Robin Wood, "An Introduction to the American Horror Film", in *Movies and Methods*, ed. Bill Nichols, vol. 2 (Berkeley and Los Angeles: University of California Press, 1985), 199.
39. Linda Williams, "When the Woman Looks", in *The Dread of Difference: Gender and the Horror Film*, ed. Barry Keith Grant (Austin: University of Texas Press, 1996), 20.
40. Ibid.
41. Ibid.
42. Ebert, "No Such Thing"; David Sterritt, "A Hollywood Monster Movie with International Flair", *Christian Science Monitor*, March 29, 2002, http://www.csmonitor.com/2002/0329/p15s03-almo.html; Andy Klein, "An Immortal Beast Longs for Death, but Does he Exist at All?" *New Times*

Los Angeles, March 28, 2002, http://www.newtimes.com/issues/2002-02-28/film3.html/I/index.html; Elvis Mitchell, "Yes, Someone for Everyone, Even Someone with Fangs", *New York Times*, March 29, 2002, http://www.nytimes.com/2002/03/29/movies/29SUCH.html; Ann Hornaday, "The Really Abominable Snowman", *Washington Post*, March 29, 2002, http://www.washingtonpost.com/wp-dyn/style/movies/reviews/A33953-2002Mar28.html; Desson Howe, "No Such Thing", *Washington Post*, March 29, 2002, http://www.washingtonpost.com/wp-dyn/style/movies/reviews/A31932-2002Mar28.html; Rex Reed, "Move Over, Kevin Costner!" *New York Observer*, April 8, 2002, http://www.nyobserver.com/pages/story.asp?ID=5702; Peter Travers, "No Such Thing", *Rolling Stone*, April 25, 2002, http://www.rollingstone.com/reviews/movie/mid=2043858.

43. "When the Woman Looks", 21.
44. This is also an important connection with her name, meaning variously "blessed woman", or "she who blesses". There are also important considerations of her journey; Beatrice is derived from the Latin *Viatrix*, meaning "voyager, traveller". Beatrice is also the name of Dante's heavenly guide in *The Divine Comedy*. Hartley has also commented that Beatrice is "the destination"; Hartley and Kaleta, *True Fiction Pictures & Possible Films*, 135.
45. The opening titles of Cocteau's version of *Beauty and the Beast* are written on a blackboard and then erased by hand, and the first shot of the film is of the clapperboard being slapped shut by a member of the crew, calling "*La belle et la bête*, take one!" Another voice calls for the production to hold, following which we are treated to a disclaimer from Cocteau himself asking the audience to suspend their disbelief and adopt a childlike simplicity to the motifs of the film, such as that "a stolen rose can bring a family into conflict". Consequently, Cocteau draws attention to the filmed nature of the drama, its constructedness, and the fact that images do not pertain to realist meanings but to metaphorical and symbolic implications in context with the fantasy of the fairy tale.
46. In *Skin Shows: Gothic Horror and the Technology of Monsters*, Judith Halberstam argues that the postmodern monster has become normalised through "consent" and "habit". The traditional monstrous other under postmodernism cannot be so easily located as it could in the past. The textual processes through which monsters were produced in nineteenth-century Gothic fiction are now reconfigured to locate the monster within the self: "Monsters within the postmodern are already inside—the house, the body, the head, the skin, the nation—and they work their way out. Accordingly, it is the human, the façade of the normal, that tends to become the place of

terror within postmodern Gothic"; Judith Halberstam, *Skin Shows: Gothic Horror and the Technology of Monsters* (Durham, N.C.: Duke University Press, 1995), 162. Hartley's monster is similarly located as a normalised other, where the façade of normality, allied with the visibility of the postmodern horror (ibid., 1), promotes the monster as surface, but with no depth. The monster of *No Such Thing* though, has too much depth for the duration of the narrative (he resembles Frankenstein's monster in this regard), but he subsequently reminds us of the fictional skin of the monster at the film's close.

47. *Presentation of Self in Everyday Life*, 81.
48. Robert Louis Stevenson, *The Strange Case of Dr Jekyll and My Hyde and Other Tales of Terror* (London: Penguin, 2002), 67.
49. Ibid., 57.
50. "When the Woman Looks", 22.
51. Jean Baudrillard, *Simulacra and Simulation* (Ann Arbor: University of Michigan Press, 1994), 6.
52. Fredric Jameson, *Postmodernism, or The Cultural Logic of Late Capitalism* (London: Verso, 1991), 10.
53. Jameson also linked depthlessness with the notion of pastiche—"blank parody, a statue with blind eyeballs" (ibid., 17). However, Hartley differed from Jameson's concept of depthless pastiche by invoking the flattened image of the horrific monster to achieve a satirical portrait of hollowed-out, affectless postmodern society that simultaneously celebrates and denigrates difference.
54. Sigmund Freud, "Fetishism", in *The Standard Edition of the Complete Psychological Works of Sigmund Freud*, ed. James Strachey (London: Vintage, 2001), 152–157.
55. This was an earlier title for the film—*No Such Thing (as Monsters)*—and Hartley released the soundtrack in 2010 under this title.
56. Jean Baudrillard, "The Ecstasy of Communication", in *The Anti-Aesthetic: Essays on Postmodern Culture*, ed. Hal Foster (New York: The New Press, 1998), 150–151.
57. Ibid., 148.
58. Ibid., 150.
59. This echoes the Tokyo Sarin gas attacks of 20 March 1995, by Ōmu Shinrikyō that killed thirteen people.
60. Cristopher Nash, *The Unravelling of the Postmodern Mind* (Edinburgh: Edinburgh University Press, 2001), 101.

CHAPTER 6

POSSIBLE FILMS

No Such Thing was a key landmark in Hartley's career. It was the last fea-
ture produced in collaboration with True Fiction Pictures, and its disastrous
debut at Cannes and problematic proximity to 9/11 meant the film had a
very minor, low-key release; the film opened on just nine screens, grossing
just $62,703[1] from a budget of "something like $5.5 million".[2] The reviews
were disastrous; Derek Elley called it "deadly dull in stretches, and just
plain embarrassing in others",[3] while Roger Ebert (never really a cham-
pion of Hartley's work) pronounced it to be "inexplicable, shapeless, dull.
It doesn't even rise to entertaining badness … with the satirical insights of
callow undergraduates who will be happy with a C-plus in film class. Char-
acterizations are so shallow they consist only of mannerisms".[4] Meanwhile,
Emanuel Levy, the author of *Cinema of Outsiders: The Rise of American
Independent Film* and a noted commentator on American independent cin-
ema, located the film within a trajectory of decline in Hartley's work:

> Instead of arresting a downward-spiraling career, *No Such Thing*,
> Hal Hartley's new movie and latest folly, demonstrates what

happens to an iconoclastic filmmaker when he neglects his instinctive talent for small, quirky, offbeat films and decides to go uproariously big.[5]

The negative reaction to the film was a decisive moment for Hartley. As he noted in 2008:

> The negative response to *No Such Thing* really left me feeling out in the cold—confused about my relation to people. What I find funny or important never seemed to me to be so unusual. How could I be so far off the mark? I walked around for months asking myself if I were really that out of touch with the world I share with other people. I don't think I've gotten over it yet.[6]

No Such Thing could have been Hartley's breakthrough film into the lucrative Indiewood sector into which many of his contemporaries had gone throughout the 1990s and early 2000s. Following the relative success of *Henry Fool*,[7] the film was produced in collaboration with United Artists and Francis Coppola's American Zoetrope. However, the failure of the film with critics and audiences precipitated a new phase in Hartley's career.[8] From 2001 to 2004, he taught film at Harvard while embarking on a new venture, Possible Films, founded in place of True Fiction Pictures. The period from 2004 to 2011 has seen Hartley reassert his independence and move into new territory. New technology has allowed his company to exert more control of his work, to sell digital downloads of music and films, and to disseminate information. Hartley has remade himself from the disaster of *No Such Thing* as a digital *auteur*. Here I explore the "digital" portion of Hartley's career, first the implications for authorship that have been provided by digital technology, the Internet, and DVD, and second Hartley's digital works, from *The Book of Life* to *Fay Grim*, and I argue that, while miniDV (digital video) and HD (high-definition) video have precipitated a change in Hartley's aesthetic, this shift is rooted in continuing themes, recurring features, and an altered focus

on performance where the focus is less on the body and character and more on the image itself.

HAL HARTLEY: DIGITAL *AUTEUR*

Digital technology has initiated a revolution in filmmaking, from the technology of filmmaking in Hollywood blockbusters to the processes of cinephilia. For independent filmmakers like Hartley—along with the Dogme 95 group or marginal filmmakers like Jonathan Caouette (*Tarnation*, 2003)—digital technology has helped initiate that which John Belton, in his pessimistic treatise, "Digital Cinema: A False Revolution", called "a different kind of practice".[9] While the general shift toward digital cinema has pushed theatrical distribution toward CGI spectacle, greater use of motion capture performance and more recently 3D stereoscopic projection, filmmakers like Hartley testify not only to the "democratization" of the means of production" of which Belton was sceptical, but also a "democratization" of the means of distribution and exhibition.[10] More accessible and cheaper digital technology allows Hartley to sell DVDs of work through his Web site (via Microcinema), but also the means to download MPEG-4 versions of new work (*Possible Film Vol. 2*, as well as the recent 2010 remaster of *Surviving Desire*), and ancillary material, such as making of documentaries (as with the recent *MONSTERS, Making "No Such Thing"* (2002), along with selling digital downloads of soundtracks, from older work, like the deleted 1993 compilation *True Fiction Pictures—Music From the Films of Hal Hartley*, and soundtracks from *Amateur*, *The Girl from Monday*, and *No Such Thing (as Monsters)*, and his musical work with Ryful. The Possible Films Web site and store has become a focal point for the distribution of Hartley's work, as more mainstream distribution has proven harder to obtain for his work. This also entrenches perception of Hartley as an *auteur*, a step back toward a more romantic notion of authorship and artistic freedom, facilitated by digital technology and Web-based modes of promotion and distribution.

The organisation of Hartley's authorship along these lines is concurrent with what Catherine Grant has pointed to as "the potential 'deterritorializing'

of auteurism" by new media technologies.[11] Offering a critique of Timo-
thy Corrigan's "deterritorialized" *Cinema without Walls*, Grant argued that
"the increasing commodification of authorship"[12] stimulates, in the new
millennium, changes in "the precise nature and direction of a significant
part of the flow of cultural and, especially, economic capital".[13] Although
written in prior to 2000, Grant's partly speculative mediation on auteurist
discourses for "niche" communities of fan discourse in online forums and
as mediated via Hollywood blockbuster DVDs (independent production is
not immune from these processes, however). In a later article, Grant again
addressed these concerns in relation to the very privileged area of DVD
audio commentaries that recuperate or recover a film's text via the "docu-
mentary performance of the 'drama of the movie's source.'"[14] Although
none of Hartley's films are currently available on DVD with audio com-
mentaries (he has stated that he "can't stand those things"[15]), some of
Grant's remarks are relevant for Hartley's construction of his authorship
via the Possible Films branding. Grant noted:

> Contemporary auteurism comprises a complex series of interre-
> lated film production, marketing, and reception practices and dis-
> courses which are all underpinned by a shared belief in the specific
> capability of an individual agent —the director—to marshal and
> synthesize the multiple, and usually collective, elements of film-
> making for the purposes of individual expression, or to convey in
> some way a personal or, at least, "personalized" vision.[16]

While much of what Grant defined here is common with earlier roman-
ticised notions of auteurism, the location of contemporary readings of
authorship within "production, marketing, and reception practices" high-
lights the related discourses mobilised by Hartley's move into the digital
domain. The "About Us" section of the Possible Films Web site high-
lights two of the practices that Grant locates in this discursive formation
of contemporary authorship:

> Possible Films is a small company run by me, Hal Hartley. I write,
> direct, and produce films and then try to market them. I also make
> music.

The Website/Store you are presently at is a project of Kyle Gilman and myself. Kyle is a motion picture editor who works with me regularly. And he is my Information Technology Chief. Together, with advice from other friends, we undertook to move into the digital retail biz.

It is hoped that this Website/Store will provide a simple to use and informative base for folks interested in what I do, as well as a convenient place to purchase digital downloads of my work.

Maybe we'll expand. But let's see how things go....

But, as far as Possible Films goes, I guess that's all it is: a loose confederation of like-minded semi-criminal artist types hanging around my apartment scheming....
(to be continued)[17]

The mission statement of Possible Films identifies Hal Hartley with both traditional notions of artistic independence outside the mainstream ("like-minded semi-criminal artist types") as well as a contemporary situation of Hartley within the context of e-commerce. The statement highlights Hartley the *auteur*, as well as Hartley the businessman, locating him within the boundaries of what Grant defines as marking the discursive boundaries of contemporary construction of the *auteur*. The Possible Films brand constructs Hartley in the "deterritorialized" fashion in cyberspace. However, the Web site also positions Hartley in a traditional "territorialized" fashion by documenting his appearances at retrospectives and most recently as a step back toward a more embodied authorial presence in "a genuinely public sphere", to use Timothy Corrigan's phrase.[18] The Possible Films Web site documents this material, although it is addressed to the potential viewer-consumer-fan "in a virtual, but seemingly *private* sphere".[19] Despite the construction of Hartley's authorship discursively and commercially along traditional independent lines, the creation of the Possible Films branding (not just via the Web site but also in the branding of two DVD collections of Hartley's work, *Possible Films: Short Works by Hal Hartley, 1994–2004* [2004][20] and *Possible Films 2* [2010])

constructs an *auteur* persona that is a part-individual, part-corporate brand. Robert Brookey and Robert Westerfelhaus have argued that promotional and intratextual material, such as DVD extra features, enter into a process of "synergistic blending" with the media products they promote to construct an *auteur* persona that in the case of Pixar and the *Monsters, Inc.* (Pete Docter, 2001) DVD is primarily corporate in nature.[21] The Possible Films brand similarly positions Hartley in a "synergistic" position, between the technological and promotional platforms used to disseminate Hartley's work and the texts themselves, both of which promote the image of the *auteur* in textual, extra- and intratextual fashions. In this respect, Hartley's digital auteurism is now more dispersed than it is "deterritorialized" along both traditional and commercial lines.

No Such Thing was Hartley's entry into the so-called Indiewood sector. As described by Geoff King, Indiewood marks "an area in which Hollywood and the independent sector merge or overlap".[22] King argued that while Indiewood represents a distinct model of industrial integration between mainstream and independent sectors, the resulting output is marked by a compromised textual aesthetic, with a "mixing of elements of high and popular culture" marked to an increasingly urban and well-educated audience.[23] Jeffrey Sconce similarly located what he calls "smart cinema" in a comparable nexus: he referred to the sector as "an American school of filmmaking that survives (and at times thrives) at the symbolic and material intersection of 'Hollywood', the 'indie' sector and the vestiges of what cinephiles used to call 'art' films".[24] Sconce situated Hartley within this critical realm, pointing to *The Unbelievable Truth*, *Trust*, and *Henry Fool* as "postmodern screwball comedies".[25] While Sconce's positioning of Hartley in the modern tradition of "smart cinema" is perhaps the correct situation of his work in terms of recent trends in filmmaking, the Indiewood sector, as the place where Hollywood and indie filmmaking collide in industry practice and markers of textual distinction, has become a location for many of Hartley's contemporaries.

As such, Hartley's absence from this sector has been noted by several commentators.

Between 2005 and 2007, two separate interviews posed the question: "what (ever) happened to Hal Hartley?" In the first, from *New York Magazine*, Logan Hill quoted Hartley's description of a moment in the early 1990s in which a magazine attempted to bring together a prominent group of indie *auteurs* to capture a snapshot of the group:

> "I remember a magazine wanted to do a big photo spread with a bunch of us—Todd Haynes, Gus Van Sant, six or seven of us-the new indies," recalls New York's onetime next-great-auteur, seated at a long wooden table in the living room of his nearly empty West Village apartment. "Maybe I was just an asshole, but I refused to do it."[26]

Haynes (*Far from Heaven* [2002] and Van Sant (*Good Will Hunting* [1997], *Milk* [2008]) have both successfully worked within the Indiewood sector, matching critical plaudits with box office success and Academy Awards. Others, like Steven Soderbergh or Richard Linklater, have done likewise, mixing mainstream work with critical markers of distinction, or utilising box office success to pursue smaller projects with more artistic freedom (as Soderbergh in particular has done). Unlike these filmmakers though, Hartley's visibility has significantly receded since the release of *No Such Thing*. As he debated with Ryan Gilbey:

> "Certainly my following isn't as big," [Hartley] says in the corner of a crowded restaurant. "Nor is the response as intense." It's hard to pinpoint any particular downward turn in the director's fortunes. He never entered the mainstream like Spike Lee or Steven Soderbergh, nor invited the same enduring affection as Richard Linklater. But neither did he fall off the map as dramatically as Whit Stillman. To paraphrase Gloria Swanson in Sunset Boulevard, Hartley's films stayed the same—it's the audiences that got small. "Trends changed. I did, too. I think about it all the time. Whether my films do well or not, I end up scratching my head.[27]

Gilbey's contention concerning the difficulty in locating a change in Hartley's work or fortunes here are debatable. It seems clear that *No Such Thing* marked a significant shift in Hartley's work. As noted in the previous chapter, thematic concerns began to shift, while the play with genre is significant; although Hartley had done this previously with *Amateur*, the extent is much more pronounced in *No Such Thing*. In many ways, this blurring of generic mainstream standards and artistic markers of distinction is typical of the kinds of texts symptomatic of Indiewood, as explored by King. However, Hartley's point regarding changing fashions is key, because, with the growth of a more prominent Indiewood section, the audience share for independent features shrank significantly as Hollywood began to cannibalise the potential indie market.[28]

Despite his films displaying many of the markers of Indiewood features, Hartley appears to have disengaged from this sector altogether. Since the formation of Possible Films, Hartley's films demonstrate different concerns thematically but are most significantly unlike his earlier work in their visual stylisation. Whereas earlier films were pronounced in their focus on performing bodies, later work is much more visually stylised and concerned with performance of the image itself. The reason for this is a significant turn toward digital technologies. The films explored in this chapter were all shot digitally and have benefitted from online promotion and distribution via the Possible Films Web site. Although *The New Math(s)* and *The Book of Life* were produced before *No Such Thing*, they marked Hartley's initial forays into digital photography and demonstrate an aesthetic choice that he has taken into later works, such as *The Girl from Monday* and *Fay Grim*, as well as the collection of short works released in 2010 under the title of *Possible Films 2* (*PF2*). The latter collection of work, produced during Hartley's time living in Berlin, mark a partial turn back toward earlier interests, especially those from the time of *Flirt* and *Henry Fool*, exploring in particular issues of artistic production and activity. The films *Adventure* and *Implied Harmonies* (both 2008) also break new ground for Hartley, representing his first documentary works, although both focus on aspects of Hartley's

own life and work, especially *Adventure*, which reflects on his marriage with Miho Nikaido:

> In his article, "What is Digital Cinema?", Lev Manovich argues that the mutability of digital data impairs the value of cinema recordings as a documents [*sic*] of reality. In retrospect, we can see that twentieth century cinema's regime of visual realism, the result of automatically recording visual reality, was only an exception, an isolated accident in the history of visual representation which has always involved, and now again involves the manual construction of images. Cinema becomes a particular branch of painting— painting in time. No longer a kino-eye, but a kino-brush.[29]

Manovich contended that digital processing of indexical footage "redefines the very identity of cinema" and that "it loses its privileged indexical relationship to pro-filmic reality".[30] For Manovich therefore, the twentieth-century challenge to visual realism that Walter Benjamin saw in the difference between painting and photography, where the "painter maintains in his work a natural distance from reality, [but] the cameraman penetrates deeply into its web"[31] becomes obsolete. Benjamin's contention is reversed (although digital "film" makes the cameraman the equal of the painter after the footage has been encoded, edited, processed, and rendered), and the cameraman maintains a distance from reality. In a different approach to medium specificity, D. N. Rodowick argued that "new" media offers nothing new at all, "but only a multiplicity of hybrid forms linked by their basis in computational operations or automatisms".[32] Now filmless, film functions via a "cinematic metaphor",[33] rooted in "simulation and information processing used in reformatting old media as digital information".[34] The "new" of new media therefore becomes a lexical misnomer, because, although digital technology offers a myth of novelty and transformation, traditional film form holds sway in most digital cinema. Although the technology offers a break from traditional aesthetic modes, digital cinema "reformats" the old media of film (and television) into "digital information", as Rodowick argued. Manovich's contention is more radical, however, stressing

again a regression to older forms, but this time with a crucial break from the indexical ontology of the image. Both arguments interrogate the switch to digital media differently, one on a level of ontology and another from the perspective of time. In a similar fashion to Rodowick, Thomas Elsaesser maintained that

> the switch from the photographic to the post-photographic or digital mode allows moving images to "represent" time in ways not encompassed by narrative, hitherto the cinema's most familiar spatio-temporal support and indexical register. In which case, the moving image will have lent itself to the culture of telling stories only for a short while, a mere hundred years or so, before it began to move on.[35]

Cinema's capacity to embalm time[36] has long been held at the heart of the indexicality of cinematic imagery. Digital methodologies, however, provide a critical challenge to this. Manovich, Rodowick, and Elsaesser all see a return to earlier methods, although all point to the *potentials* of a digital cinema unencumbered by the faithful "recording", "rendering", or representation of time. For some, narrative temporality is transformed by shifts toward a "postfilmic" cinema; Garrett Stewart opined that cinematic narrative will be transformed by digitisation, where the cinematic is "less embedded in material succession" and inclined toward narrative tropes of "real time, random access memory, selective amnesia, virtuality". Crucially though, Stewart observed in the postfilmic a cinema that is not attempting to resist "the digital by wanting to turn back media history".[37] The positioning of digital media in Stewart's conception, between American and European "uncanny" cinema, may have resonance for the ways in which Hartley's career has been positioned, and, although his work does not concern itself with the temporal transformations of character-driven narration, Stewart's image of a cinema that does not wish to turn back the clock (even though many of the films in Stewart's book do so) can be thought to position Hartley's work with respect to the alterity of digital cinema for Hartley's aesthetic.

I have noted throughout this book that Hartley's style is rooted in a basic realism and minimal abstraction on the level of the image. Subsequent abstraction is found in performance that is developed through individual modes of performance or the relationship of narrative to image in scenes of performance. With the digital films, this begins to change substantially, and Hartley's work after 1999 (*No Such Thing* excepted) is significantly altered by his work in a digital medium. The "postfilmic" works, from *The Book of Life* and *The New Math(s)* onwards via *The Girl from Monday* to the *Possible Films 2* collection of short works are located in an entirely different aesthetic of dynamic imagery and increased abstraction. In many respects, Hartley's digital work is poised between the theoretical positions explored above. Hartley's films do not altogether delete the "cinematic metaphor" in digitised work, but there is also no substantial turn toward narratives of memory or virtuality, although *The Girl from Monday* does demonstrate some temporal transformation in the use of freeze-frames, at once a digital transformation and a memory of earlier cinema, particular the films of Chris Marker. What is perhaps most pronounced about Hartley's digital work is the hypervisual "painterly" aspect of the imagery, often marked by a pronounced digital "smearing", something evident from *The Book of Life* onwards.

For artists like Hartley, who has restated his independence throughout the last decade, the use of digital technology offers more control and financial independence. For Nicholas Rombes, the turn toward the digital is not simply marked by the forces of simulation and surface, but it displays a pronounced humanism, something very much shared by Hartley's films. As he asserted,

> digital cinema is, at its heart, democratic, at least for now. In these early stages, the messy mistakist aesthetic of digital cinema stands against the pure, uncorrupted rigidity of fascism. The introduction of "mistakes" into movies—which basically amounts to a human signature—is the most humanistic, the most tragic of things.[38]

Although it is perhaps difficult to see Hartley's work as "mistakist" in the truest sense, like the Dogme works for instance, the dynamic,

smeared images of Hartley's digital films are in some sense aesthetically "wrong", a consequence of the medium in which they were produced—digital video rather than film. Hartley's turn toward digital production is in keeping with many independent filmmakers looking to offer what Holly Willis refers to as "a very direct rebuttal to the film industry's corporatisation".[39] Hartley's "science-fiction", *The Girl from Monday*, for instance, fits with

> many independent filmmakers [who] have advocated a return to the "real", the organic and authentic, deploying consumer-grade technology, often in movies centred on the search for connection and identity in a world amok with the invisible threats of surveillance, control and cyber-domination.[40]

Although these are themes to which I will return, this situation of Hartley in contemporary independent production is significant. As many have used digital technology to resist the continuing "corporatisation" of Hollywood, and the ongoing "cinematic metaphor" of classical narration that is still the dominant aesthetic model, filmmakers like Hartley have utilised alternative stylistic and thematic concerns in digital works that return to the traditional romantic focus of independent cinema. New production and distribution methods mean that the democratisation that Belton was sceptical about, but which was embraced later by Rombes, is found in a filmmaker like Hartley, whose digital work transgresses even his usual concerns to explore new forms, such as documentary, theatre, and opera, and it offers new potentials to explore the moving image in ways that his earlier work does not. As I argued earlier, the digital medium has altered the central concerns of Hartley's work. The focus on physical, embodied modes of performance has given way to a much more general concern with the dynamic performance of the image. Although particular concerns with performance remain, physically in a film such as *The New Math(s)*, and of identity in *The Girl from Monday*, this becomes embedded in a much more visually mediated spectacle.

THE BOOK OF LIFE AND THE PERFORMANCE OF THE IMAGE

A commission from French television station La Sept Arte, as part of their *2000 par vu* series of films about the approaching millennium, *The Book of Life* documents the return of Jesus Christ (Martin Donovan) on 31 December 1999. Accompanied by Mary Magdalene (P. J. Harvey), Jesus has returned to open the final seals on the eponymous book (now a Mac Power-Book) to bring about the apocalypse. In a battle with the devil (Thomas Jay Ryan), over the soul of a charitable woman (Miho Nikaido), and struggling with his conscience, Jesus decides to save the world, and the new millennium arrives as he tosses the book into the Hudson River.

Holly Willis described the stylisation of Hartley's first digital feature (although a short feature at sixty-three minutes) as a "luscious faltering blur", "a gorgeous series of blurring, trailing images that convincingly establishes a new aesthetic direction for video".[41] While Willis's hyperbole is misplaced, as Hartley's aesthetic has not become the standard for digital video stylisation, where, as Rodowick noted, the "cinematic metaphor" holds sway, her description of Hartley's imagery is particularly apt. Willis quoted Jim Denault, the cinematographer who shot *The Book of Life* (the first feature on which Hartley did not work with Michael Spiller, who has since moved into direction and work in television):

> "Rather than trying to make it look like film, we went the other direction," he explains. "We wanted that Wired magazine, cyberpunk look…. it wasn't anything we'd ever seen before." One of the key adjustments that Denault used, or abused, for artistic reasons was the shutter speed. "There's a little switch on the camera called a shutter speed switch, and we set it at 15 fps [frames per second] or lower for the entire shoot." He continues, "One of the things that makes video looks so distinctively like video is the frame rate. In video, the screen never goes dark, as it does with film."[42]

The opening moments of *The Book of Life* are a perfect illustration of the aesthetic that Denault describes here. The opening journey from JFK

airport into Manhattan is marked by a slowness and overexposure of the image that blurs and becomes pixilated. As Jesus and Mary Magdalene travel through the tunnel toward the Long Island Expressway and on to Manhattan, the camera is noticeably handheld and the image is unstable. The lighting in the tunnel stretches and blurs, a whip pan left from Magdalene's face to Jesus blurs the images of the actors' faces as the objects stretch in the shot. The shots also have a noticeably green tint to them, and light from behind the car bleeds into the frame. The slow frame rate that Denault describes above is immediately noticeable. The colours are desaturated (this is not new for a Hartley film, as his work has regularly been desaturated, but previously this was also an effect of the settings as well as the shooting style), and light is overexposed. However, what is most distinctive is the blurring of the image. The handheld camera adds to this instability, as it is much more mobile and reframes more regularly than any of Hartley's previous works, which are marked by a much more studied, minimalist sense of composition and lack of camera movement. The trip through the tunnel at the beginning of *The Book of Life* is interspersed with brief close-ups of cars' rear lights. The red of the lights blurs outside the edges of their frames; camera movements, movement within the frame and brief tilting down, leave a trail of red light as the slow exposure of the camera results in motion blur when the camera moves or objects pass before it. As the car leaves the tunnel, the film cuts to abstract shots of the surrounding scenery; a canted angle gazes at trees and concrete, the objects blur in the frame to the point of indiscernibility until the camera pans and tilts down to the road. Hartley cuts from here to a tracking shot past a line of trees. Although much more distinct in the distance, the trees in the background blur slightly, and in the foreground other trees smear quickly past; the colour is washed out and notably dull. The next cut returns to the inside of the car, shot in tight close-up, the faces of the two protagonists blur as the handheld camera and their bodes jolt with the movement of the vehicle. At points, the image is so slow that traces of outlines of faces are left by the movement of bodies (figure 22). The scene cuts back outside to long shots of New York in the distance shot with a golden filter; from an image of the

FIGURE 22. The blurring of the image de-emphasises the lines of the body, making the actors blur into backgrounds as active objects in the digital frame.

skyline (with the World Trade Center central), the scene cuts to shots of signs and bridges, once more blurring with movement from the hand-held camera.

The opening of *The Book of Life*, one of the earliest features shot entirely on digital video, is a strong example of Rodowick's contention that digital media "reformats old media as digital information". In many respects, the "cinematic metaphor" holds sway, as the visual and editing construction of scenes follows conventions of continuity editing and narrative development. What is significantly altered though is the composition of the image as digital information. The blurring and pixilation of the image testify to its digital source. Indeed, at the point at which Dave is introduced he looks up at the sky to see a plane flying overhead. The image fragments and becomes pixilated, breaking explicitly into large square blocks, as though the analogue is breaking down into digital information. For Dave, this is a premonition of the approaching apocalypse

that he has reading about in the newspaper. For Hartley, it represents an inherent intrusion of the digital, as the image becomes literally digitised; old media—a conventional point of view shot—is reformatted as digital information. Not all of the film is this extreme, however, and the film uses a mixture of aesthetics, at times using a faster documentary look of digital video with the camera canted but locked off and a more natural, brighter look to the lighting and image. At others, the stylisation is much more overt, green and gold filters are often applied, there are shifts to black and white, while lighting burns out on the screen, often extremely overexposed in blazing orange or blinding white. What is crucial and obvious is that the digital source of the photography has a telling effect on the look of the cinematography and the stylisation of the film. Hartley has commented on this effect, and he is notably demonstrative about the efficacy of digital technology on his imagery:

> If *The Book of Life* was shot in film, it might remind us much more of *Surviving Desire*, for instance, because a lot of the dialogue scenes are constructed the same way ... I'm not so interested in DV becoming as "good" as film. I'd rather allow it to have it's [*sic*] own characteristics and to use it in a way that takes advantage of those characteristics.[43]

Hartley here testified to that which was discussed earlier concerning the "reformatting" aspect of digital shooting. As he noted, the construction of dialogue scenes is reminiscent of earlier work, with close-ups and two-shot mid-shots like those used throughout *Surviving Desire*, although, unlike the earlier film, the camera is significantly canted throughout *The Book of Life*. Digital modifications are also noticeable in other sequences, such as the opening, or in the moments where Jesus opens the fifth seal on the *Book of Life's* PowerBook screen, with the images smeared and streaked across the screen, while other shots are tinted gold, especially the canted, upward-tilted shot of Jesus against the Empire State Building, one half of the screen in naturally filtered colour, with the Empire State Building filtered gold to the right of the frame. So, while the dialogue scenes might be constructed conventionally (in a "cinematic metaphor"), the digital

video source has a significant causative effect on the aesthetic of the film. In chapter 1, I mentioned this film as a key example of Hartley's fore-grounding of fictionality and the constructedness of the film text. How-ever, the film is also a really significant turning point in Hartley's career. There is a definite aesthetic break in Hartley's work (with the possible exception of *No Such Thing*, which stylistically is much more in keeping with the minimalism and compositional sense of earlier work, which is perhaps expected since it was shot by Spiller, in his final collaboration with Hartley) from this point onwards, and a turn toward a concern with the surface of the image. As Hartley noted about his engagement with digital photography: "shooting *The Book of Life*, I felt a lot of the images we were making were just eye-candy. I was having fun, but I was some-times embarrassed by how easy it was to make really cool images".[44] Whether the images are described as "cyberpunk" or just "really cool", it is undeniable that the digital has had a telling effect on the stylisation of Hartley's work, and many of the works after *The Book of Life* are much more hypervisually mediated; this is perhaps to be expected, however, because Hartley's thematic concerns have shifted in *No Such Thing*, *The Girl from Monday*, and also his play *Soon*, toward notions of mediation and the cultural role of the media. The recurring presence of microphones held by manipulators in *Soon*, *La Commedia*, and Hartley's music video for Beth Orton's *Stolen Car*, as well as the microphones that Satan con-veniently finds in *The Book of Life*, form another sign utilised by Hart-ley to signify mediation and dissemination. The visual spectacles of the digital works do something similar, as Hartley becomes more concerned with critiquing the ways in which images and narratives are mediated as means of control and domination.

THE NEW MATH(S) AND THE PERFORMANCE OF "DYNAMIC SPACE"

The New Math(s) does continue along this trajectory, exploring control and domination, although that notion of control is secondary to the con-cept of the piece. Produced in 1999 in collaboration with Dutch television

for the BBC's *Sound on Film* series,[45] the short film was a collaboration between Hartley and the Dutch avant-garde composer Louis Andriessen. The film, a performance piece lasting fifteen minutes with no dialogue, was described thus:

> Two students and their teacher seem to be fighting—literally— over the proper solution to a complex mathematical equation. Is it the key to time and space or a coded instruction manual about their own secret urges? An alchemical action movie? A real life cartoon with original music by Dutch heavyweight Louis Andriessen. Hal Hartley fashioned this piece of fight choreography with three of his recent performers/collaborators, Miho Nikaido, David Neumann, and DJ Mendel.[46]

Set principally in a classroom, the film juxtaposes the precision and structure of mathematics and music, with the frenetic movement that threatens to disrupt the perfection of mathematical structure and reduce it to chaos. At the beginning of the film, the teacher (Mendel) arrives in his classroom, presumably to teach a maths class; he finds only one pupil, a young woman (Nikaido) awaiting him. However, before he acknowledges or addresses his pupil, he is distracted by a complex equation written on the blackboard. He searches through books perplexed, unable to solve the problem. Struggling to discover the solution, the teacher is interrupted by the arrival of a second pupil (Neumann), who arrives in the same elevator from which the teacher had emerged, his movement mirroring that of the teacher's arrival. The teacher, meanwhile, still flummoxed by the equation, flees the classroom to take solace in the bathroom where he proceeds to meditate on the mysterious problem. What ensues is a violent chase narrative that threatens to challenge the precise nature of the mathematical metaphor that lies at the heart of the film, which for Hartley, as he states in the film's introduction, lies between "the precision of mathematics and the craziness of kung fu".

In the introduction to the film screened on BBC TV in March 2001, Hartley commented that the film is based principally on his initial reactions to Andriessen's music, which for him conjured images of

"mathematics" and "fun". Andriessen meanwhile sees these concepts as fundamental to Hartley's films, such as *Amateur* and *Simple Men*, but he contends that *The New Math(s)* belongs to the cartoon approach to filmmaking, which he stresses is the "most profound" form of film, as "it doesn't even pretend to be real". Not only does this film utilise tropes of the cartoon, especially smearing of the image, but the violent performance of the martial arts film, where the spectacle of the body performing is central to the pleasure attached to the genre. Performance is at the heart of the conceptualisation of the film, as this excerpt from the rehearsal notes testifies:

> Our aim is to interpret each action described in the script in the most physical way possible. That could mean perfectly still as well as moving fast and violently. But the violence is casual. Expressionless, but fluid and easy. Graceful. Wonder. A childlike curiosity about what you can do with your body and the mysteries of math.[47]

Much of what Hartley outlined here can be tied to the cartoon, especially: the "most physical way possible", "perfectly still", "moving fast and violently", "casual" violence, and "fluid and easy" all carry connotations of the cartoon. Bodies in the cartoon move fast and fluidly, often literally fragmented and disrupted through violence. *The New Math(s)* takes this metaphor into its own physicality, fast and fluid movement disrupting the stability of the narrative and the "precision of mathematics". A great deal of this is signposted in the music, with electronic dissonance and motifs of travelling, sometimes in juxtaposition with the imagery of the film where movement and music do not match. The central performances in the film extend Hartley's interests in dance (Mendel and Neumann have appeared in several of Hartley's films subsequent to *The New Math(s)*), and they follow patterns of repetition and performed violence that have been seen in earlier works. However, as the film is a short rather than an embedded scene in a longer narrative, the dance is much more closely integrated with its narrative than scenes in other works, such as *Surviving Desire* and *Amateur*. What remains is the

consistent focus on performance and performing bodies from those ear-lier works. Altered, like in *The Book of Life*, is the digital stylisation and the increased use of canted angles, which feed into later work also.

The stylisation of the film, especially the kind of digital smearing used in *The Book of Life*, reinforces the cartoon aesthetic. The imagery lacks visual stability. Therefore, the image itself is granted a sense of movement, not just the objects that are represented. There is a slight breakdown of visual coherence in the images that often makes the quick-est movements of the performers, especially in the film's kung fu fight sequences (like many Asian martial arts films, this performance is closer to dance than it is to formal fighting technique), blur. The smearing of body motion at these points increases the precision of the mathematical structure of time (there are repeated shots of clocks in the film that rein-force the focus on temporality) and space, granting the image a dynami-cism of its own: it "moves" independently of the objects within its frame. This is an example of what Aylish Wood, in *Digital Encounters*, describes as "dynamic space", where "the presence of dynamicism within a shot yields a different kind of space, one requiring another conceptualization of effect-based elements in the organization of narratives[:] ... dynamic space emerges when digital effects give extended movement to spatial elements".[48] Although Wood is discussing digital computer-generated special effects, the principle can be applied to this instance in Hartley's film, where the digital effect is on the surface of the image rather than within it. The digital smearing of the image generates a dynamic space, where the digital stylisation introduces "a particular kind of spatio-tem-poral dimension into the narrative".[49] The smeared images contradict the sequence in the narrative, the precision of mathematic logic combined with the "fun" kung fu sequences that disrupt the stability of the narrative and its spatialisation. Space becomes dynamic particularly at the point at which the action is at its most dynamic. Instead of a surface effect, the digital smearing introduces a different "spatio-temporal dimension" that disrupts the equilibrium of the narrative and its spatial stability.

Temporality is a key theme in the film. A shot of the clock becomes a recurring motif, as do shots of the elevator's turning wheel and circularity.

The initial shots of the clock, from the point of view of student and teacher respectively, are marked by jump cuts, cutting closer each time, to emphasise this particular theme. This mathematical structure does not reach a conclusion, but instead reverts to its beginning, doomed to begin again in some implied eternal return. In some respects this is very closely linked to the motif of the apple, with its obvious biblical connotations of forbidden knowledge, and a Catholic inability to erase guilt and sin. Additionally, the focus on visual and narrative tropes of repetition is in keeping with Hartley's interest in repetition across his oeuvre, where narratives have often resolved in a circular way, like *Simple Men*, rather than achieving resolution in a linear fashion. Like the spinning wheel of the elevator mechanism, the classroom wall has a rotating fan embedded in it—the fan functions as a visual symbol of that circularity. At several points in the narrative, Hartley used a repetitive sequence of shots to show the mechanism of the elevator both stationary and in motion. The first time we see the sequence, the wheels of the mechanism are stopped. The female student is in the elevator, where she discovers an apple stuck to a mathematical equation. She starts to take a bite but stops. Paradoxically, this is the apple that she has already bitten into when she solved the equation in the classroom before writing another in the bathroom. Meanwhile, the teacher and male student are in the bathroom attempting to solve the equation that the female student has left in there. This marks a period of stasis in the narrative, signified by the lack of movement not only in the wheels of the elevator's mechanism, but also in the bodies of the performers. So far, the students have fought with each other (when the female one has rejected the advances of her peer); the teacher has fought with the female student (after she solves his equation—she will later write it on the blackboard); and the teacher has fought with the male student (after he erases the solved equation from the blackboard). Here, body movement is stilled—"perfectly still" as opposed to "moving fast and violently"—echoing the stillness of the mechanism of the elevator. The male student makes motions toward the equation but is waved away by the teacher. Finally, they move in unison, silently marking beats as the teacher counts on his fingers.

FIGURE 23. The mirroring of movement in the dancing bodies stresses a focus on repetition and a gendering of female agency.

The mechanism begins to move on the first repetition. The female student turns a switch to ON, which begins its movement. This occurs at the point at which the teacher is about to make an attempt at solving the puzzle left by the female student. He tentatively reaches out to touch the mirror as if reaching out into the unknown. Disturbed, he and the male student embark on a chase to find the female student. In a *tour de force* shot, Hartley frames the two male characters on rooftops running up and then down before crouching and looking around in perfect unison; below the female student drifts by between them (figure 23). The mirroring movement here stresses a gendering of the narrative. The female has agency in this respect. She stimulates narrative movement here (literally in the case of the ON switch), while the two male characters are merely playing catch up. This is linked to the symbol of the apple. Although we initially see it held in the hand of the male student, it is ultimately empowered by the female in its biblical significance as the symbol of ultimate and forbidden knowledge. Once the audience become cognizant

of the repetition in the narrative, where past becomes future and future the past, the symbol of the apple becomes linked to the female in the narrative, where it is empowering, while, as is typical for Hartley's work, the masculine descends into chaos in pursuit of the female, out of control and "simple", to echo an earlier film's title.

A fight ensues, the image smearing dynamically to remind us of the cartoon again,[50] before the narrative impetus is lost again. The mechanism is now seen to slow and stop. Then, the male student steals the apple from the female student (illustrating how he comes to be in possession of the apple at the "beginning" of the narrative). The mechanism begins to turn again. The scene then returns to as it was at the beginning of the narrative, presumably ready for this to happen all over again. The final images of the film show the mechanism slowing and stopping in a series of overlapping shots. Cutting from a point-of-view shot from the perspective of the female student, a sequence of shots of parts of the mechanism stopping is presented from four different angles, the sequence overlapping rather than cutting in sequence. The narrative therefore delivers a final stasis, but that stasis is the initial state of the narrative at the outset. The repetition therefore emphasises the temporality of the narrative, from stasis to movement and back again in relation to the central narrative motif of circularity, its key symbols, the apple and the mathematical equations, and the gendered protagonists. The female student, in conjunction with the apple, holds the significant narrative agency, stimulating the narrative by eating the apple, while the two male characters are stumped by both equations, one even destroying the first equation (which the female character writes again at the end of the narrative), as well as fighting with each other, quibbling over the equations and leading the chase for the woman. As so often happens in Hartley's work, the female offers a stable centre of the narrative, whereas the masculine performance descends into chaos and futility. In many respects, *The New Math(s)* is one of Hartley's most typical works, one of the most fully realised short works as well as a clear distillation of the digital stylisation that has become a predominant concern in the works produced since his first foray into digital work in the late 1990s.

THE GIRL FROM MONDAY
AND THE ROMANTIC PERFORMANCE OF STILLNESS

Hartley has reflected more recently on the main changes in his work; at the end of the book of interviews with Kenneth Kaleta, discussing the changing tone of difference and the celebration of the outsider in his work, Hartley noted that

> the hero's difference is much sadder for me now than before. *No Such Thing* and *The Girl from Monday* may be more emotionally accessible, but I've definitely outgrown, somehow, my enthusiasm for celebrating the outsider's lovable difference. I take that for granted now. I'm more concerned with what—exactly—they have to survive.[51]

The notion of emotional accessibility in Hartley's work reflects some of his earlier comments regarding *Henry Fool*, about the more emotionally "obvious" tone of the film. Nevertheless, the tone of his dialogue and the performance style of his films have long been a blockage for contemporary audiences accessing his work, with the often remarked "quirkiness" being the common critical response to Hartley's work. Where there is a key change in Hartley's work, as it is difficult to see a wholesale change in his approach to dialogue or the "deadpan" manner of delivery of his actors, is that shift he notes from celebrating the difference in the outsider (this is very close to Hartley's fondness for Godard, especially *Bande à part*) to the struggle of the outsider. In the two films he mentions, the struggle is often both internal and with bigger social and cultural forces. In *The Girl from Monday*, this is capitalism itself and the increasing commodification of sex, knowledge, and bodies.

Hartley's notes for *The Girl from Monday* describe it as "a fake science-fiction movie about the way we live now".[52] The film utilises a number of science fiction tropes, although is more an art film than it is a sci-fi blockbuster, featuring an observer Other from another planet (evoking John Sayles's *The Brother from Another Planet* (1984) and an Orwellian society of oppression, domination, surveillance, and capitalist totalitarianism. The film is set in the near future; the "Great Revolution"

has come to pass and the "liberated" state of New York City has been seized by Triple M, the Major Multimedia Monopoly, bringing with it the "Dictatorship of the Consumer". The Dictatorship promises citizens all the freedoms of liberal capitalism, of technology, personal freedom, and liberty. The film's protagonist, Jack Bell (played by Hartley regular, Bill Sage), works for the advertising agency that helped sweep Triple M to power. Jack is responsible for a policy known as the "Human Value Reform Act". The Act sees all individuals floated on the stock exchange; every time the individual ("an investment with growth potential") has sex and remains unattached, his or her credit rating increases, depending on the state of the market, under the logic that the "most sexually active and sexually available adults are the biggest spenders". Sexual activity for reasons other than financial gain (pleasure, love, perversity) are prohibited, and, if caught, "criminals" will be heavily punished by the worst means possible—teaching high school. Horrified by the implications of his Act, Jack is also the leader of a counterrevolutionary group that leads action against Triple M by distributing copies of contraband literature (Thoreau's *Walden*), attacking the state-owned media, and having sex "because they feel good". Into this scene, drops "the girl from Monday" (played by the Brazilian model Tatiana Abracos, whose exotic looks highlight her otherness), an alien from Star 147X in the constellation Monday. The girl, who takes the name Nobody, begins to learn how to use her body. If she stays too long, she will be stuck forever, like those who came from Monday before her.

As I discussed in chapter 2 in relation to *The Unbelievable Truth*, the commodification of the body is a theme that Hartley has addressed in the past; namely, Audry's negotiated passage through the adult structures of commerce in the effort to keep her end of her bargain with her father. That film engaged with the problematic relationship between a deep-rooted American mythology of self-reliance, community, and economic self-interest in the context of 1980s Reaganomics. Baudrillard's comment that objects are "controlled, not by natural ecological laws, but by the law of exchange value"[53] was cited as an example of the ways in which bodies and individuals are designated as commodities. The same

becomes true of *The Girl from Monday* in which contemporary economics, this time in the context of the late 1990s/early 2000s economic boom, attributes economic value to the body of the individual. The intertextual reference to Henry David Thoreau's *Walden* (the subtitle of the book is *Life in the Woods*), which documents that author's two-year contemplative isolation near Walden Pond in Massachusetts, promotes a similar conceptualisation of an attachment of natural "laws" rather than economic "laws". The book is a romantic meditation on nature and spiritual self-discovery away from the modernisation of the Industrial Revolution. The first chapter of the book is titled "Economy" and comprises Thoreau's reflections on the economics of contemporary society and his economic survival in isolation; among other subjects he critiques and castigates are philanthropy, the "virtues" of poverty, and slavery. In addressing the growth of the industrial factory, he notes that "as far as I have heard or observed, the principal object is [of factory manufacturing of clothing], not that mankind may be well and honestly clad, but, unquestionably, that the corporations may be enriched".[54] The resonance with the central focus of *The Girl from Monday* is clear concerning the exploitation of human suffering and labour for commercial gain.[55] The essentialist and romantic content of the book also has resonance for the inhabitants of the film, where relationships, bodies and, social interaction are dictated by capital; "not by natural economic laws" to return to Baudrillard. Thoreau's return to nature and his critique of the industrial society is a romantic touchstone for the inhabitants of Triple M's New York.

Cecile (Sabrina Lloyd), Jack's colleague at the ad agency and the initial object of his affection, is drawn into the political struggle by her interaction with Thoreau and her sexual interactions with both Jack and William (Leo Fitzpatrick), a seventeen-year-old counterrevolutionary, with whom she becomes involved; it is after her sexual transaction with William that Cecile is sentenced to hard labour in a high school, having failed to register the encounter with the stock market—she is contradictorily sentenced for "engaging in sexual activity that robs the Revolution of its right to personal value. Generating no income for the

common cause, which is the autonomy of the individual. Gross imped-
ance of human potential for progress, a blow against a thriving economy,
an inconsiderate perverse insistence of one's own selflessness". Again,
echoing *The Unbelievable Truth*, the contradiction of capitalism and the
American ideology of self-interest ("the autonomy of the individual")
and common good ("a blow against a thriving economy") are reflected in
Cecile's "selflessness". Freedom is juxtaposed with the laws of the econ-
omy, where that freedom is a commodity with economic value under the
revolutionary order of Triple M's ascendancy. It is subsequently in high
school that Cecile is given *Walden* by William.

The high-security high schools of the film (echoing the concerns with
gun crime and inner-city youth violence that are embedded in Ameri-
can culture, especially following the Columbine shootings of 1999 in
which twelve students and one teacher were killed by Eric Harris and
Dylan Klebold) are mental prisons, where students are highly medicated
with attention deficit drugs, and are educated through "virtual reality
PlayStations", in a system intended "to screen out the smart kids, and
keep the rest as dumb as possible", according to Funk, the corrupt prin-
cipal. Abnormal achievement, such as that demonstrated by William,
can only mean they are "immigrants", counterrevolutionaries sent from
Star 147X. In this environment, Cecile discovers *Walden*. All of the high
school scenes are shot in black-and-white as part of an overall distancing
effect in the film. The school-prison scenes are drained of colour, fitting
with the model of extreme conformity of the environment. Subsequently,
the ad agency intends to place vending machines of high-caffeine drinks
into the school to stimulate the students to create panic and distraction
for the populace.

What is outlawed, however, is personal expression: certain texts, like
Walden, are outlawed as "expression deemed malcontent, anti-social,
cynical". The Web is configured personally (given the growth of social
networking and personalisation of ad space after the film was made,
this is particularly relevant) to identify users and tailor online experi-
ence to individual emotional states and therefore to promote commer-
cial growth. Books are considered counterrevolutionary—"something

you could hold in your hand, read on your own, think about in private: this was considered elitist, immoral and bad for business". After introducing the students at the entrance to the school, surrendering guns and being checked by security scanners, we see them in the classroom, virtual reality helmets on; they move silently, choreographed in unison. They reach their hands up toward unseen virtual objects, their learning conducted in slow, uniform silence. The virtual here is reflected in the actual, where the movements of Hartley's performers are choreographed to express similarity. I noted in chapter 3 that dance has a communal aspect, where the "folk" number expresses community and inclusivity. Here, that inclusivity becomes conformity and control. The students are rooted in the virtual, linked to the corporate, where the uniformity of their movements translates to a minimisation of expression—there is no joy, no spontaneity, just the uniform movements of similarity. Performance therefore performs a different function here. There is a dance-like quality to scenes throughout the film (one of the soldiers is played by David Neumann, the film's choreographer): dance that plays partly with genre conventions, as well as with the rhythm and patterns common to images of totalitarianism.[56] Over the images of students in virtual reality helmets, Cecile reads from *Walden*'s final paragraph: "but such is the character of that morrow which mere lapse of time can never make to dawn. The light which puts out our eyes is darkness to us. Only that day dawns to which we are awake".[57] Juxtaposed with the images of students blinded by virtual reality and the information culture of the Internet, Cecile's awakening through literature and the romantic text of *Walden* is clear. The contraband literature becomes a key article in the text, smuggled from Cecile to one of her colleagues, Rita, Convict 13K/2 (Juliana Francis).

In some regards, the use of *Walden* here is similar to the use of *The Brothers Karamazov* in *Surviving Desire*. There is one sequence in particular that is very similar to that earlier film.[58] At one key stage in the film, Convict 13K/2 is reading a passage from *Walden*. She reads in voice-over over the images of Jack being ejected from the ad agency after Abercombie has denied him protection; while Nobody selflessly

FIGURE **24.** Reminiscent of scenes in *Surviving Desire*, the choreography of student violence is blurred to emphasise the dynamicism of movement and the frenetic social scene.

gives herself to Funk so that he can increase his stock by having sex with her, a guard also aggressively has sex with her, the image smearing in black-and-white; and, having drunk the high-caffeine drinks now in the school, the students riot. Rita sits in the middle of a medium-long shot as we see her read, while all around her the students fight; some pop up behind her with guns, while some streak in and out of a shot (figure 24). Meanwhile, she sits still, slowly turning pages and reading. Again, the shot is highly choreographed. The black-and-white image streaks, shot with a low shutter speed; Rita's lack of movement contrasts with the hyperkinetic violence around her. She reads from *Walden*:

> Let us spend one day as deliberately as Nature, and not be thrown
> off the track by every nutshell and mosquito's wing that falls on
> the rails. Let us not be overwhelmed. Weather this danger and you
> are safe, for the rest of the way is down hill. If the engine whis-
> tles, let it whistle till it is hoarse for its pains. If the bells ring, why

should we run? We will listen to the music they make instead. Let us settle ourselves, and work and wedge our feet downward through the mud and slush of opinion, that alluvion which covers the globe, till we come to a hard bottom and rocks in place, which we can call *reality*.[59]

The images of violence, chaos, abuse, and crisis on-screen (this is once more echoed by the visual stylisation of the unstable, dynamic image) are contrasted with Rita's passivity, her retreat into *Walden*, into the romantic "Nature" of the novel, denoted by her centrality in the image. Rita's passivity is not a political or narrative passivity, but an avoidance of the aggression in the imagery: "If the bells ring, why should we run?" Like the final dialogue in the film, when Nobody returns to the ocean and to Star 147X (and returns to her No-Body-Less state), watched by Jack, who chooses not to return to his home star, Rita is engaged in resistance, an avoidance of the excessively corporate, overcommercialised state that turns the material of the body into the material of economics. In the last line of his voice-over, Jack says, "I hope, and I try, to resist. Even me, whom no one needs pity, even I can see this now. What humans do, trying". Rooted in the intertextuality of Thoreau, the political resistance and romantic attachment to nature and beauty, opposed to advertising and commerce, is the final note of optimism in the film. Romanticism and artistic expression oppose, again romantically, the oppression of commerce and the systematic assault on freedom, love, and value without economic worth.

Hartley's take on "the way we live now" is a playful experiment with generic tropes, although its stylisation is perhaps its most experimental facet. Introduced as "A Science Fiction by Hal Hartley" in the credits, the film is a "fake science fiction" film that avoids many of the conventional tropes of the genre, such as spaceships or special effects. In many regards the film is reminiscent of French New Wave approaches to the genre, such as Jean-Luc Godard's *Alphaville* (1965) and Chris Marker's *La Jetée* (1962). *The Girl from Monday* shares with both films a concern with form. Like the previous digital films made by Hartley, the film exhibits a similar smearing of the image. Again, like *The Book of Life*,

this is due to the reduced shutter speed used to shoot the film; every single frame of the film was shot with a slow frame rate.[60] In addition to this, the film also exploits differing tonalities of colour throughout, where shots were often filtered for a tonal effect: "A wintry cityscape might progress from rose to burnt orange, or a suicidal Jack might be filmed with sallow yellow and green. The choice was dictated by content and intuition".[61] Again, this is very in keeping with the stylisation of other Hartley works, where colour, especially reds and yellows, burn on-screen over a New York in turmoil. Sarah Cawley, the cinematographer who shot the film, noted that the overall aesthetic was "an alienated, urban future, where people are very estranged from each other, even when they are in close proximity".[62] This fits closely with the urban modernity of *Alphaville*, whose ultramodern concrete surfaces testify to an alienating urban landscape in which the highways, corridors, and Modernist architecture of Paris stand for the aesthetic of the future. *The Girl from Monday* is slightly different, and the otherworldly environment is located outside the city in nature. This is where Jack repeatedly returns to replay his attempted suicide, where he finds Nobody and where she returns home. This recurring return to nature is in keeping with the film's romantic attachment to nature, but it also offers this in juxtaposition with the alienated urban spaces of the film's cityscapes.

The film is one of Hartley's most abstracted and alienated works. Hartley has pointed out (in the film's making-of documentary) that the science fiction conceit of the film allows him to explore several themes without a significant amount of depth. However, he has also confirmed in interviews that what is central to the film's concept is its distanciation and alienating effects:

> my real interest is, as always, how we are now. But sometimes we need a distancing effect, to help us see the contradictions inherent in our shared experience. I think this is a very realistic movie about the way we live now. Simply the decision to tell it as if it were a science fiction movie, how the people talk as if they're in a science fiction movie, should necessarily create this disconnect, which is a way of thinking about what irony is, this awareness

of this disconnect about the way we perceive the world and this momentary view of a different way of looking at the world.[63]

Again, this returns us to earlier concerns in Hartley's work, and the influence of Brecht (and Godard) on his work. The science fiction tropes are essentially distractions (hence the "fake") that create a distancing effect. The dialogue, as well as the dystopian setting, evoke, but do not equate to, the science fiction, which, like the musical sequence in *Surviving Desire*, is "shorn of classical ... genre tropes".[64] The distancing effect brings into focus a key theme of Hartley's work, namely, the ways in which people struggle to communicate. In earlier works, this was often handled by utilising circular structures of repetition in dialogue that effaced communication;[65] however, here the science fiction codes worked into the dialogue stress a lack of realism in the characters where genre tropes create an alienating effect. Additionally, the highly choreographed and stylised performances by generic characters such as the soldiers reinforce this effect, along with sequences of violence, that are performances, generic performances to boot, which contribute to the alienating effect.

The final key element of the film's stylisation, and perhaps its most significant, is the use of freeze-frames throughout to abstract key moments and determine a particular structure of time and memory in the film. The key referent of the turn to still images, always in black-and-white, is Marker's *La Jetée*, a science fiction "photo-roman" about a postapocalyptic Paris in which a man is experimented upon by scientists looking to perfect time travel. The man goes back in time to an earlier idyllic Paris; he falls in love. Upon his final return, he returns to Orly airport, where he witnesses his own death. This image that has haunted him from childhood, and he realizes finally that this image of the death of a stranger was in fact his own death. In *Chris Marker: Memories of the Future*, Catherine Lupton argued that

> *La Jetée* recognizes that memories become memories "on account of their scars"; their intensity is directly related to the proximity of trauma and loss, and the paradoxical function of memory is

both to shield the subject from this trauma, and to expose them to its presence. In Marker's film the founding memory poses the enigma of the hero's self-hood, which turns out to be his own annihilation.[66]

Whereas, for Marker's protagonist, the memory is finally actualised in the traumatic realisation, upon death, of the meaning of the memory that has haunted them, for Hartley's protagonist, the memory is becoming actualized in the narrative's succession. The key sequence in the film that uses still images is the recurring moment of Jack's attempted suicide. The sequence is repeated shot for shot three times with some difference. First, when Jack attempts the suicide: the sequence repeats key shots; a long shot of an attendant at the car hire center; a close-up of Jack's wrist barcode being scanned; a line of dialogue asking for a mid-size car; a close-up of Jack's face as he drives across the bridge; the moment when Jack gets the gun from the woman in the red and white dress. The images still at key moments: in a close-up of Jack just before he raises the gun to his head, and of the moment at which he points the gun at his head. The frame freezes and the colour quickly drains from the image. This is essentially repeated twice more, once explicitly as a memory, and finally when Jack takes Nobody to the ocean to return her home. Although in this final instance the narrative moment is different, the keys shots and dialogue are repeated. For Jack this moment is a key memory for him, a point that marks "the hero's self-hood", but which also determines his annihilation. At the heart of his subjectivity, Jack has forgotten his origin. Although he fulfils his role as a counter-revolutionary, his origin as an "immigrant" is forgotten, because he has become addicted to humanity. His embodiment (and he is the architect of the economic function of material embodiment) defines his new self-hood, so to return to this moment is his defining memory-image. As Bergson argued, "the memory of the past offers to the sensory-motor mechanisms all the recollections capable of guiding them in their task and of giving to the motor reaction the direction suggested by the lessons of experience".[67] The freeze-frame images, while they locate a

relationship between trauma and memory, also actualise the process of memory within the narrative. As a voice-over-heavy film, *The Girl from Monday* is already inscribed with a particular past-ness (as all films are), but it also has a register in the past tense. Individual moments become memorialised: Jack investigating the counterrevolutionary attack on Triple M's distribution centre; Jack and his medical contact investigating the high- caffeine drinks being stormed by Triple M soldiers; William's death. With William's death, the sequence is not a montage of frozen images, but a single shot that periodically freezes as his body falls, intercut with close-up reaction shots of Nobody, Cecile, and the soldier who killed him. Trauma becomes inscribed as memory, and while the degree of frozen images is not equivalent to that of *La Jetée*, the photographic slides in the moving images inscribe trauma at the level of memory for the protagonist as he recounts the story, presumably from a later moment in time. As an "immigrant" from a noncorporeal temporal-spatial frame, Jack, we can assume, is not simply moored by physical and temporal laws of succession, and the return to earlier moments, or the inscription of the past into present becomes a narrative frame that produces a different temporal effect into the narrative.

Charting the historical shift in frame(d) time, Garrett Stewart argues that in the shift from photo to slide to film to pixel ("photo/slide/film/pixel"), different levels of narratographic time are evoked: "The past will not die. Photographic tracing is time's memory work, in this case the return of a suppressed event".[68] While the events of *The Girl from Monday* are not specifically "suppressed" but given motor extension, "the past will not die in the film". The digital stills in this miniDV feature do "memory's work", a memory of cinema along digitised lines, and narrative memory. The "cinematic metaphor" is not avoided entirely, while the photography becomes a memory trace located within the "present" from an as yet unactualised future. Digital cinematography does not liberate the narrative altogether from linearity, although the manipulations provided by digital photography, editing, and postproduction incorporate different approaches to the temporality of narrative, as well as demonstrating a further example of abstraction and alienation in Hartley's

work; although it must be said that the degree of experimentation in *The Girl from Monday* is perhaps much more so than any of his other work to date.

FAY GRIM AND THE PLAY WITH GENRE

The same cannot be said, however, of *Fay Grim*. Although there is some manipulation of the image, including montage sequences of freeze-frames, the degree of abstraction in this film is much less than in previous films. Shot in high-definition video, the film returns very much to a film aesthetic rather than the smeared digital aesthetic of previous films shot on miniDV. As such, there is a much more conventional look to the film—in many respects a return to earlier Hartley work—with HD video substituting for 35mm film. This is a complete return to the cinematic metaphor. However, this is to be expected in what is a sequel to *Henry Fool*, which has been described as Hartley's *The Empire Strikes Back* (Irvin Kershner, 1980), as the second part of a projected saga.[69]

In the last chapter, I asked several questions of *Henry Fool*'s final shot. The discussion noted how the absence of meaningful spatial and performative contexts produced a significant ambiguity in the way in which the narrative resolved (or did not). Where is Henry in relation to the terminal? Where is the plane? In which direction is he running? Hartley had contended that this ambiguity was not a result of intention in the screenplay but was developed in editing. In many respects, however, it is this ambiguity that provides the initial impetus for the narrative principle of *Fay Grim*. The film picks up the narrative eight years later than the events of *Henry Fool*. Henry has been missing since he fled the country for Sweden posing as Simon, who was sentenced to ten years in prison for helping a fugitive escape the country. Fay, now a single mother, bringing up Ned, whom she is determined to stop becoming like his father (and failing, as Ned is expelled from school for receiving oral sex from two girls in a bathroom). Fay is then approached by CIA agent Fulbright (Jeff Goldblum), who informs her that the country is keen to get hold of Henry's *Confession*. As it turns out, Henry's *Confession*, once dismissed

by Simon's publisher, Angus James (here playing a much more promi-
nent role), it turns out, is a highly coded account of secret government
plans and locations. In return for Simon's freedom, Fay travels to Paris
to retrieve the eight books of Henry's *Confession*. Her travails take her
across Europe, from Paris to Istanbul, in search of her errant husband,
and into the clutches of a dangerous Jihadist terrorist (a former garbage-
man friend of Henry's) who holds Henry hostage.

Like the films that came before it, *Fay Grim* is a combination of recur-
ring features from Hartley's earlier work combined with a different con-
cern with the stylisation of the image. Although not quite as pronouncedly
experimental as the earlier miniDV films, the film demonstrates a par-
ticular concern with canted angles. Almost every frame in the film is
canted, a device commonly used in film noir. Hartley has commented
that this aspect of the film's stylisation is intended to de-emphasise the
seriousness of the subject, effectively to work at odds with the high-
mindedness of the material, as perhaps a Hollywood blockbuster would
do, such as the *Bourne* (Doug Liman/Paul Greengrass, 2002–2007) films
or a film such as *The International* (Tom Tykwer, 2009), which treat nar-
ratives of political intrigue, corporate corruption, and action in serious,
realist fashions. As Hartley noted, this was intended to create references
to a number of different types and genre of film:

> [Canted angles are] not as pronounced in films, but then you see
> something like Rodriguez's "Sin City," based on comic books,
> which have always given themselves that kind of freedom.... I
> was thinking more German Expressionistic films and James Bond
> movies. I wanted to let the audience know right away that it's
> okay to have fun with this; you can laugh. A lot of the people are
> talking, big ideas, whatever.... But don't let it get oppressive.[70]

In many respects, *Fay Grim* functions more as a generic parody than
it does a satire of international political conflict. Although the film ref-
erences numerous instances of American intervention in international
affairs—the Soviet occupation of Afghanistan, the Iran-Contra incident,
the invasion of Iraq—the focus is more on a parody of films influenced by

those events, and those that engage with the 9/11 climate. For instance, the Istanbul-set sequences are reminiscent of films set in the Middle East after 9/11, such as *Syriana* (Stephen Gaghan, 2005) or *Babel* (Alejandro González Iñárritu, 2006). However, Hartley conflates this genre with several others, such as the comic book film mentioned above, and the superhero film.[71] The conflation and play with generic iconography and the de-emphasis of the "oppressive" aspects of the political thriller mean that in most regards, *Fay Grim* resembles not *Henry Fool* the most, but *Amateur*.

Hartley has engaged in playful experimentation with generic categories in other films, such as *No Such Thing* and *The New Math(s)*, but the parody of generic characters and meanings in *Fay Grim* is highly reminiscent of *Amateur*. The two CIA agents, Fulbright and Fogg, partly resemble the two accountant-hitmen, Jan and Kurt, and other agents, from France, Britain, Russia, and Saudi Arabia, have generic roots in James Bond films, and even in the *Bourne* films more recently. Hartley also includes a character named Herzog, which, while it does not have direct generic antecedent, is typical in Hartley's work to name characters after noted art-film directors (after Ozu the choreographer in *Flirt* and Buñuel, Henry's parole officer in *Henry Fool*). Yet, while this has no generic precedent, the intertextual reference to Herzog is valid because there are parallels in the figure of Henry Fool with some of Werner Herzog's protagonists, such as Brian Sweeney Fitzgerald in *Fitzcarraldo* (1982), who are mythic, driven, and possibly insane. Henry Fool himself shares some of the characteristics of the Herzog protagonist: a love of art; a committed philosophy; a tendency toward violence; and a mythic standing outside "conventional" society. The reference to Herzog is another, albeit more specific, intertextual reference in the film, where other aspects of the film play with more generic icons.

One of the key elements of this generic play, again like *Amateur*, is its approach to violence. This partly resembles the digital stylisation of *The Girl from Monday*, in that it involves the use of freeze-frames. Points of violence and action in the film—such as the pursuit in the stairwell of the Parisian hotel or the moment in which Fay binds the Bellboy's wrists

in her hotel room—are rendered as a montage of stills. Scenes become drained of movement; these are usually of violence, although the film also opens with a series of stills of Fay in more mundane surroundings carrying a bag of groceries. Whereas *Amateur* turns violence into a performance, a dance-like sequence drained of its spectacular affect located in the body, *Fay Grim* inscribes this distancing effect in the image itself. Both films confront the pleasurable aspects of cinema violence: *Amateur* confronts this directly by turning scenes of violence into a protracted performance that is both comic and disturbing, whereas the latter film comments not just on violence as pleasure but on the deeper notion of filmic illusion. The freeze-frames in *The Girl from Monday* reflect, through an intertextual nod to Chris Marker, a structure of subjective memory to which the protagonist returns, but the violence in *Fay Grim* strikes right at the heart of the difference between "film time" and "cinema time". Laura Mulvey, in *Death 24x a Second*, commented that the now freely available freeze-frame in cinema (made easier through digital editing methods and for viewers by the pause button on their DVD players) problematises the notion of time on-screen. This, like the technique Hartley used in his digital work, reconfigures cinema and the illusion at its heart, the persistence of vision that makes cinematic movement possible:

> the oppositions between narrative and avant-garde film, between materialism and illusion, have become less distinct and the uncertain relation between movement and stillness, and between halted time and time in duration, is now more generally apparent. Rather than stripping away a mask of illusion to reveal film's material, the relation between film's attributes can be reformulated more dialectically. This affects the opposition between "film time" the inscription of an image onto the still frames of celluloid, and "cinema time", the structure of significance and flow that constitutes the temporal aesthetic of any movie.[72]

Although Mulvey's contention is correct in some regard that, certainly in Hartley's work, the narrative and avant-garde film (as they always have) form a close relationship between the anti-illusionist materialism

of experimental work and the temporal and spatial illusion of more conventional realist work, this cannot be seen in other regards. The illusion of "cinema time" is still the dominant mode; images of cinema remain in motion. However, the freeze-frame no longer reflects an "inscription of an image onto the still frame of celluloid", as there is no longer any celluloid of which to speak. The still frame is now a distant memory in a postfilmic climate. The freeze-frame is no longer a series of frame duplications that remain still twenty-four times a second. Instead, the image is encoded in this metaphor. Therefore, the freeze-frame evokes a memory of "film time", now replaced by a "digital time". In utilising freeze-frames in *Fay Grim*, Hartley reminds the viewer of a "film time" in montage, just as had previously been done by Godard in a film like *Germany Year 90 Nine Zero* (1991) where freeze frames remind the viewer of the material of cinema. For Hartley, the image is immaterial, shot and exhibited digitally.[73] Therefore any materiality is in itself an illusion. The focus is therefore on "the structure of significance and flow that constitutes the temporal aesthetic" of this particular film (something that can be further disrupted by the possibility of the viewer's choice of freeze-frames).

"Significance and flow" are disrupted at key points in *Fay Grim*. And this interruption does not constitute a significant alienation effect, but the slowing of time does constitute a *"montage of digital attractions"*, as described by Martin Lefebvre and Marc Furstenau, whereby the digital editing effect is utilised to call attention to itself.[74] Not only do those sequences use montage literally, as a collision of still images, but the dialectic of "halted time and time in duration" forms an attractional montage moment where the effect calls attention to itself. Film violence in itself is often attractional, as I explored in chapter 4, and to use this technique at the very point of a different mode of attraction denies further the pleasure associated with the violent attraction, distancing (potentially even frustrating) the viewer.

Other techniques are used to distance the viewer, although from a narrative perspective rather than this illusionistic material sense. Throughout the film, Hartley uses captions to stress time, an episodic

structure for the narrative, as well as to externalise Fay's motivations and thought processes. At times, the captions seem to refer to the captions Hartley used in *The Unbelievable Truth* (especially one that says "meanwhile"). Initially, the captioning suggests an episodic structure for the narrative: the first, "Paris/10:15 am/Rendezvous in the ladies room" [*sic*], sets up an expectation that the narrative will be segmented into a recognizable structure (like a DVD, where individual scenes are named and can be accessed at random); the second backs up this expectation: "meanwhile/back home/the writing on the wall". With the first caption, however, there is an expectation that the narrative will develop into a "ticking clock" scenario (like the TV show *24* [2001–2010]), where time will be at stake. However, this does not necessarily prove to be the case, as subsequent captions externalise key points of narration, such as, after Fay has moved hotel in Paris (we first see a caption that reads "10 minutes later/another/hotel" as Fay gets out a car), a caption reads, "her new coat has/FAKE/pockets" (the word FAKE is written much larger than others). Although this conveys information that is seemingly of little importance (it does explain why Fay has to hide a mobile phone in her underwear, though), the caption plays an important function in relaying Fay's thoughts to the audience. This is much more so the case when, confronted by Juliet, the British agent (Saffron Burrows), and hiding the bellboy with two books of Henry's *Confessions* in the bathroom, Fay interprets a message conveyed by Simon in code from objects on the wall. Fay, standing in front of Juliet, looks directly at the camera, and the frame freezes; a series of captions read, "*ottoman + thanksgiving = turkey ÷ wild party = ?*" The caption here therefore abstracts the thought process of the protagonist, externalising visually rather than through expositional dialogue, as a more conventional film might do. Other captions serve more conventional functions, signposting flashbacks to different times—such as 1998, the setting of the first film, where Henry first meets Bebe (Elina Löwensohn), who mistakes him for Simon on the flight to Sweden, or Fulbright's flashback to 1989 in Afghanistan, from which he remembers Jallal Said Khan (Anatole Taubman), a garbageman mentored by Henry Fool in prison for writing pornography, who

Fulbright decides to install in a puppet regime after the fall of Soviet rule (of course, Jallal resembles Osama Bin Laden, an activist believed to be helpful to the U.S. government, but who eventually turned against them). The captions, like in *The Unbelievable Truth*, become key narrative signposts. Although they do not undermine the authority of the narrative, as some did in the earlier film, obfuscating the narrative timeframe, they do misdirect the viewer's expectations. The convoluted and contrived narrative is not thoroughly signposted for the viewer, there is no "ticking clock", and there are few signposts in the final hour as the narrative becomes darker emotionally. Like other parts of the film, such as the treatment of tropes of the spy thriller and the film's dialogue and music (a mixture of spy thriller stings and motifs from the first film), the captioning forms part of the playfulness of the film, its surface treatment of the generic parody, partially distancing the viewer, confusing expectations and externalising the thoughts of the protagonist, using an overt visual technique to create identification rather than point of view shots or empathy.

One of the key issues I have explored throughout this chapter is the mix of new avenues of exploration in Hartley's digital films, such as experimentation with the visual image, and continuity with previous works. The final issue of analysis in *Fay Grim* is Fay herself. Like previous Hartley heroines, Fay is engaged in a liminal journey. Her narrative passage is one from innocence to worldly knowledge. Perhaps the main way this is emphasised is through her costuming. Initially, Fay is dressing conservatively, but appropriately for a Long Island winter, in a woollen cardigan and black scarf. Her costuming is appropriate to her role in Queens as a mother (although she's quick to point out that she's "single ... sort of"). Nevertheless, Fay's performance is at odds with this role. She retains the flirtatiousness and overemphasised gestures demonstrated in the first film. She is always on display; her performance style is much bigger than the style of those around her, especially those of Jeff Goldblum and James Urbaniak (less rigid than the first film, but not in the sense that he has adopted Henry's mannerisms), which are much more minimalist. In that respect, Hartley puts Posey on display,

her performance style emphasising her liminality in later scenes, such as those in Paris when she becomes the "sexy superhero" (at times she is reminiscent of the female characters in Louis Feuillade's thriller serials *Fantômas* (1913) and *Les Vampires* (1915), especially on the Parisian rooftops). Her innocence is marked, and her active performance contrasts with those around her. However, as her liminal passage continues and she reaches Istanbul, this ostentatious performance activity becomes less stated. Her costume changes again—she purchases a hijab, with which she is draped in the final sequences. Although there are significant gendered implications to the wearing of the hijab, for Fay the garment resists her capacity to be put on display (figure 25). Although her liminal phase is not closed, but ambiguously remains open (the film partially resembles *Trust* in this respect), Fay has entered a new phase. The active performance of sexuality in earlier scenes is absent, the hijab entailing a different performance of feminine masquerade, as she runs to try to meet Henry at the dock, where Simon has again helped Henry to flee. Fay sadly watches her husband leave (she is no longer "single ... sort of", but understanding of her husband), deeply affected by the death of Bebe at the hands of a policeman (signified by a lengthy pause-marked gesture in close-up). The camera concentrates significantly on Fay in the final shots, her pensive hand gestures (the hijab blows off her head, revealing her hair) signifying a difference in her performance style (this, however, does replace one mode of feminine performance, sexuality, with another, emotion) that is paused rather than active. Hartley films her in close-up until Henry leaves and the soundtrack is filled with approaching sirens and car doors closing. Finally, the sound of a gun being cocked is heard (the viewer almost expects to hear the words "don't move" like the ending of *Simple Men*). Fay is therefore a typical Hartley heroine, engaged in a rite of passage, moving from an immature innocence to a more worldly understanding of what is around her, personally and politically. The playful tone of the first two-thirds of the film drops away in favour of a darker shift in tone (this is in some way reminiscent of the first film, which did likewise with a child abuse and murder plot leading up to Henry's first escape). For Fay the liminal journey is not completely

FIGURE 25. The costuming of Fay (Parker Posey) stresses the liminality of her role in the drama, as ostentatious performance signs are replaced by more minimal gestures and display of body.

resolved, although her (feminine) performance undergoes a revision gesturally and in costuming.

The films I have analysed in this chapter encompass a significant portion of Hartley's work. The independent film community of the 1990s has moved closer to the Hollywood mainstream, into the Indiewood realm, yet Hartley has moved in a different direction. *Fay Grim* was shot largely outside America, although shot partly in Queens (the setting of the first film), Hartley citing a variety of reasons for this, both budgetary and tonally in terms of changes in the city.[75] Between 2004 and 2009, Hartley lived in Berlin, producing a series of films collected in *Possible Films 2*. The digital works, including the *PF2* films, are different from the work Hartley produced between 1989 and 1998 (*No Such Thing* aside). There are differences in the way in which Hartley's authorship is organised and promoted digitally (via Possible Films, including the publication of *Soon* in 2010), and miniDV and digital HD filming have stimulated a

different aesthetic in his work, experimenting with different perspectives on time, movement in the image, and the performance of the image. Performance still remains a key concern in Hartley's work, although this has shared prominence with new concerns in experimentation with the image, narrative structure, political engagement, and different art forms. Due in part to changes in the industry, new technologies, and different ambitions in Hartley's work, the filmmaker occupies a very different position in the independent American film terrain, more marginal than before, but emphasising the ways in which culture, technology, and film aesthetics have changed in the last decade.

ENDNOTES

1. Box Office Mojo, "No Such Thing (2002)", *Box Office Mojo*, 2010, http://boxofficemojo.com/movies/?page=main&id=nosuchthing.htm.

2. Nick Gomez and Hal Hartley, "Once Upon a Time in New York", *Filmmaker*, 2002, http://www.filmmakermagazine.com/issues/fall2002/features/once_upon.php.

3. Derek Elley, "No Such Thing", *Variety*, May 14, 2010, http://www.variety.com/index.asp?layout=review&reviewid=VE1117798065&categoryid=31&cs=1.

4. Ebert, "No Such Thing".

5. Emanuel Levy, "No Such Thing", *Emanuel Levy: Cinema 24/7*, 2002, http://www.emanuellevy.com/search/details.cfm?id=1951.

6. Hartley and Kaleta, *True Fiction Pictures & Possible Films*, 135.

7. *Henry Fool* remains Hartley's biggest grossing film domestically and his only feature to gross more than $1 million, with a total gross of $1,338,335; Box Office Mojo, "Henry Fool (1998)", *Box Office Mojo*, 2010, http://boxofficemojo.com/movies/?id=henryfool.htm.

8. Hartley has pointed out that the move to form Possible Films was not a response to problems related to producing *No Such Thing*, but a necessity for the way in which *The Girl from Monday* was conceived as a film shot digitally on a low budget that would be distributed via Hartley's own CD/DVD store; Hannah Eaves, "'Free to Investigate': Hal Hartley", *GreenCine*, April 24, 2005, https://www.greencine.com/central/node/444?page=0%2C4.

9. "Digital Cinema: A False Revolution", in *Film Theory and Criticism: Introductory Readings*, ed. Leo Braudy and Marshall Cohen, 6th ed. (New York: Oxford University Press, 2004), 907.

10. Ibid.

11. Catherine Grant, "www.auteur.com?" *Screen* 41, no. 1 (2000): 101.

12. Ibid., 108.

13. Ibid., 105.

14. Catherine Grant, "Auteur Machines? Auteurism and the DVD", in *Film and Television after DVD*, ed. James Bennett and Tom Brown (New York: Routledge, 2008), 112. Grant is quoting from Timothy Corrigan's *A Cinema without Walls: Movies and Culture after Vietnam A Cinema Without Walls: Movies and Culture After Vietnam* (New Brunswick, N.J.: Rutgers University Press, 1991), 118.

15. Peter Sobczynski, "An Interview with Hal Hartley", *24 fps Magazine*, date unknown, http://www.24fpsmagazine.com/Archive/Hartley.html.

16. "Auteur Machines?" 101.

17. Hal Hartley, "About Us | Possible Films", *Possible Films: The Official Website of Hal Hartley & Possible Films*, date unknown, http://www.possiblefilms.com/about/.

18. *Cinema without Walls*, 119.

19. Grant, "Auteur Machines?" 110.

20. The first Possible Films DVD collection includes liner notes that contextualise Hartley's work in terms of biography and intentionality and in many respects locates Hartley's authorial agency "culturally and socially monitor[ing] identification and critical reception" (*Cinema without Walls*, 105). The extratextual material promotes a particular reading and consumption of the text and locates Hartley in "*the business of being an auteur*" (ibid., 104); Hartley, *DVD Notes, Possible Films: Short Works by Hal Hartley 1994–2004*.

21. Robert Brookey and Robert Westerfelhaus, "The Digital Auteur: Branding Identity on the Monsters, Inc. DVD", *Western Journal of Communication* 69, no. 2 (2005): 112.

22. Geoff King, *Indiewood, USA: Where Hollywood Meets Independent Cinema* (London: IB Tauris, 2009), 1.

23. Ibid., 25.

24. Jeffrey Sconce, "Irony, Nihilism and the New American Smart Film", *Screen* 43, no. 4 (2002): 351.

25. Ibid., 350.

26. Hill, "Resident Alien".

27. Ryan Gilbey, "Reheating Hal Hartley", *The Guardian*, March 9, 2007, http://www.guardian.co.uk/film/2007/mar/09/2.

28. In *Down and Dirty Pictures: Miramax, Sundance and the Rise of Independent Film* (New York: Simon & Schuster, 2004), Peter Biskind locates this swing at the popularity of Quentin Tarantino's *Pulp Fiction* (1994), which, for him, marked the end of the "classic" era of the independent film. At times, Biskind's description of *Pulp*'s blending of "art and commerce" (ibid., 192) is very similar to King's argument regarding the textual "mixing of elements of high and popular culture" in Indiewood films.

29. Lev Manovich, "What is Digital Cinema?" *manovich.net*, 1995, http://www.manovich.net/TEXT/digital-cinema.html.

30. Ibid.

31. Benjamin, *Illuminations*, 227.

32. D. N. Rodowick, *The Virtual Life of Film* (Cambridge, MA: Harvard University Press, 2007), 186.

33. Ibid., 98.

34. Ibid., 94.

35. Thomas Elsaesser, "Early Film History and Multi-Media: An Archaeology of Possible Futures?" in *New Media, Old Media: A History and Theory Reader*, ed. Wendy Hui Kyong Chun and Thomas Keenan (New York: Routledge, 2005), 23.

36. André Bazin, *What is Cinema?* trans. Hugh Gray, vol. 1 (Berkeley and Los Angeles: University of California Press, 1967), 14.

37. Garrett Stewart, *Framed Time: Toward a Postfilmic Cinema* (Chicago: University of Chicago Press, 2007), 208.

38. Nicholas Rombes, *Cinema in the Digital Age* (New York: Wallflower, 2009), 27.

39. Holly Willis, *New Digital Cinema: Reinventing the Moving Image* (New York: Wallflower, 2005), 23.

40. Ibid., 24.

41. Holly Willis, "From Mags and Gates to Bits and Chips", *The Independent*, November 1, 1999, http://www.independent-magazine.org/node/446.

42. Ibid.

43. Hartley and Kaleta, *True Fiction Pictures & Possible Films*, 112–113.

44. Ibid., 115.

45. The BBC's *Sound on Film* project was a short series of commissioned short films that paired filmmakers with noted composers from avant-garde, electronic, and trip-hop; in addition to Hartley's collaboration with Andriessen, Werner Herzog produced *Pilgrimage* with religious composer John Tavener, the Brothers Quay created *In Absentia* with electronic composer Karl-Heinz Stockhausen, and Nic Roeg produced *Sound* in collaboration with Adrian Utley from trip-hop electronica pioneers Portishead. The films debuted at London's Barbican with live performances of the scores by Andriessen and Tavener on 1 March 2001. All of the films were subsequently screened on BBC TV during that March.

46. Possible Films, "The New Math(s) synopsis", 1999, http://www.possiblefilms.com/projects/new_math/synopsis.html.

47. Possible Films, "The New Math(s) Interview", *Possible Films: The Official Website of Hal Hartley & Possible Films*, 1999, http://www.possiblefilms.com/projects/new_math/interview.html.

48. Aylish Wood, *Digital Encounters* (Abingdon: Routledge, 2007), 54.

49. Ibid., 55.

50. The smearing of the image is a key way in which *The New Math(s)* resembles a cartoon. The use of "smear" animation in cartoons was an important technique used the Warner Brothers animation studio in the 1940s, particularly by Chuck Jones and Bob Clampett. "Smear" animation used individual drawings in which figures or objects were stretched or smeared to create a further sense illusion of kinesis where the succession of "static" images would be slower in comparison. This gave the image an increased sense of motion and made it more dynamic. For a filmmaker like Jones, the energy that burst forth from the image could provide a greater emphasis on the individual gestures that were rendered, since they were often held longer to exploit comic potential, but for a director like Clampett, "smear" animation could simply make the images explode with energy and rapid, frantic movement. Hartley exploits both here—gestures and poses held "perfectly still" for emphasis and smearing (animation in the sense that Manovich would see digital cinema as "painterly") for "moving fast and violently" with "fluid and easy" movement. Michael Barrier offers a detailed explanation and flipbook demonstration of "smear" animation in *Hollywood Cartoons: American Animation in its Golden Age* (New York: Oxford University Press, 1999), 437–485. Barrier also offers a comparison of the use of smearing in Clampett's *Coal Black and de Sebben Dwarfs* (1943), and Jones's *The Dover Boys* (1942) (437–445).

51. Hartley and Kaleta, *True Fiction Pictures & Possible Films*, 142.

52. Possible Films, "The Girl From Monday | Possible Films", *Possible Films: The Official Website of Hal Hartley & Possible Films*, 2005, http://www.possiblefilms.com/2005/01/the-girl-from-monday/.

53. Baudrillard, *Selected Writings*, 33.

54. Henry David Thoreau, *Walden* (New York: Houghton Mifflin, 1854), 20.

55. Hartley has pointed out that although he was reading Thoreau when he wrote the script for the *The Girl from Monday*, the central premise of the film ("a culture of advertising") is Orwellian, a link that was illuminated for him by Thoreau; Hartley and Kaleta, *True Fiction Pictures & Possible Films*, 139.

56. This is something that Benjamin notes in "The Work of Art in the Age of Mechanical Reproduction, *Illuminations*, 234–235, that Fascism aestheticises politics, while Communism politicises art. With the translation of conformity and uniformity into performance in *The Girl from Monday*, Hartley is evoking this tendency of Fascist art to turn politics into aesthetics, but in turn embedding this in a broadly political aesthetic with overtones of Godard and Marker.

57. Thoreau, *Walden*, 268.
58. In quite a number of regards, the short duration and lack of narrative development in *The Girl from Monday* is redolent of *Surviving Desire*, which forms more of a sketch than a fully developed feature. Similarly with *The Book of Life*, all three films share a playful experimental focus with style and with the broad themes with which they deal. None resolve completely, nor do they fully develop their narratives, as the longer features do. As such, they are more formal experiments than they are completely realised projects. "Shorter films", Hartley once contended, "can achieve a fullness of expression and execution, while still be being essentially sketchy.... Shorter films don't insist on resolving. They don't cry out for the rhythm of conclusion. They can merely collapse, explode or disintegrate" (Hartley, "Surviving Desire", 223). Each of these shorter features is in this vein, where the narrative collapses or does not fully resolve.
59. Hartley has changed this passage from *Walden* slightly, the text, from chapter two, reads slightly differently:

> Let us spend one day as deliberately as Nature, and not be thrown off the track by every nutshell and mosquito's wing that falls on the rails. Let us rise early and fast, or break fast, gently and without perturbation; let company come and let company go, let the bells ring and the children cry—determined to make a day of it. Why should we knock under and go with the stream? Let us not be upset and overwhelmed in that terrible rapid and whirlpool called a dinner, situated in the meridian shallows. Weather this danger and you are safe, for the rest of the way is down hill. With unrelaxed nerves, with morning vigor, sail by it, looking another way, tied to the mast like Ulysses. If the engine whistles, let it whistle till it is hoarse for its pains. If the bell rings, why should we run? We will consider what kind of music they are like. Let us settle ourselves, and work and wedge our feet downward through the mud and slush of opinion, and prejudice, and tradition, and delusion, and appearance, that alluvion which covers the globe, through Paris and London, through New York and Boston and Concord, through Church and State, through poetry and philosophy and religion, till we come to a hard bottom and rocks in place, which we can call *reality*, and say, This is, and no mistake; and then begin, having a *point d'appui*, below freshet and frost and fire, a place where you might found a wall or a state, or set a lamp-post safely, or perhaps a gauge, not a Nilometer, but a Realometer, that future ages might know how deep a freshet of shams and appearances had gathered from time to time. If you stand right fronting and

face to face to a fact, you will see the sun glimmer on both its surfaces, as if it were a cimeter, and feel its sweet edge dividing you through the heart and marrow, and so you will happily conclude your mortal career. Be it life or death, we crave only reality. If we are really dying, let us hear the rattle in our throats and feel cold in the extremities; if we are alive, let us go about our business. (Thoreau, *Walden*, 72, 74)

60. Patricia Thomson, "A Futuristic Farce in Manhattan", *American Cinematographer* 86, no. 3 (2005): 99.
61. Ibid., 100.
62. Ibid., 99.
63. Eaves, "'Free to Investigate': Hal Hartley".
64. Fuller, "Shots in the Dark", 84.
65. Rawle, "Hal Hartley and the Re-Presentation of Repetition".
66. Catherine Lupton, *Chris Marker: Memories of the Future* (London: Reaktion, 2005), 95.
67. Bergson, *Matter and Memory*, 152–153.
68. *Framed Time: Toward a Postfilmic Cinema*, 43.
69. See the special edition of HDNet's *Higher Definition* (episode 420), in which critic Robert Wilonsky makes this claim and interviews Hartley and the stars of *Fay Grim*. Essentially the episode is a promotional video for the film, which was produced and distributed by HDNet. The episode can be found in full on Magnolia Home Entertainment's DVD release of *Fay Grim*.
70. Aaron Hillis, "Hal Hartley on 'Fay Grim'", *IFC.com*, May 21, 2007, http://www.ifc.com/news/2007/05/hal-hartley-on-fay-grim.php.
71. Parker Posey has commented that the costuming of Fay in the Paris sequences of the film was intended to position her as a superhero. The long black dress-coat that Fay wears in those sequences emphasise her body and its movements. Posey has commented upon this herself in interviews; Michael Hixon, "What About 'Fay'?" *The Beach Reporter*, May 17, 2007, http://www.tbrnews.com/articles/2007/05/17/stepping_out/step2.txt. And she has also attributed the look to Hartley's intention to dress her as a "sexy superhero"; Jessica Gelt, "60 Seconds with ... Parker Posey", *Los Angeles Times*, May 17, 2007, http://articles.latimes.com/2007/may/17/news/wk-q-a17.
72. Laura Mulvey, *Death 24x a Second: Stillness and the Moving Image* (London: Reaktion, 2006), 30.
73. *Fay Grim* was released by Magnolia Films almost simultaneously in cinemas and at home. As part of Magnolia's "day-and-date" experiment, the

film was released theatrically and on DVD very close together. Following festival screenings from Sundance in January to Cannes in May, the film received a limited theatrical release on 18 May 2007 and was released on DVD on 22 May 2007.

74. "Digital Editing and Montage: The Vanishing Celluloid and Beyond", *Cinémas: revue d'études cinématographiques / Cinémas: Journal of Film Studies* 13, no. 1 (2002): 89.

75. Nick Dawson, "Filmmaker Magazine | Director Interviews", *Filmmaker*, May 18, 2007, http://filmmakermagazine.com/directorinterviews/2007/05/hal-hartley-fay-grim.html.

Possible Films 2

> Shooting your own things isn't such a big deal anymore when the equipment is so manageable. But I've always liked to shoot anyway. Not a feature, of course, when there is so much to do and such intense schedules. But with things this intimate, it's my principle joy.[1]

At the time of writing this book, Hartley's most recent works are the collection of shorts titled *Possible Films 2*, a follow-up to the first *Possible Films* DVD, released in 2004, collecting short works made between 1994 and 2004. The five films in the collection, *a/muse* (2009), *Accomplice* (2009), *Adventure* (2008), *The Apologies* (2009), and *Implied Harmonies* (2008), were made during Hartley's time in Berlin. Each of the films continues thematic threads that have run throughout his career, namely, the concern with performers and the creation of art. In *a/muse*, a would-be actress (Christina Flick) corresponds with an American film director in exile in Berlin (just as Hartley was during his time there). She traces him to his apartment, and then to a theatre where he is reportedly directing a play. She finds he has left the country. Finally, she receives a

letter from the director, who has returned to the United States; he informs her that he has turned his back on the film industry and has decided to become an importer of European windows, having been impressed with their quality in his time in Germany. He nevertheless encourages her to make the "great German film" that he could not.

The title of the film can be read in three different fashions, as *a muse* (the central subject of the film, in which the actress fantasises about being the film director's muse), as *amuse* (the film itself as a humorous flirtation with the subject), or as *a/muse* as a combination of the two. Essentially, this refers to Hartley himself, and partly to the concepts that run through the three fictional works (*a/muse*, *The Apologies*, and *Accomplice*) in the collection, as being playfully concerned with processes of creating art. The intimacy to which Hartley refers in the quote at the outset of the chapter is evident in each of the three films; the films appear to be shot in Hartley's own apartment. In *Accomplice*, a poster for *Trust* (with its French title of *Trust Me*) can be seen on the wall in the background (this is also glimpsed in sequences in *Implied Harmonies*). There are constant themes running through each of the films about creativity and the overlap between abstraction and the real. In *The Apologies*, a writer (Nikolai Kinski), torn between artistic integrity and commercial ambition, meditates on his latest project, a musical version of the *Odyssey* (the CEO is cast as the King). He lends his apartment to a young actress friend (Bettina Zimmerman). She uses the apartment to rehearse a monologue, in costume; we see her rehearse, repeat lines, and reinterpret the dialogue she is delivering. Finally, the writer's girlfriend (Ireen Kirsch) arrives to confront him. She gives a perfectly delivered monologue herself of trite aphorisms, a perfect "Hollywood" ending. *The Apologies* offers a conflict between the rehearsal process of the performer (something often seen in Hartley's work, from his earliest features and short work) and the performances of the real. The performance of the writer's girlfriend is juxtaposed with the performance of the girlfriend. The film frames one of these as a process of exploration, inquiry, and process, while the other is presented as a representation. Both are in some sense mimetic, but one interrogates abstraction and another undermines the notion of the

real in performance. Is the girlfriend's performance as rehearsed as that of the actress? Both are performers, one a social performer delivering a disciplined performance for an audience (albeit not the one she intends the performance to be for), the other an artistic performer, engaged in similar processes of *becoming-a-performance*. Hartley's exposes the rehearsal and artistic process of one, and hides the other (a paradigmatic version of the film could follow the angry girlfriend out for revenge, rather than the actress, although this would imply something much more formulaic).

The two documentaries in the collection, *Adventure* and *Implied Harmonies*, are both, in different ways, about creativity. The latter is a fairly straightforward documentary about the production of the Hartley-directed opera *La Commedia*, Louis Andriessen's version of Dante's *Divine Comedy*, in Amsterdam. Hartley documents the process of the opera's development and staging, following the development of the filmed material to be projected on five individual screens, the rehearsal of the music and the staging, interspersed with interviews of the principle creative talent. Although this sounds like a fairly standard making-of documentary, Hartley interrogates his own creative process through crosscut sequences featuring his assistant (Jordana Maurer) reading Hartley's letters to her, documenting his inspiration for the staging, asking her to send books, talking about the process. At the beginning of the film Hartley admits that he does not particularly like opera, but he becomes involved in the production to get to know Andriessen better (they worked together previously on *The New Math(s)* and *Inanna*, a 2003 play). The crosscutting of the production process with the letters read by Maurer present a portrait of the artist's process of inspiration, poaching, and insecurity, and this is where the documentary deviates from the standard format of the making-of promo. Like the other films in the collection, *Implied Harmonies*, as the title suggests, explores the creative process, this time a collaborative one (hence *Harmonies*), and the artist at work.

Adventure also provides a portrait of the artist at work. The film is ostensibly about Hartley's wife, Miho Nikaido, and her return to Japan

to visit her family. Hartley uses the trip to explore his relationship with his wife. The film is intimate (featuring shots of a topless Nikaido dressing and of her asleep), and returns Hartley to earlier work—in the Tokyo sequence, Hartley returns to locations from *Flirt*, where he first filmed her, complete with fragments of the soundtrack from the film. While the film sets itself up as a portrait of Hartley and his wife, the film also presents a portrait of the artist. There is an impression that Hartley is always filming, especially intimate moments; in some respects this is a poetic home movie about his relationship with Nikaido and his camera, the two most significant relationships in his life. Because his wife is also a creative practitioner (dancer, actress, fashion designer), this is a process in which she is also engaged and has been throughout his career since their first film together. Indeed, the film features shots of her performing—Hartley documents her visiting temples and strolling through nature. Rather than appearing objectively documented, the shots seem performed, staged, as though performance is at the heart of the relationship and the ever-present camera's effect on the reality of their situation. Therefore, although the film presents its intention as providing a document of Nikaido's adventure, the thematic material covered by the film runs further than this, to Hartley himself, the artist and the ways in which filmmaking is interwoven with the fabric of his reality and the transformative effect it has on his relationships. Like all the films in the collection, the film touches on subjects concerning the artist, creativity, and the performances enacted before the camera.

The final film in the collection, *Accomplice*, at just three minutes is the shortest, but perhaps the most significant. Like *Ambition*, the film returns to the theme of the artist as the outsider-thief. A girl (Maurer) receives instructions from an unnamed source to duplicate and erase some stolen tapes before the authorities can arrive to seize them. The tape is of Jean-Luc Godard being interviewed by David Bordwell. Hartley has noted that he did find these tapes in the Walker Art Centre in Minneapolis in 1992, from where the voice-over in the film says they were stolen.[2] In the section of the interview excerpted in the film, Bordwell asks Godard about his films exploring the landscape of a commercial mainstream

cinema and the possibility of "using what people are expecting to see". The question leads Godard into the same place as the criminal in the film, of poaching material, returning us to the question of the artist as criminal. Godard's reply, however, comes not from the Bordwell interview, but from an interview Hartley did with Godard himself in 1994.[3] Godard stresses the possibility of making films, of making images and sound: "after all, I say I am, innocently representing a certain belief in motion pictures. We will always be able to do a small movie with friends and to show to someone. Ok, you won't get the Oscar for this, but, after all, why are you writing? And why are you …? So, it will be possible … I have always said that … to make movies, to make images and sound is possible one way or another".[4] Godard's comments here typify the *Possible Films* project, about small films, and the drive to create. Each of these films is small, exploratory, unfinished (their sound is especially is rough, unfinished location sound, sometimes cut awkwardly),[5] but each represents and interrogates the desire to create, the creative process, and the ways in which that conflicts with the real. The films are visually stylised like the digital works, with the continued obsession with the canted angle and the bright, fast look of digital film, although there is none of the digital smearing evident in *The Book of Life*, *The Girl from Monday*, and *The New Math(s)*. The short works are in keeping with Hartley's philosophy of the short film in that they are "essentially sketchy", and they "collapse, explode or disintegrate".[6] Although there is continuity across Hartley's work in the last decade, there has been a decline in the number of features produced (just three, compared with seven between 1989 and 1999)—access to financing has become more difficult. In many ways, this testifies to the very different conditions under which independent cinema operates following the boom period between 1984 and 1994; contemporaries of Hartley's like Steven Soderbergh, Todd Haynes, Gus van Sant have achieved mainstream success (and in the case of Soderbergh become one of the most financially successful filmmakers in Hollywood), but others have become more marginal figures. The relative success of Hartley's work in the 1990s has never been matched in the 2000s: his audience has waned.[7]

Conclusions

Throughout the course of his career, Hal Hartley has produced a series of features and short films that have developed and sustained a discourse around performance that realise a series of separate, but interlocking, discourses regarding social, cultural, and aesthetic modes of performing consciously or unconsciously before an audience. The exploration of social and cultural modes of performance in Hartley's work extends out of an approach to aesthetic performances that foregrounds abstraction and deviation from realist models of form and methodology. By locating paradigmatic modes of performance (realist acting, dancing, mime, gestural movement) in combinations that sometimes contravene logical generic and narrative motivation (everyone expects dancing in a musical, but not in a minimalist film such as *Surviving Desire*), Hartley's work forces performance to the fore, emphasising the illusionistic nature of performance in mainstream cinema that attempts to circumvent the artifice of acting to suggest a more lifelike, unrehearsed, and empathetic representation of "real" people.

Hartley's films effect the reappearance of performance through the exposition of the performer in tropes of rehearsal and antirealist presentations of performative approaches to scenes of violence and dance. The consequence of this focus on performance is the exploration of performance, where the notion of the performer extends beyond the aesthetic mode into sociocultural practices, in which the actor is doubled as a social performer and as a character, such as in the teen films, where the actor is performing as a character who is performing in an efficacious quasi-ritual; the performer is revealed as a socially and culturally constituted individual involved in the process of presenting a self to the everyday world. The codes of the everyday and the aesthetic codification of the fictional individual become overdetermined as they refer to both the practice of an actor and that of character. Therefore, the exposition of the artifice of the cinema becomes coterminous with the exposition of the performative mechanics of a series of cultural and social conventions, including gender, nationality, social roles, and the stability of self-identity.

The basis of the abstraction of performance in Hartley's films is rooted in the basic abstraction of the text. Through the abstraction of the film text, Hartley exposes the supposedly self-evident stability of the realist text, thus creating a tension between realism and abstraction through his oeuvre. Although generally opposed to notions of overt empathetic displays of sentiment, the majority of Hartley's films are not antirealist, in that they combine realism with moments of abstraction, especially where shifts in performance mode are evident. Predominantly, however, the tension between realism and abstraction functions to create and maintain a critical distance within the text, a Brechtian style of alienation that helps develop the critical stance within films such as *Flirt* and *The Book of Life*, in which the means of creation and dissemination of performances are exposed through the development of a self-reflexive mode of narration that explicitly demonstrates the manner in which the text is authored, constructed, and distributed through cultural channels (although this is not true of all of Hartley's films). The rejection of empathy also extends into the chief perspective on performance, where acting and performing is consciously revealed as an abstraction of the numerous signs of performance that present external signs as signifiers of internal states. Erving Goffman's important work on the dramaturgy of everyday performances shows how the external signs that constitute a social role (place, costume, make-up, gesture, movement) are similar to those that combine to constitute an explicitly fictional construct. Hartley's approach to performance also brings these two elements into close proximity through the abstraction of the actor's technique and the sign systems that constitute a character. The repetitive joke in *The Unbelievable Truth* about Josh's appearance emphasises this thread of Hartley's work, which relies on the recognition of stereotypical appearances and their relationship to commonplace images to demonstrate the materiality of performance signs corresponding to the Brechtian quotability of alienated performance.

The abstract quality of Hartley's approach to film style extends into the use of repetition as a central component of performative structures. Repetitious mechanisms in Hartley's work, such as circular conversations,

repeated gestures and shots, and comic repetition, frustrate the development of narrative and character development. (Yet many of Hartley's characters are also frustrated, alienated individuals, trapped in social and economics circumstances out with their control.) In addition to functioning as another means of abstracting the text, stressing the constructedness of the film text, repetition exposes the lack of naturalism in the processes of performance. Performance is always a repeat; rehearsals are aimed at perfecting performances until they appear spontaneous. The use of repetition in performance emphasises the repetitious nature of *all* performances. Once more this highlights the Brechtian nature of performance in Hartley's films, where the use of repetition reminds the viewer that "what you are seeing now is a repeat".[8] Repetition reinforces the quotability of performances where the endless repetition of the same abstract gestures, intonations, and stereotypes is rehashed over and over again until the individual units of performance come to signify nothing but their own repeated nature. Therefore, as Deleuze notes, the use of repetition stresses only repetition against difference, where the individual units of signification are stripped of meaning, only to be subordinated to mechanisms of repetition; as Deleuze argued, "repetition is, for itself, difference in itself".[9] Difference extends into social performance where the use of repetition can broadly signify differences in gender and national identity, as in *Flirt*, where repetition stresses the commonplace nature of the narrative in order to expose the constructedness of both the film text and reactions to gender and social relationship between the protagonists; repetition emphasises the quoted, stereotypical nature of the situations represented and the characters' relationships to one another, in which performance on a social level is implicated as a determining factor in delineating character in the eyes of other characters.

The use of repetition also extends into the mechanisms of performing in Hartley's films. Gesture and dance both revolve around processes of repetition that emphasise the abstract nature of both modes of performing, especially when combined with other modes of performing. This is especially the case where dance is utilised by Hartley within narratives that do not supply generic motivation for shifts in performance

mode. Dances in *Surviving Desire* and *Simple Men* involve the virtual/ actual linkages in memory processes to intensify the abstraction of performance signs. Where dances are involved in relationships of feedback and foreshadowing within narrative, the individual gestures and poses of dancing are scrutinised for their reflection of virtual images in the activation of memory. *Surviving Desire*, especially, involves virtual images that reflect previous moments in the narrative—of Jude's trajectory and individual moments within it—in the actual images of the dance scene. In turn, the actual images of the dance are virtualised in the course of the narrative as future moments also reflect tableaux and gestures from the dance. *Simple Men* also uses virtual images, although differently, to invoke intertextual linkages with Godard's *Bande à part* and more general cultural images of female sexuality to emphasise the relationships between characters and the importance of gender to forms of cinematic spectacle (especially scenes of dance, where women are usually the object of the camera's gaze, à la Stanley Donen). Gesture and dance both invoke repetition to stress the quotability and transferability of individual units of performance that engage in systems of meaning and exchange that provide both meaning and abstraction to individual gestures. The gestures explored in *Henry Fool* engage a process of systematisation with other stylistic devices that fragment and draw attention to abstract units of performance that gain meaning only through contextualisation within a narrative framework that references social and cultural modes of performing.

The consequence of this heightened emphasis on performance is the specific development of cultural discourses that are developed and sustained by the heavy importance of performance and performing in Hartley's work. One of the key performative discourses revolves around the tropic presentation of violence. Scenes of violence in *Simple Men* and *Amateur* and *Fay Grim* are presented as conscious or alienated performances, extending the use of dance into different modes, where the body of the performer is utilised to expose and explore the representation of cinematic violence. Or, as with *Fay Grim* and *The Girl from Monday*, violence is defamiliarised via the use of effects like choreography and

still frames. Therefore, violence becomes gestic in the Brechtian sense, allowing the viewer a space in which to explore her own reaction to violence in general, not just the confusing spectacle, by turns comedic and disturbing, currently being viewed. The gest of violence forces the viewer to confront her own desire to derive pleasure from on-screen violence. Hartley's subversion of conventions of cinematic violence exposes the bloodthirsty desire of the contemporary audience to view ever more graphic scenes of death and bodily mutilation. By emphasising the performed nature of screen violence, Hartley's films question the role of the material body in presentations of cinematic violence; stylistic embellishments, such as rapid editing, loud music, and moving cameras, are absent, abstracting the body in violence and particularly the viewer's proprioceptic reaction to images of the body in pain.

The cultural basis of performing also confronts metaphorical notions of violence in the constitution of identity. The performative potentials of ritual liminality are crucial in many of his films, including *Trust*, *The Unbelievable Truth*, *Amateur*, *Henry Fool*, *No Such Thing*, and *Fay Grim* in which characters are forced to explore the roles that they assume they inhabit in society, only to discover that the roles are less fixed than first believed. The interface of liminal structures confronts a series of discourses around the performance of identity—of gender, nationality, economics, and social role. In *Trust*, liminality allows Maria to experience a quasi-form of structuring with Matthew in a family environment, literally trying on the role of motherhood. By doing so, the film emphasises the arbitrary nature of social roles, especially those for women, in which the stability of specific roles (mother, whore, teenager) is found to exhibit less fixity than presumed by those involved. Metaphorical liminality allows a trying out and testing of the structures and signs of roles in a performative fashion before post-liminal identities are fixed forever. However, the liminal films, *Trust* and *The Unbelievable Truth* especially, choose not to reflect on the post-liminal choices of their main characters, instead leaving Maria and Audry ambiguously on the cusp of womanhood, unsure of their roles in adult society.

Performances of gender, cultural and national difference are also key threads that run throughout Hartley's work. The emphasis on performance exposes the social and cultural constructedness of fixed genders and identities, as the liminal films do. *Flirt, Simple Men* and *No Such Thing* stress the problematic relationship between the articulation of an indented self through the mobilisation of material signs of performance and the reading of an audience that fails to read the projected subject in the manner intended by the performer. Miho struggles to project an actual self due to the oppressive social gaze of the camera that is subsequently displaced onto an ever-present diegetic audience that subjects her projected performance to intense scrutiny; the audience therefore reads her performance as a stereotypical projection of womanhood, although she intends differently. Likewise, Bill in *Simple Men* struggles to project a coherent intended self. Whereas the discourse on performing in *Flirt* is sustained by the abstract repetition of the text, *Simple Men* reflects on a psychological repetition compulsion that creates slippages and incoherency in the performance of an intended (stereotypical) masculine self. Bill simply falls into cycles of self-defeating behaviour, failing to conform to standards of masculine strength in the face of the articulation and celebration of powerful female sexual difference. The performance of male stereotypes is made problematic as it is exposed *as* a performance, one in which the performer is deluded by the "naturalness" of the culturally constructed stereotype. *No Such Thing* also revolves around culturally constructed stereotypes in the guise of the monster. The monstrous masculinity of the monster is examined as a fictional construct in a world in which the order of simulacra problematises the existence of a stable reality for the inhabitants of a media-saturated world. The monster and Beatrice are linked by a common difference, but one which is contingent upon the performance of generically and culturally derived roles that are consciously fictional, and constructed and sustained by the media.

Hal Hartley's films simultaneously explore both the performance of the film performer and the performance of the subject in sociocultural spheres. The performance of the text and the performances of the

performers are exposed as analogous on aesthetic, social and cultural levels where performance is over-determined–the performer in front of the camera is made congruent with the social performer before the public eye (this is also reflected in the social gaze of diegetic audiences at the performer in the guise of parents, colleagues, institutional and legal bodies, etc.). This discourse runs throughout Hartley's work, where performance is the central conceit of his films' approach to social and cultural constructions of identity. While, as chapter 6 demonstrated, there has been a partial shift away from the central concern with performance, toward a greater focus on the abstraction of digital images (although this is not sustained in *Fay Grim* or *Possible Films 2*), performance remains a key concern for Hartley's work, especially in the shorter works that began this final chapter, in which Hartley interrogates a creative process that has repetition at its heart. This change seems largely to have been precipitated by changes in technology and shifts in the film industry that have allowed (or forced) Hartley to engage with recurrent themes differently or in altered contexts. Nevertheless, the contribution that Hartley's work has made to the American art cinema has largely been in the field of performance. This does not, it must be reiterated, diminish the contribution of Hartley's regular ensemble of performers in shaping this contribution; the close association of particular actors with Hartley's work, Martin Donovan especially (despite only producing four films together), are a significant signifier of the important role that the agency of Hartley's regular collaborators have played in defining the performance text of Hartley's work.

ENDNOTES

1. Hal Hartley, "POSSIBLE FILMS 2: Hal Interviewed by DJ Mendel | Possible Films", *Possible Films: The Official Website of Hal Hartley & Possible Films*, October 2009, http://www.possiblefilms.com/2010/03/possible-films-2-hal-interviewed-by-dj-mendel/.
2. Ibid.
3. Ibid.
4. The transcription appears slightly differently in the published version of the interview. Hal Hartley, "In Images We Trust: Hal Hartley Interviews Jean-Luc Godard", *Filmmaker* 3, no. 1 (1994): 18.
5. Just as Sophie Wise argued that the "spect(actor)" "completes" the unfinished text of the Hartley, the rough, fragmentary quality of the *Possible Films 2* works is testimony to the experimental strain that runs throughout Hartley's career from his first features onwards.
6. Hartley, "Surviving Desire", 223.
7. At the time of writing, Hartley's Possible Films has just 807 "fans" on Facebook and 363 followers on Twitter. Both are run by Hartley himself. Although this is not an absolute indicator of the size of Hartley's audience, it does indicate how marginal a figure he has become in the past ten years, despite the fairly high online presence his work has.
8. Brecht, *Brecht on Theatre*, 122.
9. Deleuze, *Difference and Repetition*, 94.

BIBLIOGRAPHY

Altman, Rick. *The American Film Musical*. Bloomington: Indiana University Press, 1989.

Anderson, John. "Hartley's No 'Amateur' at Pulling America's Leg". *San Jose Mercury News*, May 19, 1995. http://drumz.best.vwh.net/Hartley/Reviews/sjmn-amateur.html.

Anderson, Kevin Taylor. "Finding the Essential: A Phenomenological Look at Hal Hartley's *No Such Thing*". *Film & Philosophy* 7, no. 1 (2003): 77–91.

Andrew, Geoff. *Stranger than Paradise: Maverick Film-makers in Recent American Cinema*. London: Prion, 1998.

Anonymous. "Homage to Hal Hartley—A place to discuss film making genius". *Homage to Hal Hartley—a place to discuss film making genius*, June 1, 2002, http://movies.groups.yahoo.com/group/homagetohalhartley/message/187.

Aristotle. *Poetics*. London: Penguin, 1996.

Artaud, Antonin. *The Theatre and Its Double*. London: Calder, 1993.

Austin, Thomas. "Star Performances". In *Contemporary Hollywood Stardom*, edited by Thomas Austin and Martin Barker, 103–104. London: Arnold, 2003.

Baron, Cynthia, and Sharon Marie Carnicke. *Reframing Screen Performance*. Ann Arbor: University of Michigan Press, 2008.

Baron, Cynthia, and Diane Carson. "Analyzing Performance and Meaning in Film". *Journal of Film and Video* 58, no. 1 (2006): 3–6.

Barrier, Michael. *Hollywood Cartoons: American Animation in its Golden Age*. New York: Oxford University Press, 1999.

Barthes, Roland. *Elements of Semiology*. New York: Hill and Wang, 1977.

———. *Image-Music-Text*. Translated by Stephen Heath. London: Fontana, 1977.

Baudrillard, Jean. "The Ecstasy of Communication". In *The Anti-Aesthetic: Essays on Postmodern Culture*, edited by Hal Foster, 145–154. New York: The New Press, 1998.

———. *Selected Writings*. Edited by Mark Poster. Cambridge: Polity, 2001.

———. *Simulacra and Simulation*. Ann Arbor: University of Michigan Press, 1994.

Bauer, Douglas. "An Independent Vision: Film Director Hal Hartley". *The Atlantic*, April 1994. http://drumz.best.vwh.net/Hartley/Info/atlantic-profile.html.

Bazin, André. *What is Cinema?* Translated by Hugh Gray. Vol. 1. Berkeley and Los Angeles: University of California Press, 1967.

———. *What is Cinema?* Translated by Hugh Gray. Vol. 2. Berkeley and Los Angeles: University of California Press, 1967.

———. "William Wyler, or the Jansenist of mise en scène". In *Realism and the Cinema: A Reader*, edited by Christopher Williams, 36–52. London: Routledge & Kegan Paul, 1980.

Belton, John. "Digital Cinema: A False Revolution". In *Film Theory and Criticism: Introductory Readings*, edited by Leo Braudy and Marshall Cohen, 901–913. 6th ed. New York: Oxford University Press, 2004.

Benjamin, Walter. *Illuminations*. Edited by Hannah Arendt. London: Pimlico, 1999.

———. *Understanding Brecht*. London: Verso, 1998.

Bergson, Henri. *Matter and Memory*. Translated by N. M. Paul and W. S. Palmer. New York: Zone, 1996.

Berliner, Todd. "Hollywood Movie Dialogue and the "Real Realism" of John Cassavetes". *Film Quarterly* 52, no. 3 (1999): 2–16.

Bevington, David. *Action Is Eloquence: Shakespeare's Language of Gesture*. Cambridge, MA: Harvard University Press, 1984.

Birdwhistell, Ray L. *Kinesics and Context: Essays on Body Motion Communication*. London: Penguin, 1970.

Biskind, Peter. *Down and Dirty Pictures: Miramax, Sundance and the Rise of Independent Film*. New York: Simon & Schuster, 2004.

Bordwell, David. "The Art Cinema as a Mode of Practice". In *The European Cinema Reader*, edited by Catherine Fowler, 94–102. London: Routledge, 2002.

Bourdieu, Pierre. *Distinction: A Social Critique of the Judgement of Taste*. Cambridge, MA: Harvard University Press, 1984.

Box Office Mojo. "Henry Fool (1998)". *Box Office Mojo*, 2010. http://boxofficemojo.com/movies/?id=henryfool.htm.

———. "No Such Thing (2002)". *Box Office Mojo*, 2010. http://boxofficemojo.com/movies/?page=main&id=nosuchthing.htm.

Branigan, Edward. *Narrative Comprehension and Film*. London: Routledge, 1992.

Brecht, Bertolt. *Brecht on Theatre: The Development of an Aesthetic*. Edited by John Willett. London: Methuen, 1974.

Bresson, Robert. *Notes on the Cinematographer*. Translated by Jonathan Griffin. Copenhagen: Green Integer, 1997.

British Board of Film Classification. "BRIDGET JONES'S DIARY rated 15 by the BBFC". *BBFC.co.uk*, April 2, 2001. http://www.bbfc.co.uk/website/Classified.nsf/c2fb077ba3f9b33980256b4f002da32c/d0e2732a7ea21a7080256a24002aedee?OpenDocument&ExpandSection=2#_Section2.

Brookey, Robert, and Robert Westerfelhaus. "The Digital Auteur: Branding Identity on the Monsters, Inc., DVD". *Western Journal of Communication* 69, no. 2 (2005): 109–128.

Brunette, Peter. "The Three Stooges and the (Anti-)Narrative of Violence: De(con)structive Comedy". In *Comedy/Cinema/Theory*, edited by Andrew S. Horton, 174–205. Berkeley and Los Angeles: University of California Press, 1991.

Burch, Noël. *To the Distant Observer: Form and Meaning in the Japanese Cinema*. London: Scolar, 1979.

Burgoon, Judee K., and Thomas Saine. *The Unspoken Dialogue: An Introduction to Nonverbal Communication*. Boston: Houghton Mifflin, 1978.

Butler, Judith. *Gender Trouble: Feminism and the Subversion of Identity*. London: Routledge, 1990.

Carnicke, Sharon Marie. "Screen Performance and Director's Visions". In *More than a Method: Trends and Traditions in Contemporary Film Performance*, edited by Cynthia Baron, Diane Carson, and Frank P. Tomasulo, 42–67. Detroit: Wayne State University Press, 2004.

Carson, Diane. "Plain and Simple: Masculinity through John Sayles's Lens". In *More than a Method: Trends and Traditions in Contemporary Film Performance*, edited by Cynthia Baron, Diane Carson, and Frank P. Tomasulo, 173–191. Detroit: Wayne State University Press, 2004.

Chion, Michel. *The Voice in Cinema*. Translated by Claudia Gorbman. New York: Columbia University Press, 1999.

Comolli, Jean-Louis, and Jean Narboni. "Cinema/Ideology/Criticism". In *Movies and Methods*, edited by Bill Nichols. Vol. 1. Berkeley and Los Angeles: University of California Press, 1976.

de Cordova, Richard. *Picture Personalities: The Emergence of the Star System in America*. Urbana: University of Illinois Press, 1990.

Corrigan, Timothy. *A Cinema Without Walls: Movies and Culture After Vietnam*. New Brunswick, NJ: Rutgers University Press, 1991.

David. "Henry Fool (1997)—IMDb user reviews". *Internet Movie Database*, August 27, 1999. http://www.imdb.com/title/tt0122529/usercomments?start=30.

Dawson, Nick. "Filmmaker Magazine—Director Interviews". *Filmmaker*, May 18, 2007. http://filmmakermagazine.com/directorinterviews/2007/05/hal-hartley-fay-grim.html.

Deer, Lesley. "Hal Hartley". In *Fifty Contemporary Filmmakers*, edited by Yvonne Tasker, 161–169. London: Routledge, 2002.

———. "The Repetition of Difference: Marginality and the Films of Hal Hartley". Newcastle upon Tyne: University of Newcastle upon Tyne, 2000.

Delamater, Jerome. "Ritual, Realism and Abstraction: Performance in the Musical". In *Making Visible the Invisible: An Anthology of Original Essays on Film Acting*, edited by Carole Zucker, 44–63. London: Scarecrow, 1990.

Deleuze, Gilles. *Cinema 1: The Movement-Image*. London: Continuum, 2001.

———. *Cinema 2: The Time-Image*. London: Athlone, 2000.

———. *Difference and Repetition*. Translated by Paul Patton. New York: Columbia University Press, 1994.

Dempsey, Laura. "Pieces Don't All Fit Together in Henry Fool, But That's Okay". *Dayton Daily News*, August 28, 1998. http://drumz.best.vwh.net/Hartley/Reviews/ddn-hf.html.

Dostoyevsky, Fyodor. *The Brothers Karamazov*. Translated by David McDuff. London: Penguin, 1993.

Drake, Philip. "Reconceptualizing Screen Performance". *Journal of Film and Video* 58, no. 1 (2006): 84–94.

Dyer, Richard. "Entertainment and Utopia". In *Genre: The Musical: A Reader*, edited by Rick Altman, 177–189. London: Routledge & Kegan Paul, 1981.

———. *Stars*. 2nd ed. London: BFI, 1998.

Eaves, Hannah. "'Free to Investigate': Hal Hartley". *GreenCine*, April 24, 2005. https://www.greencine.com/central/node/444?page=0%2C4.

Ebert, Roger. "No Such Thing". *Chicago Sun Times*, March 29, 2002. http://rogerebert.suntimes.com/apps/pbcs.dll/article?AID=/20020329/REVIEWS/203290303/1023.

Eisenstein, Sergei. *The Eisenstein Reader*. Edited by Richard Taylor. London: BFI, 1998.

Elkins, James. *Pictures of the Body: Pain and Metamorphosis*. Stanford, CA: Stanford University Press, 1999.

Elley, Derek. "No Such Thing". *Variety*, May 14, 2010. http://www.variety.com/index.asp?layout=review&reviewid=VE1117798065&categoryid=31&cs=1.

Elsaesser, Thomas. "Early Film History and Multi-Media: An Archaeology of Possible Futures?" In *New Media, Old Media: A History and Theory Reader*, edited by Wendy Hui Kyong Chun and Thomas Keenan. New York: Routledge, 2005.

Feuer, Jane. "The Self-reflective Musical and the Myth of Entertainment". In *Genre: The Musical: A Reader*, edited by Rick Altman, 159–174. London: Routledge & Kegan Paul, 1981.

Foucault, Michel. "What Is an Author?" *Screen* 20, no. 1 (1979): 13–29.

Freud, Sigmund. *Beyond the Pleasure Principle and Other Writings*. London: Penguin, 2003.

———. "Fetishism". In *The Standard Edition of the Complete Psychological Works of Sigmund Freud*, edited by James Strachey, XXI:152–157. London: Vintage, 2001.

Fried, John. "Rise of an Indie: An Interview with Hal Hartley". *Cineaste* 19, no. 4 (1993): 38–40.

Fuller, Graham. "Shots in the Dark". *Interview*, September 1992.

Fuller, Graham, and Hal Hartley. "Being an Amateur". In *Amateur*, by Hal Hartley, x–xlvi. London: Faber & Faber, 1994.

―――. "Finding the Essential: Hal Hartley in Conversation with Graham Fuller, 1992". In *Collected Screenplays 1*, by Hal Hartley, vi–xxix. London: Faber & Faber, 2002.

―――. "Responding to Nature: Hal Hartley in Conversation with Graham Fuller". In *Henry Fool*, by Hal Hartley, vii–xxv. London: Faber & Faber, 1998.

Gelt, Jessica. "60 Seconds with ... Parker Posey". *Los Angeles Times*, May 17, 2007. http://articles.latimes.com/2007/may/17/news/wk-q-a17.

van Gennep, Arnold. *Rites of Passage*. Chicago: University of Chicago Press, 1960.

Gerow, Aaron. "The Word Before the Image: Criticism, the Screenplay, and the Regulation of Meaning in Prewar Japanese Film Culture". In *Word and Image in Japanese Cinema*, edited by Carole Cavanaugh and Dennis Washburn, 3–35. Cambridge: Cambridge University Press, 2001.

Gilbey, Ryan. "Pulling the Pin on Hal Hartley". In *American Independent Cinema: A Sight and Sound Reader*, edited by Jim Hillier, 142–145. London: BFI, 2001.

―――. "Reheating Hal Hartley". *The Guardian*, March 9, 2007. http://www.guardian.co.uk/film/2007/mar/09/2.

Goethe, Johann Wolfgang von. *Maxims and Reflections*. London: Penguin, 1998.

Goffman, Erving. *The Presentation of Self in Everyday Life*. London: Penguin, 1990.

Gomez, Nick, and Hal Hartley. "Once Upon a Time in New York". *Filmmaker*, 2002. http://www.filmmakermagazine.com/issues/fall2002/features/once_upon.php.

Gore, Chris. "No Such Thing". *Film Threat*, March 28, 2002. http://www.filmthreat.com/Reviews.asp?Id=2021.

Grant, Catherine. "Auteur Machines? Auteurism and the DVD". In *Film and Television after DVD*, edited by James Bennett and Tom Brown, 101–115. New York: Routledge, 2008.

———. "www.auteur.com?" *Screen* 41, no. 1 (2000): 101–108.

Gunning, Tom. "The Cinema of Attractions: Early Film, Its Spectator and the Avant-Garde". In *Early Cinema: Space, Frame, Narrative*, edited by Thomas Elsaesser, 56–62. London: BFI, 1990.

Halberstam, Judith. *Skin Shows: Gothic Horror and the Technology of Monsters*. Durham, NC: Duke University Press, 1995.

Hallam, Julia. *Realism and Popular Cinema*. Manchester: Manchester University Press, 2000.

Hanson, Matt. "The Sophisticated Yet Ultimately Awkward World of an American Auteur". *Dazed & Confused*, January 1995. http://drumz. best.vwh.net/Hartley/Info/d&c-interview.html.

Hartley, Hal. "About Us—Possible Films". *Possible Films: The Official Website of Hal Hartley & Possible Films*, date unknown. http://www. possiblefilms.com/about/.

———. *Collected Screenplays 1*. London: Faber & Faber, 2002.

———. *DVD Notes, Possible Films: Short Works by Hal Hartley 1994– 2004*. New York: Possible Films, 2004.

———. *Flirt*. London: Faber & Faber, 1996.

———. "In Images We Trust: Hal Hartley Interviews Jean-Luc Godard". *Filmmaker* 3, no. 1 (1994): 14, 16–18, 55–56.

———. "POSSIBLE FILMS 2: Hal Interviewed by DJ Mendel— Possible Films". *Possible Films: The Official Website of Hal Hartley & Possible Films*, October 2009. http://www.possiblefilms.com/2010/03/ possible-films-2-hal-interviewed-by-dj-mendel/.

———. *Simple Men & Trust*. London: Faber & Faber, 1992.

———. "Surviving Desire". In *Projections*, edited by John Boorman and Walter Donohue, 1:223–259. London: Faber & Faber, 1992.

Hartley, Hal, and Isabelle Huppert. "National Public Radio Morning Edition: Director Hal Hartley Discusses his New Film, Amateur". Interview by Pat Dowell, April 12, 1995. http://drumz.best.vwh.net/Hartley/Info/npr-profile.html.

Hartley, Hal, and Kenneth Kaleta. *True Fiction Pictures & Possible Films: Hal Hartley in Conversation with Kenneth Kaleta*. New York: Soft Skull, 2008.

Heath, Stephen. *Questions of Cinema*. Bloomington: Indiana University Press, 1981.

Herold, Charles. "Flirt (1995)—IMDb user reviews". *Internet Movie Database*, November 30, 2009. http://www.imdb.com/title/tt0113080/usercomments.

Hill, Logan. "Resident Alien: Whatever Happened to Hal Hartley?" *New York Magazine*, February 7, 2005. http://nymag.com/nymetro/movies/features/10951/.

Hillis, Aaron. "Hal Hartley on 'Fay Grim'". *IFC.com*, May 21, 2007. http://www.ifc.com/news/2007/05/hal-hartley-on-fay-grim.php.

Hirsch, Foster. *Acting Hollywood Style*. New York: Harry N. Abrams, 1996.

Hixon, Michael. "What About 'Fay'?" *The Beach Reporter*, May 17, 2007. http://www.tbrnews.com/articles/2007/05/17/stepping_out/ep2.txt.

Hoffman, Adina. "Plot Is a Hal of Mirrors". *Jerusalem Post*, July 29, 1996. http://drumz.best.vwh.net/Hartley/Reviews/jp-flirt.html.

Hornaday, Ann. "The Really Abominable Snowman". *Washington Post*, March 29, 2002. http://www.washingtonpost.com/wp-dyn/style/movies/reviews/A33953-2002Mar28.html.

Howe, Desson. "No Such Thing". *Washington Post*, March 29, 2002. http://www.washingtonpost.com/wp-dyn/style/movies/reviews/A31932-2002Mar28.html.

Internet Movie Database. "No Such Thing (2001)—Box office/business". *Internet Movie Database*, 2002. http://www.imdb.com/title/tt0248190/business.

James, Caryn. "The Nun, the Amnesiac, the Prostitute and the Thugs". *New York Times*, September 29, 1994. http://drumz.best.vwh.net/Hartley/Reviews/nyt-amateur.html.

Jameson, Fredric. *Postmodernism, or The Cultural Logic of Late Capitalism*. London: Verso, 1991.

Johnston, Claire. "Double Suicide". *Focus on Film*, no. 2. Criterion Collection DVD Notes (1970).

Jones, Kent. "Hal Hartley: The Book I Read Was in Your Eyes". *Film Comment* 32, no. 4 (1996): 68–72.

de Jonge, Peter. "The Jean-Luc Godard of Long Island". *New York Times*, August 4, 1996. http://drumz.best.vwh.net/Hartley/Info/nyt-profile2.html.

Jousse, Thierry. "Love and Punishment". Translated by Sébastien Walliez. *Cahiers du Cinéma*, no. 474 (1993): 74–75.

Kelly, Laura. "Auteur Scores with Urban Myth". *Fort Lauderdale Sun-Sentinel*, July 17, 1998. http://drumz.best.vwh.net/Hartley/Reviews/flss-hf.html.

Kemp, Sandra. "Reading Difficulties". In *Analysing Performance: A Critical Reader*, edited by Patrick Campbell, 153–174. Manchester: Manchester University Press, 1996.

King, Geoff. *Independent American Cinema*. London: IB Tauris, 2005.

———. *Indiewood, USA: Where Hollywood Meets Independent Cinema*. London: IB Tauris, 2009.

kintop432. "The Unbelievable Truth (1989)—IMDb user reviews". *Internet Movie Database*, August 27, 1999. http://www.imdb.com/title/tt0100842/usercomments.

Klein, Andy. "An Immortal Beast Longs for Death, but Does He Exist at All?" *New Times Los Angeles*, March 28, 2002. http://www.newtimes. com/issues/2002-02-28/film3.html/I/index.html.

Klevan, Andrew. *Film Performance: From Achievement to Appreciation*. London: Wallflower, 2005.

Komatsu, Hiroshi. "Japan: Before the Great Kanto Earthquake". In *The Oxford History of World Cinema*, edited by Geoffrey Nowell-Smith, 177–183. Oxford: Oxford University Press, 1996.

Kornits, Dov. "Hal Hartley—Nobody's Fool". *efilmcritic.com*, May 17, 1999. http://www.efilmcritic.com/feature.php?feature=37.

Lamb, Warren, and Elizabeth Watson. *Body Code: The Meaning in Movement*. London: Routledge & Kegan Paul, 1979.

Lefebvre, Martin, and Marc Furstenau. "Digital Editing and Montage: The Vanishing Celluloid and Beyond". *Cinémas: revue d'études cinématographiques/ Cinémas: Journal of Film Studies* 13, no. 1 (2002): 69–107.

Levy, Emanuel. *Cinema of Outsiders: The Rise of American Independent Film*. New York: New York University Press, 1999.

———. "No Such Thing". *Emanuel Levy: Cinema 24/7*, 2002. http:// www.emanuellevy.com/search/details.cfm?id=1951.

Litton, David. "No Such Thing". *Movie Eye*, 2002. http://www.movie-eye.com/reviews/get_movie_review/614.html.

Long, Mike. "The Unbelievable Truth". *DVDreview.com*, March 30, 2001. http://www.dvdreview.com/reviews/pages/321.shtml.

Lovell, Alan, and Peter Krämer, eds. *Screen Acting*. London: Routledge, 1999.

Lupton, Catherine. *Chris Marker: Memories of the Future*. London: Reaktion, 2005.

Maland, Charles J. "Capra and the Abyss: Self-Interest versus the Common Good in Depression America". In *Frank Capra: Authorship and*

the Studio System, edited by Robert Sklar and Vito Zagarrio, 95–129. Philadelphia: Temple University Press, 1998.

Manovich, Lev. "What Is Digital Cinema?" *manovich.net*, 1995. http://www.manovich.net/TEXT/digital-cinema.html.

Marks, Laura U. "A Deleuzian Politics of Hybrid Cinema". *Screen* 35, no. 3 (1994): 244–264.

———. *The Skin of the Film: Intercultural Cinema, Embodiment, and the Senses*. Durham, NC: Duke University Press, 2000.

Marshall, P. David. *Celebrity and Power: Fame in Contemporary Culture*. Minneapolis: University of Minnesota Press, 1997.

McCarthy, Todd. "Simple Men". *Variety*, May 18, 1992. http://drumz.best.vwh.net/Hartley/Reviews/variety-sm.html.

McDonald, Paul. "Reconceptualising Stardom". In *Stars*, 2nd ed., edited by Richard Dyer, 175–211. London: BFI, 1998.

———. "Why Study Film Acting? Some Opening Reflections". In *More than a Method: Trends and Traditions in Contemporary Film Performance*, edited by Cynthia Baron, Diane Carson, and Frank P. Tomasulo, 23–41. Detroit: Wayne State University Press, 2004.

McLean, Adrienne L. "Feeling and the Filmed Body: Judy Garland and the Kinesics of Suffering". *Film Quarterly* 55, no. 3 (2002): 2–15.

Merritt, Greg. *Celluloid Mavericks*. New York: Thunder's Mouth, 2000.

Metz, Christian. *Film Language: A Semiotics of the Cinema*. Translated by Michael Taylor. Chicago: University of Chicago Press, 1991.

Mitchell, Elvis. "Yes, Someone for Everyone, Even Someone with Fangs". *New York Times*, March 29, 2002. http://www.nytimes.com/2002/03/29/movies/29SUCH.html.

Morris, Desmond. *Manwatching: A Field Guide to Human Behaviour*. London: Jonathan Cape, 1977.

Mulvey, Laura. *Death 24x a Second: Stillness and the Moving Image*. London: Reaktion, 2006.

————. "Visual Pleasure and Narrative Cinema". In *Movies and Methods*, edited by Bill Nichols, 2:303–315. Berkeley and Los Angeles: University of California Press, 1985.

Naremore, James. *Acting in the Cinema*. Berkeley and Los Angeles: University of California Press, 1994.

Nash, Cristopher. *The Unravelling of the Postmodern Mind*. Edinburgh: Edinburgh University Press, 2001.

Nietzsche, Friedrich. *Thus Spoke Zarathustra*. Translated by R. J. Hollingdale. London: Penguin, 2003.

Pearson, Roberta E. *Eloquent Gestures: The Transformation of Performance Style in the Griffith Biograph Films*. Berkeley and Los Angeles: University of California Press, 1992.

Pierson, John. *Spike, Mike, Slackers & Dykes: A Guided Tour Across a Decade of Independent American Cinema*. London: Faber & Faber, 1995.

Possible Films. "The Girl From Monday—Possible Films". *Possible Films: The Official Website of Hal Hartley & Possible Films*, 2005. http://www.possiblefilms.com/2005/01/the-girl-from-monday/.

————. "The New Math(s) Interview". *Possible Films: The Official Website of Hal Hartley & Possible Films*, 1999. http://www.possiblefilms.com/projects/new_math/interview.html.

————. "The New Math(s) Synopsis", 1999. http://www.possiblefilms.com/projects/new_math/synopsis.html.

Pride, Ray. "Reversal of Fortune". *Filmmaker* 6, no. 4 (1998): 56–58, 91–92.

Prince, Stephen. *Classical Film Violence: Designing and Regulating Brutality in Hollywood Cinema, 1930–1968*. New Brunswick, NJ: Rutgers University Press, 2003.

Quandt, James, ed. *Robert Bresson*. Toronto: Toronto International Film Festival Group, 2000.

Rafferty, Terrence. "Flatlands". *The New Yorker*, August 12, 1991. http://drumz.best.vwh.net/Hartley/Reviews/ny-trust.html.

Rawle, Steven. "Hal Hartley and the Re-Presentation of Repetition". *Film Criticism* 34, no. 1 (2009): 58–75.

Reader, Keith. *Robert Bresson*. Manchester: Manchester University Press, 2000.

Reed, Rex. "Move Over, Kevin Costner!" *The New York Observer*, April 8, 2002. http://www.nyobserver.com/pages/story.asp?ID=5702.

Richie, Donald. *Japanese Cinema: An Introduction*. Oxford: Oxford University Press, 1990.

Rigsby, Jeff. "No Such Thing". *Flak Magazine*, 2002. http://www.flakmag.com/film/nosuchthing.html.

Rodowick, D. N. *The Virtual Life of Film*. Cambridge, MA: Harvard University Press, 2007.

Rombes, Nicholas. *Cinema in the Digital Age*. New York: Wallflower, 2009.

Romney, Jonathan. "Apocalypse, Now with Powerbook". *The Guardian*, August 27, 1998. http://drumz.best.vwh.net/Hartley/Reviews/guardian-tbol.html.

———. "Hartley's Globe-trotters". *The Guardian*, February 21, 1997. http://drumz.best.vwh.net/Hartley/Reviews/guardian-flirt.html.

———. "Right Road, Wrong Track: Jonathan Romney Prefers Cheap Talking Heads to Fancy Forked Tongues". *New Statesman and Society*, November 6, 1992. http://drumz.best.vwh.net/Hartley/Reviews/nss-sm.html.

Rothman, William. "Violence and Film". In *Violence and American Cinema*, edited by J. David Slocum, 37–46. London: Routledge, 2001.

Rubin, Martin. *Showstoppers: Busby Berkeley and the Tradition of Spectacle*. New York: Columbia University Press, 1993.

Ryan, Alan. "Private Selves and Public Parts". In *Public and Private in Social Life*, edited by S. I. Benn and G. F. Gaus, 135–154. Beckenham: Crook Helm, 1983.

Sarris, Andrew. "Hal Hartley's Henry Fool, A Study in Rejection". *The New York Observer*, June 22, 1998. http://drumz.best.vwh.net/Hartley/Reviews/nyo-hf.html.

Schechner, Richard. *Performance Studies: An Introduction*. New York: Oxford University Press, 2002.

———. *Performance Theory*. London: Routledge, 2003.

Sconce, Jeffrey. "Irony, Nihilism and the New American Smart film". *Screen* 43, no. 4 (2002): 349–369.

———. "'Trashing the Academy': Taste, Excess and an Emerging Politics of Style". *Screen* 36, no. 4 (1995): 371–393.

Self, Robert T. "Resisting Reality: Acting by Design in Robert Altman's Nashville". In *More than a Method: Trends and Traditions in Contemporary Film Performance*, edited by Cynthia Baron, Diane Carson, and Frank P. Tomasulo, 126–150. Detroit: Wayne State University Press, 2004.

Shaviro, Steven. *The Cinematic Body*. Minneapolis: University of Minnesota Press, 1993.

Sobczynski, Peter. "An Interview with Hal Hartley". *24 fps Magazine*, date unknown. http://www.24fpsmagazine.com/Archive/Hartley.html.

Sparshott, Francis. "Dance: Bodies in Motion, Bodies at Rest". In *The Blackwell Guide to Aesthetics*, edited by Peter Kivy, 276–290. Oxford: Blackwell, 2004.

Stambaugh, Joan. *Nietzsche's Thought of Eternal Return*. London: Johns Hopkins University Press, 1972.

Stanislavski, Constantin. *An Actor Prepares*. Translated by Elizabeth Reynolds. London: Methuen, 1980.

———. *Building a Character*. Translated by Elizabeth Reynolds. London: Methuen, 1979.

Stern, Lesley, and George Kouvaros. *Falling for You: Essays on Cinema and Performance*. Sydney: Power, 1999.

Sterritt, David. "A Hollywood Monster Movie with International Flair". *Christian Science Monitor*, March 29, 2002. http://www.csmonitor.com/2002/0329/p15s03-almo.html.

Stevenson, Robert Louis. *The Strange Case of Dr Jekyll and My Hyde and Other Tales of Terror*. London: Penguin, 2002.

Stewart, Garrett. *Framed Time: Toward a Postfilmic Cinema*. Chicago: University of Chicago Press, 2007.

Thompson, John O. "Screen Acting and the Commutation Test". *Screen* 19, no. 2 (1978): 55–69.

Thompson, Kristin. "The Concept of Cinematic Excess". In *Film Theory and Criticism: Introductory Readings*, edited by Leo Braudy and Marshall Cohen, 513–524. 6th ed. Oxford: Oxford University Press, 2004.

Thomson, Patricia. "A Futuristic Farce in Manhattan". *American Cinematographer* 86, no. 3 (2005): 99–100.

Thoreau, Henry David. *Walden*. New York: Houghton Mifflin, 2004.

Tomasulo, Frank P. "'The Sounds of Silence': Modernist Acting in Michelangelo Antonioni's Blow-Up". In *More than a Method: Trends and Traditions in Contemporary Film Performance*, edited by Cynthia Baron, Diane Carson, and Frank P. Tomasulo, 94–125. Detroit: Wayne State University Press, 2004.

Tomlinson, Doug. "Performance in the Films of Robert Bresson: The Aesthetics of Denial". In *More than a Method: Trends and Traditions in Contemporary Film Performance*, edited by Cynthia Baron, Diane Carson, and Frank P. Tomasulo, 71–93. Detroit: Wayne State University Press, 2004.

Travers, Peter. "No Such Thing". *Rolling Stone*, April 25, 2002. http://
www.rollingstone.com/reviews/movie/mid=2043858.

Turner, Victor. *The Anthropology of Performance*. New York: PAJ, 1988.

———. *From Ritual to Theatre: The Human Seriousness of Play*. New
York: PAJ, 1992.

———. *The Ritual Process: Structure and Anti-Structure*. New York:
Aldine, 1969.

Viera, Maria. "Playing with Performance: Directorial and Acting Style
in John Cassavetes's Opening Night". In *More than a Method: Trends
and Traditions in Contemporary Film Performance*, edited by Cyn-
thia Baron, Diane Carson, and Frank P. Tomasulo, 153–172. Detroit:
Wayne State University Press, 2004.

Wexman, Virginia Wright. "Kinesics and Film Acting: Humphrey Bog-
art in The Maltese Falcon and The Big Sleep". In *Star Texts: Image
and Performance in Film and Television*, edited by Jeremy G. Butler,
203–213. Detroit: Wayne State University Press, 1991.

Williams, Christopher. "After the Classic, the Classical and Ideology:
The Difference of Realism". *Screen* 35, no. 3 (1994): 275–292.

Williams, Linda. "Film Bodies: Gender, Genre and Excess". *Film Quar-
terly* 44, no. 4 (1991): 2–13.

———. "When the Woman Looks". In *The Dread of Difference: Gen-
der and the Horror Film*, edited by Barry Keith Grant, 15–34. Austin:
University of Texas Press, 1996.

Willis, Holly. "From Mags and Gates to Bits and Chips". *The Inde-
pendent*, November 1, 1999. http://www.independent-magazine.org/
node/446.

———. *New Digital Cinema: Reinventing the Moving Image*. New
York: Wallflower, 2005.

Wise, Sophie. "What I Like About Hal Hartley, or Rather, What Hal
Hartley Likes About Me: The Performance of the Spect(actor)".

In *Falling for You: Essays on Cinema and Performance*, edited by Lesley Stern and George Kouvaros, 243–275. Sydney: Power, 1999.

Wood, Aylish. *Digital Encounters*. Abingdon: Routledge, 2007.

Wood, Jason. *Hal Hartley*. Harpenden: Pocket Essentials, 2003.

Wood, Robin. "An Introduction to the American Horror Film". In *Movies and Methods*, edited by Bill Nichols, 2:195–220. Berkeley and Los Angeles: University of California Press, 1985.

Worringer, Wilhelm. *Abstraction and Empathy: A Contribution to the Psychology of Style*. London: Routledge & Kegan Paul, 1967.

Wyatt, Justin. "The Particularity and Peculiarity of Hal Hartley: An Interview". *Film Quarterly* 52, no. 1 (1998): 2–5.

Zucker, Carole. "Passionate Engagement: Performance in the Films of Neil Jordan". In *More than a Method: Trends and Traditions in Contemporary Film Performance*, edited by Cynthia Baron, Diane Carson, and Frank P. Tomasulo, 192–216. Detroit: Wayne State University Press, 2004.

INDEX

Lightning Source UK Ltd.
Milton Keynes UK

176987UK00001B/70/P